THE
ARTIST
OBSERVED

28 Interviews with Contemporary Artists

JOHN GRUEN

a cappella books

© 1991 by John Gruen

a cappella books
an imprint of
Chicago Review Press

Editorial offices:
PO Box 380
Pennington, NJ 08534

Business/Sales offices:
814 N. Franklin St.
Chicago, IL 60610

Editorial coordinator: Richard Carlin

Cover and interior design: Fran Lee

The interviews with Michael Heizer, Lucian Freud, Pierre Alechinsky, Agnes Martin, Lucas Samaras, Roy Lichtenstein, and Jim Dine are reprinted by permission of *ARTnews Magazine*.

Library of Congress Cataloging-in-Publication Data

Gruen, John.
 The artist observed : 28 interviews with contemporary
artists, 1972–1987 / John Gruen.
 p. cm.
 Includes bibliographical references.
 ISBN 1-55652-103-0 : $19.95
 1. Artists—Interviews. 2. Art, Modern—20th cen-
 tury. I. Title.
N6490.G725 1991
709'.2'2—dc20
[B] 90-27645
 CIP

TO THE MEMORY
OF
KEITH HARING

BY THE SAME AUTHOR

The New Bohemia
Close-up
The Private World of Leonard Bernstein
The Party's Over Now
The Private World of Ballet
Gian Carlo Menotti: A Biography
Erik Bruhn: Danseur Noble
The World's Great Ballets
People Who Dance
Keith Haring: Radiant Child

CONTENTS

Author's Note vii
FRANCIS BACON 1
ROBERT MANGOLD 13
LARRY RIVERS 25
JACKIE WINSOR 39
RICHARD DIEBENKORN 51
JIM DINE 65
AGNES MARTIN 77
RICHARD LINDNER 89
RUFINO TAMAYO 99
RICHARD ANUSZKIEWICZ 115
MICHELANGELO PISTOLETTO 129
WILLIAM BAILEY 137
BRIDGET RILEY 151
SAUL STEINBERG 161
MICHAEL HEIZER 173
DOROTHEA TANNING 183
DAVID HARE 195
JACK YOUNGERMAN 207
ROY LICHTENSTEIN 219
LUCAS SAMARAS 229
CATHERINE MURPHY 239
GEORGE RICKEY 245
ROBERT RAUSCHENBERG 261
GEORGE SUGARMAN 275
RICHARD HAAS 285
PIERRE ALECHINSKY 297
DOROTHEA ROCKBURNE 307
LUCIAN FREUD 315

AUTHOR'S NOTE

I firmly believe that an artist's work is unalterably and utterly tied to his inner life. And to the way he lives, speaks, behaves, and feels—to the way he is.

All the artists represented in this collection—from those dealing in the abstract to those involved in the figurative, whether painters or sculptors—are people whose art is the sum and substance of their unconscious persona. Hear Agnes Martin speak of her love for distant horizon lines in the Southwest, and you can instantly conjure her translucent grids. Follow Francis Bacon on a journey of late night pub-crawling, and you'll soon encounter his bleary, reeling characters seen out of distinctly alert yet unfocused eyes. Just look at Saul Steinberg—the physical man—and there, without question, you'll meet the awkward logic of his line, texture, and wit.

The retinal games of Bridget Riley, the mammoth visions of Michael Heizer, the Brecht-Weill syncopations of Richard Lindner, or the angst-ridden subjects of Lucian Freud are all tied to some inner need—something so urgent and pressing that it could only be expressed through that odd activity known as making art.

These interviews, conducted over a period of more than 15

years, all fix on a certain moment in an artist's life and career. What an artist may have thought, felt, or produced in, say, 1975, 1980, or 1985 may not necessarily be what he thought, felt, or produced years later. And yet, interviews are the signposts that mark a particular stage in an artist's ongoing creative life. As such, they offer insights into the creative process and, more often than not, the mood and tenor of the times that fostered it.

Artists are extremely verbal. Practicing a silent, solitary art, they can get feistily argumentative or give vent to their most cherished passions. To hear an artist speak of his art is to know a person grappling with the unknown yet secure in the pursuit of a precisely felt vision. In constant battle with the elusive, the artist nevertheless gives shape and form to a reality that is uniquely his own. It is this confrontation with an ambiguous muse that lends poignant credence to Willa Cather's words, "An artist's saddest secrets are those that have to do with his artistry."

With the exception of my interview with Francis Bacon, published in British *Vogue,* all the pieces in this collection first appeared in *ARTnews Magazine.* I wish to thank Milton Esterow, its editor and publisher, for his faith in me, and Donald Goddard, Amy Newman, and Sylvia Hochfield for their friendship and keen editorial eye throughout the years. My special thanks to Richard Carlin of a cappella books for initiating this project.

John Gruen
New York, 1991

THE
ARTIST
OBSERVED

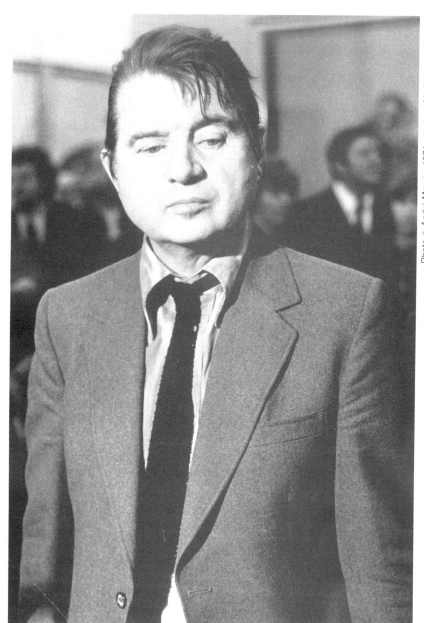

FRANCIS BACON

NIGHT

"Oh, Mary, Mary! It's Francis! She's come and brought a friend. How are ya, ducks? What'll it be, Francis? Champagne? Get out a bottle of champagne, Ian—the best, mind you. Oh, she says *two* bottles. What? *Three* bottles? Oh, Mary, she's treating us all. Get glasses for all, Ian. What's your friend's name? Well, isn't that nice. And a journalist, is she? From New York! You a queer or a straight journalist, ducks? The queerer the better, I always say. Well, when you get back to New York, say hello to Elaine of *Elaine's*; she's been here, you know. They've all been here. Ask Francis. And Francis has been coming around for 20 years, haven't you, Mary? Painted me too, and more than once, she has. In the early days, Francis waited behind this bar, for drinks, didn't she Ian? Then he got all rich and famous. But Francis Bacon always comes back. It's her second home, you might say . . . g'wan, Ian, pour another round of drinks—and open another bottle, and this one's on the house!"

Muriel Belcher. A proprietress to reckon with. She sits

regally on the first barstool of her tiny club, the Colony Club on Dean Street, Soho, London. Muriel is famous. She's been written up in all the smart London journals and papers—her place is littered with blowups of them—and invariably, the name Francis Bacon appears among the list of her famous and infamous habitués.

Wandering off, I look them over and find this quote from Bacon: "She dissolves the sexes so that they come together in a relaxed way to live out their hour's fantasy. Her language has become very exaggerated and she turns on 'He' and 'She' like 'Hot' and 'Cold' until she doesn't know who 'He' and 'She' is anymore, and that vaporizes the atmosphere for a start. She creates this state where people feel free to talk about themselves and their desires. I love her looks. I think she's extraordinary looking. She has a very grand air about her. There's something there that has come from an ancient world—perhaps the Babylonian world. I've learnt ways of approach from Muriel. She made me understand how to attempt, at least, to enchant."

Bacon has brought me to Muriel's in answer to a question I had asked him earlier that day. I had wanted to know how he lived. And he was showing me—standing here, chatting animatedly with Muriel in her rather sad little club where the atmosphere *is* exhilaratingly permissive, where the crowd of men (and perhaps three women) can be seen reflected in dusty mirrors, where their talk is washed over by the sound of a piano at which a handsome black man sings the gay and sentimental American songs of the '40s and '50s. "Play 'Lover Man,' " someone shouts across the room to Harry at the piano. And Harry sings the old throat-catching Billie Holiday song, and Francis Bacon turns silent, and listens. Then he moves to a corner where three young men of indeterminate background, profession, and apparel surround him, put their arms around him and speak to him in a Cockney that is as fast as it is unintelligible. There is an intensely familial air about this group crowding around Bacon. He seems to know all their secrets, and seems to share in their every concern.

One of them, a handsome red-headed fellow, brings him back to Muriel's barstool, and the three drink and gossip and laugh and make time stop. I look at Bacon. He is a slight man.

Standing in this semi-darkness, smoking and drinking and a bit shaky on his feet, he presents the image of an awkward teenager, aged 62. This duality in him—the stance, mannerisms and appearance of youth, and the reality of his age—combine to give his gestures a curious sense of timelessness, as though he had never quite experienced the process of growth, nor had ever laid claim to the calamities or ecstasies of young manhood. A time-vacuum seems to encircle him, very akin to those strange and fragile glass enclosures that frame certain figures in his paintings. But this is merely an outward image.

But now, Bacon has had a great deal to drink. His mind, however, is lucid. He leans close to me and says, "This is how I live. It doesn't *look* very violent, but somewhere it *is* quite violent. At least, under the surface. You see, I've never learned to live comfortably. Comfort is an unnatural state for me. The point is, I think that life is violent and most people turn away from that side of it in an attempt to live a life that is screened. But I think they are merely fooling themselves. I mean, the act of birth is a violent thing, and the act of death is a violent thing. And, as you surely have observed, the very act of living is violent. For example, there is self-violence in the fact that I drink much too much. But I feel ever so strongly that an artist must learn to be nourished by his passions and by his despairs. These things alter an artist whether for the good or the better or the worse. It *must* alter him. The feelings of desperation and unhappiness are more useful to an artist than the feeling of contentment, because desperation and unhappiness stretch your whole sensibility. And so, come . . . let's have more to drink. Another round, Muriel. Open another bottle."

But Muriel informs us that it's closing time: "Go on, the lot of you. Drink it down and be done with it. Got to close shop. Take all the queenies with you, Francis . . . take them along . . . take them on your bloody rounds. Goodnight, my beauties. Come back tomorrow . . . I'll be here to listen to all your tired old fairytales. Now get going!"

"We'll stop at The Londoner," says Bacon with a smile. Only the red-headed young man joins us. On the way, by taxi, the young man talks to Bacon about a scheme involving the opening of a private club. "It'll take money, of course," he says.

"But in no time we'd be rolling in it. Come in with me, Francis. I've got the connections, you've got the name. We'd be successful in no time. What do you say, Francis?" Francis only smiles in reply. There is no commitment. "Here we are," he tells the driver.

The Londoner, also in Soho, is more elegant than Muriel's, but doesn't begin to have the ambience or poignant seediness of The Colony Club. There is *one* familiar similarity, however. Harry, the black pianist, who only minutes earlier had sung his heart out at Muriel's, is presently doing the same at The Londoner. And the songs are all the ones we'd just been hearing. Bacon is instantly recognized by the bartender and by several of the guests. Once more he orders several bottles of champagne. Once more he is surrounded by a particular few men. But in a while he turns to me.

"I never think about happiness," he says out of nowhere. "I never think about happiness or unhappiness. Of course, there are times when a relationship with someone or with one's self gives one moments that make one happier. But it would be stupid, at my age, to think of happiness. Actually, I think about the most banal things, but they somehow all link up. As for people, I never hang out with artists, and I never hang out with writers. Artists and writers generally bore me. I like people who run clubs and gambling places. And I like crooks and villains. I remember living in Tangiers once—it used to be the playground of English crooks—and I knew a great number of them, and they were a great nuisance to me. But on the other hand, they had a kind of life and vitality about them that was far more interesting than any artist or writer I've ever met.

"You must understand, life is nothing unless you make something of it. I've learned, as life progresses, to become more cunning. I know where I would automatically go wrong, which I wouldn't have known when I was younger. Anyway, I've become more cunning both in my work and in my relation-ships. When I say cunning, perhaps it's the wrong word. I think *knowledgeable* is a better word, because, in fact, I don't like cunning people.

"Of course I suffer. Who doesn't? But I don't feel I've become a better artist because of my suffering, but because of

my willpower, and the way I worked on myself. There is a connection between one's life and one's work—and yet, at the same time, there isn't. Because, after all, art is artifice, which one tends to forget. If one could make out of one's life one's work, then the connection has been achieved. In a sense, I could say that I have painted my own life. I've painted my own life's story in my own work—but only in a sense. I think very few people have a natural feeling for painting, and so, of course, they naturally think that the painting is an expression of the artist's mood. But it rarely is. Very often he may be in greatest despair and be painting his happiest paintings."

DAY

I had been warned. An English acquaintance couldn't have been clearer: "Don't, for God's sake, talk to Francis Bacon. He's an awful man—perfectly dreadful, and not to be talked to. Besides, he's always pissed; God knows how he ever gets any work done. He's a sinister one, that Bacon. You'll have a ghastly time of it, I promise you. And if you *do* see him, which I doubt, you'll have to drink him under the table. He hangs out with the dregs of the world: crooks and perverts and jailbirds and thieves and, probably, child molesters. Don't waste your time on him. He's unbearable and he's hopeless!"

But on a sunny afternoon, Francis Bacon, undoubtedly Britain's greatest living painter, appears at my door on Chester Square. It may have been his gallery's persuasiveness that made him acquiesce to an interview. And so, Bacon appears at my door, wearing a suit and tie, looking oddly handsome, with his hair combed, his face cleanshaven, his fingernails in good repair—about as sinister-looking as an English choirboy. He smiles, says he hopes he isn't late, asks after my well-being in London, hopes he can answer my questions.

He accepts a Scotch, sits down on the sofa, and lights a cigarette. There is, to be sure, a certain diffidence—a certain sense of oblique alertness, perhaps even suspicion. He is clearly not one for small talk, and I sense the effort of his amenities. But his voice is gentle, his words are clearly and intelligently

articulated. No villainy seems to lurk behind his appearance or behavior. While he later confessed that he had braced himself with several drinks before our meeting, he appears far from drunk or tense or anxious.

And yet, anxiety, terror, and turmoil attend his every work: writhing figures on dirty, crumpled beds; snarling dogs; screaming, contorted faces; scenes of physical agony, misery, and despair spill with bloodcurdling accuracy and intensity upon his canvases. But these chilling dramas unfold with a miraculous economy of color and composition. The dynamics of a Bacon painting are formulated by means of an unerring instinct for the right pictorial thrust and gesture. The uniqueness of his style is based on a vision that concerns itself with precise, yet never photographic observation. It is a deeper form of reality, as acutely felt as it is observed. The terror it may engender is merely a byproduct of a clarity filtered through intuitions that unwittingly unmask the cores of fear—exposed nerve endings residing just beneath the skin. The results are invariably disquieting.

Oddly enough, Bacon disclaims any attempt to produce terror or anxiety in his work.

"These qualities of terror and anxiety that people so often talk about are the last things I've actually ever attempted to convey," he tells me. "I *have* attempted to be as realistic as I possibly can. If you really think about life, about realism, about a lump of meat on your plate, that, in itself, if you think about it, is a very frightening thing. And so, I've really been rather curious as to why people find my work ridden with anxiety. It is certainly not how I think about it. I've attempted to convey my own apprehension of images. I've tried to make images that would unlock the valves of feeling on different levels. For me, to be as realistic as possible has meant extreme deformations.

"For example, I'm very interested in trying to do portraits, which now is almost an impossible thing to do, because you either make an illustration or you make an abstract suggestion. The point is, you never know what stroke will make an illustration or a charged and meaningful appearance. It's a continuous hazard, chance, or accident. I don't know, for instance, when I start to work, how I can possibly do this thing.

I start, in a sense, almost like an abstract painter, although I hate abstract painting. I hate abstract painting because I think it can only end in decoration, since it's very often pretty and very attractive. But this dilemma I have about painting portraits . . . how are you going to make a nose and not illustrate it? What stroke will make this nose a strong nose? Well, it's chance. It is when, for a moment, chance has given you something which you can seize on, and begin to build on. All the way through, on anything of mine that works at all, it is like an accident that has slid into the right position.

"But I must insist that my subject matter is *not* negative. I've done one or two male nudes with a hypodermic syringe in the arm, it's true, but I've used the hypodermic syringe like a rivet of reality—to rivet the body further back—to make one more aware of the body—to give the body a heightened sense of reality. Or the triptych I once painted in which one of the figures has a red swastika band around his arm . . . well, I happened to be looking at some Nazi photographs, and I thought that the armband would have a meaning for me only in the sense of making the figure hold together more roundly. I'm sure I shouldn't have added the swastika, but there you have it. I just used it as a vehicle of chance. The point of it is that I never try to "say" anything. I'm only suggesting to myself, 'How can I touch on ways of making this thing more immediate and more real.'

"Actually, I always know what I want to do, but I never know how to do it. I plan, I think, I lay down all sorts of plans for myself about how it will be, or how it will look, but as I'm so reliant upon accident, it takes a long time for the accident to happen—for the sensation I want to come about. It takes a long time to make my plans fall into the form of reality that will satisfy me. I don't begin by drawing on the canvas. I make marks, and then I use all sorts of things to work with: old brooms, old sweaters, and all kinds of peculiar tools and materials. I know my paintings don't look like that, but they start out like that, because, you see, otherwise I should be making only illustrations.

"So that is the dilemma—perhaps the dilemma of all art today—because if you *know* how to do something, it's going to

be just an illustration of an idea, and that's not at all what I'm after. To tell you the truth, I can't explain my art, or even my working methods. It's like the person who asked Pavlova, 'What does the Dying Swan signify?' and she answered, 'If I knew, I wouldn't dance it.' "

Francis Bacon accepts another drink. He shifts restlessly. I ask him why so many of his faces or portraits suggest a frightening and terrifying scream. "That has absolutely to do with two things," he answers. "When I first started to paint, I bought a little book in Paris which had rather beautiful color illustrations of diseases of the mouth, and it affected me very much; and then, of course, I was very much influenced by the screaming nurse in Eisenstein's film *Potemkin*. And so, these screaming heads have really nothing to do with Expressionist ideas. What I was after was the marvelous glitter of the mouth—you know, the saliva and the teeth and the color of the inside of the mouth—that sort of thing, and nothing more.

"You see, when one is right inside the work, and if it seems to be going, when the form and image is coming up to some kind of reality, then it's very stimulating and exciting, because that's when you bring things nearer to the nervous system. You must understand that I don't paint for anybody except myself. I'm always very surprised that anybody wants to have a picture of mine. I paint to excite myself, and *make* something for myself. I can't tell you how amazed I was when my work started selling!"

"And how do you live?" I ask him.

NIGHT

After Muriel's Colony Club, and after The Londoner, and after nine bottles of champagne drunk by a quantity of people—but mainly by ourselves—Francis Bacon suggests another club, a club without a name. The taxi ride is very long. The smell of the London waterfront is all-pervasive. The red-headed man is still with us. Drink has fatigued us, but we are nonetheless buoyant—that familiar floating-in-air feeling. In the taxi, Bacon's friend resumes his quest for Bacon's partnership in a

private club. But to no avail. Bacon cajoles him into other topics. "How's your mum?" he asks. "She's still poorly . . . got to be with her all the time. . . ."

The taxi speeds to its distant destination. It is past 2 A.M. The streets are empty. London sleeps, but not at this dark and dreary club, a very large and very sinister place. It is filled to capacity and stifling. Its occupants seem comprised of London's murky underworld. A giant of a man cautiously lets us in. Again, Bacon is welcomed at once. In a moment, a short, fat, squat man—perhaps the proprietor—comes to greet us. His features have a quirky, somnambulistic look—a look reminiscent of Mongoloid heads with their blank, unfocused, sleepy eyes. But he is incredibly verbal, spewing forth Cockney verbiage too fast and too thick for me to comprehend. Bacon listens intently. The red-headed man finds a group of friends who come to join us. In the haze and heat of the place, they seem eerie, furtive, tainted creatures, men bearing the looks of criminals. Amidst them, Francis Bacon assumes their characteristics—some disturbing and potent element intensifies and curdles his appearance. He has become a Francis Bacon painting.

We all stand in an ill-lit corner of the vast room. Drinks are brought by a blonde, forlorn-looking waitress. Bacon begins to sway, but his mind is still lucid. Suddenly he turns to me and says, "Did you know that my father trained horses in Ireland? My family wasn't the least bit interested in art. I was born in Dublin but I'm not Irish. I lived in Dublin until I was 16. I left home. I never got on with either my mother or my father. Then, in 1928, I went to Berlin. Christopher Isherwood's books on Berlin are really very gentle and gentlemanly versions of what Berlin was like then—because even at the moment I was there, it was not in its full, splendid decadence. It was already feeling the beginning of the Nazi movement. But nevertheless, it was the most extraordinary place. It was curious to go from Dublin to Berlin. Anyway, I then went to Paris, and I drifted around and did odd jobs, and suddenly, one day I thought, 'Well, I'll try and paint.' I'd already reached the age of 30.

"I've had the luck of never having gone to an art school. Of course, they can't teach you anything at an art school. It's sad to see the young people studying at art schools today. They have

this feeling that something will be unlocked in them. But there is nothing. They must find everything for themselves. There is no way of helping them. Oh, you can talk to them, and they can tell you how they feel about things. I thought that when American art had first struck the youth of England *something* would have happened. But nothing did. Of course, they came very much under the influence of de Kooning and Pollock and people like that. I think that what these artists did was a necessity for *them*. And yet, when I saw their work, I nearly always found it very empty. I never thought the artists themselves were empty. I once met de Kooning and he wasn't empty at all, but I always found his work very empty. I mean, even his realistic things have very little depth.

"And Rothko. I was terribly disappointed when I saw his work when it came here to London. I expected to see marvelous abstract Turners or Monets. But you see, in an odd way, the very fact that you don't have subject matter leaves the paintings *too* free. In theory it should work, but in practice it hasn't worked out, because too much free-fancy can take over, and you can't just make a decorative image. It's just not possible. I suppose something marvelous will eventually come out of American abstract art. It had a vitality—a marvelous vitality— the way those artists put paint on canvas. It had that living quality. Kline had it—they all had it, and that was marvelous. It should have taught young artists a lot of things, but the trouble was it didn't lead anywhere; it just stopped dead in its tracks. I suppose Jackson Pollock was the most gifted, and yet, even with him, when I saw his work, I found it to be a collection of old lace. Strange!"

Bacon's eyes are red with drink and fatigue. He empties another glass. "Look around you," he says. "This is where I live, this is where I feel at home. You can bet I'll never be offered a knighthood with the sort of life I lead. God knows, I'd run a mile from it. I wouldn't want anything *that* awful to happen to me. You know, a publisher once said to me, 'I'll give you any amount of money if you would write the story of your life.' Well, I couldn't do it. Firstly, you'd have to be a Proust. You see, anybody just putting down things—the relationships they've had, and so forth—is really very boring. It's only when

you can turn it into something very remarkable, the way Proust has done, that it would be worthwhile. Finally, to write about my life would only amount to a bit of gossip—do you know what I mean? Just a bit of gossip.

"I've had a funny kind of life. What I've learned is that we each have a unique way of feeling. It's like everyone's face being, finally, different. But I'll tell you one thing. I think I could easily become a drunk. But as I want to work, I don't allow that to happen. Also, I gamble much too much. Actually, I'm the most ordinary person possible. It's just that I like throwing myself into the gutter. Every artist wants to throw himself into the gutter—it's part of his life—it's a necessity.

"And life is more violent along the gutters, and more meaningful and more richly to be experienced. But, as I say, I drink and I gamble too much. I gamble, and in the long run I lose. You might say that I lead a kind of gilded gutter life. I drift from bar to bar, from gambling place to gambling place . . . and when I don't do those things, I go home and paint some pictures."

1972

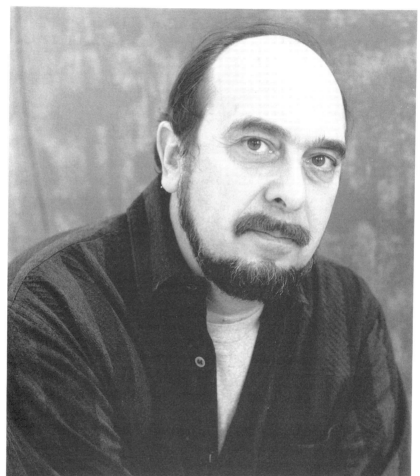

ROBERT
MANGOLD

Where did they spring from, the Minimalists?
I don't mean stylistically: I mean as people. Can we trace their aesthetic predilections to family background? Was the system of their thinking austerely conceptual at an early age? Were there early philosophic, metaphysical, or metaphoric insights that would ultimately produce the lean rhetoric of their imagery? Or was it a reductive trauma that set their Minimalism in motion?

In the case of Robert Mangold, one of the most celebrated Minimalist painters, no such questions apply. He refreshingly admits that as a youngster he wanted to be another Norman Rockwell. Growing up in the country—in North Tonawanda, near Buffalo, New York, where he was born on October 12, 1937—Mangold thought of becoming an illustrator. He wanted to do magazine covers like Rockwell. He liked the idea of magazine illustration, because magazines appeared on the newsstands every week or every month. It was a very visible art form.

As for family background, it was as homespun and rural as a Rockwell cover. "My mother played the piano and the organ, and she did quilting," says Mangold. "My father worked in the

Wurlitzer organ factory. But we also had a small family farm. We grew our own vegetables. Mother canned. We had a little stand out in front and sold vegetables. I had an uncle who was a fruit farmer, and I worked for him during the summers. Another uncle was a dairy farmer, and I worked for him as well. It was country living."

Clearly, Robert Mangold was not to the Minimalist manner born. Indeed, even to this day he finds it almost impossible to ascribe a raison d'être for the way his work looks, the way it's made, or what its content or meaning might be.

"I have the hardest time writing statements," says the artist. "I have a hard time defining what I'm doing and the way I'm doing it and the reason I'm doing it. I mean, I work with an idea for a couple of years and then go on to something else. To keep the work alive, I have to make shifts here and shifts there. And then, when I make those shifts, I'm preoccupied with realizing the image. But when I do these things, I don't think philosophical thoughts. I simply keep involved. And I *am* involved in the making of art. I'm a maker of images. But as far as any philosophical or metaphysical or spiritual implications are concerned, I have no connection with any of that."

How then does one become a Minimalist painter?

For Mangold, it was a process of exploration and elimination. In high school he discovered he had an ability to draw. His teachers encouraged him and told him he should go to art school. He soon wrote letters applying to New York's Pratt Institute, the Chicago Art Institute, and the Cleveland Institute of Art.

"Cleveland was the only school that wrote back," Mangold remembers. "They said, 'Why don't you come and visit us?' I did, and it looked great to me. They had a four-year program that not only included painting and sculpture, but commercial art, weaving, pottery, automobile design, and so forth. So I decided to go to Cleveland. My parents approved, because I was brought up with the idea that all the decisions in life were mine. As it turned out, I was the first person in my family to go to college."

In the fall of 1956, Mangold journeyed to Cleveland and duly enrolled in the Institute's illustration department. By the

second year, however, he gravitated toward the fine arts division, deciding that its students and teachers were livelier and more interesting. Switching departments, he now took up painting, sculpture, and life drawing. The goal was to become an art teacher.

"Around 1957, some of the students in my painting class and I drove up to the Carnegie International in Pittsburgh. It was my first exposure to contemporary painting. A great many of the Abstract Expressionists were represented, and that show absolutely turned my life around. I mean, I remember going up the elevator and getting off on a floor that had this great big room filled with Willem de Kooning, Adolph Gottlieb, Franz Kline, and Jackson Pollock and, suddenly, I was confronted with something I had never been exposed to before. The experience was powerful and moving."

Mangold was stunned by works that seemed literally to free him—to make him feel that in art *anything* was possible— that the language and vocabulary of the painter could be as diverse, daring, and radical as any artist of imagination chose to make it. Naive as he admitted to being, Mangold instinctively realized that to make art was to be in touch with one's most creative and mysterious self.

"Of course, the minute I got back to Cleveland, I started painting like the Abstract Expressionists. I was doing these large canvases—all conjunctions of the stuff I had seen in Pittsburgh, plus a goodly dose of Alberto Burri and Antoni Tapies, both of whom were also represented in that show. I don't know what the faculty felt, but here was this potentially good realist painter going off the deep end. The point was, I was exploring things—trying to make some sense out of what I was feeling and thinking."

When Mangold concluded his studies in Cleveland, he had been painting canvases charged with an energy based more on enthusiasm than knowledge. As he put it, he was attempting something about which he knew very little: "I didn't have the foundations. I didn't know what that art was based on or came out of. I went from a literal realism to a contemporary mainstream, and it just didn't look right. It seemed imitative and kind of empty."

Before he graduated from Cleveland in 1959, Robert Mangold had won a Summer Art Fellowship at Yale University, a happenstance which led to his being accepted into Yale's graduate school in 1960. He emerged from Yale with an M.F.A. in 1962.

"I was actually a bit hesitant about going to Yale. The fact was, I wasn't very interested in Josef Albers and his theories and, at the time, Albers *was* the Yale Art School. Still, Yale had a great art history department and, best of all, it was close to New York. I knew I could educate myself at Yale—could, finally, learn all about contemporary art. So off I went to Yale. I read voraciously, and what I read strongly affected my work. When I read books on Cubism, my paintings became very cubistic. When I studied Surrealism, they became surrealistic— that sort of thing. It was my way of digesting it all.

"I also started going to the Museum of Modern Art, and that was a revelation. So little by little, my work assumed a greater cohesiveness. What was interesting is that, throughout all my experimenting, there was a sense of structure—a two-dimensionality. Everything was kind of right angles to the sides, sectioning the canvas like a Gottlieb pictograph. It was an interesting discovery."

Clearly, Yale was a breeding ground for ideas, and its atmosphere of learning provided Mangold with a heretofore missing sense of self-reliance and security. If he had not yet discovered his own voice, a breakthrough was at hand, not only in matters of art, but in his personal life as well. At Yale, Mangold met Sylvia Plimack, a fellow painting student. They were married in 1961. Upon their graduation, the young couple moved to New York.

"It was 1962, and it was a new starting point. I was very glad to be out of school. In New York, Sylvia and I began making friends. We were introduced to people, and we started making a life. During the early '60s, things were in a ferment. Everything seemed to have turned over in the art world. Abstract Expressionism was drying up, and the Pop Art movement was riding high. People like Jasper Johns, Robert Rauschenberg, Andy Warhol, and Roy Lichtenstein were

coming up. Also, at the time, galleries were still looking for young artists. In a way, everything was possible.

"Sylvia and I continued to paint. We also found a job as superintendents of a fancy little apartment house. It was on 72nd Street, between Madison and Park Avenues. It was a terrific job—and we had a place to live. Sylvia also got a job at an art supply store, and I worked as a guard at the Museum of Modern Art. Being a guard was great, because you didn't begin work until late in the day. It's funny, but a lot of Minimalist artists worked as guards at MOMA. I met Robert Ryman and Sol LeWitt there, working various shifts. Dan Flavin had been a guard the month before I started. Anyway, being a guard was interesting, because you'd come in each day and be faced with all that art! You'd stand there for hours, and some of the greatest paintings began to pall. You just couldn't look at them anymore. But the one painter I never tired of was Piet Mondrian; he kept looking better and better. So I was a guard for a couple of months, and then I landed a job at the MOMA library, where I worked for about a year."

The move to New York eventually inspired a drastic change in Mangold's work. By 1964, all aspects of his former imagery disappeared. Having studied, digested, and executed the widest possible range of contemporary painting, he was now convinced that for him the road lay in the starkest, most astringent form of simplicity. It would be a matter of throwing everything out and starting from the most elemental position possible. The work would be about flatness and edge, and the oscillating relationships of edge to interior space. It would be about the most minimal series of elements producing a new and rarefied totality. Thus it was that Robert Mangold became a so-called Minimalist painter.

"Suddenly, I felt very good about what I was doing. In 1965, after playing around with ideas about arbitrary composition and investigating concepts of scale and part-to-whole relationships, I had my first one-man show at the Fischbach Gallery. I called it *Walls and Areas*. The pieces were very simple four-by-eight sections built out of masonite or plywood. Some were painted very opaquely and they resembled wall sections.

Then there were some that had a sprayed surface and had more
of an atmospheric quality. They looked very architectural. You
see, I was investigating all kinds of things for myself."

It was during this period—the year between 1965 and
1966—that the Jewish Museum mounted the first major exhibi-
tion of Minimalist work, a show that pointedly omitted the
Minimalist painters Mangold, Ryman, and Brice Marden,
among them.

"The Minimalist movement was developing very quickly,
but the decision was to define Minimalism as a sculptural
movement. That was the direction, because most of the exciting
things seemed to be happening in sculpture. So painting, for
whatever reason, was out. I can remember at the time people
saying that painting was dead. I must say, I felt very strongly
connected to the sculpture, even though I wasn't interested in
it for myself. But I was very interested in what the sculptors
were doing."

Indeed, even as the sculptors took center stage, Mangold
continued to explore his own increasingly refined brand of
Minimalism. In 1967, he once again showed at Fischbach, this
time with works based on sections of a circle. There were half
circles, quarter circles, and other kinds of segments of circles.
Color was relegated to a very minor role in these works. The
emphasis was on the subtlest delineation of form in serial
progression. Continuing to paint on boards and masonite,
Mangold's imagery was intended to be perceived as a contin-
uum in which the sequence of imagistic events formed the
whole.

Throughout the years, Mangold and his wife had easily
integrated their lives within the art world of the '60s. Mangold's
job at MOMA had given way to a permanent teaching post at
the School of Visual Arts. Both artists were developing their
distinct styles (Sylvia Plimack Mangold was then producing
highly accomplished figurative work which would eventually
focus on large night-time landscapes usually framed by bands
of illusionistically painted masking tape—a tantalizing combi-
nation of trompe l'oeil with atmospheric realism). In 1963, the
Mangolds had become parents of their first son, James. A
second son, Andrew, was born in 1971. In 1969, Robert

Mangold received a Guggenheim Fellowship, and with it came a significant change in the couple's lifestyle.

"A lot of things happened all at once," recalls Mangold. "For one thing, Sylvia and I had moved from one studio to another. Sylvia didn't have much space to paint in, and she was pregnant with our second child. She had just begun to show. I had shown for several years, but hadn't sold much. Also, New York and its art world was sort of getting to me, and I wanted to get away from the city. So we used the Guggenheim money to buy a house in the Catskills. It was a bit far, but finally, it worked out very nicely. I would commute and teach. We lived there for about five years. Then we moved to Washingtonville, New York. We've been living there ever since."

Removing themselves from New York proved both felicitous and somewhat disquieting. Mangold associated living in the country with growing up and farming. He was fearful that it would affect his work adversely. But his need to get away far outweighed his qualms.

"It was the art world. I needed to get away from it. There was this total preoccupation with careerism, and I just felt less and less connected to the situation. I didn't want to be involved with who was on the cover of such and such magazine or who was writing this or that article—and why wasn't I mentioned? And yet that seemed to be the inescapable factor among artists in the city. Also, there were all those political assassinations, and there was Eva Hesse's death, which was very disturbing to me. And there was that other business. All of a sudden there was interest in my work from Europe. Dealers would come to the studio. It was like a parade. Your studio wasn't your own. You had to hide things that you didn't want people to see. It was crazy. I felt the need for seclusion rather desperately. I don't know about Sylvia. I think she liked the idea of having more space, but I don't think she felt the need to get away as strongly as I did. Actually, I don't know that I still feel that way. I could probably live in New York now."

But in the country, work progressed with ever increasing originality. Among the first works Mangold executed there were very large polygon-shaped canvases with big elliptical circles touching the edges. They represented a major shift in

direction; until the late '60s, Mangold had been more concerned with a conceptual, systematic approach to imagery. These new, highly emblematic works were also executed as a reaction against the sequential paintings Mangold had made on boards and masonite. He now wanted to go back to painting on canvas, and he wanted the single work of art to make the complete statement.

"I was also beginning to think of how color would play a role. Up until then I would designate one color to a whole series of works. But at this point, I wanted to think of a specific color for each work. Also, the pencil became the sectioning tool. So from around 1970 on I did these single canvases in various shapes, and I also switched from using oils to using acrylics, and I rolled on the paint instead of spraying it. This all lasted until around 1977. I worked steadily, and there were no dramatic shifts in the work. In the meantime, I began showing at the John Weber Gallery—that was in 1972—mostly because a lot of my friends were there: Sol LeWitt, Carl André, Dan Flavin, and Bob Ryman.

"Then, around 1977 a shift *did* occur. My way of working from the '60s to the mid-'70s was that I would work on little masonite models. That would be my preparatory work. But in 1977, I started using sheets of paper for my preparatory work, and I'd use the brush on the paper—I'd brush the color on it. Then, on the painting proper, I'd go back to using the roller. But I found that something was missing, and what was missing was the surface effect I had gotten on the paper when using the brush. I very quickly realized that the brush surface was necessary. There was a need for the surface of the paintings themselves to be more tangible, more tactile, more *'there.'* So I began using the brush instead of the roller."

If ever so subtly, the visible hand of the artist was now in evidence. Mangold's paintings assumed a Minimalism charged with a certain human presence. Surfaces, now sensitized by brush strokes, possessed an understated glow—a fragile shimmer that lent implied depth to the still rigorously Minimalist imagery. This, added to a positively lyric use of color—mustard yellows, chocolate browns, dove grays, sky blues—turned each of the canvases into reductive hymns to Matisse.

The geometry of Mangold's work solidified dramatically in 1980. He had been painting × marks and plus marks within canvases of various geometric configurations. Continuing to manipulate the × s and pluses in differing and disparate ways, he slowly saw them emerging as actual × -shaped canvases and plus-shaped canvases. The boldness and clarity of these new paintings, with their strong allusions to *De Stijl* and Constructivism, next gave way to works the artist calls *Frame Paintings*. Here, Mangold constructed variously shaped and colored canvases resembling actual frames. When you hung the "frame" on the wall, the wall itself became the central image—a framed wall area now fully integrated within the work.

In May 1986, Robert Mangold began exhibiting at the Paula Cooper Gallery in Soho. His first show there was yet another departure within a still rigidly maintained Minimalist vocabulary. The most startling difference was in the brushwork. Vigorously scumbled, it produced surfaces of surprising agitation, as though Mangold were trying to break through the barriers of a self-imposed emotional distance.

"They're kind of crazy, those pictures," he says. "The shapes are quadrilateral, each side having a different dimension. Within these shapes I've drawn a kind of elliptical, egg-shaped figure that touches all four sides, but is symmetrical. They're very brushy and each is in a different color: ochre, yellow, green, orange, and blue-gray."

How, in effect, does Mangold view his work within the context of art-historical references? As a Minimalist painter, what are his art-historical allegiances?

"I would say that between the '60s and '70s it was very important to keep your allegiances and sources American. There was that sense that American art was very different from European art. During that period, European art was still the enemy. You didn't want to deal with Matisse color or Monet color. Then, during the '70s, there was a kind of reconnection to Europe.

"The thing that's more peculiar to me than to a lot of other artists is that I never could find a connection that I felt strongly about in my work before the 20th-century. In other words, when I went to a museum I was mostly bored except for the

20th century area. I thought there was something wrong with me not being able to make that connection. It wasn't until I discovered Europe—and obviously it was there all the time—that I made a strong connection with early Italian painting—the pre-Giotto period. Those panel paintings of the 13th and 14th centuries interested me a lot. The thing is, I had no connection to illusionism. So the mode after Giotto didn't interest me. Of the 20th-century painters, Mondrian is still important to me. And I appreciate his work more and more as the years go by. Matisse would be another painter like that."

Finally, does Mangold perceive any inherent dangers in Minimalist art? When does a Minimalist work become boring?

"When it gets too elegant. I never like my work to get too elegant. Real elegance has a way of making me nervous. If I make a series of works that in retrospect seem too elegant to me, I usually make a turn from that point and roughen them up somehow. Elegance is something I very consciously try to avoid. When it happens in my work, I usually sense it and do something about it. As I said, I'm mainly preoccupied with realizing the image. When all is said and done, I am a maker of images—nothing more and nothing less."

1987

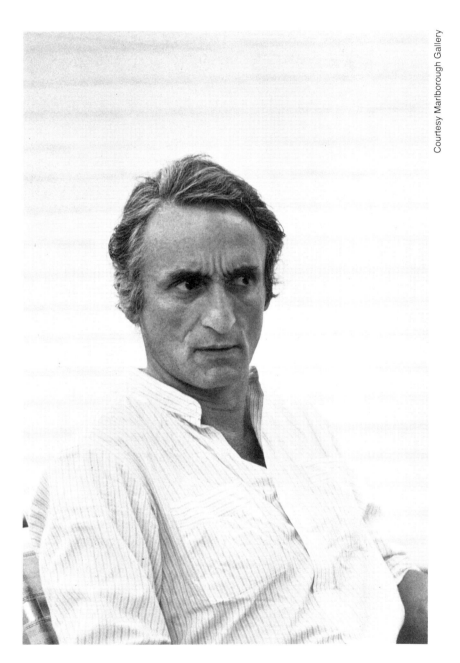

LARRY
RIVERS

The sound emanating from Larry Rivers's studio on Little Plains Road in Southampton, New York, on a hazy afternoon in August announced that the artist was in one of his musical moods. It was the lemony wail of a saxophone, an instrument Rivers once played professionally with such '40s bands as Shep Fields, Jerry Wald, and Johnny Morris. Today, however, the saxophone serves as a sentimental indulgence— an object of affection to be picked up and blown when the spirit moves him.

As it turned out, Rivers was playing his sax to an audience of one—a pretty, dark-haired girl seated on a couch, her head nestling in a pillow. It was not so much a jazz improvisation as a one-sided dialogue the subject of which seemed charged with erotic overtones. A visitor could only surmise that Rivers was in the act of making musical love to an entirely enthralled listener. When it was over, introductions were made and the dark-haired beauty, now stirring from her cozy position, was identified as Sivia Loria. Within minutes, a handsome, casually dressed man in his 30s appeared from some unseen corner of the studio. This was Sivia Loria's husband, Jeffrey, one of River's most avid collectors.

Indeed, Jeffrey H. Loria, a private dealer and collector, had some months earlier commissioned Rivers to paint two mammoth canvases for which, sight unseen, he paid the artist a fortune—a six-figure sum, which no one would name, but is probably in the vicinity of half-a-million dollars. These two canvases measuring 9 × 12 feet each are *Golden Oldies I* and *Golden Oldies II*, and they represent a nostalgic return to River's own creative past—a potpourri of familiar paintings and drawings the artist had executed during the '50s and '60s.

An unkind critic might call these two works the products of a drowning man seeing his life flash before him. But to call Larry Rivers a drowning man would be to underrate an artist who, since 1949, when he held his first one-man show at New York's tiny Jane Street Gallery, has emerged as one of the country's most volatile, unpredictable, and enduring artists.

Rivers says that *Golden Oldies I* and *II* were inspired by recent television commercials which sell record albums of well-known singers of the past at discount prices.

"I saw those dopey ads of, say, Tony Bennett singing 30 seconds of one song and 30 seconds of another song, while the titles of his greatest hits roll down the screen. This was the man's life as a professional singer and those snippets of songs were the golden oldies with which his career had been associated. So I said to myself, 'This idea is so corny I'm going to use it too. I'll put snippets of my best known paintings and drawings on a big canvas and it will be the golden oldies of *my* life.' Of course, once I started, it became a marathon project and it involved a terrific amount of work. I mean, I had to look back at 20 years of stuff I hadn't really given that much thought to, and the experience was pretty weird."

In effect, *Golden Oldies I* includes, in collage fashion, works done during the '50s: *Washington Crossing the Delaware, Cedar Bar Menu I, French Money,* and over a dozen drawings of the period. *Golden Oldies II* centers on works of the '60s, including *The Last Civil War Veteran, Dutch Masters and Cigars, French Vocabulary Lesson, The Greatest Homosexual, Camels,* and various drawings.

This autobiographical panorama marks the return of Rivers as draughtsman and pre-Pop arbiter of familiar subject matter transmuted into personal statement. Instead of being a re-

interpretation of former sensibilities, it is, in a sense, a confirmation of Rivers at his most lyrical, poetic, and independent—the Rivers who, during the early '50s and in the face of the rising tide of Abstract Expressionism, chose to follow his own highly idiosyncratic path. Thus, these golden oldies, zigzagging and careening across the canvas, find Rivers not so much re-evaluating or re-inventing his work as placing it within a context of memory and nostalgia. Indeed, even as the images took shape, colliding, juxtaposing themselves, and exploding into a new reality, River's own mind seemed to reel with the life-associations they so vividly evoked.

Says Rivers, ''There I stood, figuring out what pink to use while I was putting in the *French Vocabulary Lesson,* which I painted in 1962 and is really a portrait of my wife Clarice, when I began thinking about her—remembering certain arguments we had . . . certain times when I had gone on drugs and she had left me for a while. And when I put in the French words, I remembered how we had gone to study French together at the Alliance Française before going on a trip to Paris and how, maybe, if she had been a smarter woman we might still be together. So I thought about her and about our two daughters and how life changes. Now she's in Greece . . . but is she happy? When I put in Clarice's face I thought, 'Wouldn't it be great if she were here because then I'd really get a clearer portrait of her, maybe make it better.' So that all came back to me.

''When I put in *The Greatest Homosexual,* I remembered how a gay friend of mine asked me, 'Why did you call it that?' So I thought about it, and remembered how, on my way back from Europe in 1964, I stopped in Washington and went to the National Gallery and saw David's *Napoleon in His Study*. I looked at it and decided to do a painting of it. Well, the pose in which David put him or the pose Napoleon chose for himself had a particular look to it. It was a certain satisfaction with his body, and I thought, 'That's very gay looking.' Then I thought, 'If Napoleon were gay, he's probably the greatest homosexual in the world.' ''

And so, as Rivers reminisced, the film of memory was replayed in the artist's mind—a film that had actually begun on

August 17, 1923, in the Bronx, New York, where Larry Rivers was born and named Yizroch Loiza Grossberg, the only son and eldest child of Samuel and Sonya Grossberg. The child's father was a plumber and later owned and operated a small trucking firm.

By 1940, Rivers had embarked on a career as a professional jazz musician, a career which was later intensified when he took courses in composition at the Juilliard School of Music. Touring with various bands, he developed a close friendship with Jack Freilicher, a fellow jazz player, then married to the painter Jane Freilicher. It was through Jane Freilicher that Rivers came into contact with the world of painting. Later, she and the artist Nell Blaine urged him to attend classes given by Hans Hoffmann in New York and Provincetown.

"That was around 1947," recalled Rivers. "Hoffman was the first important artist who seemed to take me very seriously. He made me realize that I was peculiar. He laughed at some of the things I said—and he left me alone. I noticed that he paid less attention to me because he had the feeling that there was no use talking to me because I was going to do things my own way. I mean, I never got hung up on those silly 'push-and-pull' things that other kids picked up and thought were going to solve all sorts of painting problems. Anyway, I certainly never became an Abstract Expressionist. I guess I was painting like Pierre Bonnard."

Indeed, when Rivers held his first exhibition in 1949 at the Jane Street Gallery, Clement Greenberg, then writing in the *Nation*, hailed him as being a better painter than Bonnard—an opinion he was later to reverse. Be that as it may, from that moment on, the 25-year-old painter was on his way, and he plunged headlong into a creative milieu that found him mingling with the leading artists of the day—Willem de Kooning, Franz Kline, Philip Guston, and such younger artists and poets as Grace Hartigan, Alfred Leslie, Helen Franken-thaler, Frank O'Hara, Kenneth Koch, and John Ashbery, each of whom not only responded to Rivers the painter, but Rivers the outrageous, egomaniacal buffoon ready to take everything and everyone by storm. His drive and ambition where phenom-

enal. As for his personal life, some have suggested that in those early years it was decidedly messy.

"I decided I would try everything before the age of 30—and I did. In 1945, I married a girl named Augusta Burger. She already had a young son, Joseph. Then, she and I had a son, Steven. Well, the marriage didn't last. We separated after a few months, and I was left to raise the two kids together with Augusta's mother, Berdie Burger. Berdie was great. She helped me out financially and I could paint in earnest—and I could do a lot of other things too.

"In the opening years of the '50s, I behaved pretty much as though I were gay. I think I decided, as a young man, that it was really hopeless to try to make any sense out of the jangled and jumbled thing called 'male-female relationships.' So, it seemed to me that queerdom was a country in which there was more fun. And I met some extraordinary gays. Let's face it, there are gays and gays. Also, I think when I saw Jean Cocteau's *Blood of a Poet* my knowledge that Cocteau was gay affected my response to the film. Of course, I was a child when I saw it, but I had a long talk with Frank O'Hara about it. There was something about homosexuality that seemed too much, too gorgeous, too ripe. I later came to realize that there was something marvelous about it because it seemed to be pushing everything to its fullest point."

In 1951, Rivers painted his first major work, *The Burial,* inspired by Gustave Courbet's *A Burial at Ornans.* That same year he met John Myers, who ran the Tibor de Nagy Gallery, and in December of that year he held his first exhibition there. The association with Myers—a stormy one—would last some 12 years. As Rivers put it:

"John Myers was terrific. He helped me in every way— with money, with introductions, with articles about me—things like that. I know the role he played in my life. But one can't remain indebted forever. You see, I was with him for years and we benefited mutually from one another's relationship. But he was so unbelievably possessive that I couldn't take it any more. So, at one point, we made a very graceful separation and we continued in a very nice way, being friends, and I want to say

here and now, for the future, so that it's put down: John Myers was very important to me. He was a marvelous, intelligent, sensitive, nutty, sad man, and there was something in him that could never really put out that special flame of his. He's still got it."

It was during his years with Myers and the Tibor de Nagy Gallery that Rivers produced some of his most important works. With the late poet Frank O'Hara he collaborated on *Stones,* a series of lithographs in which poetry and illustration commingled to stunning effect. When O'Hara's play *Try! Try!* was produced by the Artists Theater in 1952, Rivers created the sets. Then, in 1953, the artist painted his *Washington Crossing the Delaware,* a reinterpretation of Emmanuel Leutze's 19th-century classic. Rivers's painting was acquired by the Museum of Modern Art in 1955 and constitutes one of his most original and seminal works. The subsequent years saw large, shocking canvases of life-size nude portraits of his friends and family, notably, *Double Portrait of Berdie* (his mother-in-law), which so riled the critic Leo Steinberg that, in a review in *Arts,* he deemed the painting technically inept and called it "a picture in which genuine nastiness couples with false charm."

With Abstract Expressionism riding high, Rivers firmly eschewed its precepts. Maintaining and holding fast to his own vision, he executed large sprawling canvases such as *Red Molly, The Journey, The Athlete's Dream, The Studio,* and *The Twenty-Five Cent Summer Cap,* among others, which were vibrant studies in fragmented realism showing double-exposures of figures and a highly sensual handling of decorative detail and banal, everyday subject matter. It was a stylistic vocabulary as pictorially viable and original as it was engaging, for it was a rhapsodic celebration of the commonplace made the more personal and poignant by the presence of what was closest to Rivers—his family, his friends, the objects he loved. These were painted in smudged, vaporous colors articulating a rhythmic continuity suggesting the haunting, improvisational nuances of jazz.

Frenetically productive though he was, Rivers made of his private life an equally frenetic drama of experiences that found him entering into complex relationships with people who supplied him with daring, often dangerous opportunities to test

his emotional, psychological, and physical stamina. There were drinking bouts, mad, night-long parties, and perilous experiments with drugs; there were sexual encounters at once tormenting and exhilarating, and, always, the goading need to push himself ahead—to place himself at the very center of whatever spotlight would chance to fall upon him. As Frank O'Hara once wrote: "Into the art scene of the '50s Larry came rather like a demented telephone. Nobody knew whether they wanted it in the library, the kitchen, or the toilet, but it was electric."

In 1958, Rivers was chosen as a contestant on the *$64,000 Challenge*, a popular quiz show of the period. For the first time he received nationwide television exposure and emerged from the experience $40,000 richer and an overnight celebrity. He savored and delighted in the attention and was soon picked up by the more rarefied world of society people and art collectors. If life was a round of chic parties of which he might be the host, Rivers never for a moment abandoned his compulsive need to work. Following a trip to Europe, he returned to New York and painted one of his strongest canvases, *The Last Civil War Veteran*, inspired by a *Life* magazine photograph.

With his newly acquired fame, some order had to be placed in his private life. His mother-in-law, Berdie Burger, had died in 1957. His two young sons were becoming preteenagers and had more or less been left to fend for themselves. To ameliorate the situation, Rivers sent for a young Welsh-born music teacher to come from Europe and help care for the children. This was Clarice Price, a lively and entirely seductive girl of great charm and vitality, whom Rivers came to adore. The two eventually married in 1961. Three years later, their daughter Gwynne was born and, in 1966, came Emma, their second child. Rivers had by then moved into a house in Southampton to which he added a large studio. He also maintained a block-long studio on East 14th Street in New York.

In 1962, Larry Rivers broke with his dealer John Myers and left the Tibor de Nagy Gallery. He had been wooed and won by Frank Lloyd, director of the Marlborough Gallery.

"John Myers and I had become very different people when 1962 rolled around," recalled Rivers. "Our relationship had

become rather routine. Also, he began to realize that my choices were wider, juicier—and so I left him and the gallery. I went with Marlborough, and, when that happened, John flipped his lid. He sued me, he wouldn't speak to me, he talked behind my back, and it became really crazy."

During that period, River's work underwent several major stylistic changes and the tide of his popularity seemed to take an ambiguous turn. Oddly enough, though under contract with Marlborough since 1962, he did not exhibit there until 1970. It was not through any lack of work. There were simply other options he wanted to exercise. For example, in 1965, Brandeis University offered to mount a Rivers retrospective of some 170 paintings, sculptures, drawings, and prints in its Rose Art Museum. The show subsequently toured the Pasadena Museum of Art, the Minneapolis Institute of Arts, and the Jewish Museum in New York. It was also at the Jewish Museum that the artist exhibited a vast painting-construction, 33 feet long, entitled *History of the Russian Revolution: From Marx to Mayakowsky*. Other painting-constructions followed, notably, *Don't Fall, Lampman Loves It,* and *The Elimination of Nostalgia* (a self-portrait with his sons Joseph and Steven, and wife Clarice).

Rivers spent the winter of 1966–67 in London with his friends, the painter Howard Kanovitz and his wife Mary, working on large lithographs that were later shown at London's Robert Fraser Gallery. In 1967, the artist traveled to Africa with filmmaker Pierre Gaisseau to make a television film for NBC, which Rivers titled *Africa and I.* This was an impressionistic view of the sights, sounds, and customs encountered in Kenya, Nigeria, the Congo, Ethiopia, and other countries. Several outstanding paintings on African subjects also resulted from the trip.

Absenting himself more and more from his wife and children (and all too often quenching his thirst for new personal adventures), his marriage floundered.

"Clarice decided she couldn't live in the studio anymore. She wanted out because of the traffic—too many people, too much going on. So she moved uptown into an apartment. I don't think I stayed one night there. Well, we kept up a pretense for a while, and then I decided to live my own life and

she lived hers. My life included being on speed and making movies. I also lived with a girl, and it lasted a long time. That was Diana. But it ended, too. So, although I'm still officially married to Clarice, I've been pretty much on my own for nearly nine years."

When Rivers finally exhibited with Marlborough in 1970, the works were mainly painting-constructions. Their critical reception was decidedly mixed if not downright cool. Perhaps an even greater blow came with Rivers's exclusion from the major Metropolitan Museum exhibition *New York Painting and Sculpture: 1940–1970,* organized by Henry Geldzahler. Suddenly, Rivers found himself somewhat out of field—at least from a critical and art establishment point of view.

Reflecting on these events, Rivers seemed thoughtful yet unperturbed:

"About joining Marlborough: Ten years later, I realized it was a mistake to have left John Myers. The fact was, I didn't understand the nature of that part of the art world—the dealer part. John had that nurturing thing . . . it was personal and it was felt. Frank Lloyd's sense of himself is that art is a commodity to be sold. Some artists are impressed by that. But there was something in my art that didn't go with Lloyd's rhetoric. It went much more with Myers's rhetoric, which is to be more sensitive about the art. Frank Lloyd could sell it, but he couldn't feel it. But I joined Marlborough, because inside of me was still that naive boy who said, 'It's a miracle that this is happening to me!' And, I mean, they had Robert Motherwell and Mark Rothko and I thought, 'Wow! That's the big time!' Aside from all that, they were guaranteeing me $25,000 a year and, in 1962, that was a fantastic deal. So I went with Lloyd.

"Frankly, to say that a gallery is the whole thing in an artist's life is really silly. Perhaps it was wrong of me not to have shown at Marlborough sooner than I did, and I probably didn't understand what reputations consist of. I mean, I was known for one thing—the paintings of the '50s and '60s—but then I got interested in a certain sculptural kind of painting, and that's not what I was known for, but that's what I showed at Marlborough. Actually, things really started to change critically for me with *The History of the Russian Revolution,* which was shown at

the Jewish Museum and was bought by Joe Hirschhorn. Well, I was put down for it. But then, I never really got a certain establishment OK from the critics. I mean, from a certain point on, people like William Rubin, who was under the thumb of Clem Greenberg—that little government there at the Museum of Modern Art—eliminated me. And I was never the favorite of the Guggenheim Museum, either. So it was tough. And the Met show that Geldzahler put together . . . well, being left out of that was a real put down. It pointed to the possibility that I didn't count.

"Luckily, I had that persistence—a kind of life-force that has guided me all along. Finally, I decided I couldn't spend my time being insulted because Geldzahler didn't include me in the Met show or that the critics didn't like my work. What I did was listen to the soft sounds—the beautiful cooing sounds instead. I sold work in Europe and I sold things on my own. I was through with the idea that a gallery was taking care of me. In my heart of hearts, I've always known that one has to take care of one's art and one's life oneself. So that psychological change worked wonders.

"I was selling so much that Marlborough, whom I've never really left, came around wanting to give me $100,000 or $200,000 yearly guarantees. But I'm not interested. Still, I had a large drawing show there about three years ago, and nearly every drawing was sold. Then, last October, Harold Diamond, who is a private dealer, brought Robert Miller into the picture. Miller opened a new gallery last year, and I had a show there. But the way it was done was that Miller bought all the paintings in advance through Harold Diamond—he bought them at a 40% discount, which made it OK with Marlborough. Anyway, I now show all over the place, and the critical tide is changing. When I had the Robert Miller show last year, Hilton Kramer wrote a big Sunday article in the *Times* that said good things about me. In the past, he just hated my work."

Turning to his current show of *Golden Oldies* at the A.C.A. Gallery, Rivers explained that it came about out of the blue.

"There is this man, Jeffrey H. Loria, who is a private dealer. Today, everybody seems to be a private dealer. Anyway, Loria

got in touch with me, came to the studio, and bought two paintings. I sold him a small version of the *Veteran* for $16,000, and a painting called *Beauty and the Beast* for $28,000. He didn't argue for a second. The next thing I know, he commissions me to do the *Golden Oldies,* for which he gave me big monies before I even started painting them.

"Also, my works started to rise precipitously in value at auctions. The head of the painting division at Parke-Bernet seems to be a big fan of mine. Suddenly, I found one of my African paintings on the cover of an auction catalogue, and the work called for about $44,000. So, my friend Jeffrey Loria seemed to be catching on to a certain idea. He has not only bought paintings from me but from other people who own my paintings and he now has a sizable investment."

With this dizzying recitation of impressive figures for his art, is Larry Rivers a millionaire?

"I don't have a million dollars in cash, but if I put some of my assets together, it might add up to a million dollars," he says simply.

There seems to be no question that Larry Rivers represents the epitome of the successful New York artist. Asked to comment on his relationship vis-a-vis his native city, Rivers is quick to state that New York has been the catalyst of his career: "It's where the glamour is. It's where the money is. It's where the art is. Those are the things I love. Of course, I was living up in the hills of the Bronx forever, and I didn't get to Manhattan until I was 18. And I come from a rather ordinary Eastern European, Jewish Russian background . . . I was a small-time boy. But when I hit Manhattan—that did it!"

Looking back on his turbulent life, Rivers is bemused and amazed at the fact that his sons are now grown men and that his daughters are fast becoming young ladies.

"Joseph is 35 and Steven is 32. I can't believe it! They've both been through hell, but they've survived. Joe is a very successful filmmaker and Steven is also involved in films. And my daughters are thriving. Gwynne is 14 and Emma is 12. They come to visit me and I like having them around. Basically, I'm a nice bourgeois Jewish father and do my duty . . . I like my

children and I care for them. I'm still married to Clarice and I see her and we're friendly, but I like being on my own. I don't see that many people.

"As for other artists . . . do artists see other artists when they're in their 50s? Comes a moment and people slip away! I still have a relationship with Howard Kanovitz. I admire his work. He's a friend. There's Alex Katz—I also admire his work. Of course, I think I'm better than everybody. I liked Richard Lindner. Since his death, I've become even more enamoured of his work. He was an artist I could talk to. Once in a while, I have lunch with Jasper Johns. Robert Rauschenberg is a difficult number. When we see each other we are so guilty over our mutual animosity that we kiss!

"At the moment . . . at this point in my work, I'm looking back. I think of the nostalgia of life—of time, of death. I look for the connection with my roots. I'll probably be doing a big painting of some cousins who were alive when I wasn't even born yet. That sort of thing. I feel that the relationship between life and art is nothing to be ashamed of. It's my life that matters and my art is part of that. I mean, Rothko . . . he saw color. But did he see life? And Barney Newman . . . he saw the stripe. But did he see life? Well, I have to put my life in my work, because that's me. That's what I'm about."

1978

Photo: Louis Psihoyos. courtesy Paula Cooper Gallery

JACKIE
WINSOR

"Basically, you make things out of the structure of who *you* are," says Jackie Winsor, the 38-year-old sculptor touted to be one of the most original and innovative artists of her generation.

Having made the above statement, Winsor, a person given to extreme privacy, will nevertheless give few clues as to who, in fact, she is. In conversation, her words and ideas, perceptive and intelligent in every way, center almost exclusively on the concept, ideology, and execution of her work. While aware of the connection between an artist's persona and his or her art, Winsor prefers to speak in hyperboles—masking personal information by way of allusion and inference.

Asked why she made art in the first place, she answers that art is a place where adventure and discovery lie. "Making art is one of the most pioneering things one can do. When I look at my past, I see a girl who by the age of 13 had moved 10 times, and my origins and family were in 19th-century England, in Canada. The morals and the structure of my past were 19th century, but as we moved from one place to another, I was being pulled from one century into another—from a rural to an

urban situation—and the thing I learned most was the notion of change and adaptability."

The spare biography issued by Jackie Winsor's gallery dealer, Paula Cooper, offers the information that the sculptor was born in Newfoundland, Canada in 1941. Twenty-three years are skipped to reveal that Winsor attended the Yale Summer School of Art and Music in 1964, the Massachusetts College of Art (where she earned a B.F.A. degree) in 1965, and Rutgers University, where she emerged with an M.F.A. degree in 1967. Four single-spaced mimeographed pages are then taken up with Jacqueline Winsor's accomplishments: nine one-woman shows beginning in 1968 at the Douglass College Gallery in New Brunswick, New Jersey, and subsequent solo exhibitions at the Nova Scotia College of Art and Design, the Paula Cooper Gallery in New York, the Contemporary Arts Center in Cincinnati, the Portland Center for Visual Arts, the Museum of Modern Art in San Francisco, the Wadsworth Atheneum, culminating with her 1978 show at New York's Museum of Modern Art.

Also listed are dozens of group shows (including several Whitney Annuals) in museums and galleries throughout America, Germany, France, England, and Holland. A lengthy and impressive bibliography attests to the wide interest in her work by a large number of art critics and writers. The sculpture of Jackie Winsor has clearly made an impact on the American and European art scene and market, and there is no question that her work commands serious attention.

A cursory glance at Winsor's oeuvre instantly reveals that the artist's primary concern lies in a highly charged manipulation and transformation of very simple forms: squares, circles, cubes, and spheres. These forms are constructed in a variety of materials, including rope, brick, plywood, twine, pine, nails, and lathing. Winsor has also worked with trees in nature, fabricating indoor and outdoor sculptures that in their symmetry follows the "tree-ness" of the tree itself. Essentially, it is the self-sufficient materiality of her objects that lends her work its presence, immediacy, strength, and integrity. While Winsor's art distantly echoes Minimalist concerns by virtue of its simple

geometric restraint, the clarity of her vision is obsessive if not downright fanatical in terms of execution.

Winsor's modus operandi finds her spending hours, days, weeks, and months on a single piece, which may involve the painfully slow process of nailing, coiling, winding, gauging, or placing pieces of wood one next to another in the completion of any particular work. This process, requiring a single act repeated ad infinitum, produces a tensile sense of vitality. What gives particular pleasure is Winsor's meticulousness, the pristine cleanliness of her work and the immaculate sheen and beauty of the finished products. These hand-wrought works hark back to an age where the artisan reigned and where manual craft became an integral element of the created object.

In an essay appearing in Winsor's MOMA exhibition catalogue, art historian Ellen H. Johnson of Oberlin College writes: "Winsor's sculpture obstinately proclaims mass, weight, and density, properties which she combines with space in such a way that mass and air tend to become one solid substance. Winsor's sculpture is as stable and as silent as the pyramids; yet it conveys not the awesome silence of death, but rather a living quietude in which multiple opposing forces are held in equilibrium. Jackie Winsor marshals her strands of rope and metal, her 1×1 inch sticks and layers of laths and pounds of nails as laboriously as Cézanne organized his countless petites sensations, but she does it like a Yankee pioneer."

And indeed, in works such as *Double Circle, Bound Square, Laminated Plywood, Fifty-Fifty, #2 Copper,* and the more recent *Burnt Piece, Wire Piece,* and *Drilled Piece,* the sense of organization and, above all, the sense of silence combine to offer a near-atavistic presence. They are pieces that seem to lie dormant only to be awakened by the sensibilities brought to them by the spectator.

Says Winsor: "The overall element I see is self-containment. My aim is that the pieces not intrude on you, but that they give you time to come to them. They don't bother you until you want to have an exchange with them. My rope pieces, for example, create a kind of stillness, yet contain an emotion within them. That emotion is activated or becomes apparent the

moment you seek it out. That's when communication takes place. Again, they come out of the structure of who *I* am. My work has to do with who I am and how I figure things out. And what I do is this: I have an idea in my mind, and in my mind the idea is perfect. In my mind I go through all the construction of a piece; I take it all the way to the end. Then, of course, you face reality. You have to actually start doing the piece and so, from completion—the mind's idea—you go to the absolute beginning. What I do when I'm building a piece is traveling the distance from where I am to its completion and back again, imagining what I want out here and making the steps, building them in my mind. I know that if I get into trouble along the path, what I can do is go back, say, a quarter of the way and start from there. So it's always a matter of negotiating the space between the reality of where I am and where the point of completion is in my mind."

Jacqueline Winsor is a tall woman of great good-humored liveliness. Decidedly down-to-earth, she is not given to casual banter or small talk. The color of her eyes is a striking, electric blue set in a mobile, open face that frequently breaks into a dazzling smile. Dynamic, clearheaded, she seems possessed of an almost primitive sense of awareness. And yet, while her responses are quick, she is also oddly guarded. The ambiguity of her personality becomes clear when questions turn to even such unperilous subjects as her general background and education. Where she senses intrusion, she will only give the barest hints of feelings that must obviously run deep. Often, questions are answered indirectly.

"I have an older sister, and she faced more than I," she says when asked about her home life. "I remember when she came home with a pair of dungarees and my father didn't like that. My father didn't think that women should wear pants. But you see, he came out of a different century. The fact is, my parents, who now live in Boston, changed through us; they were taking steps with us. So, it was about adaptability and effecting change. As for me, I went off to college and then, in the late '60s, moved to New York."

How was Winsor first exposed to art?

"Like everything else, I had no preconceptions of what art

was about. Throughout my childhood I learned how to do things when given the fact that I didn't know what *anything* was about. Sculpture, for example. I never had any formal training in it. I made up my own tools and my own rules about it. But about my first encounter with art: I saw this Indian on horseback out in front of the Boston Museum of Fine Arts and I was curious about that, and it made me want to go into the building. I don't remember what I saw once I went in, but I do remember seeing the horse out in front—that stuck with me. Actually, I could have become any variety of things, because I always did things that were neither encouraged nor discouraged. I could have become a dancer, for example.

"But I began to paint when I was an undergraduate. The paintings were figurative. The concern was that they be wholesome; I painted figures that were convex and muscular. I have never shown them. What I was doing was following the course I was on. But what didn't get carried along that course was painting. Still, I'm involved with certain painterly ideas in my sculpture—the wholesome aspects of it. The fact is, when I was painting, things got in the way. For example, color. I loved color, but color seemed to get in the way. And I liked sumptuousness, but that got in the way too. So, I chose to leave these things out and chose to deal with what was left.

"I started simplifying; I started out with less. In my graduate year, I started taking some black and white photographs of sleeping people. The quality that was in the photographs interested me. Now, it wasn't that I wanted to be a photographer, but there was something in them that I liked. So, I had two elements: I had paintings and I had photographs, and what finally emerged was *form*. I spent time discovering two-dimensional form and internal space. Well, from these forms and the drawings I had made of them, it occurred to me that I could do a shape three-dimensionally. And that was the break that led into sculpture. It was like going over a bridge and meeting another land mass. Of course, there was a lot of 'I don't know' around all that. But it was very exciting. It was like opening a door—and I went right through it!"

Winsor's early pieces centered on upright or coiled ropes that the artist wound and rewound to form highly muscular

units of static energy. They stood or lay in the gallery space like silent, magic talismans sleeping the deep sleep of dreamers. Their voluptuous self-containment emanated an aura of the transfixed and hypnotized. To touch these pieces was to touch some living thing—an object of tremendous resistance that nevertheless yielded some undescribable force, a potent and tactile sensation bordering on the eerie. Other works—the coiled hemp and wood pieces, the cylindrical copper wire pieces, the wood and nails pieces, or the laminated plywood pieces—produce a similar effect of contained mystery and magic.

From a purely formal point of view, one is never less than in the presence of work that has been completely thought through—work that in matters of shape, clarity, and craftsmanship has the capacity to make rigorous and full-blown statements about the dynamics of form in space. This quality holds true for Winsor's indoor pieces as much as for the outdoor works in which nature holds sway, for, when in the outdoors, the artist will bind trees or construct timber shapes that meld easily and naturally with the landscape, producing shocks of recognition that merely heighten one's response to nature in general.

"My work is real," says Jackie Winsor. "If you were doing figurative painting, you would be creating an illusion of reality that's out there. Well, I'm creating a physical reality from knowns, and it's creating those knowns in a way that matters to me. What my work is about is putting things together, and putting things together a lot. I'm interested in what is holding things together and in presenting you with the real, in a real way, so you get to read what that real-ness is about. What also interests me are peculiarities. I know that something is pleasing to the eye because it's flawless. When I make my pieces, I'm absolutely fastidious about taking away the flaws. I'm as concerned with that in the rope pieces as I am in the lumbered wood. I spend a lot of time with them so that *you* don't spend a lot of time with them.

"As for the labor involved, the best way I can answer that is by saying that when you look at someone who is 80 years old, you know they're made up of lots of days and weeks and

months and years. Part of your reading of them as being this sage of life is that you know they have gone through a kind of volume of experiences, and I'm interested in that relationship of time and who somebody is. I relate that to the human being and I relate that to the pieces I make.

"Another element that the pieces are about is creating completion about that particular unit. When you experience completion, you're finished. You have already reached the age of 80 with that piece. Then, the pieces go off into the world on their own. I mean, I've created my relationship to *it* so that it can create that completion with you. The pieces are a reflection of me in their completion. And in that completion it becomes a mirror reflection with you. You can go and experience completion. You know, one of the definitions of religion is 're-bind.' So words and phrases very often have other meanings. It's as in life: You strive to create a sense of warmth and wholeness and completion."

Turning to her involvement with certain materials—rope, plywood, and bricks—Winsor maintains that, because they exert their own power and individuality with such force, it produces a strong reaction in her.

"What interested me about, say, the rope, was that it so stubbornly had its own personality. It really persisted in identifying itself: its weight and heaviness and, as you pulled it out, its linear quality. Its personality was so strong that I wanted to bring part of me to *it*. When I started working with ropes, I thought I would never work with plywood. I mean it was so trashy! However, after a point, and after I went through all those things about who I am and what I had done, plywood began to merge with the form I had taken, and so I began to use it. When the personality of plywood became clear to me—how it could come together with me—then I began to sit on the floor and began laminating it and, as I did that, I could see all those tiny eight-inch layers going up. The point is, my opening up in its direction made me understand the personality of plywood. And that's true of all the materials I use. It's a question of really identifying with them, responding to their real-ness—to what they bring to you and what you can bring to them. But that involves a lot of time and a lot of work."

As a woman, Winsor has often been asked why she is drawn to the sort of hard labor generally associated with brawny masculinity. The question elicits impatience.

"Look, what I got when I was very young was that women worked very hard. My mother is very hard working and she is as strong as my father. The idea that men are stronger than women is a matter of what your culturation is about. As far as I'm concerned, most people's capacities are the same. Yes, I've had women assistants who came in being very limp-wristed. They came in with culturation that said women weren't physically as strong as men. They were not willing to use their hands or their bodies. But once they began working with me, they soon were as strong as I am. It has to do with a willingness to use one's abilities at full capacity. Actually, so-called masculine pursuits aren't being done very much anymore—bricklaying, for example. What it's supposed to come down to is that only males use their muscles, and that's absurd, because women can use their muscles just as competently. Of course, if a woman wants to put stopping blocks in front of her, there are stopping blocks everywhere!"

What sort of art does Winsor admire?

"I'm interested in art that captivates my curiosity. I like to ask, 'What in the world is *that* about?' I like things that are intriguing. One of the artists I admired most was Gordon Matta-Clark, who died of cancer last summer. He was only in his 30s and he made the most amazing things, like a series of fried photographs! Well, I could *not* understand it. He had the most perplexing ideas. One time he went out and bought some land, but the land was about six inches wide and 100 feet long! And he cut abandoned buildings in half—literally cut them in half by himself! His ideas were incredible.

"Of course, when I studied art history, I picked out the things that interested me, like the Venus of Willendorf, the Winged Victory, and the Pyramids. I like them as images. I'm also interested in archaeological items, especially those where it's difficult to reconstruct what their function was or why they took on this or that particular shape. It's that kind of thing that intrigues me."

Not wishing to speak about her personal life, Jackie Winsor

remained silent on subjects such as marriage or on her private status as a single woman. Her gallery dealer, Paula Cooper, was equally uninformative. "I don't know whether Jackie is married or not," said Cooper. "All I know is that she's a very private person who is very direct, honest, and dignified. I consider her a good friend, and my dealings with her as an artist have always been easy and comfortable."

Asked what a Winsor sculpture sells for, Cooper said that most of the works have one price: $15,000.

"Jackie is very particular about her work—so particular that she insists on having a contract with the people who buy any of her pieces."

Commenting on this unusual arrangement, Jackie Winsor says:

"I've invested a lot of myself in my pieces and they all take a long time to make, and it's a bit traumatic when a piece leaves me. What the contract does is to define who will become the physical owner of my pieces. It stipulates that we are in partnership, I as the creator and they as the people who are the caretakers and lovers of my work. Its purpose is to protect the collector, the artist, and the work of art. There are various clauses. One of them says that the piece will be maintained in its original condition and will not be intentionally destroyed, damaged, or altered. Another says that the collector agrees that the work of art will not be reproduced as a facsimile and used for commercial purposes. There's a resale clause. If the work is resold, I get 15% of the profit. There's a stipulation that the pieces can't be shown publicly without my consent. Conversely, I have the right to borrow my work for exhibition purposes within a certain period of time—say, five years. Also, if a piece gets damaged, I am to be contacted to see if I can repair it or oversee the repairs.

"The penalty for breach of contract is very great. The collector is liable to damages triple the amount of the original purchase price or of the price at the date of breach, whichever is greater. You see, I feel that when someone buys one of my pieces it's a real commitment. I'm concerned about art abuse. I like to know that my pieces are in good hands. So far, I've not run into any trouble about this and no one has complained."

Clearly, Jackie Winsor is an artist in charge of her life and her art. At the same time, she will leave room for the unexpected and the unforeseen. "I'm sure that as much as one knows about oneself, there is always going to be a surprise around the corner. And what keeps you absolutely awake about yourself is the possibility that something different and new may befall you at any moment."

Offering a broad and warm grin, Winsor concluded by saying, "If I have not revealed things to you that you may have wanted to know, it's because I chose to invite you into my parlor but not into my boudoir. There's a level in me I'm willing to say is there. As for the rest . . . that belongs to me."

1978

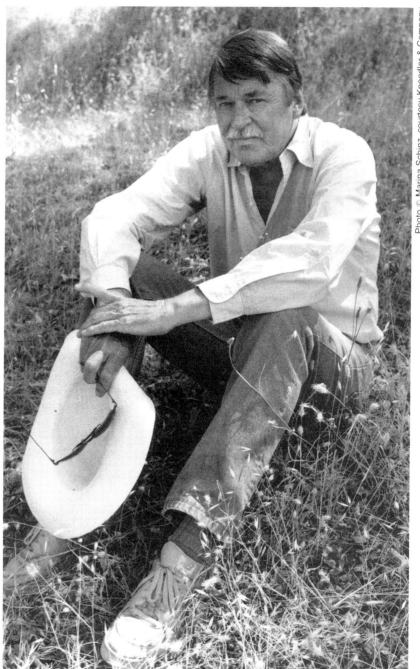

RICHARD
DIEBENKORN

D uring the opening of a recent show at Knoedler's, Richard Diebenkorn stood in the gallery greeting friends and admirers. He seemed a solitary figure despite the hubbub around him. Tall, with head inclined, he chatted, barely glancing at his work. In a way, the newly completed *Ocean Park* series seemed to echo the artist's own air of detachment. Like him, the paintings were muted, reserved, and eminently self-contained.

There is an air about Diebenkorn that suggests supreme reticence. The aura is disquieting and, of course, intriguing. His attentiveness alone produces alertness and self-awareness. One senses an analytical mind silently scanning questions— weighing options. And, as in his *Ocean Park* paintings, one senses the tension beneath the calm exterior.

The show once again attested to Diebenkorn's singular vision of symmetry and logic. With few dramatic changes, the imagery of these recent works continued to yield an abstract language suffused in the sort of space and light encountered in the music of Aaron Copland—a lean and spare vocabulary that, for all its terseness, contained an harmonic thrust straight from the heart. And the experience of Matisse, always transmuted by

51

Diebenkorn into love and homage, continued to give these paintings a radiance that turned geometry into palpable if understated emotion.

To think of Diebenkorn as a California painter has long been irrelevant. He is among a handful of major American artists to have achieved unobtrusive greatness. Looked at as a whole, his work resounds with the distinct intensity of the natural painter. From the early abstractions of the 1940s and mid-1950s to the figurative work of the 1950s and mid-1960s to the *Ocean Park* paintings begun in 1967, Diebenkorn's oeuvre is all of one piece.

If the happenstance of the so-called "California School" momentarily placed him within a stylistic and geographic context, his fierce independence soon superseded any allusions to place or look.

In point of fact, the only thing California about Diebenkorn is his place of residence. He lives and works in Santa Monica. Beyond that, he is a product of Edward Hopper, Piet Mondrian, Paul Cézanne, Henri Matisse, and Willem de Kooning. Although he has been aligned with the late David Park and Elmer Bischoff, his distinguished California contemporaries, the openness and immediacy of their abstract and figurative imagery and their lusty application of paint have never been a part of Diebenkorn's predilection or aesthetic. To be sure, they formed a triumvirate bound by artistic and personal association (Park, 11 years his senior, was briefly Diebenkorn's teacher at the California School of Fine Arts in San Francisco in 1946; Bischoff was a colleague, and later, a fellow teacher at the same institution).

In the early days, when each artist was steeped in abstraction, they would hire a model and hold weekly drawing sessions. There were lively discussions based on mutual interests and concerns. At the time, Clifford Still was teaching at the California School of Fine Arts, and he proved a strong influence. The New York School began to be a source of great curiosity and interpretation. The emigré Surrealists offered further speculation.

Indeed, throughout the late '40s and well into the '50s, there was no question that Park, Bischoff, and Diebenkorn were

tied in creative outlook. But by the early '60s, when all three painters were immersed in figurative work, Diebenkorn grew increasingly restive. He was dismayed to note that art critics, museum directors, and gallery dealers began to assign an "ism" to their collective paintings.

"We didn't know we were forming a school," recalled Diebenkorn during a recent conversation in New York. "Not until Paul Mills came around and told us we were a movement—The California Figurative Painters! Well, I just hated this thing of getting people together and forming a school. I remember being just wildly threatened by that. We had a meeting at David's house—there was Elmer, Paul Mills, and myself—and I remember raising my voice and saying, 'This should not happen.' Well, David was all for it, because he was going to be the granddaddy of it all—the leader. Elmer was sort of on the fence. But I just hated it. You see, we were going to be labeled. Paul was going to make David, Elmer, and me the nucleus of this movement, and he was going to bring in a bunch of satellites. I didn't go for that at all."

It is a measure of Diebenkorn's independence and single-mindedness that he withdrew from the restrictions and artificialities fostered by what seemed a group enterprise to pursue a far more personal creative path. From the first, he had sought to make art on his own terms, even as he acknowledged the influence of his peers and predecessors. As he once wrote, "If what a person makes is completely and profoundly right according to his lights then this work contains the whole man." It has always been the whole man that informed Diebenkorn's work.

Born on April 22, 1922, in Portland, Oregon, and raised in San Francisco, Richard Diebenkorn's love of art began in early childhood.

"I was drawing for as long as I can remember," he says. "And for as long as I can remember, I wanted to be an artist, but what kind of artist, I didn't know. If somebody had pumped me on it, I might have said I wanted to be a commercial artist or (that word!) a *freelance* artist. I was always interested in looking at drawings or paintings in magazines like the *Saturday Evening Post*—illustrations.

"Very early on, even before grammar school, I'd draw on shirt cardboards, and what I drew were trains—locomotives. Because the cardboards had an elongated shape, they were perfect for a locomotive and tender. I made endless portraits of locomotives. Then I drew and painted all through grammar school. For me, the high point of the day was when the paints came out. In art class I was kind of the star. But I painted very differently at school—broadly, flamboyantly. At home it was always much more personal—smaller. School was public. Home was private.

"Throughout high school, I was a pretty ordinary guy, and for some reason I stayed away from art classes. Actually, I remember looking into the rooms where the art classes were given, and it seemed kind of arty to me. It didn't make any sense to me. The drawings people were making seemed oversimplified. Anyway, the idea of taking art in high school just didn't appeal to me. But I continued to paint and draw at home. There were pictures hanging all over my room, and they illustrated my current enthusiasms. There were quite a few years when I was involved with medieval lore—weaponry, violence. The pictures I made looked very real—very tangible. I can remember questions at the time—perhaps in high school or even earlier. I would ask myself, 'Why can I really do this sometimes and other times I'm just on the surface of things? Why can't I really get into it?' And I remember thinking, looking at something I had really liked, that it was the image that pulled me in or kept me out. It was always trial and error. It still is."

Diebenkorn's first vivid encounter with a work of art was with Edward Hopper's *House by the Railroad*.

"It was the first experience I had with a rectangle of canvas that really moved me and arrested me. It wasn't the painting itself I saw, but a very good reproduction. It changed things a lot for me right there. It was a real focusing. Somehow, it had all the important things in it for me. It had the time of year that I loved most—a fall day, where the reflected light doesn't hit the shadows—where the shadows stay black. That kind of day. It was so clear! There was a spareness. And I loved that. I just loved the way Hopper looked at the world. So, some early paintings of mine came out looking quite a bit like Hopper's.

But I felt, at the time, that I was just doing my own thing—and this Hopper, well, he was there too."

In 1940, following his father's wishes, Diebenkorn enrolled at Stanford University. The aim was to embark on a professional career. Painting was left in abeyance for the first two years at Stanford as the 18-year-old student discovered the worlds of literature, music, and history. But in the third year, he took courses in the art department, where he studied painting with Daniel Mendelowitz, a student of Reginald Marsh, and Victor Arnautoff. Cézanne quickly became a hero, while Picasso and Matisse were not far behind in strongly impinging themselves on Diebenkorn's sensibilities.

"My father didn't want me to become a painter," Diebenkorn remembers. "He thought it would be a marvelous hobby—something to do on the side. He wanted me to become a professional man—a doctor or a lawyer. But I didn't become a professional man. The war was on, and the military came to my rescue.

"At Stanford, I signed up with the Marine Corps. I did this because they were the only branch of the service that guaranteed my being able to stay in college until I graduated. Of course, they were lying in their teeth. They took me after two quarters. They put me in uniform, and sent me to the University of California at Berkeley, where I stayed for a semester. There, I studied physics, which I loved. I also took some painting classes with Erle Loran and others. But then, in 1943, I was assigned to a base in Quantico, Virginia, which was about 40 miles south of Washington, D.C. Well, that was great, because on weekends I could visit the Phillips Collection, the National Gallery, and the Corcoran. It was a fantastic education for me—all that art!

"Of course, I wasn't painting in Quantico, but I did some portrait drawings of a couple of sergeants as gifts, which they would send home. Several officers saw those drawings and they too wanted to be drawn. They thought I had talent and, as a result, I was assigned to the camp's photographic section. There was a bunch of Disney people there, and lots of art materials. I couldn't do the things that the Disney people required of me, so, they left me alone, and I pursued my own

work. Anyway, after Quantico, I was shipped to California, briefly, and then on to the Hawaiian islands, where I stayed for six months. The U.S. was getting ready for the Japanese invasion, which never came about—fortunately. The plan, however, was to have teams of three people—a writer, a photographer, and an artist—to land ahead of the invasion and sort of scout the place out. I would be among them. It just raised my hair! Well, it never happened. The atom bomb was dropped. Altogether, I served in the Marines from 1943 to 1945."

Before Diebenkorn was shipped to Hawaii, he had a brief leave in San Francisco to visit his family. (He had been married in 1943, and the young couple lived with Diebenkorn's parents.) On this occasion, he chanced to visit the San Francisco Museum. There, he purchased a magazine called *DYN*, which had caught his eye.

"I leafed through this magazine, and I saw pictures in there that had a great effect on me. There was a Robert Motherwell and several William Baziotes. Now, I was steeped in Picasso and Matisse and Cubism, and I suddenly realized that there was clearly something different there—very much related, but something else as well. That got under my skin right away. And so, it was goodbye to doing my landscapes and drawing my comrades. I started to do abstract painting, and I did that until very late in 1955."

Thus it was that Diebenkorn's first major shift into abstraction began. The imagery was instantly assertive despite its leanings toward Picasso Cubism as well as the splatterings of Motherwell. While the earliest abstraction still hinted at figuration (Diebenkorn wanted to successfully meld the figurative with the abstract), his work ultimately gave way to an imagery that in color, line, form, space, and composition offered a near-compendium of the purely abstract elements seen in Matisse, de Kooning, Motherwell, and Adolph Gottlieb. Still, a charged and explosive unity of structure and design gave these canvases their confidence, individuality, and directness. Indeed, Diebenkorn was well on his way toward creating his own Abstract Expressionism even as the big guns in the East were calling the shots.

In 1946, the artist enrolled at the California School of Fine Arts (now the San Francisco Art Institute) and, following a semester of work, was given a grant which enabled him to go to New York. He would see for himself what the big guns were up to. Diebenkorn, his wife, and their first child holed up in Woodstock, N.Y. for the winter (it was the cheapest place to stay), and forays into New York City gave Diebenkorn the opportunity of meeting the dealer Sam Kootz, Bradley Tomlin, whom he admired, and William Baziotes. He also met Raoul Hague and Judson Smith, both of whom offered friendship and advice. The stay was brief, but Diebenkorn worked feverishly in Woodstock—"Butting my head against the wall," as he put it. Repeated visits to the Museum of Modern Art yielded new discoveries and influences, including Joan Miró for one, and Mondrian, for another.

The artist and his family returned to San Francisco in the spring of 1947, and an offer to teach at the California School of Fine Arts was gratefully accepted. It marked Diebenkorn's entry into a teaching career that would span well over 20 years. In 1948, he was given a one-man show—his first—at the California Palace of the Legion of Honor in San Francisco.

In 1950, needing to experience a dramatic change of ambience and locale, the Diebenkorns moved to Albuquerque. The artist enrolled as a student at the University of New Mexico. He obtained an M.F.A., and also produced a body of work which would eventually be shown at the Paul Kantor Gallery in Los Angeles. Diebenkorn's two-year stay in the Southwest proved both ambiguous and salutary: ambiguous, because most of his colleagues mistrusted his affirmation of the abstract ethos; salutary, because the work that emerged from his studio resonated with a newfound ferocity. He produced paintings that bore the atavism of things observed in an arid desert landscape, and the menacing sensations of a milieu of mystery and remoteness.

Diebenkorn left New Mexico in 1952, and briefly returned to California, before assuming his second teaching post at the University of Illinois at Urbana. If his single year in Illinois proved somewhat gloomy, his work continued to mature and be invested with an ever-increasing organic power. More

importantly, color assumed a clarity and vibrancy heretofore missing, one that the artist directly attributes to his vision of a major Matisse retrospective held in Los Angeles during the summer of 1952. "It absolutely turned my head," he says.

Following their stay at Urbana, the Diebenkorns, now parents of two children, decided to move to Manhattan and spend some time in New York. It was not the happiest experience, although Diebenkorn came into greater contact with New York artists and was in closer touch with the machinations and dubious pleasures of the New York art world. His acquaintance with Franz Kline led to Kline's suggesting to the Poindexter Gallery that they take him on (he showed there in 1956), and he enjoyed the company of painters such as John Hultberg and Ray Parker, among others. Still, the confusion of New York was not for him. Abruptly, during the summer of 1953, he and his family returned to California and settled in Berkeley.

By 1955, Richard Diebenkorn had achieved considerable stature as an abstract painter. He had exhibited at the Kantor Gallery, the San Francisco Museum of Art (1954), and at the Allan Frumkin Gallery in Chicago. As an abstractionist he was fulfilling his goals and producing work of depth and originality. Even his New York peers considered him one of theirs.

"Things were going very well for me," recalls Diebenkorn. "There was a marvelous momentum—from the Albuquerque time, through living in Urbana for a year, then to New York for the summer— and the momentum continued to build. I felt I was discovering a lot for myself. It seemed as though things were just moving along wonderfully. Still in 1955, I felt a little bit of resistance, but, I continued with the abstract painting. Then, doing them became a little tougher, even though they were even more successful as I went on—I mean, successful in my terms. Then, one day, I felt it was all done. There were things working on me . . . pressures that caused me to change.

"You see, I was trying to demonstrate something to myself, namely, that I wasn't going to get stuck in any dumb rut. I felt I could move into something else. I got kind of a thrill out of doing that. I said, 'I can leave all this behind.' In 1956 I had a show at the Poindexter Gallery in New York of the abstract

work I had done in 1955, and I got a good response, especially from artists, some of whom were generous and admitted they liked my work. Also, there were those who didn't, but I could see they liked it from their own work. So I felt good about the Poindexter show. But still, I wasn't going to retrace my steps."

It was at this point that Diebenkorn returned to figuration. In an essay on the artist, Gerald Nordland, director of the Frederick S. Wight Art Gallery at the University of California, quotes Diebenkorn describing his changing attitude: "I came to mistrust my desire to explode the picture. At one time the common device of using the superemotional to get 'in gear' with a painting used to serve me for access to painting too, but I mistrust that now. Something was missing in the process—I sensed an emptiness—as though I were a performer. I felt the need for an art that was more contemplative and possibly even in the nature of problem solving. It was almost as though I could do too much too easily. There was nothing hard to come up against. And suddenly the figure paintings furnished a lot of this."

As it turned out, his friends, David Park and Elmer Bischoff, were at this time also making impressive pictorial inroads in their own recently adopted figuration—and a kinship developed. It was a series of still-lifes that began Diebenkorn's journey into the representational—works of striking solidity and tension. Figures followed soon after, and with them, Diebenkorn's best-known paintings of this period. Frankly emotional yet charged with terseness, these latter works contained a somber eloquence. A single woman, seated or standing, and usually lost in thought, becomes the focal area in interiors or landscapes drenched in a diffused light. Color is intense, sensuous, specific. Form is simplified. Nothing is particularized. The *whole* of the painting achieves psychological impact, not its single passages.

Given Diebenkorn's always thoughtful and judicious reasons for attempting something different, he admitted to certain reservations over his switch to figuration.

"I had all sorts of moments and days and weeks when I would go back to abstract painting," he says. "I had thought that I made a very bad and hasty decision and—let's go back to

the abstract painting. Of course, that happened many times during the early *Ocean Park* period, where I would go back to representational painting. Well, I had these twinges, because during the '50s abstract painting was a religion, and it didn't admit to any backsliding to representational imagery. I mean, when the three of us—Park, Bischoff, and I—had an exhibition of our representational work in New York, we were attacked. You wouldn't believe the incredible things people said to me!

"At any rate, throughout my abstract period, Clem Greenberg and I had a relationship—all the way through. Apparently he liked my work. He never told me this, but it came out later that he was very much with me in my abstract painting. Well, he sent two people to see me when I was living in Berkeley. This was two or three months after I made my defection. One was Kenneth Noland, and he just as much as told me, 'What the *hell* have you done?' He had come expecting to see abstract painting. I said, 'I'm not doing abstract painting anymore.' He was really very disappointed. Then Tony Caro came and visited, and he was also disappointed. He was telling me about the wonderful thing he was getting into. He was showing me photographs of his work before and after, and I remember the marvelous heads in clay that he did, and also the new metal stuff. But this clay work I liked a great deal, and I told him so. Well, that didn't go over too well . . . that I was liking something he was leaving in disgust."

For over a decade Richard Diebenkorn, regardless of fashion, produced representational paintings, works on paper, and etchings and drypoints containing all the consistency and distinction that had marked his previous decade of abstraction. Expressive and ardent, their content registered even more fully his abiding love for the lessons of Matisse. Indeed, in 1964, following a trip to Leningrad and Moscow (as a guest of the Soviet Artists Congress, under the aegis of the U.S. State Department), where he had seen the great Matisse paintings in the Shchukin Collection, Diebenkorn's work reverberated with a singular radiance and Matissian clarity. Still, this was American painting through and through by virtue of a certain rough-hewn and staccato compositional thrust, in which line

and form revealed an aggressive intonation, and wherein light contained the pearly moistness of the American West Coast.

In 1966, Diebenkorn moved into a studio in Santa Monica that had belonged to his friend, the painter Sam Francis. It was a move that proved prophetic.

"Actually, it took six months for Sam to vacate his studio," recalls the artist. "During the interim, I worked in the same building, but in a smaller space that had no windows. I worked in this little airless room, and I just worked on paper, because I couldn't work on large canvases. What I was doing were things that were representational, but they were getting very, very flat. Very, very simplified. It represented a great change in my figurative painting.

"Maybe somebody from the outside observing what I was doing would know what was about to happen. But I didn't. I didn't see the signs. Then, one day, I was thinking about abstract painting again. Then, as soon as I moved into Sam's space, I had large canvases and I did about four of them—still representational, but, again, much flatter. Then, suddenly, I abandoned the figure altogether."

Diebenkorn now began to produce a series of large abstractions, each of which he numbered and titled *Ocean Park*, so named after the section in Santa Monica where his studio is located. These works (there are some 140 of them to date) constitute one of the most rigorous and supremely refined accomplishments in 20th-century art.

Robert T. Buck, Jr., director of the Albright-Knox Art Gallery in Buffalo, N.Y., wrote tellingly about these new works on the occasion of Diebenkorn's retrospective traveling exhibition in 1976:

> These luminous and open works called the *Ocean Park* series . . . are nonetheless carefully controlled by superimposed linear structure, fusing both closed form and spontaneity into what the artist himself described in earlier years as 'tension beneath calm.' The works are the product of concern continually in evidence in Diebenkorn's work with added attention to surface, chromatic range, spatial definition, luminosity, and resolution of open and closed form.

One must emphasize that, in these works, light is the central theme—the all-encompassing factor in an imagery already notable for its intense structural lucidity. Diebenkorn says that he cannot really describe the quality of this light: "I probably went to Santa Monica's Ocean Park district because of the light. But I didn't know it until I started realizing that I was very involved in this light. It took a couple of years after I was in it. And then, I suppose, it's when people started to remark about the light in my pictures, and how it looks like Santa Monica, that I started to investigate my pictures, saying, 'Ah, yes—that's it!' When I lived in Berkeley, it was the same—people who hadn't been there said, 'Oh, I see your pictures all over the place!'

"It's interesting too, because Tom Hess once said that he didn't believe my light. He said, 'This person is looking at Skira books, and that's where it comes from.' He was most antagonistic. Well, it was a common thing for people who hadn't been to California saying there's something bogus about all this.

"It's funny how California painters weren't really trusted by the New York art intelligentsia—especially back in the '50s. I mean, I'm not a sunbather, but I played a bit of tennis, back then, and I'd get a suntan, and I'd come to New York, and there would be this little sneer and people remarked about my suntan. Anyway, about the *Ocean Park* paintings and the light in them—I just can't describe one light . . . it's just *there*."

And how does Diebenkorn get *into* an *Ocean Park* painting?

"Usually, I'm full of excitement about an image I want to put down. I lose it right away. Other times, I know I just have to get going—and it's a great bore. When I was painting abstractly in my 20s, there was all this energy, and I'd be charged and into a painting in a couple of hours. You get older, and you don't have that kind of energy. So I have two or three days of some real dismal dragging-around, hoping that something will get together and strike a spark.

"The energy comes back once you get working. But just to be looking at these dreary shapes! It just puts you to sleep! I don't know that I work specifically to make color a certain way.

I just work to get *all* the elements right. There's much drawing beforehand. But the paintings don't necessarily come out of them. But it's the bent. It's the way that brings me to a *kind* of imagery.

"Of course, I don't go into the studio with the idea of 'saying' something—that's ludicrous. What I do is face the blank canvas, which is terrifying. Finallly I put a few arbitrary marks on it that start me on some sort of dialogue. I need a dialogue to get going. In earlier years, I would have specific ideas for a painting—something I may have dreamed or caught a glimpse of. I don't rely on that sort of thing anymore, because once I got started, it didn't last.

"Now the idea is to get everything right—it's not just color or form or line—it's everything all at once. Of course, that doesn't work either, so it's a continuous struggle. Sometimes you sail along. When I'm halfway there with a painting, it can occasionally be thrilling, and I can stop and say, 'Gee, how lucky I am to be doing this activity that I like to do!' But it happens very rarely; usually it's agony. If it doesn't come out looking agonized, it's because I have a dread of that appearing in my work. I go to great pains to mask it. But the struggle is there. It's the invisible enemy."

1986

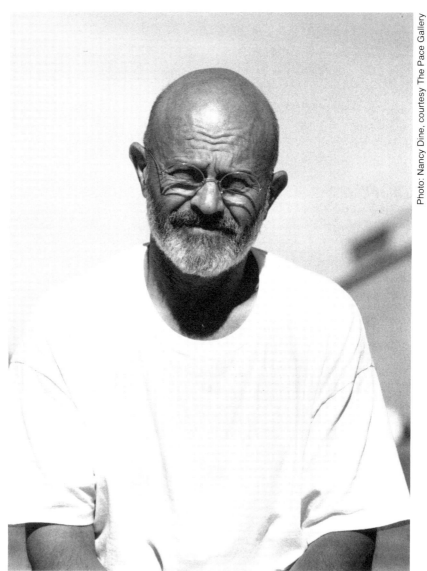

JIM
DINE

To speculate on the psychological implications of Jim Dine's 15-year obsession with painting uninhabited bathrobes (11 monumental oils of robes made up the bulk of his recent exhibition at the Pace Gallery) is to ponder Dine's personal identity. Four of the robes were given the all-encompassing title of *4 Robes Existing in this Vale of Tears*—an oddly revealing title for an image so singularly depersonalized. And yet, these "invisible-man" wraps, each possessed of a larger-than-life weight and amplitude, seem to suggest that the missing figure in each of the robes desperately longs for the comfort and warmth they so seductively promise the would-be wearer.

During a recent interview, Dine offered some intriguing clues on the subject.

"The robes have become much more mysterious than they used to be, and that's because I understand them more. Obviously, there's some hidden significance there. But what's funny is that I don't own a bathrobe. I don't wear one. I don't walk around in one. I never see bathrobes around me, nor do I see people wearing them. I don't have a bathrobe to paint from. What I use is what I've used from the very beginning—a newspaper ad which I clipped out of *The New York Times* back in

1963. The ad shows a robe with the man airbrushed out of it. Well, it somehow looked like me, and I thought I'd make that a symbol for me. Actually, it all began when I wanted to paint a self-portrait . . . and just couldn't. It's important for me to say this, because what I really wanted to do was to sit in front of a mirror and paint a portrait of myself. But at the time, I was in analysis and the pressures I felt prevented me from going through with it.

"Also, in the '60s, I had achieved a certain notoriety as a so-called avant garde artist, and a lot was expected of me. So you see, if I was going to do a self-portrait I had to find some avant garde way of doing it. Well, I just couldn't put the figure in it, because I was afraid of being called retrograde. It was a fear of being called a sell out. So, I found a different way of doing it. Anyway, those early robes were just about painting, or exercises about *things* or autobiography through objects. And I couldn't talk about them because I just didn't *know* why I did certain things."

Jim Dine is a reclusive, secret man. Stocky, heavy-set, with a bearded, alert face out of Cézanne, he exudes both energy and a strong sense of diffidence. Behind an open smile and eager, inquisitive eyes, there lurks a wariness—a certain distrust seemingly engendered by some inner unresolved personal conflict. But there is also an expansiveness about Dine, a healthy ego-driven sense of bien-être, one which permits him to speak freely about himself even as he is careful to retain an ample measure of guardedness.

Dine's career has been well-documented, far more so than the personal circumstances out of which it sprang. What is known about Dine the artist is that, within the span of some 18 years, he has held over 60 exhibitions in galleries and museums in the United States, Canada, and Europe, and that his output has been as prolific as it has been varied. Working in all media, he has evolved a style uniquely his own, one that is strongly rooted in recognizable imagery, produced by way of a progressively refined craftsmanship based principally on the rigorous disciplines of drawing.

It was around 1960 that Dine's career came into focus, and it did so in the wake of the Happening and Pop Art movements.

Through his early friendship and association with Allan Kap-
row, Claes Oldenburg, George Segal, Robert Whitman, and
Lucas Samaras, among others, Dine became involved with the
events and exhibitions being held at such anti-establishment
galleries as the Judson and Reuben in lower Manhattan.
Indeed, as early as 1959, both Dine and Oldenburg shared their
first one-man shows at the Judson Gallery, with Dine exhibiting
a series of constructions and assemblages made out of old
clothes and varying "anti-art" objects. The following year saw
Dine participating in staged Happenings spearheaded by
Kaprow.

With it all, and from the very first, Dine's excursions into
the day's avant garde found him curiously restive. Even as he
appeared to thrive in a milieu of experimentation, and even as
critics took note of a young artist of witty and outrageous
imagination, Dine inwardly resisted the acclaim that was all too
quickly coming his way. In the early years, his imagery fixed on
actual objects—workmen's tools, bathroom appliances, house-
hold appurtenances, pieces of clothing—affixed on blank
canvases or incorporated in constructions that proved both
theatrical and daring. Instantly dubbed a Pop artist, Dine just as
instantly resented the label and, at the height of the movement,
was quick to protest such pigeonholing.

"I'm not a Pop artist," he told this writer in 1966. "I'm not
part of the movement because I'm too subjective. Pop is
concerned with exteriors. I'm concerned with *interiors*. When I
use objects, I see them as a vocabulary of feelings. I can spend
a lot of time with objects, and they leave me as satisfied as a
good meal. I don't think Pop artists feel that way. Their work
just isn't autobiographical enough. I think it's important to be
autobiographical. What I try to do in my work is explore myself
in physical terms—to explain something in terms of my own
sensibilities."

Looking back on it, Dine confirmed his early feelings: "Of
course, I liked the notoriety of those years. It was a way for
people to get to know us. But I was being lumped together with
a whole bunch of people, only *some* of whom belonged
together. I wasn't really part of them, except maybe in the
Happenings. You see, Kaprow always said that Happenings

were an extension of painting . . . that painting was through! Of course, that was ridiculous. That was just *his* problem with painting. But for me, it is merely a painter's theater, and I had fun with it. Actually, I never thought Happenings were all that revolutionary. But Kaprow was a big influence on me. I valued his opinion, and so I went into what he advocated, creating some four Happenings that I thought were really pretty good. Finally, however, I removed myself. I gave up the Happenings and, right off, everybody thought I had sold out. Kaprow was really down on me, and made me feel absolutely terrible.

"Anyway, in 1962, Martha Jackson came to my studio and bought a few paintings, and offered me a show. Again, Kaprow thought I had sold out. I was moving uptown! But you see, I *had* to get down to painting and, besides, I wasn't oblivious to what was going on elsewhere. I mean, there was Robert Rauschenberg and there was Jasper Johns, and, at the time, I thought they were the most important artists alive. I couldn't think of a bad thing they'd done. I don't feel that anymore. In fact, I don't even consider Rauschenberg anymore. Now I consider de Kooning a far more important artist than Rauschenberg. But in 1962 . . . well, Johns and Rauschenberg were the greatest! I didn't know them personally, but I loved their work. Also, they were always having emotional breakdowns, and I was having a breakdown too, and that kind of tied me to them, except that they were using booze to overcome their breakdowns, while I was using a doctor—a psychoanalyst."

If an artist's work is irrevocably tied to the development of his persona, then Jim Dine stands as an example of the artist as the ever-questioning and inwardly oriented human being. The emotional components of any artist's life must perforce color the fabric of his creative impulses and, in the case of Dine, these components have produced a man of complex and highly vulnerable sensibilities.

Jim Dine, his wife Nancy, and their three young sons live on a farm in Vermont. One day each week, Dine travels to New York to visit his analyst. On one such trip, Dine made time for a lengthy talk. We met for drinks, and the occasion yielded a personal panorama of a man secure in his art yet still somewhat troubled with the ways of his life.

"I was born in Cincinnati, Ohio, on June 16, 1935," he began. "I have a younger brother. My father was definitely not inclined toward the arts. My mother, on the other hand, was artistic. She loved music. My family, on my mother's side, are quite unusual. They acquired their artisticness because they're Jews in the Midwest. It's quite strange to be a Jew in the Midwest—at least, it was for their generation. You see, Cincinnati has always been extremely cultured. The Germans came early, and the German Jews came and started the symphony. Unlike Cleveland, which is a robber-baron town, Cincinnati is a town of old money. So, there was an early symphony, an early art museum, none of which is as good as Cleveland, but they had this history of finesse—one grew up with some culture.

"In the summertime, I studied art at the museum. I was very prodigious at drawing. I was very gifted, very crazy, very sensitive. And I was encouraged by no one. Then, when I turned 15, my mother died. It was a very wrenching thing. My father remarried, and he didn't want me to live with him. So, I left home and went to live with my grandparents. My brother, who was younger, continued living with my father and his new wife. Well, the moment I left home, I became an adult. Of course, I wasn't, but at 15 I was on my own, and I became an artist. I took it upon myself to go to the Cincinnati Art Academy and worked there at night with people who were school teachers, shopkeepers, and the like. They were amateurs. I painted there three nights a week. I also learned to drive. I was free, and it was the only thing that kept me whole. Basically, however, I was a mess.

"Inside, I felt like James Dean. Outside, I was a super-jock—a tough guy. But inside it was all different. You know . . . misunderstood—the tragic figure. I was Rimbaud clothed in Rod Steiger. It was very painful, but extremely interesting. Also, I discovered early on that I had a reading disability. That was painful too. You see, I'm left-handed, and there's a screw loose in my head in terms of a motor thing. So, I have trouble reading, and literature has meant more to me than anything, except for music. The fact is, both music and literature really mean more to me than painting. Anyway, what I was trying to

do in all those years was to become a painter and to learn how to read. I was also making some plans about getting the hell out of Cincinnati."

Upon graduating high school, Dine entered the University of Cincinnati, but stayed there for only one year. ("I couldn't take it. I was at sea with my psyche.") The following six months were spent at the Boston Museum School, but, again, the experience proved discouraging. Finally, at the age of 19, Dine enrolled in the art department of Ohio University, in Athens.

"The art department at Ohio University was hopeless. I mean, it didn't exist. They had people there who wanted to become art teachers, and the teachers there were old women who had been taught at the Columbia School of Education like in 1910. Well, they couldn't stand me, and were quite happy to just leave me alone. So, I went into high-gear, painting like crazy, drawing like crazy, and making prints. The work was figurative and Expressionist, which seemed to have been my orientation. In retrospect, I feel that Expressionism and Surrealism, which I came out of, are crosses to bear, because they cloud one from speaking clearly—from becoming oneself.

"As a college student, I schooled myself totally in the New York School, via *ARTnews*. I remember stealing bound volumes of *ARTnews* from the '50s, and sitting there, tearing out pictures, and looking at de Kooning, Pollock, Kline, and everyone else of that period. I knew about everybody. It was an impressionable time for me. I was teaching myself about New York—the moves. Frank O'Hara, John Ashbery, and Kenneth Koch became familiar names to me. Anyway, I was glamorized by New York."

While at Ohio University, Dine met his future wife, a fellow art student. They were married in 1957. Upon receiving his B.A. in 1958, Jim and Nancy Dine resolved to tackle New York.

"We got to New York, and we were sort of nobody, and I felt like a yokel. I was 22, married, and without a job. But almost immediately I found one teaching art at a school in Patchogue, Long Island. Of course, we came into New York all the time, and we started to meet people. I looked up a friend of mine with whom I had gone to high school—Marcus Ratliff, who is a graphic designer. He was living at the Judson Student House with Eva Hesse, and going to Cooper Union. Also going to

Cooper was Tom Wesselman, and working at the Cooper Union library was Claes Oldenburg. As it turned out, my very first show was at the Judson House, together with Ratliff and Wesselman. That was in 1958. I also met Lester Johnson and Red Grooms, and everybody was incredibly productive and incredibly young! Anyway, I continued teaching in Patchogue, and I continued to draw and to paint. My work continued to be figurative, but it was beginning to tend toward the absurd.

"We had very little money, but I must say, my family was always very generous. I have an uncle—my mother's brother—who would send me money. And I have a cousin, Richard Cohen, who was always very encouraging about my work. In fact, he was very instrumental in my becoming a serious artist. If I'm painting at all, it comes out of my cousin Richard and the artist Kitaj, both of whom spoke to me about art at a time when I needed it most. I would say that these two people changed my life."

In 1959, the Dines moved to New York City, renting a small apartment in Yorkville. Their first son, Jeremiah, was born that same year, and Dine found a small teaching job in the city. By this time, he had met Kaprow, and exhibited his first constructions at the Judson Gallery, together with Oldenburg. In 1960 came the show at the Reuben Gallery and his involvement with Happenings. 1961 saw the birth of the Dines' second son, Matthew, and in 1962 Dine became associated with the Martha Jackson Gallery.

"Martha Jackson came to me and said, 'How much money do you make teaching?' I told her I made $4,000 a year. She said, 'I'll give you the same amount per year, and a contract. For that, you will give me paintings, for which I'll pay you $100 each, and drawings, for which I'll pay you $25 each.' Well, that wasn't much money, but Martha got me out of teaching and . . . what the hell! Besides, I thought some of those paintings I did were embarrassing. So, for 4,000 bucks she got quite a few paintings, and she gave me money each month."

It was during this period that Jim Dine was suddenly plunged into serious psychological turmoil.

"I had seen it coming for a long time, but things really came to a head. I was successful. I was getting a lot of attention, and

the paradox is that I was withdrawing. I was cutting myself off
from friends. I was productive, but I could hardly get to my
studio. I couldn't leave the house. It was fierce anxiety. I just
went nuts. So, I started analysis and began a very long
involvement with myself—which goes on to this day. But at the
time, I was going kind of crazy. Still, I worked all the time,
always surrounded by my immediate family. What was fright-
ening was that a lot of things were happening to my career.

"I had only one show at Martha Jackson. Then, I went with
Sidney Janis. Also, Iliana Sonnabend came into the picture. She
came to the studio, bought some things and said she'd show me
in Paris. Then Leo Castelli came and said *he'd* take me on. So, in
the summer of 1962, Leo gave me $500 and said he'd try to work
me into the season—but it was vague. Well, I couldn't take the
vagueness. Janis was less vague. He also gave me money, and
we paid Castelli back, and I finally went with Janis. I thought,
'Wow! This is big stuff! Sidney Janis!' Well, it turned out that
Sidney was the most ineffectual dealer I ever dealt with. He did
nothing. Every painting that was sold came about because
people either walked into the gallery or because they were
people *I* knew. I don't think he ever really sold any of my
paintings on his own, as he must have done for the generation
before mine. At any rate, I had three shows with Janis—in 1963,
1964, and 1966."

Dine continued to produce highly evocative works involv-
ing the paraphernalia of everyday life—paintings and construc-
tions of robes, household utensils, ties, toothbrushes, and
utilitarian objects placed like props in front of various-colored
canvases. There were strong, eloquent drawings of the same
objects, as well as of the figure. A superb draughtsman, he gave
an indepth intonation to an imagery that made of even the
simplest everyday object a lesson in refinement and sensuality.
Indeed, while working within the precepts of the going Pop
tendencies, Dine's art invariably contained a personal warmth,
and in its execution, strong "painterly" overtones. By 1966, his
name was made and his reputation established. Although
Dine's work was being seen in Paris and in London, the artist
had never traveled to Europe, and it now occurred to him that
a trip abroad was in order.

"In 1966, I went to London. Before that, I had no time. I was too busy becoming famous, having children (his third son, Nicholas, as born in 1965), and having nervous breakdowns. It never entered my mind to go to Europe, because New York was the place to be. But then, I received a commission from Editions Electo in London to do a series of prints. They put money up front, and I took the whole family for a two-month's stay there. Well, when I hit London, I felt as though I had gone home. I mean, I felt that London was where I belonged. I was 30 years old, and I felt I could live there forever!

"And so, I made my prints, and they were lousy—horrible! But I made some money, and it freed me in a certain way. When the two months were up, we came back to New York, and Janis laid on me that I owed him a lot of money. Well, that got to be a terrible mess, and I stopped painting for three years—from 1966 to 1969. I went to teach at Cornell University for a year, and then, in 1967, I decided to go back to London. We lived there for five years.

"We lived on Battersea Park and later on Chester Square. I began to paint again. I also did sets and costumes for a play based on Oscar Wilde's *Dorian Grey*. At one point, I went to Rome and got a job on a movie directed by Elio Petri. I did the paintings for the actor playing an artist in the film. I also began to do a lot of writing—prose and poetry—and I entered into a heavy correspondence with my New York poet friends: Ron Padgett, Kenneth Koch, Ted Berrigan, and David Shapiro. I had a marvelous time, and living in London was fantastic. I played tennis every day, and went out every night. I became the guy people looked up when they passed through London. Suddenly, I had a way of being friendly, and that interested me, because I had never been friendly before. Anyway, I was a great success in London. I've exhibited there since 1964, with Robert Fraser. I have a slight fame there, and I feel I behaved impeccably during those five years.

"In 1968, I went to Paris for the very first time. And that was an amazing experience, because when I got there I couldn't bring myself to go into the Louvre. I didn't enter the Louvre until 1970! You see, that first time—in '68—I was too amazed by the streets and the boulevards and the architecture. I really

know Paris! And I know it because I don't speak French. I walked the complete length of the city for days on end without talking to anybody. I just *looked*. The longest I've ever stayed in Paris was two weeks. But I know that city backwards and forwards.

"The European experience has made me understand myself. It sounds terribly pretentious to say this, but Europe taught me what my destiny is as an artist. It has solidified that. And that's because there are eyes there that I can trust— especially Kitaj's. Kitaj has been my friend since 1965, when he came to New York for his first show at the Marlborough Gallery. We instantly liked each other. He's from Ohio, too—Cleveland. But he's a real Jamesian figure. He's lived in Europe for almost 25 years now. What's so great is that Kitaj and I always have something to talk about. It seems as though we were born to talk to each other. Whenever I go to London now, I stay with him. He's painting better than ever. He's become a very straight figurative artist now, but in a very personal way."

In 1970, Jim Dine was given a retrospective exhibition at The Whitney Museum. There were one-man shows in Berlin, Toronto, London, Munich, Turin, Brussels, and New York. Still making London his home base, Dine commuted between various cities in Europe and New York. Then, in 1971, he felt the need to return home.

"Once again, I got messed up. London was great but, again, I was going sort of crazy and getting crazier all the time. I felt I *had* to be back in America. I felt it was my landscape. I also felt I had to get back into analysis. So, back we came, and we bought an old farm house in Vermont, where we've been living for the past six years. The Vermont experience is something not many Jewish boys have. It's very Tolstoyan, and, believe me, we existed under the most dire conditions, particularly during that first year. Anyway, we settled in Vermont, and I continued to work— drawing mainly. The fact is, throughout the years, my work hasn't really changed dramatically. It's only strengthened."

Having broken his ties with the Janis Gallery, Dine was without a New York gallery throughout most of his European stay. Then, in 1970, he began showing at the Sonnabend Gallery, which had opened a New York branch in Soho.

"I had shown with Iliana Sonnabend in France during the Janis years. I wasn't terribly close to her, and she thought I was nuts. But at one point she came to see me in London and offered to show me both in Paris and New York. I had two shows with her in New York—one of paintings and one of drawings. But a couple of years ago I left her. Again, it was over money. Also, I didn't like the kind of art she was showing; I found it offensive. Well, to make a long story short, I decided to go with the Pace Gallery. Arnold Glimcher, who owns it, had seen my drawings at the Museum of Modern Art in a show called *Drawing Now*, and he called me and asked whether I'd like to show with him. I agreed, and that sort of brings me up to date."

Dine's exhibition at the Pace received unqualified critical praise. His series of monumental robes were deemed on a par with "Rothko's universe," and his charcoal drawings of nudes were considered no less than masterful. Asked where, precisely, he thought he stood in the current art scene, Dine replied that he did not consider himself part of any movement.

"I'm not interested in the so-called figurative movement. I don't align myself with present-day figurative painters, and I don't sit in on panels about figurative art. You see, the artists I'm interested in who are figurative artists are Giacometti, Balthus, Kitaj, and Lucian Freud. Balthus is the greatest muse. Or I look to the past: Matisse, Picasso, Cézanne. I go to Cézanne constantly."

As for his psychological life, Jim Dine seems to have found some relative calm. "I think I'm starting to understand myself better, and I've had the best year I've ever had. I'm still with the same doctor, and he's changed too, which is interesting. But in many ways, I feel as though I'm just beginning . . . that my life is just beginning. I've reached a whole new plateau. You see, in the past, my needs were very great and my fears were very great and my defenses looked like torture. Well, I've come to terms with a lot of things, because, when all's said and done, there's really very little one can do about a lot of things. You just accept them. The point is, you just have to keep on working, and you just have to keep on living. That's the ballgame."

1976

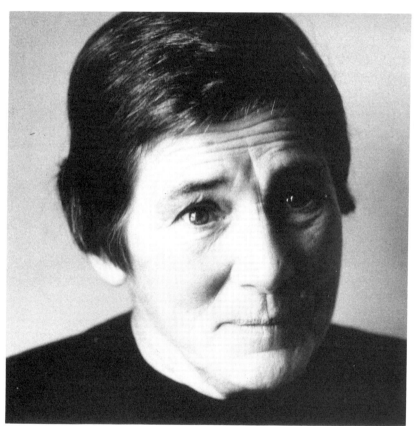

AGNES
MARTIN

For some 15 years, critics have written of Agnes Martin in hushed and reverential tones. To some, she has become a saint. "Her art has the quality of a religious utterance, almost a form of prayer," wrote one New York critic, reviewing her exhibitions at the Elkon and Pace Galleries. Indeed, these litanies abound as Martin's drawings, prints, and paintings, centering primarily on images of grids, are analyzed, dissected, interpreted, and placed in comparative perspective within the spectrum of 20th-century American abstract art by writers intent on inventing a dialectic that would accurately reveal their content and meaning.

In language often cerebral and obfuscating, Agnes Martin's critical adherents have placed upon her the heavy mantle of high priestess. Her art (depending on who is looking at it) has been called minimal, classical, or romantic. There is no question, however, that her devotees consider Martin a visionary— an artist possessed of perceptive powers that have transformed her style into a heightened visual experience, the effect of which produces mysterious and highly potent shocks of recognition.

Repeatedly, her work has been praised for its delicacy, its startling control, it obsessive and quite breathtaking clarity of

repeated forms, and for its haunting articulation of color and light. Throughout the years, these unequivocal critical accolades have contrived to make of Martin's art a product of near-mystical perfection and inspiration. To a large degree, the deification of Agnes Martin has been abetted by the artist's own Cassandra-like writings and by her compelling persona that, in combination, have lent credence to her rise as an enigmatic, yet undeniably influential, creative force.

To meet Agnes Martin in person is to be in the presence of an austere and primitive sensibility—a presence that yields a slight sense of apprehension. Her appearance recalls photographs of Gertrude Stein at her most reserved and diffident. Her femininity is masked by apparel at once suitable and ungainly. During our meeting in New York (she had flown in from her retreat in Cuba, New Mexico, to fulfill lecture engagements in the East and also to sign her latest paintings at the Pace Gallery), Martin wore heavy workmen's clothes. Exuding extraordinary energy, she seemed oddly ill at ease within the claustrophobic confines of the city. The pure air of New Mexico still clung to her, and the light of the open landscape seemed continually reflected in her intense blue eyes.

The artist dislikes interviews. She shuns them and, indeed, permits no one to visit her in New Mexico, where she has lived in virtual seclusion since her abrupt departure from New York in 1967. With persistence, and at the discreet urging of her dealer, Miss Martin reluctantly agreed to give me a bit of her time. Upon learning that a tape recorder would be employed, she became visibly distressed. "I don't like my words to be tape recorded," she said. "It means that you have me in your power, and I don't like being in anyone's power." Nonetheless, Miss Martin, who had just finished signing her paintings at the Pace, relented, and invited me to share the short taxi ride back to her small midtown hotel. "You can ask me some questions in the cab," she told me. Noting my chagrin (the drive would take less than five minutes), she was persuaded to let our interview take place in the hotel lobby. After more pleading, she permitted the use of the tape recorder.

With the din of telephones, perpetual Muzak, and the

hectic comings and going of hotel personnel and guests, we precariously settled into our talk. Throughout, Martin firmly directed her eyes away from her interviewer, while in her hands she nervously twisted and retwisted a white paper napkin. As it turned out, the artist rarely answered direct questions, but spoke in oracle fashion on matters that seemed applicable to the life of the artist.

"Toward freedom is the direction that the artist takes," she began. "Art work comes straight through a free mind—an open mind. Absolute freedom *is* possible. We gradually give up things that disturb us and cover our mind. And with each relinquishment, we feel better. You think it would be easy to discover what is blinding you, but it isn't so easy. It's pride and fear that covers the mind. Pride blinds you. It destroys everything on the way in. Pride is completely destructive. It never leaves anything untouched. First it takes one way . . . telling you that you're all right . . . boosting up your ego, making all kinds of excuses for you. Pride can attack your neighbors and destroy them. But sometimes, pride turns, and destroys *you*. It takes a long time for us to turn against pride and get rid of it entirely. And, of course, with every little downfall of pride, we feel a tremendous step up in freedom and in joy. Of course, most people don't really have to come to grips with pride and fear. But artists do, because as soon as they're alone and solitary, they feel fear. Most people don't believe they have pride and fear, because they've been conditioned on pride and fear. But all of us have it. If we don't think we have it, then that's a deceit of pride. Pride practices all kinds of deceits. It's very, very tricky. To recognize and overcome fear and pride, in order to have freedom of mind, is a long process."

Looking fixedly into the cluttered distance, Miss Martin spoke in fervent tones. If she had personally achieved a loss of pride and fear, she did not voice it. But her career—long and circuitous—indicates a major struggle with the self, and an ultimate releasing of an imagery that indirectly attests to a clearing of dark inner forests.

Agnes Martin was born in Maklin, Canada, in 1912. At the age of 20, she came to the United States and, in 1940, became an American citizen. Settling in New York, she intermittently

attended Columbia University between 1941 and 1954, ulti-
mately receiving an M.F.A. degree. During the '40s and early
'50s, Martin's work was representational, centering on por-
traits, still-lifes, and landscapes. For a time, she traveled to
Oregon, California, and New Mexico, where she taught at
Eastern Oregon College and the University of New Mexico. In
1956, Martin returned to New York and, in 1957, moved to
Coenties Slip, working in the proximity of, among others, Ad
Reinhardt and Ellsworth Kelly. While deeply impressed by the
Abstract Expressionists, then showing at the Betty Parsons
Gallery and elsewhere, she did not follow in their stylistic or
aesthetic precepts, but began to paint in a reductionist mode,
producing paintings that recalled early Mark Rothko in their
simplified geometric frontal forms.

The subsequent years found Agnes Martin moving away
from Rothko's generally romantic overtones—his luminous,
floating rectangles—toward a more precise and impersonal
image. Her paintings became progressively more symmetri-
cal—highly organized and delicately executed squares, rectan-
gles, and circles, all bathed in pale and muted colors. Her
preoccupation with the detached and geometric culminated in
an intense fixation on grids, which have become Martin's
overriding signature and style. These compositions, with their
philosophic and spiritual allusions, brought Martin serious
critical and public attention, and, by 1967, her work was
deemed as daring as it was original.

Inexplicably, and for reasons she has never made public,
Agnes Martin stopped painting for some seven years, begin-
ning in 1967. The only work during that period consisted of the
production of a series of prints entitled *On A Clear Day* and
centering on grid variations. Martin was willing to touch on her
abrupt departure from painting and from New York.

"At that time, I had quite a common complaint of
artists—especially in America. It seemed to have been some-
thing that happens to all of us. From an overdeveloped sense of
responsibility, we sort of cave in. We suffer terrible confusion.
You see, it's the pressure in the art field in America. I think they
must not have these pressures in Europe, because the artist
lives so much longer over there. They have a class there that

considers it to be their business to support culture. But I'm not criticizing. Anyway, I left New York and traveled for about a year and a half, waiting for some inspiration.

"You see, if you live by perception, as all artists must, then you sometimes have to wait a long time for your mind to tell you the next step to take. I never move without a sort of command from my mind. And so I left New York. I went on a camping trip. I stayed in forest camps up North that could camp 3,000 people, but there was nobody there. I was there alone. I enjoyed it. I had this problem, you see, and I had to have my mind to myself. When you're with other people, your mind isn't your own. Well . . . finally, you see, I remembered New Mexico. I was there before, but I traveled a long way, as far as I could go, and in every direction. And then, I went to New Mexico and built a lot of buildings made of different materials.

"I had an inspiration about a land thing—like Robert Smithson. I thought I was going to build a garden. I mean, I was going to build an eight-foot wall, 40-yards square. It was going to be like a Zen garden, or at least something like it, but with absolutely nothing alive in it. We have a lot of interesting materials where I live. The mountains are volcanic, and there are a lot of different kinds of lava, some of it very light and very white. I was only going to let people in this construction one at a time, and if their response to the silence would be good, then I would have considered the structure successful. And so, when I went to this mesa in New Mexico, where I'm still staying, I had this inspiration. But I haven't done it. I don't know if I'll ever do it, because I can almost *see* what I'm going to do. I'm 64 now."

Still with eyes averted, and speaking in a kind of possessed monotone, Martin next spoke on the subject of painting.

"Painting is a very subtle medium, and it speaks of the most subtle phases of our responses, and so, it is much more rewarding to the painter. I think that, since the Abstract Expressionists, painting is in the same category as music. It really *is* abstract. There is no element of the environment that represents it anymore. Not that I think that abstract painting is the only kind of painting. There are lots of kinds of music and lots of kinds of painting. But now, there is abstract painting,

free of environmental elements and even relationship to the environment . . . and that is a much broader sort of feeling. You can really go off when you get out into the abstract!"

Agnes Martin fell silent. Many moments passed. Suddenly she said, "Mark Rothko's painting is pure devotion to reality. That's what it is! I wish you could publish that I don't believe for a minute that Rothko committed suicide. Nobody in that state of mind could. He was murdered, obviously . . . by the people who have profited or have *tried* to profit. Why, Rothko might have been the happiest man in this world, because his devotion was without mark or stain. He just poured it out, right from his heels!"

Another pause, and then, "Barney Newman's paintings are about the joy of recognition of reality. Jackson Pollock's are about complete freedom and acceptance. It's remarkable that the Abstract Expressionists followed the same line, in that they gave up relative space. That was the first thing. And then, they gave up any arrangement, just when a man in England was writing about positive and negative space! Well, they just threw it out, and then they got this remarkable scale, and they recognized that they had gotten out into abstract space. And then, of course, they gave up forms. They all did that, but they did it in such varied ways. And *still* they managed to fight. But I'm not going to talk about that."

Would Martin have liked being a part of the Abstract Expressionist movement?

"I'm afraid I wasn't in the running," she said. "But I do place myself as an Expressionist. The fact is, I don't believe in influence. I think that in order to be an artist, you have to move. When you stop moving, then you're no longer an artist. And if you move from somebody else's position, you simply cannot know the next step. I think that everyone is on his own line. I think that after you've made one step, the next step reveals itself. I believe that you were born on this line. I don't say that the actual footsteps were marked before you get to them, and I don't say that change isn't possible in your course. But I *do* believe we unfold out of ourselves, and we do what we are born to do sooner or later, anyway.

"But we all make mistakes. I mean, when I exhibited with

the Minimal artists at the Dwan Gallery, I was much affected by my association with them. But, don't you see, the Minimalists are idealists . . . they're nonsubjective. They want to minimalize *themselves* in favor of the ideal. Well, I just can't. The Minimalists clear their minds of their personal problems . . . they don't even leave *themselves* there! They prefer being absolutely pure, which is a very valid expression of involvement with reality. But I just can't. I rather regretted that I wasn't really a Minimalist. It's possible to regret that you're not something else. You see, my paintings are not cool."

It was not until 1974 that Agnes Martin resumed painting. A dramatic change came with her exhibition at the Pace Gallery in May 1976, when Martin's work bore no traces of her well-known grids, but focused entirely on vertical stripes. What is more, the artist's former emphasis on subdued, chromatic color was abandoned in favor of what, for Martin, amounts to a shockingly vivid palette. The stripes are painted in pale blues, pinks, and whites, suggesting a geometry of the senses at its most tranquil and undisturbed. Yet another major signal of change came with Martin's sudden eschewing of symmetry. The bands vary both in width and placement upon the canvas. The shift, to the unstudied eye, is extremely subtle, yet within the canon of Martin's oeuvre, it constitutes an almost violent departure from the strict adherence to the relentlessly symmetrical that was the hallmark of her previous work.

Asked about this new preoccupation, Agnes Martin claimed that it was as much of a shock to *her* as to anyone else.

"I can say that it took me a great intensity of work to find out that I had to give up the symmetrical. I was painting just small paintings, and I painted and painted every day. I don't know how many of those small paintings I did, or how many I threw away. I just couldn't understand what was the matter. I could hardly believe that *that* was what I had to do!"

Does something *tell* Martin what she must paint.

"No. Something tells you that you *haven't* yet painted what you must paint. Then, when you finally paint what you're supposed to paint, then something tells you, 'OK, this is *it!*' If you accept a painting that has good points, but isn't really *it*, then you're not on the track. You're permanently derailed. It's

through discipline and tremendous disappointment and failure that you arrive at what it is you must paint.''

Martin is not certain whether she will return to painting grids, but she spoke of how she came to paint them in the first place.

''One time, I was coming out of the mountains, and having painted the mountains, I came out on this plain, and I thought, 'Ah! What a relief!' (This was just outside of Tulsa.) I thought, 'This is for me!' The expansiveness of it. I sort of surrendered. This plain . . . it was just like a straight line. It was a horizontal line. And I thought there wasn't a line that affected me like a horizontal line. Then, I found that the more I drew that line, the happier I got. First I thought it was like the sea . . . then, I thought it was like singing! Well, I just went to town on this horizontal line.

''But I didn't like them without *any* verticals. And I thought to myself, 'There aren't too many verticals I like.' But I did put a few in there. Finally, I was putting in almost as many verticals as horizontals. But, I assure you, that after looking at the work of students, they think that artists such as myself are involved with structure. Well, I've been doing those grids for years, but I never thought 'Structure.' Structure is not the process of composition. Why, even musical compositions, which are very formally structured, are not about structure. Because the musical composer *listens* all the time. He doesn't think about structure. So you must say that my work is *not* about structure.''

Once more, Agnes Martin fell silent. And still she kept twisting the white paper napkin in her hands. Now, quite suddenly, she turned her head, fixing her eyes upon me. Very quietly she said, ''We all have the same inner life. The difference lies in the recognition. The artist has to recognize what it is. Having lived 40 years by myself, I've done a lot of recognizing. I have no personal ties and, of course, I don't miss them. But I don't want to discourage people who have a different sort of set up. That isn't the point. The point is that if you work by yourself, rather than in some social group, that's very different, and it takes self-recognition to do it. It's inevitable with all artists. People think they are different, because they recognize their response. But they are no differ-

ent. We all have the same life. But I'm telling you what the response is: it's recognition."

Martin hesitated when asked how she spends her days in New Mexico. Finally she said, "I don't get up in the morning until I know exactly what I'm going to do. Sometimes, I stay in bed until about three in the afternoon, without any breakfast. You see, I have a visual image. But then to actually accurately put it down is a long, long way from just *knowing* what you're going to do. Because the image comes into your mind *after* what it is. The image comes only to help you to know what it is. You're really feeling what your real response is. And so, if you put down this image, you know it's going to remind other people of the same experience.

"First, I have the experience of happiness and innocence. Then, if I can keep from becoming distracted, I will have an image to paint. But the funny thing is that, at one time, I had the image, and I tried to paint if for months and months. But there really was no image. There was no image, no feeling, no inspiration, no *nothing!* It meant I had come to the end. I never stop painting until I come to the end. I don't know about other painters. They have a continuous flow. But I *do* come to the end. And when I start again, I'm in a very low, unproductive condition. Then it works up and up and up. For months, the first paintings don't mean anything—nothing. But you have to keep going, despite all kinds of disappointments."

According to Martin, her show at the Pace constituted a kind of end. Her new project will be the making of a film.

"As soon as I brought my paintings to New York, I went out to buy moving picture equipment. I'll be making a movie. Of course, I'll never consider my movie making on the level of painting. But I'm making it in order to reach a large audience. The movie will be called *Gabriel*. It's about happiness—the exact same thing with my paintings. It's about happiness and innocence. I've never seen a movie or read a story that was absolutely free of any misery. And so, I thought I would make one. The whole thing is about a little boy who has a day of freedom—in which he feels free. It will all be taken out-of-doors. I feel that photography has been neglected in motion pictures. People may think that's exaggerated, but, really, I think

that photography is a very sensitive medium, and I'm depending on it absolutely to indicate this boy's adventure.

"Now, you have to understand that when I make a movie, my inspiration is not to make a movie. The materialistic point of view is that there is technique and expertise in the making of something. But that is not so. And it's not how I work. If I'm going to make a movie about innocence and happiness, then I have to have in my mind—free of distraction—innocence and happiness. And then, into my mind will come everything that I have to do. And if it doesn't come into my mind what to do, then we just cannot proceed. You see, the artist lives by perception. So that what we make is what we feel. The making of something is not just construction. It's all about feeling . . . everything, everything is about feeling . . . feeling and recognition!"

1976

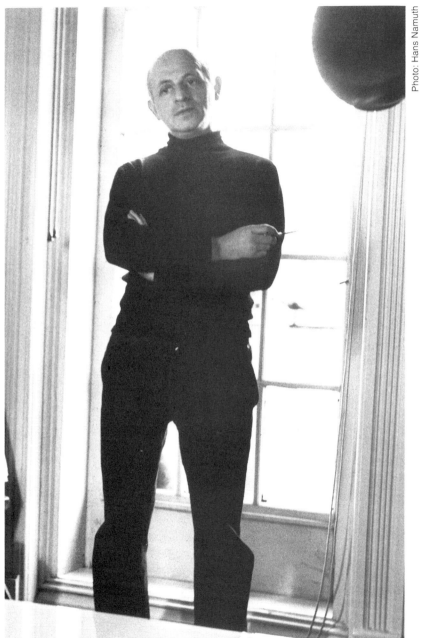

RICHARD
LINDNER

R ichard Lindner was an artist of extraordinary gentleness
whose work dealt almost exclusively in cruelty.

His imagery fixed on the bizarre lowlife of his native
Germany transmuted into sinister American nightmares
drenched in garish New York colors. With stiletto precision, he
shaped male and female figures of supreme hostility whose
encounters produced a ferocious sexuality. No other 20th-
century painter has depicted women with greater fanaticism or
greater eroticism. A savage lust informs their monumental
geography and the promise of their embrace implies instant
annihilation.

And yet, Lindner saw these rapacious creatures as mythic
goddesses, sacred beings consumed by secret desires. Dressed
in outrageous garb or seen in terrifying nakedness, they emerge
as fantasy figures of unthinkable potency. Their icy grandeur
creates a devouring heat and the men seen within this
ambiguous climate seem themselves enthralled by the voyeuris-
tic dramas that Lindner invented with such devastating cool.

During the mid-'60s, Lindner's paintings were mistakenly
swept into the vortex of Pop Art. It was assumed that the stark
immediacy of his mundane subject matter—pimps, whores,

killers, cruel dogs, and mad parrots painted in slick and glistening colors—was the product of contemporary experience and the celebration of seamy American life. In point of fact, Lindner predated Pop by nearly 20 years, during which time the artist was considered something of an outsider—someone whose stylistic roots seemed firmly planted in Constructivist soil. Indeed, the immaculate geometry of his figures can easily be translated and isolated into abstract structural shapes—circles, squares, triangles—which, in turn, re-emerge as the components of figurative elements: breasts, eyes, shoulders, legs, et al.

Again, the sensibility that informs his subject matter is not an American Pop sensibility (although America was Lindner's pictorial hunting ground), but one that had long been immersed in European culture and derived its impetus from old-world bourgeois life and standards. Still, the razor-sharp quality of his technique, the almost abrasive glare of his light, and the startling nature of his pictorial content ultimately brought Lindner's pictures within the ambience of Pop Art and, much to his surprise, the movement helped to catapult his name into the forefront of American art.

Two days before the artist's death on April 16, 1978, at the age of 76, Richard Lindner agreed to an interview. His first major exhibition in New York in 10 years had just opened at the Sidney Janis Gallery and Lindner had traveled from his home in Paris to be present at the opening. The exhibition found the artist in dazzling form, with canvas after canvas producing its familiar frisson of malevolence. Lindner's creative vigor had not diminished; indeed, it had intensified and coalesced into an ever terser and more eloquent statement of pure form and gorgeous, poisonous color. And the atmosphere of threat and apprehension that inhabited each work continued to wield its disquieting power.

Lindner looked very frail at his opening. A short, small-boned man with sad, questioning pale blue eyes, he had complained of being unable to shake a recent bout of the Russian flu, a bout that caused him to lose some 15 pounds. Still, he seemed delighted to see the many friends and visitors who had come to greet him and to celebrate his opening. With

him was his wife Denise, an extremely pretty French woman 40 years Lindner's junior. During the opening, a date was set for an interview. ''We'll have an elegant lunch, and then we'll go back to my apartment and talk,'' Lindner told me.

The lunch a few days later was indeed elegant and the artist seemed in fine spirits. I learned that his wife had returned to Paris. ''She loves New York, but likes Paris better,'' said Lindner. ''Denise is a very good artist, but for some reason she refuses to show her paintings. It's really very strange.''

During lunch, Lindner explained that, although he had been living in Paris for many years, he had always kept an apartment in New York.

''Paris is *so* boring! I need to recharge myself by coming back here all the time. Actually, all the sketches for my paintings are made in New York. Just to see the color of a New York truck or taxi excites me! There's life in New York; Paris is dead. All the ideas for my paintings come from what I see here. Then I go back to Paris and paint the pictures. I've not shown in New York for 10 years because there have been several retrospectives of my work in Europe. Also, I wanted to remove myself from the New York art scene. My last show here was with the Cordier and Ekstrom Gallery . . . finally, it didn't work out and I left them. I don't know . . . I suppose my feelings about New York are unjust. I mean, I've never had a bad review, but somehow I've never really had any real recognition in America. Critics and museum people just never knew what to do with me or where to place me. In Europe, my work hangs in the best museums and things are not so confusing. To tell you the truth, I wouldn't like to be a young painter living in New York today. I wouldn't know how to begin here!''

Lunch over, we strolled a few blocks to Lindner's apartment in the East 70s. Comfortable and immaculate, the modern living room had been turned into a studio. A specially constructed easel with small pulleys and cranks stood near the windows. A charcoal sketch of a man with a bowler hat rested upon it. We sat on a wide, low leather couch and Lindner began to recount something of his past.

''Although I was born in Hamburg, my first youth was

spent in Nuremberg, the most medieval and the most cruel city in the world. The worst instruments of torture were invented there, like the Iron Maiden. People were thrown into wells. Of course, Hitler made Nuremberg his headquarters. But it was a beautiful city. It was a city of canals, like Venice. It had rich merchants and it has a great history of art. But even as a boy I was aware of a great coldness there . . . something sinister that came out of every crevice of the city.

"My mother was an American. When she was 20, she came to Germany, met my father, and married him. They settled in Hamburg. My mother has been dead for many years, but I'm still trying to discover her riddle. Her obsession was to become as European as possible, but she failed. As a child, I found her behavior almost grotesque. What I mean is she could never quite reconcile her enormous desire for being a true European mother with her strong puritanical temperament. The harder she tried, the more bizarre it became. And I became more and more confused as to what she expected of me.

"In a way, she reminds me a little of George Grosz. When Grosz came to America, he wanted to be more American than the Americans. He even wanted to paint like Norman Rockwell! He brought with him an *idea* of what an American was like. Again, it was a grotesque idea and Grosz failed, just as my mother failed. While Grosz hated the German people he drew and painted, I'm convinced that he was a little like them. You see, one cannot escape what one is."

As a young man, Richard Lindner trained for a career as a concert pianist. During his early 20s, he began to concertize and was hailed as a highly promising talent. Becoming a painter had never once entered his mind.

At the age of 24, Lindner moved to Munich. There he met a former schoolmate who was studying painting at the Munich Academy.

"This friend asked me to visit him at the Academy, and when I entered that beautiful old building I was transported. I walked through many hallways and galleries, and when I reached his studio I saw two or three artists sitting there painting and smoking and talking. In the center of the room stood a fat naked woman who was posing. The atmosphere was

so congenial . . . it was like a dream world! Then and there I resolved to stop being a pianist. The fact is, I couldn't stand the pressures of concertizing. I suppose if I had been a real musician I would never have stopped. But I gave up music and applied for entrance at the Academy. I was accepted and stayed there for three years. I became a master student. I learned all the basics and my first works were very academic still-lifes. I learned how to draw extremely well from very bad painters. I soon found out that from a good painter you never learn anything. Picasso and Matisse were terrible teachers. The only thing a good painter can do is stimulate you.

"Anyway, after my Academy training I went to live in Berlin. I lived there for two years, 1927 and 1928. Well, Berlin was a fantastic city. I mean, it was criminal! It was rotten with talent! *Everything* was going on. It was as George Grosz had depicted it, full of decadence and meanness. It was lurid and perverted and marvelous. And so was Paris, when I finally got there. Paris was also rotten, but with big, big talent everywhere.

"I was already married when I got to Berlin. My first wife was a fellow art student at the Munich Academy. We lived together for a few years, and then she fell desperately in love with a writer—a close friend of mine. She didn't exactly leave me, but she lived with the writer. It was an understood relationship, but it took a bad turn. The writer became very ill and died. When that happened, my wife committed suicide."

In 1929, Lindner returned to Munich and took a job as an art director of a well-known publishing firm. When the Nazis rose to power, Lindner escaped to Paris and, by 1933, became politically active, while also continuing to paint. In 1939, the French government interned Lindner for political reasons, but he was released a few months later. At the start of World War II, the artist joined the French army and later the British army. In 1941, he emigrated to the United States and settled in New York. To support himself, he found work as an illustrator for such magazines as *Vogue*, *Town & Country*, *Harper's Bazaar*, and *Fortune*.

"There wasn't much of an art world in New York when I came here," said Lindner. "There were two or three galleries, and nobody sold anything. I met all the New York artists, but I

was always an outsider. I didn't fit in. You see, I wasn't part of any movement. I made a good living as an illustrator, but I got very tired of it. Actually, I didn't begin to be a full-time painter until 1950; there was always something interfering. But then, in 1950, I started to make time for myself. By 1952, I decided to take a teaching job. I taught at Pratt Institute for 12 years. Later I taught at Yale, but that was only for a short time. Actually, I didn't like teaching. I taught because I wanted time to paint."

Speaking very softly and with a slight German accent, Richard Lindner now discursively began to touch on what lay behind his paintings—the strange scenarios that, he claimed, came straight out of his imagination.

"Subject matter for me is always a man, a woman, a child, and a dog. Dogs, like children, are the real grown-ups. And dogs and their owners have always amused me. The other day, I was in an elevator and there was an old lady holding a poodle. She said to it, 'Say hello to the nice gentlemen!' Germans love German shepherds, because they can command them; Germans love to command. Anyway, I never use a model. Models disturb me. They want to talk, and I don't like that. I never do color sketches. I do color on the canvas. About color: I have always felt that in order to be a good painter one should be color-blind, because color doesn't have to be seen. It needs only to be *felt*. When I told that to some of my students, they thought I was crazy!

"Anyway, my paintings have a lot to do with balance and composition. I like structure. As for the women in my paintings, you have only to look at my wife to know that the women I paint are not at all my type. Sometimes the women are very big for reasons of pictorial balance. But, of course, those women *have* haunted me. Still, I have never really been hurt by a woman. All my women have stayed friends. No, I'm not in the least attracted to the kind of women I paint. However, I think that one must deal with one's complexes.

"Of course, there is the bordello aspect to my women, and the criminal aspect. Of course, we are all criminals; it's all a matter of degree. Crime is as human as being charitable. Naturally, we must have tribal laws. But crime . . . crime is like art, and the artist has always understood the criminal. The fear

of the criminal is the same as the fear of the artist: both are terrified of exposure. It's basic to their nature.

"But women . . . ! When I paint them it's an expression of pure love. I could put this love into any medium. I could put it into sounds. I could put it into words. Actually, I was talking about this to Bill de Kooning. Bill and I are always being accused of being women-haters. The fact is, we love woman. I'm looking forward to the day when a woman is president. It's the most logical role for her. With a woman as head of state, there would be no wars. Take her vanity: It all goes into the mirror; it would never affect her role as leader. Man's vanity goads him into all sorts of destructive activity. Luckily, women are changing all that.

"Already I sense how men are having a harder and harder time proving their manhood. Women have found out their secret. And men are losing their feathers by the minute. Man's secret is that his so-called manhood is a myth. It's a 19th-century concept that's been fed and nurtured and swallowed by generations of women who, in the meantime, have had all the time and years to strengthen and deepen their own mystery and power.

"Today, women look at men as mystic strangers. Not at all, mind you, as weaklings or creatures devoid of character or substance, but as strangers—mystic beings without any real secrets. Man's touted enjoyment of sex, for example: It no longer worries women. They're enjoying it just as much as, if not more than, men. And they enjoy it openly and fearlessly. Man's ego is being changed by all this, and it's beginning to worry him. Women have a greater sense of fantasy. At the same time, they are far more realistic than men.

"And they are wonderfully in command of themselves! Have you ever watched a woman bathe? They do it ever so slowly, almost in slow motion. They observe themselves as though they were works of art. They linger and pause, and they move as in a trance. Beautiful! Beautiful and endlessly fascinating!"

Lindner paused, closed his eyes and savored the thought. In a moment, he opened his eyes, smiled, and added, "Of course, they *are* terrifying! But, you know, my work is really a

reflection of Germany of the '20s. It was the only time the Germans were any good. On the other hand, my creative nourishment comes from New York, and from pictures I see in American magazines or on television. America is really a fantastic place! That's why I admire Andy Warhol so much. He's not a great painter but he's an extraordinary stimulator. He really opened America's eyes to the beauty of the utilitarian, everyday object—to the importance of the can!

"I admire the Pop artists—Warhol and Roy Lichtenstein and Claes Oldenburg—but I'm not one of them, never was. My real influences have been Giotto and Piero della Francesca, timeless and ageless artists. I look at them all the time! And I hope that something of their strength has come into my pictures. Basically, it's what I'm aiming for: that kind of structural solidity . . . that kind of power!"

The interview had come to a close. Two days later, Richard Lindner died in his sleep. The works he created will remain a disturbing and unique testament of an artist's superb crafts-manship, originality, and vision.

1978

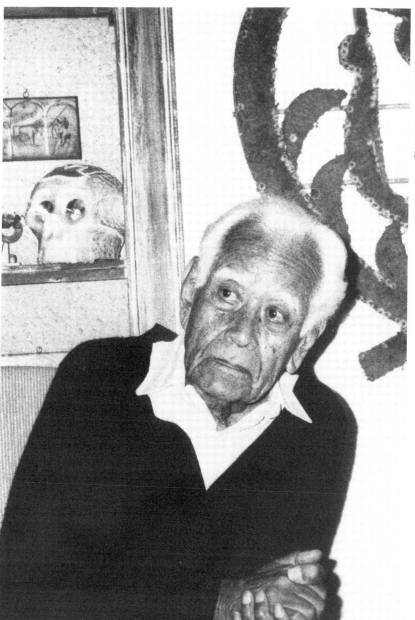

RUFINO
TAMAYO

In his 79th year, Rufino Tamayo's strong and impassive face is unlined. There is serenity in his dark eyes and a quiet dignity in his mien, stance, and walk. His hair is snow-white, contrasting dramatically with his sun-tinged complexion. When Tamayo speaks, the lilt of his English contains the music of some plaintive Mexican song. Like his work, the man is possessed of an aura of the subdued and mysterious. And yet, there is nothing oppressive about Tamayo. Highly cultivated and entirely cosmopolitan, he is an artist of far-flung interests—an internationalist who has never allowed his strong Mexican heritage and roots to interfere with his quest for an identity of widest possible sophistication.

No Mexican artist of his generation has achieved Tamayo's particular international recognition, and none have brought to bear upon their work such consistency of personal vision. The fact is, Tamayo's ouevre has remained resolutely Mexican without making of this unmistakably national imprint a matter of political or sociological crusade. Other Mexican artists, such as the deeply nationalistic Diego Rivera, José Orozco, and David Siqueiros, have used their art to make political state-ments. Rufino Tamayo has violently refused to follow in the

propagandist tradition of these artists, preferring to place his "Mexican-ness" at the service of subjects devoid of militancy or of messages extolling the Mexican Revolution or the proletarian cause. Reaching for the universal and responding to the poetic imagery of his country's deeper cultural roots, Tamayo opted for a vocabulary that transformed this imagery into a personal language in which color, composition, and subject matter combined to create a world of fantasy strongly tinged by the more tragic overtones of his Mexican heritage.

In October 1977, Tamayo and his wife, Olga, traveled from their home in Mexico City to Washington, D.C., to be present at a retrospective of Tamayo's work at the Phillips Collection. Entitled *Rufino Tamayo: 50 Years of His Painting*, the exhibition was assembled and organized by Dr. Eleanor Green and included some 66 works spanning the years 1925 to 1977. The show was a prodigious panorama of one man's ongoing dialogue with creative forces that have produced paintings distantly indebted to Cubism and Surrealism, but primarily the result of an inner confrontation with the mythic symbols of the Mexican ethos. But perhaps more to the point is Tamayo's strong stylistic individuality—an approach that has placed him closer to the aesthetic realms of Cézanne, Picasso, and Braque than to the sensibilities of painters of his native land.

Indeed, Tamayo's long and productive life continues unimpeded by postrevolutionary concerns but flowers in the soils of pre-Colombian and ancient Indian art transmuted into a language understood the world over. As he put it, "Perhaps it was an accident that I *am* Mexican. What I am first of all is a citizen of the world."

Rufino Tamayo was born on August 28, 1899 in Oaxaca, Mexico. From 1917 to 1921, he studied at the Academy of San Carlos in Mexico City—an experience that made the young artist aware of the direction he did *not* wish to pursue.

"At the Academy, the lessons were highly academic, which was not to my taste," says Rufino Tamayo. "We were made to copy plaster casts as precisely as possible, and I soon realized that this was not good for me. I knew this, because in the Academy there was also a museum that I visited very often. I saw old masters—European masters—and they all had a very

strong personality. Well, I began to realize that to develop an individual personality was a very important thing. But in the classes I was attending, the teachers were killing personality rather than helping it to grow and so, as soon as I could, I left the Academy. I was very lucky, because I met the Secretary of Education of Mexico, who happened to be born in my home town—Oaxaca—and he liked me and made it possible for me to obtain a job in the Archaeological Museum in Mexico City. That was the real beginning for me, because it exposed me to the pre-Colombian art—to the popular art of my country—and immediately I noticed that *that* would be my source. From that moment on, it became the basis of my art."

Even as the Big Three of Mexico—Rivera, Orozco, and Siqueiros—embarked on their political and historical narrative murals during the '20s and '30s, Tamayo, along with such antimuralist rebels as Agustin Lazo, Manuel Rodriguez Lozano, Carlos Orozco Romero, and Carlos Mérida, opted for more elitist attitudes—easel painting that centered on decoration, abstraction, and stylization of form. Of them all, Tamayo looked beyond his own geographic and artistic borders, and resolved to follow in a path that would ultimately provide him with a lasting quest for personal and creative freedom.

"It was 1926, and I was getting more and more disgusted with the art being produced in my country," says Tamayo. "Even those painters who went against the muralists turned out works that were bad imitations of French art. I wanted to get away from that—to get out into the real world of art—and the closest center for me was New York rather than Paris or any other part of Europe. And so, I traveled to New York. Well, when I arrived, I saw that American painting at that time was not very good either. It did not impress me because, again, it was mostly an imitation of the Europeans. What *did* impress me was coming into contact with international art. I saw *real* French painting and German painting and early American painting, and that's what I wanted to be in touch with. It was the genuine article and it gave me an even bigger overall vision of what I wanted to do."

As James B. Lynch, Jr. points out in his catalogue introduction to the Tamayo retrospective, the artist may have been

exposed to such New York exhibitions as *Prints by Georges Rouault, Sculpture by Constantin Brancusi, Modern Paintings: Ingres to Picasso, French Art of the Last 50 Years, International Exhibition of Modern Art,* and *36 Years of Matisse,* as well as individual shows by Cézanne, Braque, and Picasso—a head-spinning array of international art currents that would surely have moved Tamayo toward ever-widening creative goals. There is no question that in Tamayo's work of that period these influences made themselves strongly felt; his paintings reflected the more obvious aspects of a Europeanism that would slowly emerge, tinged by the brooding yet eloquent coloristic elements that he would ultimately make his own.

It was these works that Tamayo exhibited in his first exhibition in New York at the Weyhe Gallery in September 1926. The show proved a critical but not a financial success, and the artist, elated but insolvent, was obliged to return to Mexico where he obtained a teaching position at the National School of Fine Arts in Mexico City. By 1929, he had had his second exhibition in Mexico City's Palace of Fine Arts, and in the following year he resolved to return to New York where he established himself as a young and highly promising artist, whose still-lifes and figures became increasingly imbued with structural power and surface luminosity. Works such as *Nude, The Blue Chair, Still-Life,* and *Homage to Juarez,* all painted in the '30s, offered a Cubistic astringent view of subject matter—a blending of emblematic forcefulness and poetic color that produced an immediate impact on the New York art world. This was Mexican painting devoid of banal, stereotypic allusions but echoing some ancient heritage that made of the Mexican sensibility a matter of *accent* rather than of pure nationality.

It was during the '30s and '40s that Rufino Tamayo quickly established himself as an artist of stature. In New York, he exhibited with the Julian Levy Gallery and the Valentine Gallery. For some years, he taught at the Dalton School and at the Brooklyn Museum. In the meantime, he had married Olga Flores Rivas, a talented young pianist he had met in Mexico City. Living in New York for some 15 years, Tamayo and his wife often returned to Mexico. Indeed, at one point the artist was appointed director of the Mexican Department of Plastic

Arts of the Ministry of Education, and painted an important mural for the Conservatory of Music in Mexico City. But New York was Tamayo's home base, and there were exhibitions in San Francisco and Chicago, among other cities. Then, in 1948, the Palace of Fine Arts in Mexico City gave Tamayo his first large retrospective—the first homage his country bestowed upon him.

Tamayo's work of that period was at once ordered and secure and was possessed of the intense color that would soon place him among the finest colorists of his generation. Throughout the World War II years (which the Tamayos spent in New York), the artist produced paintings that depicted the horrors of war, and they contained a ferocious lyricism——an incantatory brutality that seemed to dispel violence even as it portrayed it. And in the midst of this middle period in Tamayo's career, there emerged the magical figures that, though strongly echoing Picasso, offered homage to alienation and sorrow.

During the '50s and '60s, Tamayo the fantasist held sway. In the prophetic *The Astronomer* of 1954, the artist foreshadowed the space age and did so with remarkable accuracy. Swirling shapes in a vast, half-lit stratosphere suggested unknown horizons; again, color and form were seen within an ambience of an almost elegiac beauty. During this time, the artist and his wife made frequent trips to Europe, and they eventually decided to settle in Paris, where Tamayo lived and worked for some 12 years. Although he found himself in a new milieu, the artist's work did not, in fact, alter dramatically. Accepted as an established figure in New York, his move to Paris was one that would simply broaden an already burgeoning career.

"I went to Paris as a painter, not as a student," declares Tamayo. "My personality was already established. But many people ask me what influence Paris had on me, and I answer: None at all! You see, my style was already known, and I soon exhibited in Paris (at the Galerie de France). I had already met many of the French painters, because most of them lived in New York during the war. But, in Paris, I met Picasso. To me, Picasso was the genius of the century—no question about that! Still, to tell you the truth, I didn't admire him much as a painter, but more as an overall creator—a visionary. Frankly, he was not

a very nice man. He certainly was not nice to his women. My wife and I became good friends of Dora Maar and of Françoise Gilot. Each one told us that, although he made many portraits of them, he would give them these works but refused to sign them. He knew they would be of less value without his signature. That's the kind of man he was—very stingy.

"Anyway, I got to know Picasso fairly well and even lived in his villa for about a week. At that time he was making pottery and we got along nicely. But the thing about Picasso . . . he was a nonstop talker and he seemed very pretentious to me. I recall having had my first show in Paris, and it was very successful. Picasso heard about it, and went around to see it while I wasn't there. Later, I heard from friends that he didn't like my show at all, and he told people how bad it was. You see, he didn't like other painters having success—he was a jealous man."

In Paris, Tamayo continued to paint and to exhibit. The shape and intonation of his work now found expression in a generally limited palette and the figurative elements in his canvases, while still dominated by Picassoesque influences, began to take on a primitive iconography. Tamayo's instinctive response to pre-Hispanic art made itself felt through figures now charged with silence, mystery, and even greater magic. Works such as *Man in the Red Hat* and particularly *Black Venus*, painted in 1963 and 1965, respectively, offered intensely poetic forays into a primitivism strongly charged with atavistic overtones. Color abetted subject matter in ways that produced its own intense sensuality; deep reds, soft mauves, dark blues, and light pinks combined in jagged, pulsating rhythms, infusing each work with a lyricism at once fiery and contained.

The '70s found Tamayo entering a period of introspection. As if surveying his past, he consciously retreated from the heated dramas of mythic concerns to a more objective and somber detachment. Paintings such as *Still-Life with Glasses*, *Man with a Red Hand*, *Dialogue*, *Time Suspended*, and *Man with Red Background* saw the artist dealing with faceless personages enacting unidentifiable roles in "settings" that seemed oddly dislocated and equally mystifying. Still, the power of something magical remained. An aura of the muted and transfixed permeated this late work, with Tamayo continuing in his vision

of a Mexican universality that remained devoid of Mexican specificity.

Reflecting upon his long career, Tamayo voiced his feelings vis-a-vis his country and his heritage.

"As I told you, in the beginning I found my sources in the pre-Colombian popular arts, which are very rich in my land. Mexican tradition has to be recognized as one of the greatest in the world. So, I went deep into all that and I found several important things. First, there is the mystery that exists in Mexican art, and not only in art but in the whole Mexican ambience, which is tragic and full of sorrow. I have friends that have come from Europe and they say, 'My God, there is something in the air here that is so strange!' You see, they feel *something* and they can't say what it is. Simply the idea of death in my country is very particular. The Mexicans are not supposed to care about death. That's a tradition from centuries back. Death is to be made fun of; it's a kind of tragicomedy. It's full of ironic overtones. When someone dies, the family sends little candy skulls to everybody and everybody eats them—that sort of thing. Still, our country is filled with a deep sense of compassion and a deep sense of tragedy. When André Breton visited Mexico, he said it was the most surrealistic country in the world. And he was right. So all that, I hope, is reflected in my work.

"Also, in my paintings, there is a certain concept of proportion that is very characteristic of my country. The proportions of the human figure in my canvases are very varied; they are far from the classic proportion, and, in that way, they resemble our Mexican mountains. Sometimes the head is very large and the legs very small and sometimes just the opposite is true. You ask me why my color has become so somber. Well, generally people who don't know Mexico think it's a very gay country. You known, 'Fiesta-time!' But that's wrong. Mexico is not a gay and happy country. On the contrary, it's a tragic country. Why? Because for centuries we have been subdued and oppressed. Naturally, one is not content when one is oppressed. So, that is why my color is predominantly subdued and somber. The fiesta colors one sees in picture postcards of my country is only a facade, and very deceptive.

"But I will tell you something. The line of my work is more

or less straight; there are no dramatic changes. My figures are not people but personages. For me, subject matter is of no importance, because the moment you give importance to the subject, then you are diminishing the value of the painting—the plastic value. I use subject matter simply as a point of departure. I'm far more interested in making a *painting* than in just painting a picture of something."

Despite Tamayo's avowed internationalism and his long years of residence in New York and Paris, he has chosen to return to his native Mexico, where he and his wife have been living since 1964. This decision has brought with it various personal dilemmas. For one, his own country has long regarded Tamayo as something of a renegade. Certain highly placed government officials have consistently decried his political neutrality and have frequently denounced his refusal to use his art as an instrument of propaganda. Many *still* regard him as an elitist, concerned only with producing an art that appeals to the aesthetic sensibilities of an international public rather than to the poverty-stricken masses of his own country.

Resentment is also rampant over the fact that Tamayo has become rich and famous outside his native land. The artist himself readily admits that present-day Mexican painters are jealous of his world-wide renown and look askance at an artist whose "Europeanized" art has brought him wealth and glory. And, indeed, Tamayo has garnered enviable honors through-out his long career. Represented in virtually every major museum and private collection the world over, he has received innumerable prizes, including the First Prize at the Carnegie International (1952) and the Sao Paulo Biennial (1953). He has been decorated by the French government as a Chevalier as well as an Officier de la Legion d'Honneur. He was nominated as a member of the Academy of Arts in Buenos Aires, and has received a Guggenheim International Foundation Award. He was elected a member of the American Academy of Arts and Letters and decorated as a Commendatore of the Italian Republic. Nearly a dozen books have been written about Tamayo and four films have been made on his life and work.

This is not to suggest that Mexico has not also honored him. In 1964, he received the National Award from the

President of the Republic of Mexico for his artistic merit, and a street has been named after him by the City of Oaxaca, his birthplace. Moreover, he is represented by several major murals commissioned by, among others, the Palacio de Bellas Artes and the Museo Nacional de Antropologia in Mexico City. Still, his greatest recognition has come from the United States, Europe, and South America.

Tamayo feels little rancor against Mexico. On the contrary, in 1974 he honored his own land and heritage by donating a museum for the permanent display of his collection of over 1,000 works of Mexican pre-Colombian art to the City of Oaxaca. And he wishes to do more. Some 10 years ago he proposed to the Mexican government that it build a museum in Mexico City that would house his private collection of contemporary European and American art—over 100 paintings and sculptures that the artist purchased throughout his travels abroad. But this particular project has been met with extraordinary resistance, a fact that has rankled and bewildered the artist.

"There has been so much trouble over that!" he says. "I still do not understand why people fight me so much about it. Except that I *do* know. You see, the so-called leftists, which to me are politicians without personal values, say that the paintings I want to give are only for the elite and not for the people. I have Picassos, Miros, Chagalls, Klees—really the best works. And I have Robert Motherwells and Mark Rothkos and paintings by Pop artists and Op artists and Abstract Expressionists and Surrealists. It's a wonderful collection to which I'm adding all the time. I'm spending money, but what is to become of these works? We have no children to whom we can leave them. So, they must be housed somewhere and I *want* this museum.

"Now, it happens that I spoke to our country's president and he said, 'Yes, You can have your museum!' But then he said I had to speak to the mayor of Mexico City, because it would be in *his* province. Well, the mayor also said 'Yes, you can have the museum,' but then, there were petty officials who had to be dealt with. You see, the problem is that I want the museum to be built close to all the other museums in Mexico City, the

reason being that if a place of culture is not easily accessible, then no one will go there. It so happens that all the museums are situated in one big park, and Mexico City has very few parks—or green places, as they are called. So, the commissioner of parks is against the building of another museum, because it would take away space from the park. But, again, it's all politics, because there already exists a building in the park that is not used by anyone, and it could easily be razed to make room for a new structure. So, this has been going on for 10 years, and I am constantly assured that the museum will happen, except that no one is doing anything, and that is very unfortunate, because to have such a museum would mean that the people of Mexico would be exposed to the best postwar art of Europe and America."

Frustration and disappointment notwithstanding, Tamayo insists that Mexico is the land in which he wishes to live and work and end his days. Still, he is strongly aware of the resentment all around him.

"People are jealous of me. It's a complex situation and politics are involved. There is a faction which wants me to paint Indians and the problems of the Revolution—even today! But I was never interested in that, because I am not an illustrator. I have always wanted to go deeper and not paint the surface of things. Anyway, I have stopped worrying about any of that. All I know is that my life has to be lived in Mexico, because I am *very* Mexican, after all. No one can take that away from me, and I love my country. Of course, I have great difficulties with my wife about living in Mexico. She would much rather live in America, because we had a wonderful life there. But I belong to Mexico, and so does she. I love the nature all around me, because of its tremendous variety. And in Mexico you have every conceivable climate—from very cold to very hot—and consequently many things happen in nature. There is the bigness of the mountains . . . and the dryness of certain places. I love it all, because I am of the earth! Still, I am sad that my wife is unhappy.

"My wife is a very curious person . . . quite difficult. I mean, she is very successful socially, but she can be terribly frank. Sometimes she says things that are terrible—things she

shouldn't say. But people seem to like her frankness. She's very independent and doesn't listen to me. But there is something very important about Olga. From the first day we married, she has taken care of me. She does everything for me and I just paint, which is wonderful. I am grateful to her for that. Still . . . she is a difficult woman."

Olga Tamayo is indeed a formidable person. Imperious, elegant, with jet-black hair she wears coiled in a bun at the top of her head, she projects tremendous energy and exuberance. Madame Tamayo is unafraid to speak her mind, whether it concerns her husband, his career, or life in Mexico.

"Always, the people in my country have been jealous of Tamayo! It is something terrible. But, unfortunately, we Mexicans are that way. We never permit anybody to be *somebody*—in anything. The moment someone rises to the top, the Mexicans will do everything to push that person down. Take the matter of the Tamayo Museum. It is something so subtle! It's the intellectual radicals and the wife of Siqueiros who are against it. They think the museum is for the elite and the wealthy people and nothing for the poor people. All those around our President are jealous of Rufino for being international, and yet, Rufino wants to give everything we have to Mexico because, you see, we have no children.

"About Rufino? Well, we have been married 45 years and all we do is fight. I was a piano student and not a bad one. But when Rufino heard me play he said, 'You're either the tops or nothing!' And that broke my confidence. Now I only play for myself. Anyway, we met through a mutual friend while Tamayo was doing his first mural—that was in 1934. He was very shy. So, after three months, I said, 'Let's get married!' It was I who proposed to him. We were married against the wishes of my parents, because they didn't want me to marry a painter. But Rufino was very lucky. We only suffered financially for two years, and then he began to be shown in the best galleries, and his career soared.

"But I will tell you something about Tamayo. The only thing he loves in life is working. That is all. I do everything for him. I am his secretary, his manager, his publicity agent. I am the housewife and the hostess. And what does he do? He only works

and he never opens his mouth. I live with a mute! Also, he
doesn't show his feelings for me. But he adores his dogs! He loves
them and he even sleeps with them—two beautiful mongrels.
Still, I have been a happy woman. I have a beautiful life—always
busy, always meeting interesting people. We have never liked to
show off. We don't need it anymore. We have everything we
want—a beautiful house in Mexico City and one in Cuernavaca.
We have six servants, two cars, and a chauffeur. What else do we
need? But for Rufino, his only pleasure is work."

Tamayo decidedly concurs on his love of work: "I work
steadily for eight hours a day, because I don't believe that the
artist has to wait until the muses come. I believe that the muses
live within you and all you have to do is paint. Anyway, my
studio is in my house in Mexico City. I get up and have
breakfast and go straight to the easel. In my work I never paint
from objects or models—no melons, no pineapples, and
certainly never any people! My art is an art of invention. While
I paint I listen to music—Bach, Mozart—and I do this until
lunchtime. Right after lunch, I go back into the studio and paint
until the light fades. That is my day. At night, we have a strong
social life. We have friends who come to the house, or we go out
and visit with them. The only artists I see are the very young
ones. Those of my own generation have always been against
me, and so I don't mix with them. Most of our friends are
writers and musicians—very few painters or sculptors.

"I am getting old, but I don't feel my age. Of course, there
are some weaknesses—that's only natural at 79. Inside, I feel as
a boy. I feel very young and I think I have a young attitude
about things. As for my health, the fact is I have always been
sick. For years and years I have been suffering from terrific
stomach problems—colitis—and there is no cure for that. But I
have been told that colitis is a sickness that helps one to live a
very long time . . . it's a sickness that keeps you alive. Natu-
rally, I think that death may come at any moment, but I seldom
contemplate my own death. What I fear most is becoming
incapacitated, because then, what's the use of living? I would
surely die if I could not work."

In 1975, Rufino Tamayo joined New York's Marlborough
Gallery, a move that finds the artist entirely satisfied.

"They have been very nice to me—so far. When I went with them, people told me they were crooks. But I have not found this to be the case. They promote me and they sell me; that is very important. Also, I have made a good friend in Pierre Levai, who handles my work there. He is a gentleman and very sensitive to my work."

Pierre Levai, who has been associated with Marlborough since 1964, considers Rufino Tamayo more than an artist represented by a well-known gallery. The two have formed a close friendship and have traveled together on many occasions, giving Levai the opportunity of knowing the man as well as the artist.

"Tamayo is a man who is at peace with himself through his work," says the dealer. "When I had the chance of knowing him better, I realized he was a man of great intellectual qualities. He's an extremely cultivated person—a man who thinks very clearly and with a great sense of logic. Tamayo truly loves his country and he has an acute knowledge of Hispanic art. I've traveled with him and I was amazed at what he knows. We visited many churches in Mexico and he analyzed the Spanish Baroque elements that were superimposed by the Mexican sensibility and primitivism. He was profoundly moved by all that, and kept marveling at the genius of his country's art.

"We are very fortunate to be able to handle Tamayo's work and, believe me, it is greatly in demand. He produces some 20 paintings a year, and his canvases command between $35,000 and $60,000 each and, I assure you, people are buying them. Of course, he is one of the greatest colorists of the 20th century. Also, his paintings are extremely mysterious—never obvious. The biomorphic shapes, and the subjects he deals with, are very strange and ambiguous. The public must reach its own conclusions about them. There are no answers. Also, each work has great authority—and his latest paintings are perhaps among his greatest. They're like a good wine. The older it is, the better it tastes."

Nearing 80, Rufino Tamayo has indeed deepened and coalesced his aesthetic vision. And he has become greatly conscious of the artist's emotional involvement with his metier.

"In a way, all my work is about love. I have reached the

conclusion that love is the biggest *motif* of life. I'm not talking about the love that may exist between two persons, but a more universal sense of love—a love for nature, for objects, for work itself. There are certain artists who have achieved this universal love. Certainly, Picasso did. And also Braque, who was a much better painter than Picasso, and Chaïm Soutine. In America, there is Motherwell; he is a great painter. But perhaps the greatest of the New York School painters was Franz Kline. He painted with an organized passion; his works just soar! Jackson Pollock I admire, but cannot like. And there is Rothko, whose work is in a class by itself—very mysterious and beautiful.

"As for myself, I look to the earth and also to outer space. I look and I paint and I feel a great love surging up in me. And always there is Mexico . . . there are spirits in my country . . . they run loose there! The Indian races hover and they have a hold on us all. I strain to listen to their voices!"

1978

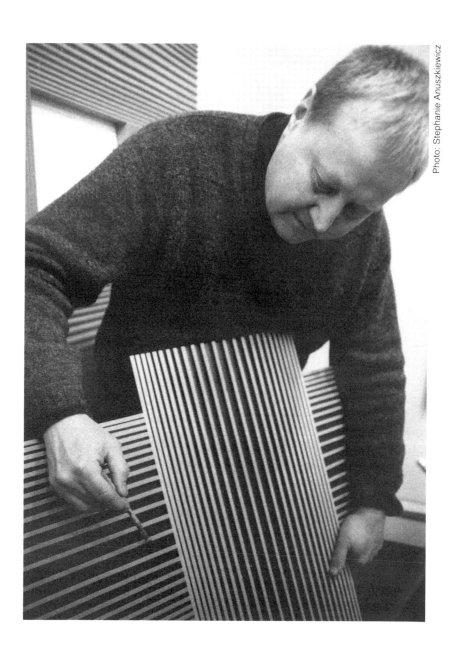

RICHARD
ANUSZKIEWICZ

Viewing the work of Richard Anuszkiewicz during his solo exhibition at the Alex Rosenberg Gallery in March 1979, one felt a decided sense of deja vu. When many American artists had left the lessons of Op Art far behind them, it seemed curiously shocking to revisit a style that would seem to have run its course and possibly outstayed its welcome. And yet, for all their familiarity, these pristine, meticulously executed works produced an altogether novel sensation. Whether through hindsight or the shock of recognition, Anuszkiewicz's paintings suddenly assumed the look of classics—works that had withstood the test of time and overridingly claimed their own ground.

The show made no concessions to novel investigations in color or form, nor did it offer slavish or self-conscious experiments in optical illusion. If anything, it reverted to a simplicity of composition that lent particular impact to a shape with which Anuszkiewicz had long been involved: the centered square. It is the durability of this image and the subtle coloristic variances within it that continued to produce that sense of timelessness and confirmed the fact that Anuszkiewicz was not merely a master craftsman but an artist of utmost expressiveness within

a genre that had heretofore been considered coldly structural, rigidly investigative, and emotionally dispassionate.

What was it that caused Anuszkiewicz's new works to yield the aura of classicism? Within the context of the artist's mentor, Josef Albers (with whom he studied at Yale between 1953 and 1955), the aesthetics of shape and color have been expanded to include what could be called reveries on color perception—an atmospheric handling of color relationships that seem both unexpected and inevitable. Whereas Alber's genius lay in formulating the logistics of color interaction, Anuszkiewicz has added line and field to create space through color—a space that Albers only hinted at.

So prismatically and chromatically beautiful is Anuszkiewicz's visual discourse with space that the results have a buoyant, floating effect, as though form and space were one and the same—an evanescent commingling of light and weight that through color releases a powerful yet subtly graded glow. It is this glowing, hot-cold quality that gives the architecture of the artist's work its substance and energy and, indeed, its classical format.

Of all the American artists who rose to prominence during the Op Art movement of the early '60s, Richard Anuszkiewicz is perhaps the only one to have held fast to his vision. (In England, Bridget Riley has done as much.) Soon after the Museum of Modern Art's 1965 exhibition, *The Responsive Eye*, painters such as Kenneth Noland, Frank Stella, and Gene Davis had severed their connection with the movement to pursue other directions. By the early '70s, Op Art had had its day and the movement never regained its momentum. In its wake, it left a trail of patently uninspired practitioners who saw what fun and games the style could produce and who used optical pyrotechnics as an end in itself. The public soon tired of these games, and serious artists, aware of the style's limitations, turned to more viable avenues of expression. With the decline of Op Art, those very painters who gave the movement its initial thrust and distinction suffered an undeserved eclipse— Anuszkiewicz and Riley among them.

Ironically, this eclipse would later serve to strengthen and heighten their genuine contribution to 20th-century painting.

Indeed, once the movement faded—once its demise removed these artists from the vagaries of labels and voguishness—their stature as individual artists rose and their works could finally be looked at with cool and informed objectivity.

The term "Op Art" had not yet been coined when Richard Anuszkiewicz burst on the New York art scene in 1960. One was, of course, aware of Alber's experiments with color and with the theories of color perception practiced by Victor Vasarely as early as 1955. But there was no so-called optical movement afoot in America. It was not until 1964 that "retinal" or "perceptual" art came to the fore, and critical response was for the most part negative. Op Art was deemed gimmicky, an art that attacked the eye, that jangled the retina, and made one wince. The press *did* praise the movement's technical brio and "scientific" approach, but the dizzying results left most critics unimpressed.

Anuszkiewicz, then in the vanguard of the movement, came in for his share of hostile reviews. Hilton Kramer critiqued his work in the *New York Times* in 1965: "Anuszkiewicz's paintings are technically brilliant but expressively empty. Like many lesser votaries of optical paintings, he forfeits the finer shades of feeling for surface effects. His virtuoso mastery of these effects remains impressive, but it is meager compensation for the emotional void that motivates it." Although other critics echoed these sentiments, Anuszkiewicz rode the crest of success throughout the late '60s and early '70s. His works were acquired by the Museum of Modern Art, The Whitney Museum, the Albright-Knox Art Gallery, the Aldrich Museum, the La Jolla Museum, the City Museum of St. Louis, the Dartmouth College Collection, the Yale University Art Gallery, the New Jersey State Museum, The Hirshhorn Museum, and the Milwaukee Art Center, and they hang in many private and public collections throughout the United States.

There is no question, however, that during the early '70s the artist's popularity waned as public taste veered from a style that had clearly run its course and was now deemed passé by gallery dealers, museum directors, and collectors. The elegance, refinement, and emblematic symmetry of Anuszkiewicz's remarkable efforts were placed in a partial state of

limbo only to re-emerge with renewed sumptuousness and validity in the last two years.

Richard Anuszkiewicz is a tall, heavy-set man with short-cropped blond hair and piercing light-blue eyes. At 49, he offers the image of peasant strength and poetic sensibility—an ambiguous amalgam of primitivism and sophistication. A shy demeanor masks drive, ambition, insecurity, and a certain aggressiveness, qualities that subtly emerged during a recent conversation that centered on his life and work. A hint of resentment lurked behind the artist's words as he touched on his recent setbacks, but it soon became clear that here was a profoundly serious painter whose work was his life and whose partial eclipse was predicted only by the capriciousness of public taste and the unpredictable climate generated by an art world all too often uncertain of itself.

"I was born on May 23, 1930, in Erie, Pennsylvania," began Anuszkiewicz. "Both of my parents were immigrants from Poland, but they met and married in Erie. It was a late marriage for them both. At the time she met my father, my mother was a widow with five children. She had married when she was 16 and still living in Poland. She and her first husband came to America and that's where all of my half-brothers and sisters were born. Then, they all decided to return to Poland, because my mother's husband wanted to start his own farm. What happened instead was that he died and my mother was left with all those children. Eventually, she came back to the States—to Erie—and the only way she could support herself and her children was to do housework. She did that for many years and had a very difficult time. Then, she met my father and could stop working. I was the product of that marriage. My father had a skilled factory job. He worked on a machine that manufactured paper. He did that his whole life. Both my parents are deceased . . . my father died just this year. Last March, he would have been 89. All my half-brothers and sisters are much older than I am. The eldest brother is no longer living, but I'm friendly with the rest. None are in the arts."

From the first, Richard like to draw. He remembers his father bringing home all sorts of colored papers and pads from his factory on which he would make endless drawings out of his

imagination. In time, he was sent to a parochial grade school. The nuns there soon realized his gifted way with pencils and paper and allowed him special privileges. It was Richard who was called upon to decorate the classroom walls and windows when Easter or Christmas approached. By the time he reached the eighth grade, he was the school artist and everyone was proud of him.

"I really had a very happy childhood and never wanted anything. Even though we lived through the Depression, I never felt it. I had companionship, affection—all the good things. What I liked best was to draw. I think I was a born Hard-Edge artist, because I would put strong black outlines around even my littlest drawings. Anyway, after grade school, I attended a Catholic high school—Cathedral Prep—but I was very unhappy there. It was very restrictive and I felt constrained, because I couldn't draw as much as I did in grade school. Well, right across the street from my high school was a vocational school called Erie Technical High. I learned that they had an arts program there and I talked my parents into letting me transfer. They had no objections and so, after two months at Cathedral Prep, I entered Erie Tech—and I couldn't have been happier.

"My grades shot up immediately and that's because, together with my academics, I had three hours of art each day, and that lasted for four years! What made it all so terrific was that our art teacher—Joseph Plavcan—was a professional painter and he gave us all the basics of drawing and painting on a very high level. As it turned out, we excelled to such a degree that most of us began winning top awards in competitions sponsored by the National Scholastic Magazine. In fact, from my sophomore year on, I entered several competitions and won many prizes. I won two Ingersol Calendar prizes. I won regional scholarships and a national scholarship that ultimately enabled me to attend the Cleveland Institute of Art."

Anuszkiewicz's high-school efforts found him working in the manner of the Regionalists—painters such as Edward Hopper and Charles Burchfield. He had little access to actual paintings, but would pour over reproductions in art books and magazines, seeking and finding inspiration from the realism of

artists who celebrated the landscape, architecture, and people of their own region. The young artist did as much. He painted Erie: its old Victorian houses, its alleyways, its backyards, its trees. He concentrated on mood, finding special pleasure in capturing the strong, contrasting light seen on windswept, rainy days when wet pavements would yield reflections of streets and turbulent skies.

When, at the age of 18, Anuszkiewicz entered the Cleveland Institute of Art, he intensified his painting and drawing activities. He claims that none of the instructors there were of any particular influence, but he absorbed all he could and, as he put it, developed more or less on his own. It was in Cleveland that he had his first real exposure to living art. He saw a Van Gogh exhibition at the Cleveland Museum and, of course, visited the museum's collection on many occasions. He also traveled to Pittsburgh for the Carnegie Internationals and, at one point, made a summer journey to Provincetown, where he studied outdoor color painting with Henry Hensche. Anuszkiewicz remained at the Cleveland Institute for five years, through 1953

"I had an easy time of it in Cleveland. I worked hard and even fell in love there—my first girlfriend! During my last year there, I won a Pulitzer Traveling Fellowship that gave me $1,500 and a choice of going anywhere I wanted. Well, I could have gone abroad, but I decided to stay in this country, because all I really knew of America was Erie and Cleveland. My one and only brush with the New York art world came when I spent that summer in Provincetown, but that was pretty traumatic, because I felt so stupid and dumb and I really felt very self-conscious and uneasy about myself as an artist. I certainly wasn't ready for New York. The upshot was that I used my fellowship to continue studying elsewhere. I had my choice of going either to the Cranbrook Academy of Art or to Yale. I picked Yale because of Albers. Albers intrigued me because he was a colorist and I had seen reproductions of his work. The other reason I picked Yale was its proximity to New York. You see, I wanted to get to New York by the backdoor—to feel my way into it. The fact was, I needed some other strong creative exposure before tackling the big city."

Anuszkiewicz candidly admits that he was probably Alber's worst student.

"I went in with nine years of work—four years of high school and five years at the Cleveland Institute—so I already had a very definite style, very much influenced by other people, but nevertheless a style of my own. The first thing I did at Yale was to go out and paint some very spontaneous outdoor landscapes. I showed these to Albers and he said, 'You have a good sense of color.' Well, that was the first and last good comment I had from him!

"You see, I was ready to try new things . . . to experiment, to do something different. But everything I tried was a flop and Albers was no help. I didn't take his drawing course, but took his color course. Even there I had a hard time of it. The fact is, Albers had a very strong, hard, dogmatic personality. In his criticism, he would not accept any kind of middle-of-the-road solutions. He wasn't willing to compromise his ideas in any way. I remember my bringing him a perfectly awful piece of work that looked like a cross between a hand and an octopus; it was an abstract shape. He looked at it and said, 'Either you're a genius or I'm a complete idiot!' I was afraid he was going to throw me out of the school! The point is , he went out of his way to upset you. Once he said, 'You known, I teach by stepping on your toes.' What that meant was that he wanted to leave you squirming so that you would *think.* I mean, he would shatter you completely—just level you and you'd have to start all over again."

If Anuszkiewicz suffered the calumnies of Albers he was by no means inattentive to the master's profounder lessons: His ability to infuse in his students a sense of meticulous observation whether in the use of color, composition, line, or subject matter. Indeed, the younger artist was exposed to all of Albers's theories and applied some of these to his Master's thesis, which he called *A Study in the Creation of Space with Line Drawing.*

"In my thesis, I concentrated on how contemporary artists dealt with space and I ended up with an analysis of Picasso's shaded contour drawings, Matisse's drawings, and Albers's own linear works. My greatest influence when writing my thesis was Rudolf Arnheim's book *Art and Visual Conception,*

from which I learned an awful lot. At the same time, I was becoming very interested in the theory of additive color. Albers would be talking of the color of Cézanne and Paul Klee, and we were becoming more and more color sensitive. So, my own paintings were becoming more and more color sensitive, even though my style was changing every two weeks! Still, I was coming on to something. I was beginning to paint semi-abstractly, although I couldn't really free myself from realism."

During his two years at Yale, Anuszkiewicz had ample occasion to visit New York. He looked at the works of the Abstract Expressionists, made the rounds of galleries and museums, and found New York more and more seductive. It was where he wanted to be, and yet he felt that the moment was still not ripe for him to make the plunge.

"I'd drive into New York on weekends and I'd look at Matisse and Picasso and Stuart Davis, and I was seeing their recent work—works shown in galleries, which was very exciting. And, of course, I looked at de Kooning, Kline, Pollock, Guston . . . all of their new work, and that was fantastic too. I went to the Cedar Bar where those artists gathered, but I was much too shy to actually talk to them. You see, I was really a good little Catholic boy, not given to being boisterous or drinking or picking fights or getting into arguments. I was more interested in listening to what someone might be saying. I wasn't assertive, because I thought I still had a lot to learn. Nevertheless, I wanted to see and understand everything that was happening—and everything seemed to be happening in New York.

"Although I was already 25, I still couldn't bring myself to move to the city. So, after Yale, I went back to Cleveland. I was trying to recoup my past glories, but of course that wasn't possible. Immediately I realized I didn't fit in there anymore. To be honest about it, I felt I was nowhere. I knew I wanted to be a painter, but I had no direction, no real style—nothing. It was a very unsettling time. Well, for some reason I decided that I wanted more college education. What I did was to go to Kent State University and get a Bachelor of Science in education. Of course, I also continued to paint and, in my painting, I decided to take all the information I got at Yale and use it for my realism.

What happened next was very strange. Instead of continuing to paint realistically, I severed it completely and began to paint abstractly—just like that!

"The reason was obvious. At Yale, Albers's ego was so strong that I was fighting him just to preserve myself. I was resisting him to such a degree that I was unable to let myself go. Once I had left, however, and Albers was no longer a threat to me, I could do what I wanted to do, and what I apparently wanted to do was to go completely abstract. But there were other factors. I was searching out a personal expression and I was getting very interested in color per se. I discovered some interesting possibilities in other people's work. Cézanne, for example. The way he manipulated warm and cool colors. That's what made it alive. And Klee was another influence, and all the Fauves and Stuart Davis. So, I was looking for my own niche. I thought I would use these complimentary usages of color as subject matter all its own."

What Anuszkiewicz found was a way of experimenting with maximum vibrations of color, and he discovered that, in order to do this, he had to control the light conditions. His earliest works in this genre were two-color paintings that he would later enhance by including patterns that appeared to be in constant motion. The artist says that these jumping patterns were influenced by the Abstract Expressionists. But to him, so-called "Action Painting" did not mean the physical action exerted by the artist himself, but by the physical movement occurring on the surface of the canvas. These high-intensity works, with their vibrant colors and moving geometric patterns, led Richard Anuszkiewicz into a style that he could finally call his own.

In 1956, the artist received his Bachelor of Science degree from Kent State. That summer he once more returned to Cleveland. To earn some money, he worked as a housepainter and, during his free hours, continued the experiments he had started at Kent—the canvases that now became increasingly bolder in coloristic subject matter. By 1957, he felt the time had come to move to New York.

"The first problem was finding a job. Through a friend I landed one at the Metropolitan Museum of Art. They were just

opening their Junior Museum and they needed someone to do restorations on scale models of classical architecture—the Parthenon, and so forth. So, I cleaned and restored these models, and I did that for a year. All the while, I continued to paint. Then, in 1958, I decided to show my work around. I went straight for the top galleries, but instead of bringing in slides and photographs, I carried the actual paintings under my arms. I went to Kootz, to Janis, to Martha Jackson, and they were all very nice, but nothing happened. Mr. Kootz told me that Leo Castelli might be looking at new work, but Castelli, while intrigued, finally said no. You see, it was a time when newcomers really had a tough time of it. Dealers dealt with well-established reputations and I never even had a show!

"So, nothing happened at all. Well, I had saved up some money and thought I'd make a trip to Europe. Two friends and I decided to visit as many countries as possible and look at as much art as possible. I had about $1,200, and I made that money last for six months. We went to France, Italy, Spain, Germany—camping out as often as possible. The experience was incredible. To be confronted by the real thing was really mind-boggling. I mean, seeing Chartres and the Cologne Cathedral—to see the cave paintings in Spain and all that painting and sculpture in all those museums! Well, it really made me appreciate art history. It didn't for a moment compare to looking at slides in a classroom. So those six months were really invaluable."

Upon his return to New York, Anuszkiewicz found a new job. He was hired by Tiffany's to design miniature silver animals, work he performed for a year-and-a-half. At the time, he had also met Sarah Feeney, a young grade-school teacher. The two dated and eventually married. It was 1960 and the artist, at 30, was still without a gallery. Then, his luck turned. Karl Lunde, the director of The Contemporaries Gallery, chanced to see some of Anuszkiewicz's paintings hanging in the office of one of the artist's friends. Lunde was so impressed that he instantly contacted Anuszkiewicz and offered him a one-man show.

"It was to have been a three-week show, but a review by Stuart Preston in the *Times* called the work 'Eye-shattering and

difficult to look at.' The owner of the gallery told Lunde to take the show down after two weeks, because nothing at all was happening. But Lunde stalled him and on the Saturday of the second week somebody came in and bought a painting. Then, one hour later, Alfred Barr, the director of the Museum of Modern Art, came in and bought a painting for the Museum of Modern Art and another one for Nelson Rockefeller. Well, that did it. Things began moving from then on. I was in MOMA's *Recent Acquisitions* show of that year. Then, three years later, I was part of MOMA's *Americans 1963*, which resulted in my being the subject of a major article in *Time* magazine. When that happened, I sold 17 paintings in one month! At this point, Sidney Janis approached me, and I joined his gallery. I had my first show there in 1965 and was also part of MOMA's *The Responsive Eye*. I stayed with Janis for 10 years and, during that time, I had five shows with him.''

Richard Anuszkiewicz broke with Janis in 1975 and moved to the Andrew Crispo Gallery where he held two exhibitions. In 1978, he began his association with the Alex Rosenberg Gallery. The artist was willing to comment on his various gallery affiliations.

''Of course, going with Janis was a major step for me and my career. Ultimately, however, we ran into difficulties. Among other things, there was no discussing policy with him. You either did things his way or not at all. For example, he had an international exclusive but he was very tough on terms and I never had a one-man show in Europe. That was one of the main reasons I broke with him. Also, I felt he didn't work very hard on my behalf. He always expected people to come to him. Well, I didn't think he should rest on his laurels. Perhaps he could rest on *his*, but I couldn't on mine, because I was an upcoming artist and I needed people to understand my work. So, I left him and went with Crispo. Again, I felt Crispo wasn't promoting my work sufficiently and finally staying with him made no sense. Then, I met Luise Deutschman at the Alex Rosenberg Gallery, my current dealer, and Alex and Luise turned out to be very interested and very sympathetic. At the moment we're trying each other out. I don't have an exclusive contract with them.''

How does Richard Anuszkiewicz assess his place in the current stream of art?

"Look, Op Art was really the last international art movement. We had a lot of first-rate American artists in it who then divorced themselves from the movement. Also, there were two concurrent movements in vogue during that period—Abstract Expressionism and Pop Art—that had very strong critical advocates. Well, these advocates helped to bring about the demise of Op Art. What was so hurtful, as far as I was concerned, was that, as much as I was given praise and popularity *before* the movement, once the movement really got on the way, I was attacked—and vehemently so. I felt betrayed by my own critics in this country, because they would not support me as the first exponent of the Op Art movement.

"I feel that I've made a major contribution to the history of color—not in the sense of Op Art, but as a continuing aesthetic idea in art history. Of course, I'm not alone. Bridget Riley made significant contributions and so did Julian Stanczak, who also studied with Albers while we were both at Yale. As for our decline, it came in the early '70s. But I did not abandon my vision nor did I jump on other bandwagons. I couldn't, because that would have made me a mediocre artist. Also, I feel I've explored areas that hadn't been touched by other artists, including Albers—perceptual ideas that I hope will be lasting."

Anuszkiewicz, who lives and works in Englewood, N.J., leads a relatively isolated life. Together with his wife and three young children, he is content to maintain a low personal profile, concentrating exclusively on his work.

"I don't see many people and that includes artists. I don't seek out social relationships for personal gain and I don't play political games—art-world games. What I do now is look to myself. I study what I've done and I use myself as a growing force. What I'm saying is that I no longer look at other artist's work for the development of my own work. I think I've reached the stage where I have set the tone for my own work and I'm feeding on that.

"As for the future, I hope to push whatever I'm doing into areas I couldn't possibly imagine. I would hope that I could do

what Matisse did—end up with a real bang at the end of my own life. I'm talking about Matisse's cutouts, which were so powerful and so simple and so direct. He didn't peter out. He had tremendous vitality up to the very end. Well, that's what I'm aiming for . . . ending with a bang!"

1979

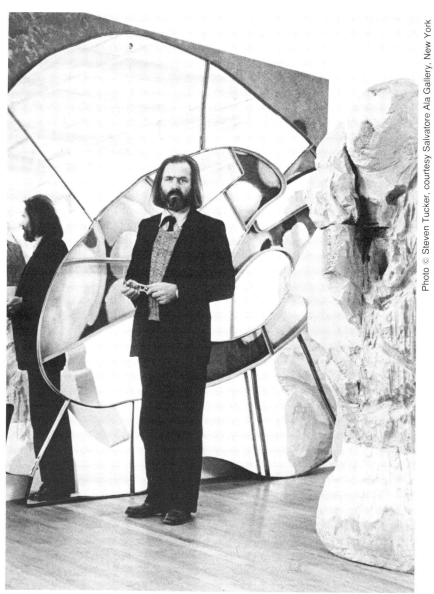

MICHELANGELO
PISTOLETTO

The bearded, chain-smoking Italian artist, Michelangelo Pistoletto, sat forward on a chaise-longue peering through thick glasses into the eyes of his interviewer. A circumference of silence surrounded the two men as the room in which they sat grew dim with the waning afternoon light. There were no mirrors to reflect the image of these individuals or the mute accoutrements of a room stifled by ornate furniture and made musty by the transparent upward rising movement of the cigarette smoke that had for hours infiltrated this space.

But, had a series of strategically placed mirrors been a part of the scene, an environment would have been created that perfectly embodied certain precepts of Pistoletto's art. The mirrors would have reflected, duplicated, even dislocated the objects, the figures, and the very space that constituted the reality of the scene. In a very real sense, the mirrors would have activated the room in ways that would dramatically alter its form, dimension, and perspective, giving a disquieting intonation to relationships between the actual and the perceived.

Pistoletto's quest for an aesthetic has recently taken him far afield from the mirror paintings for which he is perhaps best known. Indeed, since 1966, while never rejecting the mirror as

a viable creative source he has moved in favor of what the mirror reflected: the "performance" of life itself. As a leading European avant-gardist, his work now centers primarily on environmental and "performance" art.

But it was the mirrored surface that engaged Pistoletto's sensibilities from the first. His mirror paintings were considered to be foremost examples of European Pop Art, and critical as well as public response was enthusiastic and immediate. Praise was lavished on works which contained a single or multiple life-size figures painted on mirror-finish stainless steel, but left sizable areas of the mirror free to make room for the viewers to be "included" in the painting as they stood in front of it. It was Pistoletto's conceit that these works were "speaking a language of their own" and that "a painted figure affixed to the mirror surface became part of life through the movements inside the mirror."

Given the high acclaim allotted these paintings both here and abroad, Pistoletto could easily have continued to produce works that dealers and museums were anxious to exhibit and that an avid public was eager to buy. However, in 1966, Pistoletto made a dramatic decision: He would no longer cater to the taken-for-granted expectations of an art world that believed in the evolution of style within the boundaries of a given image or a mode of painting. He refused to be locked into precepts that demanded stylistic repetition or predetermination and resolved to reject the idea of style altogether.

In a manifesto entitled *The Famous Last Words,* published in 1967, Pistoletto wrote:

> In my new work, every piece grows out of an immediate stimulus of the intellect, but they in no way function as definitions, justifications, or answers. They do not represent me. Each successive work or action is the product of the contingent and isolated intellectual and perceptual stimulus that belongs to one moment only. After every action, I step to one side, and proceed in a direction different from the direction formulated by my object, since I refuse to accept it as an answer. Predetermined directions are contrary to man's liberty. To predetermine something means to make a

commitment for tomorrow; it means that tomorrow I will no longer be free. . . . Every piece I make is destined to proceed on its own way by itself without dragging me along behind it, since I am already somewhere else and doing something different.

Abandoning the notion of style, Pistoletto held an exhibition in Italy that consisted of a large series of objects designed to be as different from each other as possible.

"This exhibition made a kind of statement," said the artist. "It denied the concept of *one* style. And it was at that moment that I opened my studio as a place for collaboration. In a sense, I was taking my mirrored paintings that one crucial step further. Just as I "opened" my paintings through the use of the mirror, where the reflection became the collaborative element, this was a step into *actual* activity."

To that end, Pistoletto invited musicians, actors, dancers, painters, and sculptors into his studio and collaborated with each of them on projects that veered dramatically from any sort of stylistic similarity.

"From the studio we took to the streets," continued Pistoletto. "From 1967 on, I ceased having a studio altogether, but began to create wherever I found myself—in large cities, in small towns—everywhere except in the studio. My collaborators and I projected ourselves into the totality of actual space and made of the space itself an arena of creativity. Actual space became our canvas and within this canvas we made a collaborative journey into the unknown."

Between 1967 and 1971, Michelangelo Pistoletto and his creative enclave, dubbed *The Zoo*, worked on projects that contradicted the norms of their respective profession. That is, a musician might do a painting; a painter might choreograph a dance; an actor might create a sculpture. The point was to disprove the notion of specialization and demonstrate that the act of creation by *any* artist had its own validity and could produce its own aesthetic aura. It was Pistoletto's conviction that if artists moved into areas of exploration in fields that were not their own, they would be placed more fully in touch with

their own latent creative sensibilities and, by extension, with the multiplicity of life itself. There were other experiments.

"In 1969, this group and I lived in a small Italian coastal village and worked there for six months. We made the village square our 'canvas' and, with the collaboration of the people who lived there, staged all sorts of events. We created week-long live spectacles, each directed by one of the artists in our group. All of us had to respond to the wishes of the artist in charge and some of these 'performances' proved extremely telling.

"When it was my turn, I chose to look upon the village not as a place where these people lived, worked, went home to eat and to sleep, but as a kind of stage set. My object was not to disrupt their daily lives, but to make them highly conscious of their daily activities, making them aware that what they were doing was a form of art. For example, I would talk to a bricklayer about his work, telling him that it was a creative act. Of course, he thought I was talking a lot of nonsense and that art was a lot of nonsense. But when I made him realize that brick-laying was already a form of art and that the *act* itself was creative, he came to understand the importance of what he was doing. He became more conscious of his own identity as someone who *makes* something—and makes something *valuable.*"

When Pistoletto disbanded *The Zoo* in 1971, he continued his own activities in various parts of Italy, Germany, and Holland, creating environmental and "performance" works as well as exhibiting conceptual works, paintings, and graphics in various European Museums and galleries.

In 1979, after an absence of some 10 years, Michelangelo Pistoletto returned to America for a cross-country tour at the invitation of museums and art centers throughout the country. The trip, lasting from January 1979 to May 1980, found Pistoletto creating "On-Site" works, environments, and "performances" in such cities as New York, Atlanta, Houston, Los Angeles, and San Francisco. In addition, there were lectures, symposiums, and exhibitions of his mirror paintings and prints in various museums and galleries throughout the country.

At the High Museum of Art in Atlanta, and in conjunction with the city itself (and with the blessing of Atlanta's Mayor

Maynard Jackson), Pistoletto staged a month-long series of activities he called "Creative Collaborations." Enlisting the people of Atlanta as well as several of the city's artists, actors, jazz musicians, composers, dancers, and writers, he master-minded a wide variety of events that explored the dualities, ambiguities, and aesthetic subtleties of the creative act as it related to and commingled with life itself.

At the Georgia Museum of Art in Athens, Pistoletto created an elaborate piece for an exhibition entitled *Furniture Environments*. At the New York City Customs House, he participated in a show called *Customs and Culture*. For the Fine Art Galleries of the University of Southern California and in conjunction with the Denver Museum, he took part in a traveling exhibition entitled *Reality of Illusions*. At the Los Angeles Institute of Contemporary Art, he exhibited a series of his *Plexi-Works*, *Minus Objects*, and staged an environment he named *The Sphere*. At the University Art Museum in Berkeley, he showed *Rag Pieces*, a series of symbolic constructions. At the San Francisco Museum of Modern Art, he exhibited his mirror paintings and mounted two environments entitled *Reflections on the Wall* and *Picture of Electric Wires*. At the San Francisco Art Institute, he collaborated with several San Francisco artists on more environmental projects. For the Myth America Corporation, San Francisco, he created several "On-Site" works at Mayfield Mall, Palo Alto, and elsewhere. At The Clocktower in New York, he created his monumental piece *One Arrow*, and showed various *Minus Objects* in different locations throughout New York City.

If a line or leit-motif is to be found in Pistoletto's far-flung, free-floating, yet highly structured modus operandi, it can be said to consist of his repeated use and return to the mirror. Almost all of his works contain the mirror as a point of departure and, even when the mirror itself is absent, its theoretical implications are present: the mirror as reflection, as memory, as continuity.

Discussing his environments, "performances," and collaborations in general, Pistoletto stated: "There is a form of memory inherent in my kind of art, which is human. It stays with the people involved and heightens their sense of identity. My art, whatever form it takes, is also a handing down of

culture. What I mean is, people are basically 'receivers.' They may receive a postcard, a piece of sculpture, a photograph. But receiving these things, they also receive a culture, and my aim is to develop a cultural awareness in others—living memories that move across profound experiences.

"As for my use of the mirror: It is a place wherein I can find not only my own reflection, my own identity, but a symbol for speculation. For me, the mirror is a reflection of the mind as well as of the body. The mirror is an eye that sees things. Conversely, the eye is also a mirror that sees things. Human actions are the mirror of the mind. So, there is a mental cycle that is represented in the mirror. Of course, this is all theoretical and, as I said, open to speculation.

"You see, a mirror can never reflect itself. It represents a oneness, because it cannot double itself. This represents man's own solitude as well as his totality. The individual is *everything* but it is still only *one* thing. And yet, there *is* a way for the mirror to assume a duality, and that is by cutting it in half. Multiplicity is born out of division. So now, the two mirrors are two separate entities that have the same identity but, when manipulated, can obtain a variety of dimensions. For example, if I face one mirror toward the other, it produces an infinity of mirrors.

"The aesthetics of all this attempts to express the universal concept of existence. The relation between the mirror and man creates the parallel between multiplication of the family in a biological sense and multiplication of the individual in the family of art. Indeed, the mirrors that everyone has in their home can be considered as part of the same mirror already divided and multiplied. These mirrors represent simultaneously the partiality and the totality contained in each one of us."

Pistoletto paused, lit another cigarette, then added, "How strange it is that fate should have brought me identical twins! Yes, my wife and I have twin daughters, now eight, and in some mysterious way they represent a kind of symbolic yet very human summation of all my theories."

The 47-year-old artist and his wife, Maria Pioppi, live with their twins in a large apartment in Turin. During the summers, the family spends time in the coastal town of Corniglia, also

known as "Cinque Terre," where they live in a house perched on a huge rock with a spectacular view of the sea. But the artist does not like to sit still. He and his wife (who assists Pistoletto in most of his projects) move from city to city, country to country, continent to continent, seeking answers to metaphysical and theoretical questions. At the invitation of museums throughout the world, Pistoletto puts into action ideas upon which he has reflected for years.

"My whole aim as an artist is to continue my search of fundamental answers to fundamental questions. I am constantly seeking clarity where confusion reigns. I want to develop techniques which would be functional in helping me to find this clarity. It's my most essential need. Contemplation is not an end in itself. For me, action is everything, because there is never a point of arrival—only a point of departure."

1980

WILLIAM BAILEY

The measured symmetry and classicism of William Bailey's still-lifes produce a delectable frisson of recognition of object as abstract shape. It is intense reality transformed into pure formalism—an encounter with the recognizable that instantly announces more than is so realistically presented.

Indeed, in analyzing these works, one is placed in touch with sensibilities that produce varying levels of response, the most profound of which is an overriding sense of intimacy and quietude. The stillness of Bailey's paintings, their harmonious self-containment, their mystery and mastery, and, above all, their order are qualities that place them outside the expected framework of current-day realist concerns.

Critics have called Bailey's work calm and serene. They have marveled at the patience in them, have deemed them confident and possessed of a meticulousness that renders them alignable to the lessons of Zurburan. They have spoken of accomplishment, intelligence, sensitivity, and commitment, have praised the burnished light, the muted color, the expressive use of space, and the perfect compositional architecture. What they have not revealed is the extraordinary fact that

William Bailey paints from memory—a fact that places the artist into an even greater realm of individuality.

"No, I don't set up the still-lifes," said the painter during a recent interview. "I don't think anyone knows this. And I have never painted from the live model when doing my figure paintings. But as for the still-lifes, I have the objects—they exist—but some are in the kitchen, some are in the living room, and some are in my house in Italy. I look at them, but I don't bring them together and arrange them on a table. I simply remember them. The still-lifes I paint happen only on the canvas itself. There are no set ups away from the canvas."

A more personal revelation centered on Bailey's capacity for investing a sense of singular quiescence into his work.

"People say my paintings are calm and serene. This may or may not be so, but I can assure you I'm not calm and I'm not serene. And I'm definitely not patient. What I am is tenacious. Also, I never know where I'm going with a painting. I only know where I've been, and, frankly, I believe that every painter is in a state of continual failure. The only constant in a painter's life is failure."

This cautionary tenet is indicative of Bailey's deep concern for the tenuousness of accomplishment, the fleeting and fugitive sense of satisfaction that has been the sine qua non of all self-questioning artists. And it is this quality of doubt that has informed William Bailey's long and circuitous quest for a viable coming to terms with his life as man, painter, and teacher. A professor of painting at Yale University since 1973, Bailey has long been associated with that institution, first as student and later as teacher. The artist did not gain serious recognition until 1968, when he exhibited a series of nudes and still-lifes at the Robert Schoelkopf Gallery in New York. It was recognition late in coming for, at the time, Bailey was already 38 years old and known to only a few realist painters and a handful of admirers. Working in relative isolation, his creative development was fraught with the stop-go exigencies that often beset the life of the teacher/painter. Still, in Bailey's case, his ultimate achievement as one of the country's most magisterial still-life painters came about as the result of a young manhood spent in the grip

of experiences and influences that have strongly colored the fabric of his intellectual and emotional life.

William Bailey's somewhat professorial image is deceptive. Tall, blue-eyed, soft-spoken, he is conspicuously lacking in pedanticism. A witty raconteur, he delights in recollecting his highly peripatetic youth, lingering on events that have held special meaning to him.

"It all began in Council Bluffs, Iowa, where I was born on November 17, 1930," said Bailey. "My father was in broadcasting—selling airtime. Because of that, we moved from one city to another. By the time I was 12, we lived in about 30 different houses. I was left to myself a great deal of the time—and I drew. I used drawing as an area of dreaming. I really had no notion of art as fine art. But I liked to draw. When people asked me what I wanted to be, I said I wanted to be an artist, without really knowing what that meant.

"When I turned 15, we had just moved from Chicago to Kansas City, Missouri. My father went on a business trip and, while on the trip, he died. He was only 39 and I was still 15. We had some difficult years, but eventually my mother remarried. The man she married was a marvelous, imaginative man who was an alcoholic, something she didn't know at the time she married him. I was in high school then and I spent a good deal of my time getting my stepfather out of scrapes and trying to cover up for him. I liked him very, very much. I remember his joining Alcoholics Anonymous, but he couldn't stand it. Every time he went to a meeting, he went out on a binge! Finally, he stopped going and got himself straightened out. It was funny. He called himself a 'business typhoon,' because everything he touched blew away! Well, after some years he also died.

"My mother was very quiet and unexceptional in the sense of asserting herself. She was very interested in music. She played the piano. She was always very girlish and somewhat passive, except during those difficult years when she had to assume all the family burdens. I have a sister, Angela, who is six years my junior. She is married now and lives in North Carolina, and I rarely see her."

As a youngster in high school, Bailey continued to draw.

Among his greatest pleasures were his visits to the Nelson Gallery in Kansas City where he enjoyed copying old master drawings. As for the art courses he took in high school, they were decidedly unfulfilling, centering as they did on commercial art that, as Bailey put it, would prepare him for a position as a designer of greeting cards. Upon graduating from high school, he entered the University of Kansas.

"It was at the University that I discovered painting. I was 17 and I began to get more and more involved with the idea of becoming an artist. Of course, it was all pretty vague. I mean, I knew there were great masters, but they were from the past, and the painters I knew about of the present were the regional painters—Thomas Hart Benton and John Stuart Curry—artists to whom I was not terribly attracted. At any rate, during my first two years at Kansas, I took every drawing course that was offered. And I began to paint from the model and from still-lifes. I absolutely hated still-life painting. I couldn't stand it! I couldn't imagine anyone enjoying painting still-lifes. Anyway, there were two young teachers at the university who strengthened my impetus toward wanting to become an artist. These were Herbert Fink, who now teaches at Southern Illinois University, and Robert Sudlow, who is still at Kansas. I admired them and they inspired me."

Bailey was a loner at the university. He felt alienated and did not make long-term friendships. Instead, he immersed himself in other areas of culture. A voracious reader, he absorbed French, Russian, and English literature, thereby discovering he was not alone when it came to feeling alienated. A romantic by nature, Bailey soon felt the urge to experience new climates, new milieus, new people. At 20, and with two-and-a-half years of college behind him, he resolved to leave Kansas. His hope was to find an art school in Boston or New York so that he might draw full-time. But there was no money. A job was the answer . . . a job or the Army.

"It was 1951 and the Korean War had broken out. I knew I would be drafted once I left the university and so, because I was suffering from a kind of Hemingway romance, I decided to volunteer for the draft. I felt I wanted to test myself as a man and go through a war. Having grown up during World War II,

that was a very strong thing in a lot of us. And so that's what I did. I volunteered and was promptly sent to Japan and placed with the 40th Infantry Division. I trained in antiaircraft intelligence, which was fine except that I was seeing no action; I was not really fighting a war.

"Well, a friend of mine and I decided we shouldn't be in Japan but should go to Korea. Of course, it was not only foolish but insane. Again, I volunteered and so did my friend. We landed in Korea and were placed with the 24th Division. I was assigned to infantry support weapons and I was sent out on patrols. As it turned out, there was no great fighting raging. Mostly it was boredom and occasional periods of great fear. I was not hurt. It was the second winter of the war—1951–52— and I was 21. Later that winter, our unit was sent back to Japan and we stayed there for about a year, simply training replacements.

"We were right at the foot of Fujiama and I fell in love with Japan. At one point, I took a leave and went to live in a small fishing village and set up a little studio for myself. I worked and lived like a civilian for about a month and it felt good. All through the army I had hid the fact that I was interested in art, because I was afraid that I'd be put in some unit that made signs—latrine signs and such. But I did a tremendous amount of drawing on my own and I made a lot of gouaches. They were all very topical, illustrative, and not very good."

When William Bailey was discharged from the Army in 1953, he felt extremely dislocated. He knew he wanted to continue his art training but didn't really know how to go about it. The G.I. Bill would supply him with a minimal monthly check that would barely support him. After a brief visit home, he found himself in Wichita, Kansas, where he befriended a young man whose family owned a steel company. There were drafting positions available and Bailey readily applied for one.

"I landed a job as a structural steel detailer for the Christopher Steel Company in Wichita and lived in a funny walk-up hotel on Wichita's skid row. So, I worked during the day and tried to draw and paint at night. When I got enough money together, I decided to go to New York and look for an art school. After some looking around, I went to talk to someone at

Cooper Union. He was a very nice man, but he said that at Cooper you had to start your training from the beginning. Then he said, 'Why don't you go up to New Haven and talk to Josef Albers, who is the new head of the art school at Yale. It's supposed to be a very exciting school.' So, I put myself on a train with a manila envelope full of drawings and gouaches and some photographs of paintings. Albers saw me in his office, asked me about myself, looked at the drawings and said, 'These are awful! How could you show me these things!' I thought it was all rather gratuitous, because I wasn't at all sure I wanted to go to Yale. Then he suddenly said, 'All right, I'll take you!' "

William Bailey entered Yale University during the winter of 1953 and his first year at the art school was a happy one. He had found a center, a core, and found the proximity of Josef Albers at once enlightening, exhilarating, and exasperating. To help pay for his tuition, Bailey obtained a night job at the Winchester Arms Factory in New Haven.

"I felt absolutely split. I had two lives. One in the factory at night, the other at Yale. And even at the art school I felt that the students there had a very different orientation from my own. I mean, the talk was about the heros of the Bauhaus—people like Klee and Kandinsky—they were the kings. Well, they weren't artists that particularly interested me, although I have since come to like Klee very much. Of course, that was also the period when American art was in the grip of Abstract Expressionism and that was a marvelous tension, because Albers admired certain people: de Kooning, Kline, Jim Brooks. Still, he felt it was all one grand bandwagon. He used to run around lecturing against jumping on a bandwagon, and every time he'd see a little 'gesture' in a painting, he would point his finger and say, 'What's this?! Aha! The bandwagon!' "

During his first year at Yale, Bailey had occasion to come into contact with Conrad Marca-Relli, who had come to the art school as guest artist and teacher. It was through Marca-Relli that Bailey was exposed to metaphysical painting. The two would talk for hours about Giorgio Morandi and Giorgio de Chirico and, in time, these influences, as well as those of the Abstract Expressionists and of Albers, would find themselves in Bailey's own paintings.

"I was painting in a most peculiar way. It was figurative imagery that was formed out of abstract shapes, and it related to de Kooning and Marca-Relli, but it wasn't as gestural as de Kooning and more painterly than Marca-Relli. It was also very modest in scale and the palette was quite extended. The influence of Albers came by way of color. I based the structure of the paintings on the interaction of color, something I hadn't really fully assimilated. Of course, I had done work in Albers's very celebrated color course, but in a strange way it didn't seem to relate to painting. Well, he let me be. One thing I *didn't* do was to take Albers's drawing course, because I didn't think I liked the way he taught drawing. Oddly enough, I later taught that course myself.

"But about Albers: As students, we constantly talked about what Albers was saying, and was it true, was it right, was it the way art should be? Actually, none of us knew him as a person, only as a force. The fact is, Albers was extraordinarily eloquent in verbalizing his reaction to a painting. He always tried to differentiate between what you *think* you were doing and what was actually going on in a painting. He would say things like, 'One must recognize the difference between *factual* and *actual*. We don't want the factual, we want the actual. How is the work *really* behaving visually?' All of his teaching was based on that. What I personally garnered from Albers was the absolute urgency of art. The terrible seriousness of it and how central it was to his life. He instilled that in us. I never really ran into anyone who was so consumed by art. Truly, he was a magnificent teacher."

In 1955, William Bailey won a Yale Traveling Prize for a year's study abroad. The prize held a stipend of $2,000 and the artist decided to travel to Rome, a choice predicated by his increasing interest in such Italian contemporaries as Alberto Burri, Afro (Afro Basaldella), and Cremonini. Also, Conrad Marca-Relli was in Rome just then, and could put Bailey in touch with the art community there. Added to all this, the young artist would be placed in contact with the Renaissance masters he loved, particularly the drawings of Raphael.

"I had a chance to live in Burri's studio. Later on, I moved to a place of my own across the river—in the Trastevere

section—that was marvelous because I had a view of the whole city. Of course, it was very hard settling down to work, because I was torn between my obligation to go out and see art and be in the studio and make art. Time was very precious, and I was determined to make the money last one whole year. So, I lived very frugally. Well, I finally began to paint and I did a certain kind of architectural thing, and used the kind of wall colors that everyone falls in love with when they're in Rome. I also began doing drawings of a very different sort—very volumetric Renaissance drawings.

"In the meantime, I had gotten to know a number of the American artists living in Rome, people like Bill King, Tom Boutis, Laura Ziegler, and the writer Arturo Vivante. I did a lot of painting through the winter. As there was no heat in my studio, I went to the post office, which was the only heated public place I knew, and I would sit there and draw. The paintings I was doing had gotten quite abstract, and they weren't any good. But I did a whole bunch of little studies of oil on paper, and they were much better than the paintings."

While Bailey was in Italy, he received a letter from Josef Albers, asking him whether he'd like to return to Yale as a graduate student and if he would be willing to teach drawing, as an assistant. Albers added that the year Bailey spent in Rome would count toward his M.F.A. degree. Bailey quickly agreed and, at year's end, returned to New Haven. He was particularly happy about the teaching post that would enable him to give up his night job. An even happier prospect was an invitation from the Robert Hull Fleming Museum at the University of Vermont to mount a one-man show of the small oils on paper he had done in Rome. It constituted William Bailey's very first exhibition and it proved a success.

"When I got back to Yale, I began teaching two courses in drawing in an assisting capacity, and also wrote a thesis on drawing for my M.F.A., which I received in 1957. When I graduated, I didn't quite know what to do next. Again, Albers came to me and said, 'Why don't you stay and teach drawing?' Well, I was very pleased. I moved into a studio downtown and taught my first full-time drawing course at Yale. I also continued to paint, but the painting was moving in all sorts of

wild directions. I was searching for my own voice and wondering what I was doing.

"I began reducing the shapes until I almost reinvented Impressionism and I did paintings I wasn't happy with, but they had *something*. I was asked to show some of these works at the Kanegis Gallery in Boston and people seemed to like them and even bought them. Still, I was desperately unhappy about my work. I felt I was in a sort of stylistic corner that I couldn't extricate myself from unless I just dropped it. It was getting to be 1959 and the painting was still very fugitive. I simply couldn't deal with it. Everything I touched seemed to disappear with the next mark that I made. All the while, I continued to draw and I thought I'd try to do some sculpture, just to see if it might help the painting. And so it went until one day, quite out of the blue, I received a letter from the U.S. State Department asking me whether I would be interested in traveling abroad on a cultural-exchange program. The invitation couldn't have come at a better moment."

While at Yale during 1956, Bailey met a young art student in the painting department. Her name was Sandra Stone, and the two began seeing each other. In 1958, they were married. When the State Department invitation arrived, the couple traveled on a cultural mission that included visits to Rangoon, Burma, Manila, Taiwan, and Hong Kong. Bailey briefly taught at the University of Manila, lectured at the Imperial Art School in Burma, and talked to artists, teachers, and critics in various other cities. While the trip made a considerable impression on him, it did not move him half so much as the art he saw on his journey back to the States.

"We decided to return by way of Europe and so we stopped in Athens, Rome, Paris, and London. In Athens, we went to the museum and I saw marvelous fragments of feet, and they were all I wanted to look at—those feet—because they were so pure, so mysterious. In Paris, I went straight to Ingres—*The Bather of Valpincon* and the *Grand Odalisque*. In London, I went straight to Piero's *Nativity* and to Bosch's *Christ Mocked by Soldiers*. It was like craving certain foods.

"When I got back to New Haven, I went into the studio and started a painting of a female figure in a room. And something

clicked. It was as though the doors had opened. Here was something I really wanted to do. And I started painting more nudes in interiors. They were very stylized, very self-conscious . . . but something was definitely happening. Of course, I continued teaching, but by 1962, I felt it was time to make a move. I needed to leave the place where I had been a student, so I applied for teaching jobs at various colleges. Oddly enough, I received a call from a school I hadn't applied to, the University of Indiana, in Bloomington. The man calling me was Henry Hope. He had seen some of my drawings and said that Indiana was trying to establish a group of figurative painters. Well, because he was very persuasive and charming, he talked me into going to Bloomington. The moment I accepted I thought, 'What have I done?!' "

As it turned out, Bailey's move to Indiana was entirely propitious. He quickly discovered that it was exactly the right place for him at this juncture of his life, and he remained at the university for six years—from 1963 to 1969.

"I was gaining strength in my painting, and I knew where I was going. And I loved Bloomington—the atmosphere, the people, the kind of freedom we all had. We could come and go and not feel tied. In fact, in 1965 I applied for a Guggenheim and got it. My wife and I went to Paris and my work continued to center on figures in interiors. I had done one still-life of some eggs, but I never thought of it as a still-life. I was trying to find a way of painting that wasn't as psychologically taxing as working with the figure. I wanted a purer form of painting. Although the eggs I painted were volumetric, I was thinking much more abstractly. I was thinking of linear harmonics . . . how I could range luminosity back and forth across the forms."

While at Indiana, Bailey met the painter Leland Bell, who had come to teach there, and the two formed a friendship. It was Bell who brought Bailey's work to the attention of his New York dealer, Robert Schoelkopf. Upon seeing Bailey's work, Schoelkopf instantly invited the artist to have an exhibition. The show opened in February 1968, and a Sunday *New York Times* review was glowing. Bailey's drawings were deemed "the best of their kind," and the paintings "a remarkable accomplishment."

"I was absolutely ecstatic," recalled Bailey. "And I knew that the Schoelkopf Gallery was exactly right for me, because Bob showed people I admired: Gabriel Laderman, Leland Bell, Sydney Tillim, and Joe Fiori, none of whom were terribly well known at the time. The only known quantity in a certain kind of figurative painting was Philip Pearlstein. The rest of us were still sort of underground. At any rate, I've been showing at the Schoelkopf ever since."

It was in 1969 that William Bailey was asked to return to Yale as chairman of the art school—an invitation that Bailey accepted with mixed feelings.

"It wasn't a job I really wanted, but I *did* want to get back within the reach of New York. Well, Jack Tworkov had been the chairman, and he retired. When I got there the art school had changed dramatically. In fact, a sort of revolution was raging. I soon learned that part of the revolt had to do with the nature of my appointment. Students and part of the faculty had not been fully consulted and there was a fear that the school was going to go in a conservative direction based on my paintings and on my earlier association with the school.

"I went to Kingman Brewster, then the president of Yale, and told him I wanted no part of that and turned down the post of chairman. Well, he persuaded me to stay on as an adjunct professor of painting, which would be a full-time job. So I did that. Then, in 1975, Brewster asked me to become the dean of the art school. I agreed to fill in for one year—until they found another dean. Finally, they found Andrew Forge, who is the present dean, and I felt relieved. Now, I'm simply a professor of painting."

At 49, William Bailey has reached a plateau of creative achievement that has placed him in a stylistic realm outside the current stream of realist painting. In cursory fashion, he elucidated the aesthetics of his work.

"I'm bothered by being called a realist painter, because I think that what it's come to mean is that representation is the primary quality—the primary value—and I don't see that as being the primary value. Frankly, I don't understand a lot of realist painting. I don't know why anyone would do it. I think that all painting is abstract. The best figurative painting is

abstract. I mean, the whole idea of painting is abstract. I think I have fairly successfully evaded classification, and that has helped me in a public way, because I've never been aligned with any particular group.

"My still-lifes exist in an absolutely artificial light situation. They couldn't exist in nature, because I change the degree of illumination as I move through the painting to meet the needs of the painting. I don't make the objects particularly real. At the same time, I want the credibility of real objects—or real place. So there is always that tension between the clarity of the object—the reality— and the artifice that's employed.

"The backgrounds of the still-lifes are the hard parts. That's where I get back to the more synthetic ideas about painting, and it doesn't have anything to do with realism at all. What I want there is a tension between that expanse of substantial plane and a light-giving, color-giving modifier for the objects.

"Of course, there have been crucial influences. Albers was an influence, not stylistically but intellectually. Ingres is an important influence and after Ingres, Corot—those early Italian paintings. Morandi is always mentioned, because I have bottles on a tabletop. But I discount that connection. I admire Morandi very much, but we are not aiming at the same thing. Certainly, the notion of form, of light, of space is very, very different. The similarity is a belief in the power of the mute object. Actually, I'm a terrifically eclectic painter. I'm inspired by the most unlikely painting. Mondrian, both early and late. Matisse is one of my great heros. Cézanne and Giacometti are important to me. As for my immediate contemporaries, I respect Pearlstein and Leland Bell. I admire Al Held. But you see, I'm really interested in painting, not movements. Movements don't really have any historical integrity. They're adopted out of peculiar, often artificial circumstances."

The artist hesitated to speak of his personal life.

"Basically, I'm a very private person. I care tremendously about my family—my wife, my children. We have a son, Ford, who is 15 and very interested in electronics. Our daughter, Alix, is 12, and she is very interested in dance and also studies the piano. My wife continues to paint. She's a marvelous painter. She paints very quiet, small paintings directly from the model.

She's exactly the opposite of me. She doesn't like to paint without something directly in front of her. Her work hasn't been shown, but it will be one of these days.

"As for me, I feel I still have a tremendous amount of work to do. Things may change, but not because I'll be doing a 'new thing.' I don't operate that way. I don't make pastiches from the past. I choose my own issues, and I don't have to choose the issues that are provided by the art world at any given moment."

1979

BRIDGET
RILEY

O p art, a minor movement of the '60s, has seen most of its practitioners go the way of all flash; it was a brief optical tremor in the firmament of visual illusion. Meant to be a riveting and dazzling eye-opener, the style has degenerated into an eye-closer—a yawn-provoking adjunct to passé decor—an optical blitz to revitalize the blah-side of private and public interiors.

Among the movement's survivors only the by-now predictable Victor Vasarely, the tricky Yaacov Agam, and the entirely first-rate Venezuelan Jesús-Raphael Soto have produced optical work that still commands varying interest. But of them all, the most distinguished so-called Op artist is without question the British painter, Bridget Riley.

Riley's staying power and international recognition could be measured by the fact that a major retrospective of her work was held at the Albright-Knox Art Gallery in 1978, and then traveled to the Dallas Museum of Fine Art, the San Francisco Museum of Art, the City Art Gallery in Auckland, the Art Gallery of New South Wales in Sydney, the Art Gallery of Western Australia in Perth, and, finally, the Museum of Modern Art in Tokyo.

Clearly, Bridget Riley has transcended matters of labels and fads—has moved beyond the trivial and fashionable and has stood her ground as an artist who has made of color, form, and light a sustained and precise articulation of her own highly personal vision. For all their seeming instability, her spiraling bands, floating ribbons, sliding dots, and shifting colors contain a structural equilibrium that transforms the merely optical into indepth studies of certain absolutes: the *energy* of color; the *physicality* of space; the *action* of light; and the *quality* of tone.

As these absolutes interact, a Post-Impressionism emerges that can be traced to the work of Georges Seurat, an artist Riley not only studied and still reveres but also copied, notably his *Le Pont de Courbevoie*. Thus, Riley's images are magnified abstractions of what lies at the root of Seurat's aesthetic, namely, in Seurat's words: "Art is Harmony. Harmony is the analogy of contrary and of similar elements of *tone*, of *color*, and of *line*, considered according to their dominants and under the influence of light, in gay, calm, or sad combinations."

Riley, like Seurat, explores nature's myriad intonations as well as the myriad sensory ways in which we perceive them. A painting by Riley becomes a carefully planned arena in which an ever-fugitive pictorial momentum is set off, continually challenging our retinal perception. As the artist once put it, "My pictures need time to develop on the retina. The first contact is always a bit off-putting and abrasive. You have to go with it. It's like taking a cold shower: a shock at first, but then it feels good."

In May 1977, Riley flew in from London to be present at her exhibition of recent work shown at her New York dealers, the Sidney Janis Gallery. During the course of her show, she made time for an interview, and on a sunny May morning we met in a quiet back room of the gallery. Dressed entirely in black, including hose and shoes, the artist offered the image of Victorian understatement and sobriety. Yet Riley seemed neither somber nor eccentric. A woman of high wit, intelligence, and sensitivity, she seemed possessed of great inner strength. Still, something tremulous and vulnerable *did* lie at the surface of Bridget Riley's persona, as though some long lived-with private hurt needed continuous protection from

exposure. Gazing through alert sky-blue eyes, she seemed, at first, a bit tentative about embarking on our talk. With a smile she said, "I always rather envied Andy Warhol, who has invented a new autobiography for every occasion. I think it's a most brilliant idea. In that way, he maintains total privacy."

The 47-year-old artist is a native of London. Her family background includes a grandfather who helped Edison invent the light bulb and a great-uncle who was a founding member of the socialist Fabian Society. Miss Riley has a younger sister who is a practicing lawyer, and recently deceased parents about whom she still harbors strong feelings.

"I had a remarkable mother," said Miss Riley. "She adored beauty. She was very sensitive to it and she was able to draw one's attention to the beautiful in all kinds of situations. So, we shared this great pleasure. As for my father, he was a businessman, who eventually went to war and was a prisoner in Thailand. It was a dreadful time for him. I didn't have the same . . ." Attempting to speak further about her father, Riley became visibly agitated. She lit a cigarette and with difficulty said, "Let's just say I had an enormous affinity for my mother. I admired and respected my father but I couldn't : . . well, that's very personal."

Quickly changing the subject, the artist turned to some facets of her early education.

"I always wanted to draw and paint and I never wanted to stop doing that. I don't actually remember making any decision about it. I was terribly anxious to get to an art school. But you see, I had a war-time education, which meant that, during World War II, we left London and went to Cornwall where one's studies were rather fragmentary. I mean, somebody knew a bit about history, another person was an actress and would read Shakespeare marvelously. But there was no French, no mathematics, no biology. Well, by the time the war was over, I had no formal education. This was all remedied when I was sent to a place called Cheltenham, which was a very smart school. They didn't quite know what to do with me there, and so I said, 'Why not send me to your art wing from Monday to Friday'—and they did. I remained there for three years drawing and drawing to my heart's content."

Toward the end of the 1940s, Bridget Riley persuaded her parents to allow her to enroll in an art school located in the south of London, called Goldsmiths. There she worked with a teacher who was, as she put it, among the last exponents of the great classical tradition of draughtsmanship. She drew morning, noon, and night, arriving at the school at 10 A.M. and leaving at 9 P.M. Riley remained at Goldsmiths for another three years.

During this period, she was exposed to a handful of exhibitions held in London, notably major showings of works by Picasso, Matisse, and Van Gogh.

"Of course, during the war *everything* was shut down in London. What exhibitions there were were very isolated events. And, of course, England's attitude to modern art was that it was a continental affair. For the English, art was classical and academic. At any rate, when I saw the Picasso and Matisse shows I was tremendously moved. But it was unattainable in that I couldn't divine how this fantastic work had actually been achieved. I couldn't imagine in my mind what the process had been that had given rise to this art. But that was very typical of all England at that time."

Following her studies at Goldsmiths, Miss Riley enrolled at London's Royal College of Art, a far more competitive school and one in which she came into closer contact with students and teachers who were far more enlightened about contemporary art movements and international painting styles. At the Royal College, Riley worked with artists Johnny Minton and Rodrigo Moynahan. For the first time, she became aware of American Abstract Expressionism.

"There were very strange rumblings of what was happening in America. One heard rumors about the New York School, but I didn't actually pay much attention. All I knew was that, once one left art school, one would be very isolated indeed, and up against the very difficult English apathy and indifference to the visual arts. It was really an exceptional desert in England that lay outside the art-school door."

Riley remained at the Royal College of Art for three more years. When she left the College, she found work as an art teacher, giving evening drawing classes to adults, teaching

children, and even teaching inmates of a London prison. At one point, she found work in an advertising agency.

"While I was supporting myself, I struggled with the business of what to paint, how to paint, how, in fact, to solve the whole problem of trying to be an artist. I suffered great distress and anguish over that, and it lasted a very, very long time. The fact is, I had very little confidence in myself as an artist. I knew perfectly well that I could draw . . . but as to figuring out what to paint and how to paint it, that was another matter. Throughout the '50s, my work looked like Pierre Bonnard, sometimes like Matisse, sometimes like Van Gogh. Then, gradually, it started to look more and more like Impressionist painting. Well, toward the end of the '50s, two things happened to me that changed my life completely.

"The first was an exhibition that came to London of Abstract Expressionism. It woke the English artist up to the fact that modern art was a living, ongoing reality *now*. It hadn't stopped before the war. What happened, of course, was a wave of Abstract Expressionist influence that ultimately deteriorated. But for me, this American exhibition proved shattering. I remember looking at my first Jackson Pollocks. I know it sounds ridiculous, but I wept all that night over the colossal price involved. I mean, I didn't know anything about Pollock's life but I was inordinately moved by the extreme measures that he had selected to take in the teeth of total rejection. Pollock and also Mark Rothko were enormous revelations to me. Anyway, that was the first thing that happened.

"The second was my encounter with two men. One was Harry Thubron, who taught modern art in the north of England. He held any number of classes all over the place, and I attended some of them, and they absolutely exploded my mind. He would say things like, 'No one knows anything about the principles that lie behind Piet Mondrian or Cubism. Artists do not experience this here, and they should.' Then he would give the most inspired talks about these and other principles and it was fantastic.

"The other man I met was a painter by the name of Maurice de Sausmarez. Well, Maurice was shocked at what I didn't

know. The fact is, I fell in love with him and we started off on a most marvelous journey around Europe, going to museums, looking at everything. I read and read, and we had an incredible time together. And during all this time I began thinking more and more about Seurat, learning about the whole perceptual way he organized a canvas. I copied a Seurat and studied the relationships between the drawings and the final painting. Again, it was a fantastic revelation."

Bridget Riley now made a conscious decision about her own work. By 1960, she would be enormously precise about every mark she placed upon a canvas. At first, she began to paint totally black pictures. Soon, she pushed her forms around—blacks and whites and precise forms which in combination produced amazing optical effects. The dynamics and energy latent in the medium itself were extraordinary. Riley had hit on a personal vocabulary.

"At one point, during these new experiments of mine, somebody said to me, 'You should look at Vasarely.' So I did. At that time, he was still a good artist and that in a way was an affirmation and encouragement to what I saw was beginning to happen in my work. Well, I took off. Like Vasarely, I began working with assistants who would execute the canvases to my exact specifications. Funnily enough, Vasarely was *not* a major influence, which sounds as though I were trying to deny somebody who has a rightful place in my life, but I'm not. The fact is, he was a confirmation that what I was seeing had possibility for growth. Actually, it was my encounter with the work of Jackson Pollock that in a way concretized my ideas."

Riley elaborated on the structural basis of her work: "One of the things I've only recently been able to articulate about my work was that I had a deep suspicion that, while in the process of responding to nature, one couldn't as an artist imitate nature in her processes. Nature starts from the chaotic and then forms into the specific. Well, I don't believe that an artist can start that way. Curiously enough, you start with the specific and it opens out. And the dialogues that you have with your work is, in fact, leading you into this open-ness . . . the cosmos."

In 1961, Bridget Riley formed an association with Gallery One in London. Her first exhibition consisted of small black and

white optical paintings that caused a sensation. A second show held in 1963 proved even more scandalous.

"I was accused of eye-bashing, of having no content, of being aggressive and gimmicky," said Riley. "Still, I had considerable success."

As Riley's name became known, and as her reputation as a vanguard British artist brought her a measure of celebrity, she began to grow restive, if not angry, over the fact that the imagery she had so scrupulously brought into being was beginning to be plagiarized by manufacturers of fabrics, wallpapers, and any number of other commercial products. Indeed, this syndrome became even more acute when Riley began to exhibit in America. Invited to participate in the Museum of Modern Art's exhibition, *The Responsive Eye*, held in 1965, Riley's highly expert and visually dazzling canvases were again deemed aggressive and gimmicky, which, nevertheless, did not deter commercial manufacturers from brazenly adapting her optical images for their own use. But what riled Riley even more was that her work was not taken seriously by the critics or her fellow artists.

"I found myself being vulgarized, plagiarized, trivialized, and put firmly out of court as an artist. Naturally, I was deeply disappointed because, like all European artists, I thought that in America one found the most sophisticated and responsive people. Well, I had a few shows at the Richard Feigen Gallery in New York, and my work sold, but frankly I was hurt. And, of course, I could not believe the cavalier manner in which my work was being plagiarized. I saw my images appearing on women's dresses, on matchboxes, on linens, on towels—you name it! It was incredible! Well, I sued everybody I could for plagiarism. Unfortunately, nothing ever reached court. Things were settled out of court, and that happened in England too. Finally, I left America and didn't come back for 10 years. I succeeded in completely ignoring the whole horrible mess, and simply plunged further into work."

As the years progressed, and as Riley refined and went analytically deeper into her imagery, the tide changed. Critics began to take more serious note of her work and eloquently praised the artist's uncommon handling of the aesthetics of

color, line, and form. In 1968, Bridget Riley was invited to participate in the Venice Biennale and walked off with the painting prize—a prize she treasured because it somehow made up for the humiliating early dismissals she suffered both in England and America. Riley continued to exhibit in London and for the past few years has shown at the Rowan Gallery. In 1970 and 1971, she held retrospective exhibitions in Europe that traveled to Germany, Italy, Switzerland, Czechoslovakia, and England. In 1975, Riley resolved to return to America. She exhibited at the Sidney Janis Gallery in New York, garnering first-rate reviews. Time had obviously healed Riley's wounds; her work was now being taken seriously on an international level, giving the painter the satisfaction of knowing that she had indeed survived the passing popularity of Op Art.

Turning to her retrospective at the Albright-Knox, Bridget Riley claimed that assembling it and seeing it as a whole was a most disruptive experience.

"It's very curious, because the relationship to your work is in time. You see it, so to speak, from here backwards. But when it's flattened out, and seen as a whole, it disturbs the whole way in which you've thought about your work. You see, everything in my work evolves from what has gone before. So, it's a very disruptive thing to look at it in the retrospective context. The fact is, one is disappointed. One feels it's so little, really. Ego satisfaction and pride . . . well, that comes and goes fleetingly. It rushes over you from time to time, but you then think it could all have been more powerful, more expressive, more released somehow.

"For instance, the instability of color, which is what I'm most involved with . . . well, it's so hard to make it an identifiable experience. You look at it, and it's already shifting this way and that way, appearing and reappearing in new guises. And that is a very tenuous, delicate thing to allow to flower, to develop. So, these retrospectives make you feel how things could have been rather than what they actually are."

In London, Riley lives in an old Victorian house boasting four studios, one on each floor. The fifth and top floor is reserved for living quarters. She resides there alone. The artist is not married nor does she wish to be.

"I simply couldn't support the structure of marriage. I just couldn't! Of course, I've had close associations. As for the painter I was in love with . . . he died in 1968. He gave me a great deal. He gave me encouragement, intellectual stimulus, and, as a painter, he had the painter's understanding of art history. Oh, I have a life. I have friends and I have my work."

Is Riley a feminist?

"The movement, you mean? Absolutely not. People have tried to rope me into it countless times. But you see, I live it, therefore I have no interest in it."

Bridget Riley smiled, rose, lit another cigarette, then said, "Surely, you've gotten quite enough out of me. All the rest is right there in the paintings . . . they're really quite full of rather interesting information."

1978

SAUL
STEINBERG

A funny thing happened on the way to Saul Steinberg. The people on the crosstown bus all turned into Steinberg drawings. On their foreheads I could discern some beautiful, undecipherable pen-and-ink script that made perfect sense. Their thoughts, intense yet wondrously vague, gave instant notice of their character, their occupation, even their destination. That lady with the cubist hairdo was clearly on her way to the Picassos at the Modern. That gentleman looking like a floating question mark was surely on his way to his analyst. The bus driver himself knew exactly where he was going: Fifth Avenue, Madison, Park, Lexington . . . Paris, Rome, Istanbul, Tokyo.

I got off at Park. Of course, the glass buildings all turned into graphs. Judging by the upward zigzagging lines, I noted that business was quite good on Park. As I reached my destination, the doorman, wearing a uniform with rows of medals across his chest and a saber hanging from his belt, barred my way.

"Qui va lá!?" he shouted.

"I have an appointment with Mr. Steinberg," said I, saluting.

"Where is your passport?" he demanded.

Saul Steinberg, master of wit and fantasy, has happily discombobulated us for years. Leafing through any Steinberg book, be it *All in Line, The Art of Living, The Labyrinth, The New World,* or *The Inspector,* or coming across his drawings, watercolors, and cartoons in *The New Yorker,* one is in touch with an artist totally uncategorizable yet entirely familiar. So completely has his style impinged itself on the international psyche that Steinberg's signature has become the work itself. His imitators (they are legion) have yet to conquer his particular sensitivity of line or that admixture of humor and irony that somehow manages to capture truth even as it questions it. The outrageous logic of his pictorial invention is such that we instantly recognize some aspect of the human condition while simultaneously marveling at the economy with which it has been expressed. Indeed, no matter how baroque or convoluted, a Steinberg drawing is invariably possessed of immediacy and psychological accuracy. Above all, Steinberg's oeuvre is charged with an overriding sophistication. A unique elegance dominates line, contour, form, and, in the watercolors, coloristic delicacy and structural clarity.

All this was apparent to viewers of Steinberg's first American retrospective held in January 1978 at The Whitney Museum. Some 250 works were on view, and the catalogue, with an introduction by Harold Rosenberg and a biographical chronology by Steinberg himself, offered evidence of an artist who, in a very real sense, is the product of his own invention.

Steinberg looks exactly like a Steinberg. There is an awkward logic to the proportion of his head and features—something is slightly askew about the face. One doesn't quite know whether one is in the presence of Groucho Marx or James Joyce. Horn-rimmed glasses, which slightly enlarge his eyes, sit firmly on an abundant nose beneath which sprouts a thick mustache. When Steinberg speaks, one hears an accent . . . but of which kind? Its lazy, warm intonation suggests something Slavic or Baltic. It is, in fact, Rumanian.

I am ushered into a long, spacious room. The atmosphere is decidedly European. A lamp-shaded light fixture hangs low

over an oval dining table that stands at the far end of the room. There are comfortable couches and armchairs. Just now, a large worktable has been set up in the center of the room. Steinberg has been supervising the contents and layout of his Whitney catalogue, and the table is littered with papers, books, pens, pencils, and pads. A distinguished melange of paintings and drawings cover the walls. Small sculptures rest on various bookcases and tables. The eye almost immediately fixes on some oddly shaped canvases apparently by Piet Mondrian.

"Those are false Mondrians," said Steinberg with a smile. "I painted them myself. But they are not copies. They are invented Mondrians. You see, for me, Mondrian is the key to modern art. Among artists, he is the true intellect, the purest. The others made games, they were collagists, most of them. But the true important elements in art for me are the first waves of Cubism and Mondrian. Anyway, what I understood was how difficult it was to do a Mondrian. If you look at a Mondrian, you say, 'How simple! You do a few lines and use three colors and that's it.' But it's not. You have to impersonate Mondrian in order to understand him. It's like hunger or cold. In order to understand hunger and cold you have to be hungry and cold, and only then do you know what it is. So, 20 years ago, when I made those Mondrians, I wanted to find out how he did it. You can't figure out how he did it unless you do it."

Steinberg offered a small tour of his collection: "That's a Hedda Sterne done in 1947. She was in the avant-garde way ahead of the avant garde! Here are two Alberto Giacometti drawings. Over there is a Richard Lindner. Here are two pictures by Sigrid Spaeth, my friend. This one was done when she was under the spell of Cézanne. She did something no artist has ever done before—a refrigerator. The whiteness comes out of the blank space in relation to the rest of it; the rest of it defines the refrigerator. And this is a Josef Albers. Below it is an erotic Picasso drawing. It's not one of the best, but it's good—an old one—1937. Here are four de Kooning drawings. They are beautiful, certainly the self-portrait with his brother—an imaginary brother. Here is a Jean Hélion. Over there is a marvelous primitive from Venice. The moon comes out behind the Palazzo

Ducale, illuminating the Piazza San Marco before it had public illumination. This is a beautiful Paul Klee and here you have a small Calder."

It soon dawns upon a visitor that Steinberg enjoys leisurely conversation. He does not like programmed questions, but prefers to let talk take its natural course. Asked about his retrospective—how it was affecting him—he momentarily shirked the question, touching instead on the dangers faced by the modern artist.

"The trouble is that, as we get older, successful, or rich, we have a problem of maintaining our life as it was before and not becoming the victim of fame. This is one of the tragedies of the modern artist who had to change his social class because of his success. I'm trying to defend myself against this by not leaving New York. One thing I don't want to do is to end in some remote place. What happens is you end in cul-de-sacs where there is no way out. I am in some sort of cul-de-sac, which is East Hampton. The nearest thing is Portugal! The other cul-de-sac is Provincetown. Again, you can't go any further. Finally, the last cul-de-sac is Key West, where Hemingway went. There are other no-man's-lands, like California where some went to spite New York. Some people have a form of wisdom, like Saul Bellow, who insists on living in Chicago. Others stay in Tangiers and other strange places. The worst thing for l'Ecole de Paris was to move to the Cote d'Azur. Well, it's known that the more beautiful the climate, the more moronic the inhabitants. Anyway, I'm staying in New York so that I can be part of what's going on. Why do some of us stay in New York? Because New York made us invent what we invented—including the invention of New York."

Saul Steinberg, who unquestionably contributed to our image of what New York is all about, did not in fact land in the city until 1942. Born in 1914, in Ramnicul-Sarat, Rumania, he led a peripatetic life that, by 1932, found him studying architecture at the Faculte d'Architecture du Reggio Politecnico in Milan, Italy. In 1940, he received his doctorate in architecture and, that same year, left Europe for Santo Domingo, where he waited to gain entry into the United States. During this period he began to send some of his drawings to *The New Yorker*. These

were immediately published and, upon his arrival in America and settling in New York, his association with that publication became a permanent one.

The artist was not inclined to discuss the circuitous turns of his personal or professional life. What is known about Steinberg is that, in 1943, he held his first one-man show at the Betty Parsons Gallery and almost immediately thereafter enlisted in the U.S. Navy. He was sent to China, India, North Africa, and Italy, participating in various World War II operations. With the war's end, Steinberg returned to the United States; his first book, *All in Line,* was published in 1945. The following year he was included in the Museum of Modern Art's exhibition, *14 Americans*. A tireless traveler, he next journeyed through Mexico, France, Italy, and Turkey, with a later trip to Russia. By 1952, he had one-man shows in Rome, London, and Sao Paulo. That same year, he became affiliated with the Sidney Janis Gallery. In an unusual arrangement, he did not abandon his association with Betty Parsons, and to this day continues to have simultaneous shows at both galleries. In 1953, he began his long association with Galerie Maeght in Paris.

Throughout the '50s, '60s, and '70s, Saul Steinberg achieved worldwide recognition. His work was exhibited at museums and galleries in Belgium, Holland, Germany, Sweden, France, Italy, Switzerland, Austria, and Cuba. He published four more books and continued to draw for *The New Yorker*. A collection of his drawings was published by Editions Gallimard, and, for the American Pavilion at the Brussels World's Fair of 1958, he created a 240-foot long mural entitled *The Americans*. Resisting repeated requests for a retrospective exhibition in America and Europe, Steinberg finally consented to a traveling retrospective in Germany, organized in 1975 by the Cologne Kunstverein.

"I got bored with saying no," said Steinberg commenting on this exhibition. "But they did it without my cooperation. It was done with whatever was available in Europe, and it was basically a Maeght show. I haven't seen it; only photographs. I saw the catalogue, which is sort of elegant."

Did Steinberg not wish to travel to Germany because of anti-German feelings?

"Look, I participated in the war fully," answered Steinberg. "I saw all the theaters of war. But I want to stress one thing: Those who participated in the war are left with less revenge than those who didn't participate in it. I have noticed that the people who were in concentration camps are able to drive Volkswagens easily, while those who played the black market during the war are still anti-German, even anti-Mercedes!"

Turning, at last, to his Whitney Museum retrospective, Steinberg considers the whole process of such exhibitions as something less than exhilarating.

"These large exhibitions, retrospectives, commissions, and catalogues are a nuisance. Whatever is caused by outside forces in the life of an artist has the nature of a disaster. A man has to have his own appetite and do things according to his wishes. Life is not as simple as this, because there are outside factors that interfere with us. Now, I would say I've had other disasters that were influences in my life—wars, revolutions, persecutions, sickness—all sorts of things. And I put art history in that category. These are disastrous events that could, of course, be avoided. They could be avoided by pretending insanity or amnesia. But mistakes are attractive.

"Anyway, about the Whitney show: There are about 250 pieces, and it's incomplete, because there are lots of works that we couldn't find. Some were lost because they were sold in the days when records were not being kept. Also, things have a way of traveling. Pieces that were sold in New York can be found in Belgium after having been in Japan. But others have completely disappeared."

Faced with so much of his work at one time, what was Steinberg's reaction?

"Like all autobiographies, it's fairly fictitious. Actually, seeing the retrospective was like looking at a group show. It had to be. It's the nature of my work. What I could see clearly was the evolution, the transition from the architectural drawings into the same stenographic architectural quality of the early cartoons. I would say they had the spirit of Cubism in the sense of using a minimum of elements—a straight line and a round line, with occasional whiffs (like collages) of Baroque and

Rococo elements. I would say I came out of architecture, which was the only training I've had. Well, later on I started making excursions in watercolor—other things that were more lyrical. That's probably the influence of living in the country."

Asked whether he had ever worked in oil, Steinberg said: "I've done a few things occasionally. It has to be done thoroughly and constantly, and I have done a few oils, but it's much too seductive for me at the moment. The color itself can lead you into somnambulistic work where one is lost. . . . Well, I still think a picture is a continuation of thinking. It's not a ballet, it's not choreography or, if it is, it's damned serious and dangerous. My system of working has to do with my thinking of myself as a literary man, who found this language of drawing. The essential thing about drawing with the fingers— the pencil, the pen—is that I think of the fingers themselves as being the continuation and part of the circumvolutions of the brain. The fingerprints themselves serve as a reminder of those circumvolutions. There are other ways of doing things with the nervous system or the muscular system. Certainly, the large-scale things come from the dorsal areas—the back—the whole body, such as the art being done by the Abstract Expressionists. I would call that somatic art. It's important, it's strong, and very few can do it. It's extremely emotional and extremely danger-ous, I would say. That sort of painting is very interesting and I'm amazed that people have become professionals with that sort of art, because the nature of it is incidental and miraculous. And it's very difficult, very improbable that one can become a professional at this sort of art.

"But to come back to what I'm doing: Mine is a sort of literary work. The watercolors have derived from art history and from reproductions of nature as seen in art, more than in reality. I recognize nature from painting, mostly. When I see a cloud, I say, 'There's a Fragonard cloud' or 'That's a Japanese sunset' or 'Here is one of those murky, Parisian Impressionist days coming.'

"Where do my ideas come from? Well, it's like what a good writer does. He writes down a word and then cancels it. Then he puts down a second word and cancels that one too. He goes on and on cancelling. It's like that with entire pages and entire

chapters. That's how it's done. But what you suspect is that, when you know what you want to do, you eventually do it. You may have to figure out that you may never be able to do it. And you are ready to give it up. But these are common problems of the metier. The problem I have is that I have to reinvent my metier practically every day, because whatever is being left behind cannot be redone, mostly because it doesn't give me enough pleasure. The real pleasure is the invention. The performance is the job, sometimes a very attractive, very seductive job. I often envy the painters who have stopped at one performance, and continue it. Because they have a life of delights ahead of them. They know what they are going to do, and they wake up in the morning full of appetite for doing the same thing again. I wouldn't say there is anything wrong with this, because these are people who have always been that way, and who were meant to be that way. I, instead, get excitement out of invention."

Pressed to reveal something of his early life in Rumania, his family, or his marriage to the painter Hedda Sterne, Mr. Steinberg was adamantly uncommunicative. Still, by way of an answer, the artist spoke of the importance of running away from home.

"An artist *has* to run away from home. This is the premise. There is no modern artist who hasn't run away from home, especially an American artist, and now more than ever. Originally, he had to run away from his society. He had to find himself through isolation and in a no-man's-land. It was, of course, the big city. Artists came to New York or went to Paris. But the things that keep a man from being himself—*really* himself—are the witnesses: the family, the main-street people, and so on. Well, one has to run away from that. I would say that today, one has to run away from Soho and from 57th Street and maybe return to Nebraska. You see, New York is no longer no-man's-land. It's the center of reproduction. It's like a rabbit farm.

"I would say for myself that I ran away from home through emigrations. I'm addicted to them: emigrations caused by school, persecution, war, and military service. Sometimes I was deported, sometimes I was ordered to report to this or that

place. These were machinations made to keep me on the move. After that, I became addicted. I traveled for so many years! I couldn't stand still. It's only now that I travel less, mostly because I've found different forms of emigrations. The fact is, travel or emigration forces you to start all over again. It's the essential element of progress and evolution.

"The only people who can have interesting careers without traveling are primitives, like Jules Verne for instance. But an intellectual has to change, and has to shake himself. I was reading the letters of Edmund Wilson, and what precarious situations he got himself into. How restless he was! He too couldn't stand still. He learned Russian, Hebrew, and even Hungarian. To the end, he was restless, moving, and searching. And he would write on unpopular subjects, like Indians or Canadians. Who would touch the Canadians?! He wrote the best book about the American Civil War—*Patriotic Gore*. It makes you understand the South, the misery of the aristocracy of the South. I mean, those big mansions were full of chickens, children, and all sorts of mammies and slaves, and the owners had not one moment of privacy. There was noise and it was a life that was worse than the life of the Russian aristocracy as described by Gogol in *The Dead Souls*."

It is Steinberg's travels, particularly throughout America, that have yielded some of the artist's most pungent and dynamic images based on Americans. His observations, canny, full of wit and a kind of merciless truth couched in humor, have produced an image of the American sensibility (and geography) that few native artists have been able to challenge. Steinberg described some of his recent journeys:

"My pleasure is to take trips across America. I take a plane to, say, Salt Lake City, then I rent a car and make a program of following, say, the southern part of Texas. About three years ago, Sigrid and I followed the Mexican border, and that's where you get to places nobody goes to. They are pretty corny places, but extremely interesting, because they are still tied to the '20s. We went to a place called Uvalde, where Cactus Garner lived, and Hondo, where I bought a hat. And last year, we went to Florida. But instead of going to the coast, we went inland and there, again, you have magnificent places that are left un-

touched from the time of the Depression. You see the same gaunt people of the Depression, except that they are Mexicans or Indians—exploited laborers. There are real violent scenes on weekends—murder and drunkedness.

"There is a place called Arcadia, inland, off Sarasota. You realize when you come to such towns that you are not welcome. They want you to go to the coast, where you belong. Although I had a Florida license plate, they recognize rented cars; they recognize people who don't belong. Some of the towns we visited were prison towns. Those are very sad places and the whole town lives on this gruesome industry. The people who live there are prison guards or providers for the prison—that precarious situation of Dachau—and they keep that same sort of silence and dispassion about it, as I imagine the citizens of Dachau must have kept. Whatever makes for this silent, meager complicity is visible. Anyway, that's the sort of traveling I do these days."

Is an artist like Steinberg influenced by the great art of the past? Is he a museumgoer?

"For me, the people who look at art are even more interesting than the art itself. Actually, when I really want to look at art, reproductions are a blessing. It's like going to the opera. I wouldn't dream of going to an opera unless I first knew it by heart. It's the only way to enjoy an opera. I don't know many, but I know *Rigoletto* perfectly, and I could hear it often. And so it is with certain paintings. I first look at reproductions for a long time, then I go to see the originals. Of course, it's a great emotion to see them. It's a strange emotion, because it's like encountering a fictitious personage. And so it goes for cities. I first study the map of a town and then I go to see it, and it turns out to be perfectly true."

Steinberg claimed that he does not generally see other artists but prefers the company of writers, whom he finds far more congenial. Asked whether artists take him seriously, Steinberg pondered the question.

"Well, I'll tell you. I'm in a precarious situation, which suits me very well, because it turns out to be the safest. I am on the edge of the art world. I'm not sure that being in the center of things is the proper place for an artist. An artist has to have a

precarious situation. If they don't have it from the outside, they cause it from the inside, which is worse. It's the nature of the artist to be on the edge—on a tightrope. But I do see people I enjoy out in East Hampton. I see de Kooning occasionally and I see Harold Rosenberg often.

"As for the younger artists, they generally kick me upstairs. But I must say, there is a sort of generation insanity about not remembering the names of young artists. I like some of them very much, but somehow I can't remember their names. There's Wayne Thibaud, whom I like. He lives in California. He is one of the few men of spirit around. Actually, what I like in the younger artists is *la Cosa mentale*—artists who think. I see some young hotshots down in Soho, and they are very clever. But often they are just a flash-in-the-pan.

"What do they think of me? Well, you see, it's difficult to classify me. What annoys me is vulgar admiration. It has to do with humor. You see, sadness is much more respectable and is considered of divine origin. Being funny causes laughter, and laughter is disreputable, causing the precarious situation that we were talking about."

Turning to his work for *The New Yorker*, Steinberg said it was an excellent education—the best calisthenics he could think of.

"The exercise of inventing an idea for *The New Yorker* is a difficult thing, and it keeps me in touch with the state of the nation, as it were. It's my political work, and it's important. I would say it's much more difficult than anything else I do, and it's getting more and more difficult as I get more and more demanding of myself. Basically, I work in the realm of ideas. Essentially, the search for ideas is self-amazement. After *les bourgeois* and *les peintres*, what's left is to *épater moi-même!*"

1978

Photo: Hans Namuth

MICHAEL
HEIZER

For all his genuine sophistication and acute sensitivity, Michael Heizer affects the parlance and mien of the tight-lipped, diffident man of the plains—the brooding, good-looking cowboy of Marlboro Country. Indeed, the 33-year-old artist, best known for his visionary desert structures titled *Double Negative, Complex I,* and *Displaced/Replaced Mass,* seems entirely constrained and uncomfortable within the urban setting of an elegant East Side gallery, even when that gallery—Xavier Fourcade, Inc.—happens to be where he exhibits.

The fact is, Heizer, who was in New York to supervise his Fourcade show of seven sculptures based on the circle, is happiest when recklessly driving a big-wheel open truck across the Nevada desert, racing toward his *Complex I,* which rises like an ancient and atavistic pyramid on a high plateau in the vast and endless desert space. There, between 1972 and 1976, Heizer and his hired workmen shared a hazardous and solitary life, erecting an earth-and-concrete structure that, for all intents and purposes, had no significance other than its own mirage-like presence.

Heizer was no less active in 1969, when he created *Double Negative,* a 1,100 × 42 × 30 foot work located at Virgin River

Mesa, Nevada, where he and his crew gouged and carved 240,000 tons of rock out of facing cliffs to form two mammoth vertical trenches. This constituted the finished work. The site is so huge that it can only be seen in its entirety by helicopter or airplane. Again, its meaning and raison d'être is its own existence, nothing more and nothing less. More recently, Heizer created *Adjacent, Against, Upon,* six massive concrete and granite geometric forms commissioned by the city of Seattle. This piece, placed within an urban environment (its location is in a mile-long park facing the Port of Seattle), is among Heizer's works designed expressly for public consumption.

But, within the context of so-called Earthworks as practiced by artists such as Walter de Maria and the late Robert Smithson, the sensibility at work is one which most trenchantly eschews the taken-for-granted confines of art—museums, galleries, the home, or the city—perceiving it instead as an extension of nature itself. In point of fact, almost no one journeys to the Nevada desert to view Heizer's *Complex I* and *Double Negative* or to de Maria's *Las Vegas Piece* or to Smithson's *Spiral Jetty* in the Great Salt Lake. The documentation of such art works via photographs, films, or the written word often becomes the sole dissemination and proof of their existence.

By now, art critics have expressed endless thoughts on the social, cultural, intellectual, and artistic significance of Earthworks, attempting to find a philosophy and ethos that would explain these artists' epic and mystifying activity. For Heizer, the language of such art criticism often obscures the work itself, and he considers much that has been written about him confusing and unenlightened.

Suspicious of interviews, the artist resisted talking to someone who might yet again misinterpret his feelings and concepts. Still, he agreed to have a talk at the Fourcade Gallery.

"You'll probably think I'm putting you on," he said. "I mean, a lot of people have thought that. I feel I have a very bad reputation on that score. What bothers me is that no one really wants to know what I'm doing. I feel that most of the art magazines are just filled with a lot of incomprehensible verbiage. There's no understanding of my work.

"What people don't seem to realize is that I'm interested in

the *issues* of art. Frankly, I'm tired of having my scene slowed down by people who don't get what I'm doing. *I'm* working, but they're not working. That's very upsetting. Look, I take the stuff I'm doing very seriously. I don't think of myself as an artist that's running around expressing himself. I feel I'm performing a function for society. I think my work is important. Curators of museums are negligent. There are exceptions, of course, but most of them aren't really doing anything . . . anything that's important.''

Speaking quietly, haltingly, and in something of a mono-tone, Heizer was referring to his monumental landscape projects, those works that with their archaeological, anthropo-logical, and ecological overtones resist easy codification. Deal-ing, as he put it, in the history of materiality, Heizer seems to look beyond the mere act of creation.

"The work I'm doing out in the deserts *has* to be done, and *somebody* has got to do it. Where in hell are all the artists? I mean, we live in an age of obligation. We live in an age of the 747 aircraft, the moon rocket—objects that are constructed by man that range from the most miniscule complex electronic dial to airplanes that have wings weighing 45 tons. So, you must make a certain type of art. Of course, there are limits. If you take your work too far, you end up with entertainment.

"Basically, what I'm saying is that the European option is closed. The European tradition has to be honored, but that area is finished; it's over with. The kind of art I'm involved with hasn't really been done before. What I mean is, it's the kind of art that was originally Indian art, then it was Pilgrim art—art by all those various visitors. That's the tradition I'm interested in, the tradition of regionalism. That's essentially what I try to do.''

Heizer does not consider himself an Earthworks artist. Indeed, he refuses to align himself to those artists with whom he is generally lumped together by writers and critics of the movement.

"My work is fully independent of anybody else's, and comes directly out of myself. But during the '60s, there was this crazy phenomenon. I mean, Walter de Maria was thinking about that stuff. He had written a piece for *Fluxus,* and he made some drawings and so went into it. Smithson went into it. I

guess Robert Morris did too. It just came from everywhere. Claes Oldenburg was doing it and Carl Andre and Sol LeWitt. But whatever I was doing, I was doing it first. And whatever I was doing, I was doing it myself. My area hasn't changed at all, and there will be no change. Other people's work probably won't change, either, but distinctions will be more evident. At any rate, I don't consider myself an Earthworks artist. I never was. Look, in a lot of my work I use steel liners. They have nothing to do with Earthworks."

Michael Heizer, a native of Berkeley, California, is the son of Robert Heizer, a distinguished archaeologist currently teaching at the University of California. An expert in the study of the methods by which pre-Columbian peoples moved huge stone blocks without the benefit of the wheel, Professor Heizer clearly fired his son's imagination and sparked his interest in archaeology. The two have made expeditions to Egypt and the Yucatan, exploring Egyptian architecture and the ancient ruins of Mayan civilizations. By his own admission, Heizer's childhood was nothing if not fantastic.

"Ever since I was an infant, I drew all the time. I did millions of drawings and they were pretty good. When I turned 14, I traveled to Paris just to look at art. I lived in Paris for a year. I saw everything and went to all the museums. That's my background. I saw it all firsthand. The fact is, you can't go to school and learn about art by looking at a bunch of slides projected on a wall. Anyway, I was lucky and I'm not apologizing for my luck or my background. Later, I went to San Francisco and worked at the Art Institute. Well, I didn't go for it. I didn't like the school idea—the programs, the courses, the studies—b.s. like that. The teachers there understood, and guys like Bob Hudson and Jim Weeks encouraged me to work alone in a studio; they said they'd come and look at my stuff there. I painted big geometric things.

"Finally, I got fed up with San Francisco. There just wasn't any art to look at. And people liked to drink a lot and have a good time. No one worked. People were screwed up, and there was no art. So, I came to New York in 1965. I continued to paint, but nobody wanted to look at the stuff. I didn't sell anything for years. I mean, the paintings ~ ler Xavier Fourcade sold

three or four years ago were around for 10 years! Anyway, I lived in New York, and I had no money, but I wouldn't go to work either, because I was an artist. Finally, I had to break down. I couldn't stand the poverty. I started spraying buildings for slumlords. I did it to pay off my debts. I also met Dick Bellamy, and he started to sell a drawing or two. Then, in 1968, I started working with Heiner Friedrich in Munich. He was the very first to give me some money for my work. But the guy who *really* helped me was Bob Scull.''

From the first, Robert C. Scull, the well-known art collector, took a deep interest in Heizer's work, and was particularly intrigued by the artist's ideas on a landscape art that involved massive excavations—works Heizer called depressions or mass displacements. Scull commissioned several such undertakings and continues to do so to this day.

''Bob Scull means a lot to me. He made my work interesting, because I had an audience with this guy. He liked the stuff I was doing. Back in 1969, he came out to the desert and looked at it, and flipped out. He gave me money. But it was strictly business. I mean, he bought stuff and he commissioned things. He started small, and it got bigger in the last few years. Just recently, we moved some huge rocks from northern to southern California, and it cost a bundle. I've known Bob for over 10 years now. I spend a lot of time with him and I like him. He's one of the few people who is really into it. He knows what's going on. He sniffs out all these shows. He goes all over. He's one of the few pros on the scene.''

How does Michael Heizer actually begin a work of marathon proportion requiring months and even years to complete? And what explanation does he give to hired workmen who may question the aim and purpose of their backbreaking labor? How, in fact, does Heizer himself oversee and work on so vast a project as, say, *Complex I*?

''Well, you might say I'm in the construction business. To begin with, I have a tremendous real-estate file on every available piece of property in six Western states. I look for climate and material in the ground. When I find the right spot, I buy it. I chose where to work in Nevada after a three-year survey, which cost some 30 or 40 thousand dollars. But I wasn't

just buying real estate. I was buying gravel, clay, rock, water drainage. I was buying temperature that guaranteed a certain number of months during which I could work. I was buying isolation. When I start working, we have a pretty closed operation. The word is, we don't want people out there, because we have liability. We have blasting, and we don't have time to have guests.

"My work in Nevada is on my property. I bought it, and I control it. If I choose to, I will give it to the U.S. government. Or, I might give it to some other government. Or, I might keep it, and give it to my family. It will never be misused. There's only one other sculpture in Nevada, and that belongs to Virginia Dwan, who commissioned it.

"As for the workers: Of course, if I showed up like a prototypical artist, with long hair and sandals, and if I set myself up with an easel in the desert, I'd probably get a fast haircut and a beer bottle in my mouth. It all depends on what kind of artist you are. When I told the workers that I was an artist, they understood right away, and that's because I'm just *like* those people. So we get along. And I never give them puny tasks. We all work hard and they have their hands full. They respect that. Some of them may have thought that art was indolence. Well, believe me, they know better now. That part of Nevada is now educated to the fact that art isn't indolence. In fact, the general manager of the company we have out there went and gave a talk to the high-school kids of the local town. He told those kids, 'Look, this is what it is.' And he showed them what we were doing. So now, kids are hearing about art, and they dig up books on Picasso and other artists, and look at the pictures. They're getting interested."

Asked how kids (or anyone else for that matter) should relate to his work, Heizer was quick to reply: "You don't have to relate to it. It's not a requirement. All you have to do is just be there. It doesn't matter what you think when you see it. The point is, it's the work of an artist. I'm an artist. That's my business. That's what I do all the time. So, what you're looking at is a work of art. You've got to understand that a lot of my thinking is based on preliterate societies. I'm very conscious of the preliterate tradition. So, when you talk about relating to

my work . . . well, how do you relate to Mayan or Egyptian pyramids?''

Clearly, Heizer's view on art is fairly cosmic, and, to a certain extent, grim. He holds little in the way of hope for the permanence of art as we know it.

"When that final blast comes, a work like *Complex I* will be your artifact. It's going to be your art, because it's designed to last. It *will* stick, it's accurate, and it's going to represent you. *Complex I* is designed to deflect enormous heat and enormous shock. It's very much about the atomic age. It won't burn up. Look, I'm not out to entertain. So much damn art is about that! You mentioned Cristo to me, his *Curtain* and the other stuff he does. Well, I dismiss it instantly. I think it's fatuous, capricious. I think it's entertainment. If it has a sculptural aspect to it, well, so did Diaghilev's sets . . . something beautiful, you know. Actually, a set is more permanent. It can be placed in storage. It can be duplicated. But that other stuff . . . I don't even want to think about it. I write it off.''

Heizer's words became less audible as he spoke in genuine anger of an art he deemed perishable, fashionable, and designed to please. And yet, the artist has produced a large body of work—paintings, drawings, and sculpture—that is a study in elegance and craftsmanship. While these works my be distantly related to the artist's large-scale outdoor projects, they decidedly represent an unrugged and entirely sophisticated aspect of his creative imagination.

There is no question that Michael Heizer's career is in the ascendence. Since 1967, his work has appeared in major galleries and museums throughout the United States and Europe. He is represented in important private and public collections, and he has received highly paid commissions from individuals and cities on both sides of the Atlantic. Often the subject of controversy, Heizer's objectives are unhindered by public opinion. His aim is simply to forge ahead, creating an art that he considers valuable to society, and following a vision that nothing and no one can alter or deter.

"I have a lot of work ahead of me. I've got so much back-up work! It's work that has never been built. I've got projects that will take my lifetime to build—stuff I thought of by the time I

was 23 years old. Well, I'm determined to finish all of these works before I die. I'm not interested in the kind of work that's being done in the delicate world of the studio or seen in the quiet atmosphere of museums. That's not where my head is. What I'm after is investigation and exploration. It's not about leaving remnants or making something that's beautiful!"

1977

DOROTHEA
TANNING

S urrealism seems like a distant dream—a sliding and shifting
memory that touched the mind though seldom the heart. Its
perplexing visions sought to unlock phantoms and fantasies, to
bring us at closest proximity to an inner landscape that would
reveal our unknowable and enigmatic selves. Its masters—
Magritte, Dali, Ernst, and others—spawned an imagery suf-
fused in allusion and the tensions of the undefined. Precision of
technique yielded a demystification of reality. Accuracy dealt in
the vague, the disquieting, and the terrifying. Validating the
unconscious, Surrealism unearthed myriad intangibles. But
even as the mind produced monsters, the emotions, which
know no reason, were allowed to drift in a sea as cold and
remote as an alien, inaccessible universe.

But the emotions were tellingly called into play by a
Surrealist unlike the others—an artist who almost, but never
quite, betrayed the impulses that demanded blind allegiance to
the symphonic turbulences of the mind and the chilling clamors
of the intellect. This was Dorothea Tanning, who, today, at age
76, lives quietly and alone, in New York City.

After a lifetime of exhilarating adventure among the sacred
monsters of international art, this American artist, born on

183

August 25, 1910, in Galesburg, Illinois, has produced a large and compelling oeuvre attesting to a spirit of independence and the sort of personal vision that announces, not Alice, but a Poet in Wonderland. Indeed, for nearly half a century, Tanning created a world peopled by perilous creatures, who were nevertheless possessed of beating hearts. Working in every medium, she unveiled a dream-world fraught with danger, yet illuminated by the potentials of survival. Her imagery, throughout the years, has moved from the precise rendering of subject matter to a softer, more shadowy illusionism—a subtler and sly approach to the phantoms of the imagination.

Paradoxically, she has accomplished all this, not in the shadow, but in the light of a monument—the surrealist, Max Ernst, to whom she was married for nearly 30 years, before his death in 1976. So all-pervasive was Ernst's personality and fame, that Tanning's own career was all too often and all to unjustifiably looked upon as an extension of his—a gifted acolyte to a master. But Tanning was no acolyte. She was a full-fledged artist in her own right, whose career took wing following her first major exhibition at the Julien Levy Gallery in New York, in 1944.

When Ernst and Tanning settled in France, living there for a span of 28 years, Tanning's work was shown with regularity in galleries and museums in Paris, London, Milan, Berlin, Geneva, Basel, and Stockholm, as well as in New York. An indefatigable worker, Tanning has also been active as print-maker, sculptor, book illustrator, and theatrical designer. Since resettling in New York in 1980, she has exhibited in Arizona, at the Basel Art Fair, and at the Kent Fine Art Gallery, where her show, *Dorothea Tanning: On Paper 1948–1986,* offered viewers a renewed glimpse into Tanning's undiminished powers as draughtsman and prober of the unconscious.

Like mysterious, musical whispers, these works on paper made clear the artist's continuing involvement with an imagery in which figures—mostly female nudes often seen in breathless flight or transfixed in irrational states—quite transcended the Surrealist ethos. Here were drawings, watercolors, gouaches, and graphites charged with speed and control—celebrations of the lucid line in the service of spontaneity. Quite apart from

subject matter, they contained an irrepressible flow that seemed never less than rooted in feeling and experience.

These days, Tanning has not only been active as an exhibiting artist, but has made time to write a memoir of her life with Max Ernst. Entitled *Birthday* (after the title of an early self-portrait), the book was published in 1986 by the Lapis Press in San Francisco. In it, she recounts the myriad experiences of a relationship clearly based on mutual adoration and singular productivity. While the couple was swept up in the dizzying ferment of the French Surrealists, both in New York and Paris, they chose mostly to share a private and hermetic existence in sequestered homes in Arizona, Touraine, Huismes, and Seillans. Writing in a language of surreal-tinged lyricism, Tanning charts the joyous as well as the dark complexities of a life that seemed both radiant and fulfilling.

For a woman of advancing years, Dorothea Tanning is, in a word, stunning. Trim, erect, and proud, she has not allowed the calumnies of time to mar her glamor or vitality. The aura of youth still clings to her, and an alluring sense of wonderment unmasks the child in her. To spend some hours with Tanning is to be placed in touch with history, but it is history devoid of self-importance or turgid weight. Tanning looks back on her life with humor and with the sophistication of worldliness.

Living simply yet elegantly on lower Fifth Avenue in New York, the artist has divided her apartment into a working and living space. Three rooms have been turned into a sizable studio, complete with painting racks, painting walls, and drawing tables. The large, well-equipped kitchen also serves as her dining area. The bedroom is her real living space—a room transformed into a quasi-surreal nest filled with the traceries of lace and the slightly sinister geometry of floor-to-ceiling plants. Chaise-longue, table, easy chairs, mirrors, a bed, and endless books complete this private domain.

A fierce January snowstorm raged on the day of our appointment. Tanning remembers that it was during just such a New York storm that Max Ernst first visited her. The year was 1942.

"The way that happened was so strange," she says. "I had been invited to a party by Julien Levy, the art dealer, because he

felt I should meet the Surrealists then living in New York. You see, I was just starting out, and Julien had taken an interest in my work. And so I went, and there they were: André Breton, Curt Seligman, Eugene Berman, Pavel Tchelithew, and Max Ernst and his wife, Peggy Guggenheim.

"Well, Julien Levy must have told Peggy Guggenheim that I was a good painter and, as you know, Peggy had a very well-known gallery in New York called Art of This Century. Some weeks after the party, I received a phone call from her, saying she was putting together a show of women painters, and that she'd like to include me. She then added, 'I'm going to send Max Ernst to look at your work.' I remember vividly saying, 'Oh, can't you come too?' She said she would try. A date was set, and Max came—alone. It was snowing, just like today. Max looked at my paintings—and he was astonished. He said, 'We must show these pictures.' And indeed, they *were* shown at Peggy's.

"But, as Max was looking at my work, he also happened to see pinned up on my bulletin-board a photograph of me playing chess. 'Oh, you play chess!' he said. 'Well, sort of,' I replied. He said, 'Well, let's have a game.' So we sat down and played chess. Of course, I was very nervous. You see, I admired him tremendously as a painter. I had gone to see an exhibition of his and it was just sumptuous! And, of course, he was such a marvelous looking man. So there we were, playing chess. After a while he said, 'Your game is promising. I think I should give you a few pointers—I'll come back tomorrow!' Well, we played a lot of chess . . . and it was 10 days after Max came to see my pictures that he moved in with me. Somehow, it was destined to happen. We never had a long period of getting to know each other—of exchanging ideas, the way people do. We didn't have any of that—we didn't have to."

Tanning smiles, savoring the memory.

But all this came years after a beautiful young Midwestern girl had struggled to make a niche for herself as an artist at a time when American women painters were not yet in the forefront of American art. And it was a struggle that began in her native Galesburg.

"As a child, I was always drawing," Tanning recalls. "As

you know, most children draw what's there—the mom, the pop, the railroad station or whatever. But I was drawing other-worldly things right from the beginning. Actually, they weren't all that strange. They were fairy-tale drawings— monsters and little creatures flying around—that sort of thing. Of course, my parents were very proud—particularly my father. Well, one day, my dad showed those drawings to a buddy of his, a fellow with whom he had fought in the Spanish-American War. It turned out that this buddy was the poet, Carl Sandburg! So, Carl Sandburg looked at my little drawings and said, 'They're marvelous!' My dad told him that when I was old enough, he planned to send me to art school. Sandburg said, 'Don't do that! You'll spoil her talent.' Well, my father took Sandburg literally, and never sent me to art school. But by hook and by crook, I *did* go to art school. When I was old enough, I took off for Chicago."

But art school—The Chicago Academy of Arts—proved a disaster. As Tanning tells it, she met with a teacher who insisted that his students draw and paint exactly as he did, which was in the Picassoesque mode.

"This teacher made us paint those *scrunched*-down nudes— like those Picasso nudes of the late '20s—and if you couldn't *scrunch* them down properly, you were considered hopeless. Well, this went on for about three weeks, until one day, I was so fed up that I came in and took my charcoal and *scrunched* those nudes down so well that this teacher came around and said, 'Well, you're doing much better!' Whereupon I left. And that was my art education. I had no further art training. Instead, I learned from looking at great works of art. I went to the Art Institute and studied those great pictures. I poured over reproductions and books—and that's how I learned to paint."

In Chicago, Tanning worked at several "draggy jobs." She sorely wanted to be an artist, but needed to support herself. Her extraordinary drawing facility helped land her several commercial art assignments. Finally, with a portfolio filled with original designs, she resolved to try her luck in New York. A friend had given her the name of an art director working for *The Women's Home Companion*. Installed in a Greenwich Village rooming-house, she promptly went to see him.

"Back in the '30s, magazines used little vignette drawings to fill empty spots in their pages, and this art director very kindly asked me to do a series of them. What I had shown him was really quite unsuitable, but he could tell I needed the work. Well, I received $100.00 for 10 drawings, which was a fortune in those days. So I began to do that sort of thing for several other publications, and for quite a long while I was a commercial artist. I worked quite a bit for *Vogue* and *Harper's Bazaar*, doing full-page color illustrations of various commercial products—perfumes and such. Finally, I was hired to do institutional ads for Macy's department store—and that kept me going for several years."

All along, however, Dorothea Tanning worked steadily and very privately on canvases that in their disquieting subject matter revealed the Surrealist in the making. With uncanny precision, and a color sense of particular warmth and daring, she fashioned scenarios in which a world of strange creatures—both human and animal—inhabited rooms, houses, towns, and landscapes of incantatory eloquence. These disturbing works, so closely aligned to a European movement that Tanning was only dimly aware of, were the inner workings of a mind already authoritatively attuned to fantasy as a viable mode of expression. Because Tanning worked outside the realist or abstract genres of the time, she understandably considered herself an artist apart—an independent spirit following her own private vision. But toward the late '30s, a major artistic event brought Tanning to the realization that she was emphatically not alone.

"The Museum of Modern Art opened a show called *Fantastic and Surreal Art*, and it just turned my head around," she says. "It was like a stroke of lightning. Almost all the works came from France and other parts of Europe. There were paintings by Yves Tanguy, Hans Bellmer, Max Ernst, and that marvelous fur teacup by Meret Oppenheim! No one had ever seen such work! It was a cornucopia of discovery. I felt I suddenly belonged. I was being condoned! I could do things with my head up, and not hide them away!"

And yet, there were things about the Surrealists she found suspect: for one, the extraordinary emphasis on sexual symbolism; for another, the over-reliance on Freudian psychoanalysis

as an influence on subject matter. These were areas that Tanning never emphasized in her own work—at least, never consciously. Her imagery, she felt, may have suggested these preoccupations, but her intent lay elsewhere.

"When I began showing my work at the Julien Levy Gallery and elsewhere, critics wrote that it was bristling with sex symbols," Tanning recalls. "Well, I certainly think that sex is important and necessary and desirable, but there's also so much else! As for the fixation on psychoanalysis, I just never believed that Freud was the crux of the Surrealist movement. I was certainly never analyzed myself. I can't imagine ever wanting to be analyzed; I can't imagine having your most precious, individual traits analyzed away. These are things we must treasure!

"Of course, I realized that my work was open to interpretation—I'm a human being like anyone else—but my work isn't about sex or psychoanalysis. My work is about the enigmatic; it's about leaving the door open to imagination. You see, enigma is a very healthy thing, because it encourages the viewer to look beyond the obvious and the commonplace. I have always liked to create images wherein the viewer sees something else every time he looks at them. That's what I'm asking from the viewer.

"I also ask them to look at the craft of a painting. This may be a terrible thing to say, but for the most part, I don't think the Surrealists were very good painters. They were wonderful idea men, but, with the exception of maybe two or three of them, they mostly couldn't paint. I feel my work comes out of the whole history of painting, whereas the Surrealists just used a rather summary knowledge of brushwork to put some ideas across."

When Dorothea Tanning and Max Ernst began sharing their lives together, the shape of Tanning's career altered dramatically. It was not that her powers diminished. On the contrary, her work increased in depth and imagination, assuming a new and highly evocative mystery and ambiguity. She was exhibiting with frequency and considerable success. But the undeniable fact was that Max Ernst was the dominant creative force—an already established and celebrated artist—a

figure of international repute and acclaim. And yet, as far as the
relationship was concerned, this happenstance never marred a
oneness of mind and spirit destined to endure.

Dorothea Tanning candidly reflected on this unique union.

"As I said, Max entered my life quite serendipitously.
When he came to look at my pictures during that snow storm so
many years ago, he was indeed still married to Peggy Guggen-
heim. But I will tell you that, at the time, his relationship with
Peggy was already on the rocks. I mean, it was so much on the
rocks that he would have been ready to latch on to any lady
painter just to get out. Max was so ironic about the whole
marriage, that I could never really ever get a clear picture of it.

"What I know definitely is that Peggy saved him. One must
give her credit for that. She brought him to the United States
just the way you bring home a prize lion. She brought him out
of war-torn France, where he was having a terribly difficult time
because he was a German. Well, after he got here, he was
incarcerated at Ellis Island for a few days, during which time
she and his son by a previous marriage, Jimmy Ernst, guaran-
teed support for him. All that was about two years before Max
and Peggy actually got married, and they stayed married for
only about a year. Max was miserable. You see, he wasn't in
love. You have to be in love to get married, I think. So, when
Max came to see me, he was miserably unhappy. A few years
later, he married me."

In her book, *Birthday*, Tanning tersely and amusingly
describes her amazing wedding day.

"An event for October 1946. Man Ray thought it was
funny. With the intention to marry, we had come to Holly-
wood, where he lived. Getting married in Hollywood! We all
laughed about it, but the next morning he said, 'Maybe we'll go
too. If Max can do it, so can I.' And added, ruefully, 'Though
I've never done anything so *rectangular*.'

"On October 24, 1946, therefore, a double wedding in
Beverly Hills united, *in the eyes of the law*, Max and Dorothea,
and Man and Julie. There. It's said and done. Painless,
forgettable."

Thus it was that Tanning and Ernst combined their love,

energy, and talent to shape what can only be called a magical existence. They had lived 10 years in Arizona before moving permanently to France. In Paris, during the late '40s and early '50s, they were part of the flagging *Groupe Surrealistes*, but the hub of the Paris art world was not for them. For over two decades, they chose to live quietly outside of Paris, working on their houses, painting, receiving visitors, occasionally traveling to participate in their various exhibitions—all this and more, until Ernst's death in 1976.

"When I came on the scene in Paris, Surrealism's great moment had passed," remembers Tanning. "The war, the holocaust—all that had put an end to it. Oh, there was still the *Groupe Surrealistes,* with Breton at the helm, but it was nothing but strife, strife, strife! Breton, who more or less invented Surrealism, didn't want to face or accept the fact that Surrealism was dying out. He tried to round up the young painters still interested in the movement, but it was no match for what it had been before. And it *was* an exhilarating time—certainly for Max and for myself."

Was Tanning's work accepted by the Surrealists, even as she painted in the orbit and closest proximity of Max Ernst?

"I know the Surrealists liked my work. But, let's face it, Max was the overwhelming personality. So what I did was more or less secondary. Look, when you're with someone so famous, no matter what you do, people are going to say that you're under his influence. I remember somebody coming to Arizona and seeing a picture I'd made, saying, 'Well, yes . . . but you can see a little bit of Max in there.' Well, my work could never have been more different from Max. I could never have painted what he painted just as he could never have painted what I painted. All I know is that Max admired my work without reservation or limit—he admired it totally. And he defended it as much as he possibly could.

"Of course I suffered. I imagine that if I had been doing my work totally alone, I would probably have found much more response to it. The fact is, many people thought that Max had made a painter out of me. But, you see, what he fell in love with when he came to see me that first time, was not my beautiful

eyes, but my paintings. My eyes may have been part of it, but I truly believe that what really struck him was my work. It mattered a great deal to him."

Dorothea Tanning's still beautiful eyes are luminous with the memory of Max Ernst. When he died, she was devastated.

"It was dreadful," she says. "I pulled myself out of it by sheer force of character and will. And, let me tell you, it wasn't easy coming back from France after 28 years, and being the widow of a man who held a French passport. You know how those French death taxes are, and how they louse up your life. Well, after a year of living without Max, I had gradually come to the conclusion that the only place to be was back home. What reason would there have been for me to stay there? But coming back took some doing. It took almost three years to achieve— until that day when I went to the French consulate here in New York to sign a paper that said I was no longer a resident of France. And that day was seven years ago."

Since 1980, Tanning has quietly established a life for herself—a life that is as secretively active as it had been when she was a young woman making her way in New York in the 1930s. Only now, her activities are more interior, for Tanning, though hardly a recluse, has curtailed her contact with New York's hectic art scene as well as its social life. It is only as a painter that Tanning is in full swing. She works constantly on her large and small canvases, her drawings, her watercolors.

"My life now is quiet and serene," she says. "I have a few nice friends. I go out very little. I never go to shows. I hardly ever go to a museum or an art opening. Frankly, I don't know *what's* going on in the art world. I'm just here in my bubble, and I stay in it. Mostly, I work. I'm certainly not part of any movement or faction. And I certainly have no truck with the so-called Women's Movement. I've never been obsessed with the woman question. I think it's sad, this aggressiveness about it. It's kind of useless and melancholy. I feel that indeed there's a great difference between men and women, but a woman owes it to herself to paint or express what's in her as a woman to express. I've never had any desire to deal with the feminine mystique. You see, I'm just a human being."

Aside from painting and seeing her few friends, how else does Dorothea Tanning spend her days?

"Well, I read all the time—American books rather than French ones, nowadays. I read mostly poetry and fiction. Sometimes, though, I get so fed up with what I have around me, that I just take out a volume of the old Encyclopaedia Britannica and read up on things. The other day, I turned it open to *Knighthood*. It was what children grew up on in my day . . . you know, 'When knighthood was in flower . . . ' So I started to read and, you know, those knights were perfectly *awful* people! They were cruel, ruthless, they trampled on poor people. And as for saving the ladies, and being chivalrous— those ladies had to be very high-born indeed, otherwise they wouldn't bother to save them! What else do I do? Oh, I listen to music. There's a radio program called *New Sounds*. It's on just about when I get into my bed. It's all avant-garde music—and it's just lovely!

"Mostly, though, I work. In the last five years I've been most productive. It's as if—and I hate to even think this—now that I'm alone, I can really *do* it, really *achieve*. Strange, isn't it? But I'm getting along in age, and I won't be able to paint much longer. Maybe I'm doing all I'm doing because I feel there's not much time left. I never was a mother, you know, so I never left a string of people. But I think leaving a string of paintings is not a bad thing to do—do you?"

1988

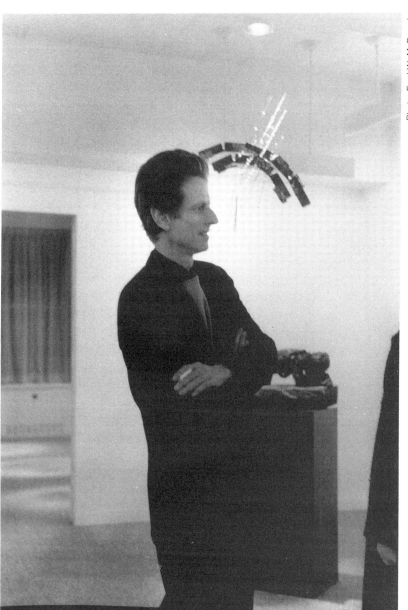

DAVID
HARE

L ike a character out of Beckett, David Hare seems possessed.
Wiry, slight of build, with a startling face that seems more
fiction than fact, Hare offers the image of someone locked
within his solitude—a reclusive figure in a dusty Soho studio
surrounded by works that compellingly reflect the artist's own
unique presence.

Long known as a sculptor and painter closely allied to the
Surrealist movement, Hare is among the few American artists
to have successfully transcended the high-flown, operatic
dramas of Surrealism, moving to a starker, rawer, more brutal
imagistic plateau in which monstrous gods and beasts of myth
inspire the anxieties of nightmares. Indeed, unencumbered by
the refinements of the Surrealist sensibility, Hare has brought
his purer, more steely American willfulness to bear upon a style
that transforms symbol and metaphor into a fierce reality,
reflecting man's inner chaos and fear.

This long preoccupation with the unconscious workings of
the human psyche was stunningly displayed in 1977, when the
artist held a 10-year retrospective exhibition at the Guggenheim
Museum, a show that centered on the myth of Cronus, the
father of Zeus, who, as the artist put it, was part man, part

earth, and part time. In sculptures, paintings, and drawings, this mythic figure was seen in all his savage manifestations—a fearful "force without form, a hound of hell, the night mind, with its criminal desires and horrors." In the words of the late critic, Harold Rosenberg, "Hare's Cronus is a personification of the chaos, violence and dissoluteness of contemporary life, and his drawings, paintings and sculptures constitute a 'portrait' of this personification."

In April 1982, David Hare exhibited a new series of paintings at the Hamilton Gallery in New York which, while less savage than his Cronus series, still echoed with the primordial. Consisting of large, ferocious heads and stark images of elephants, the show made clear Hare's continuing exploration of man's essential primitivism. These bold, atavistic images articulated the artist's search for a pictorial equivalent to certain transcendental truths—some primeval messages that would stir one's profoundest memories of what might still dwell within our most hidden selves.

If David Hare, the artist, speaks in resonant, often terrifying symbols, Hare, the man, is nothing if not a provocative raconteur of somewhat terse informality. Although his electric blue eyes alert one to a guarded temperament, one is soon ensnared by tales of a life in which chance, circumstance, and personal encounters have led him toward various forms of creative productivity.

"I was born in New York City, on March 10, 1917," David Hare began. "My father was a lawyer, and my mother was a kind of Victorian lady. I have four half-brothers, sons of my mother's first husband, whose name was Walter Goodwin. When Goodwin died, he left each of his sons a million dollars. I was not left a million dollars—I had another father—but a trust fund was set up for me. As a child, I was sent to one progressive school after another. Those progressive schools were very bad, because they moved you ahead in what you were good at, but left you behind on things you couldn't do. As a kid, I was interested in mathematics, chemistry, and biology, which is what I studied at school.

"I had no interest in art, although my mother made sculptures and had studied art for one year at the Academy in

Rome and had befriended Constantin Brancusi in Paris. Still, she was of the generation that did not consider artists or intellectuals as 'top drawer.' I mean, she thought artists, writers, and musicians were fine—you had them to dinner and you appreciated them, but you were not one of them. It was a very Victorian point of view. When, at the late age of 27, I announced to her that I would be an artist, she was very put out by it."

Hare maintained that from the first no plans for a future were made for him. With a family of upper-class standing, the youngster spent his formative years attending schools in New York, Colorado, and California. By the age of 20, and with a substantial monthly family income, Hare settled in New York, where he began to study photography. In time, he opened a photographic studio in mid-Manhattan.

"I wanted to do commercial photography—advertising photography—because I thought it was bad. I wanted to improve it. But I soon learned that *that* was what was wanted—bad photography—and that's what I did for three years, until I got very successful at it . . . then I quit. In the meantime I got married."

At the age of 21, David Hare married Susanna Wilson, the daughter of Frances Perkins, then the Secretary of Labor under Franklin D. Roosevelt. The year was 1938.

"I think we both married to get away from home. I liked Suzy, but wasn't really part of her world. Her mother, who was a formidable woman, wasn't particularly nice to me. The fact is, politics just didn't interest me. I mean, Suzy and I would go to dinners at The White House, and it was a drag. Still, I met Roosevelt and even photographed him. I did portraits of lots of political figures during my time with Suzy. Well, Suzy and I managed to stay together for four years, but finally we grew in different directions or, to put it bluntly, I grew and she didn't. We got a divorce. I was 25."

Having abandoned his work as a commercial photographer, David Hare now established himself as a portrait photographer. While still married to Susanna Wilson, he was commissioned by the Museum of Natural History in New York to photograph the Pueblo Indians. The project took one year

and Hare emerged with 50 portfolios of 11 × 14 inch color photographs which to this day constitute a major photographic achievement in the field of American Indian studies. This project over, Hare next immersed himself in experimental photography. Through chemical manipulations with negatives, he produced works which seemed to him and to others to be ahead of their time. However, Hare says that he did not think of them as art—merely as something he liked to do.

By the early 1940s, and with World War II in progress, Hare became aware of the influx of European artists into the United States, most of whom were to settle in New York. Among them was Yves Tanguy who, as it turned out, was married to Kay Sage, a cousin of Hare's. It was Kay Sage who would introduce the young David Hare to the French Surrealists and thus dramatically alter the course of his life.

"My cousin Kay got a hold of my mother and father, soliciting affidavits for other artists to come to this country: André Breton, Max Ernst, André Masson. When they got to New York, I met these people and they were my first introduction to art. You see, I was never interested in culture as such, but when I met Tanguy and Matta and Breton and Ernst and Masson, I suddenly realized that this was what I was looking for—only, I didn't know it. I didn't know there were people like that—people who weren't involved in finding jobs, but just doing what they wanted to do. And they didn't feel socially inferior the way American artists did, because remember, in the '40s, you were at the bottom of the barrel if you were an artist. The artist had no standing in American society.

"So, I got involved with these people and began looking at their work. To be honest about it, there is a lot of Surrealism that I consider absolutely pointless, because the premise is that what's interesting is the insane and the far-out. This works all right if you're a minority, but the moment you want *all* of society to be insane, the whole idea collapses. So, they had a lot of childish ideas. Still, there was a lot to admire, and the artists themselves were interesting and I liked being around them.

"Well, at one point, Breton wanted to start a magazine. He didn't want to be the editor—just mastermind the whole thing.

So, he got other people involved, and I was one of them. Breton was fantastic in the way he could manipulate people. He didn't exactly manipulate me, because I couldn't speak French well enough, but he got a lot of people to do things for him, and the magazine, which he called *VVV*, got put out. Its very first editor was Lionel Abel, because he spoke French. Well, Abel didn't work out, because he had a girlfriend who didn't like him to be at meetings all the time. So, even before the first issue came out, Breton hired Robert Motherwell to be the editor. But that didn't work out either, because Motherwell turned out to be too pedantic and finicky about everything—a worrier over minutiae. Breton hated that and fired him. So, he was still looking around for an editor to bring out the first issue, and he asked if I'd like the job. Now, I had never done anything like that before, but I said, 'Sure!' I became editor by default of *VVV* in 1942. Breton wanted somebody to do the layout, take care of the printing, and collect articles. You might say that's when I really got interested in so-called intellectual life.''

Breton's Surrealist magazine under the editorship of David Hare lasted two years, during which time four issues were published. As for its significance, Hare's assessment was candid: ''If people thought that *VVV* was an intellectual magazine of the type that had never been seen in this country before—that it was all new and fantastic and marvelous—well, that's a lot of crap! The real reason for its existence was because Breton liked to leave the stamp of Surrealism wherever he was. He never intended to stay in America, and when he went back to France, what would he say to the intellectual groups in Paris about what he'd been doing for three years in America? He'd say, 'I started a magazine. I was proselytizing for Surrealism in that barren, uneducated country!' That's all there was to it.''

During the course of working on *VVV*, David Hare met and fell in love with André Breton's wife, Jacqueline. As it happened, the Bretons were already in the process of separating, and when Breton returned to France, he divorced his wife and married someone else. For her part, Mrs. Breton, who painted under the name of Jacqueline Lamba, was a quixotic and volatile woman with a penchant for adventure and travel.

Soon after Breton's return to France in the mid-'40s, she and Hare began living together. But restless for travel, she decided to visit Mexico. Hare was to join her later.

"It was a wild time," Hare recalled. "The war was still on, and when I tried to leave the country to join Jacqueline, the authorities thought I was trying to avoid the draft. But I wasn't. I had already been declared 4-F, which meant unacceptable, because the draft board thought I was crazy. Among other things I had told them I didn't believe in shooting anybody I didn't know! Anyway, it was all cleared up, and I joined Jacqueline in Mexico. We then returned to New York and continued living together. Two years later we got married. The reason we got married was because Jacqueline and Breton had a daughter, Aube, who lived with us. She was eight or nine, and had begun going to school in New York, and the school wanted to know who her parents were. So, we made it legal. We remained married for 15 years.

"Jacqueline was remarkable. She was always willing to give up the intellect for spirit and elan. When you get right down to it, I grew up with her. She was seven years older than I, and I became an adult with her. She stimulated me. I began to be interested in lots of other things. I mean, I was still doing photography, and she said, 'Why don't you make sculpture?' I said, 'Why make sculpture?' She said, 'You're good with your hands!' Well, she was right, and I began making sculpture. She was good about it, not pushing me because it was creative or intellectual, but because she thought I'd enjoy doing that. So, through Jacqueline I became an artist—and, of course, the Surrealists were our friends."

Whatever David Hare may have thought about the general shortcomings of the Surrealists, he was nevertheless profoundly affected by their personal magnetism and lifestyles. Too, his earliest sculptures could not help but be influenced by the resonant, dream-like overtones of their work. Certainly, the momentum and energy of the Surrealist style was more than evident in works that became progressively more inhabited by associations reverberating with the strange and the eerie—figures in various metals in which shape, volume, and composition became metamorphosed into anti-rational symbols. As

such, these works were much admired by the Surrealists and on this basis, Hare was dubbed an American Surrealist. Still, the artist insists that his reaction to the Surrealists was never intellectual, only personal.

"To me, these artists were individuals, people who were older than I was, and full of ideas. I mean, Matta's mind was *always* working. Max Ernst was very opinionated yet very poetic. Breton was full of life and full of prejudices. For example, he hated eggs! Wouldn't eat them—thought they were poison. And he just hated homosexuals. Duchamp was always trying to pacify him on that score, saying that it didn't really matter if someone is a homosexual. So, these were didactic, interesting, volatile people to whom I could relate and could feel comfortable with. And, of course, they accepted me, and that was part of it all."

David Hare, by now deeply involved in sculpture, saught to exhibit his work in New York. In time, he befriended Peggy Guggenheim and, in 1944, held his first exhibition in Guggenheim's gallery, Art of This Century.

"I had been making sculptures for a year, and Peggy had just opened her gallery. I had been seeing a lot of her because of the other artists I knew. Well, like any young person, I thought I was much better than I actually was, and so felt I ought to show. I asked Peggy to come to my studio, down on 10th Street, and one evening she arrived stoned out of her mind. She had been drinking a lot and kind of stumbled in and laid down on a couch and was sort of half asleep. I brought out some things and put them in front of her. She kept slurring, 'Very nice! Very nice!' I said, 'How about a show?' She said, 'Fine!' I then took her home and called her the next day. She said, 'Did I promise you a show?' I said, 'Yes.' She said, 'Oh, all right.' And that's how I had my first exhibition!

"I'm only telling this story because most dealers don't really know their ass from a hole in the ground—nor does the artist for that matter. But it seldom happens that dealers will go to a studio and think that what they're seeing is any good. They'll show you because they're a friend or somebody else's friend or because they feel sorry for you or, as in the case of Peggy Guggenheim, because they're drunk."

Be that as it may, David Hare soon established himself as an artist of note in New York. In 1946, he was included in the Museum of Modern Art's exhibition, *Fourteen Americans*, and, from 1948 to 1959, showed regularly at the Kootz Gallery. From 1961 to 1963, he held one-man exhibitions at the Saidenberg Gallery. Between 1964 and 1977, Hare held several teaching posts and continued to exhibit in various galleries and museums throughout the country, culminating in the Guggenheim Museum retrospective of 1977.

Looking back on his life with Jacqueline Breton, Hare considered their years together as seminal to his personal and artistic growth. In 1949, the two became parents of their son, Merlin, now a commercial pilot, living and working in San Diego. But, as time went on, the couple found their marriage disintegrating.

"Around 1955, Jacqueline and I broke up, and she went back to live in France. I visited her for the next couple of years, but then saw less and less of her. By this time I had met a woman by the name of Denise Delaney and fell in love with her. We started living together and, after a couple of years, I divorced Jacqueline and married Denise. We're still married and we have a son, Morgan, who is 18 and going to Amherst. And that sort of takes me up to date."

Discussing the progress and evolution of his work throughout the years, David Hare maintained that, although sculpture was his prime mode of expression, he was more and more drawn to painting.

"Around 1957, I thought I'd like to do *painted* sculptures— combine the two mediums, because I felt that sculpture was too much rooted in reality. It could never really be an abstraction, because it was an object in a room—it was a *thing*. So, I wanted to combine painting and sculpture, but then realized I couldn't do it. You see, being the dope that I am, I thought that painting wouldn't be a very hard thing to do. I thought it would take six months to get into. Instead, it took me three years, and by the time I was into it, I got fascinated with painting all by itself. In a way, I didn't know what I was doing, but it was marvelous, because for me it was something entirely new. So, I painted for five or six years, then went back to sculpture, then back to

painting. In the meantime, I *did* succeed in doing painted sculptures, but also made paintings along with sculptures."

Asked whether he had in any way been touched or influenced by Abstract Expressionism, the going movement of the period, Hare said that although he had met and liked Jackson Pollock and Willem de Kooning, among others, he did not consider their work as being particularly new or innovative.

"I never got into Abstract Expressionism, because spilling your guts on canvas didn't seem very new to me. It didn't seem aesthetically any better than the art that went before it. Psychologically, it seemed to me concealment in the way Minimalism is. I didn't think it said all that much. But I liked Pollock and de Kooning . . . I liked them mainly as people. Actually, I think that, up to 1950, the most original American painters were Arshile Gorky and Jackson Pollock. But I never wanted to do that kind of painting myself."

Turning to his most recent work, David Hare stated that it continues to be rooted in symbol: "I like to paint elephants, because for me, they are a connection between the human being and life as it might have been 100,000 years ago. That is, elephants are still around, but also lived long before people were on earth. Of course, I know that before man we had nothing but reptiles. Still, I think of elephants as precursors of man. As for the big heads I do, they're symbolic messengers— probably the messengers I'll be with when I die. They're the companions that take you through change.

"You see, for me, there are three kinds of art: There's decoration, which could be geometric abstraction; there's figurative art, which is your view of the outside world; and then there's invented art—art that comes out of the imagination. Well, that's the kind of art that has always interested me. For me, what's of value is the *supra real*.

"Of course, I'm well aware that my work is not in the mainstream of what's going on today. And I'm not a well-known artist in the sense of Jasper Johns or Robert Motherwell. But I don't really want to be. Naturally, I'm annoyed if I'm introduced to somebody and I sense from their attitude that they think I'm a second-rate artist. Fortunately, that doesn't happen very often. For me, the important thing is to keep on

working. The more I work, the more hepped-up I get—the more excited. It's the only thing I can do every day, seven days a week, not because what I'm doing is beautiful, but just because I'm doing something into which my whole life and being goes. That makes up for any feeling of not being in the middle of the stream of art.

"Finally, art is the only thing I can do without ever getting bored. I'm not interested in art in a romantic way. I'm interested in it in the same way as I am in eating or going swimming in the ocean or skiing or going to bed with a woman. The point is, I'm not the kind of artist who wants to be fitted for life in this world. I live in my own world, and I'm very connected to that very active interior world. The fact is, I don't want to be what psychiatrists call normal. I call what I *am* normal."

1982

Photo: Ann Chwatsky, courtesy Washburn Gallery

JACK
YOUNGERMAN

N ot too long ago, Jack Youngerman had a conversation with his friend, the sculptor Jackie Winsor, about a disturbed student of theirs at the School of Visual Arts, where both teach.

"We were trying to encourage this student," said Youngerman, "and Jackie was trying to figure out what makes a kid grow up to be an artist. She felt that there's a point in a child's life when he begins to feel differently about himself—when he knows his life is going to be different from that of his friends—for better or for worse. Jackie's theory is that people who become artists are those whose families were displaced a lot or where there was illness or some sort of family trauma. I think there's a lot of truth in that. I also think it has to do with something in the preceding generation that didn't get realized—and it's fulfilled in the next generation."

Winsor and Youngerman could just as well have been talking about the course of Youngerman's own early life, filled as it was with trauma and dislocation.

Consider the facts: A skinny country boy, born in 1926, in the outskirts of St. Louis, Missouri, is raised in Louisville, Kentucky. His parents are divorced when he is seven. He lives with his mother, who had always wanted to go to art school,

but didn't, because she had to help support her own family. When the boy turns 10, he learns that his father has had a breakdown, and has entered a hospital where he will spend the rest of his life until his death at the age of 72. Later, an older brother will die as a result of drug abuse.

If these were conditions that fostered Youngerman's pursuit of art, he was not aware of it. It's true that he was one of those boys who, in school, made drawings in the margins of his books. And, at Christmas, he was one of the kids who drew the Three Wise Men with colored chalks on the blackboard. But becoming an artist never entered his mind. Still, if Jackie Winsor's theory is right, Jack Youngerman was decidedly destined to become an artist.

A talk with Youngerman in his Greenwich Village studio found him reflecting on his life only days before the opening of his retrospective exhibition at the Guggenheim Museum, and just three-and-a-half weeks short of his 60th birthday. Still lean and boyishly handsome, the intensely blue-eyed artist seemed only slightly apprehensive about the show, and not unduly concerned over the passage of time. "You keep learning," he said. "Of course, there does come a point when the learning doesn't compensate for the process of aging."

The course of Jack Youngerman's career has been as circuitous as it has been unpredictable. The fact is, Youngerman is that rarity: an American artist whose years of apprenticeship were spent entirely in Paris, and whose coming of age as a painter took place entirely outside the prevailing streams of American art. Even more significant was his relatively late encounter with art as a way of life and a potential for self-expression. Indeed, Youngerman did not set eyes on what could pass for a bona fide painting until he reached the age of 19, and even then, the notion of taking up art as a profession seemed nothing if not remote.

"I had taken some art classes in high school," said Youngerman. "And I always loved to draw, but there wasn't much encouragement. Also, there wasn't any art to speak of in Louisville. There was a small museum—the Speed Museum— but when I was growing up, during the Depression, they just showed some historical things. There was John James Au-

dubon—he had lived in Louisville—but that was about *it*. Also, when I was a kid, those big, beautiful art books with gorgeous color reproductions didn't exist. If they did, they hadn't made their way to Louisville. So, I didn't see any real painting until I got out of Louisville—which wasn't soon enough."

Following his graduation from high school, and before he turned 18, Youngerman enlisted in the Navy. He had put in a year working in a Louisville defense plant, and earned enough money to go to college for a year at the University of Missouri. But the Navy was the perfect escape route for a restless and exceptionally bright youngster.

"I joined the Navy, because I knew I'd be drafted into the Army. I also joined the Navy, because I liked their uniform better, and because I thought there might be less of a chance of getting shot. Anyway, joining up was terrific, because I'd never been out of the state of Kentucky, and going elsewhere meant going off to amazing places."

One of the amazing places Youngerman found himself in 1944 was Washington, D.C. "I was on leave with a friend, and one of the first things I did was to go to the National Gallery. I'm still kind of amazed by that, because I had no particular reason to do it. It was an unconscious urge. There was no precedent. Anyway, when I walked in, it was overwhelming and intimidating. Everything I saw at the National Gallery was European art from way back. I had a hard time thinking that anybody did it anymore. You see, I still didn't know that contemporary art even existed."

In the Navy, Youngerman qualified for officer's training school, and he was sent to the University of North Carolina in Chapel Hill. He remained there for two years.

"Most of my education at Chapel Hill was navigation, naval history, and gunnery. But there were a few electives, and I took an art course. It was a drawing class and, for some reason, I really got into it. At one point, the teacher pinned some of my works up on the wall. That was probably the first time in my life that I felt good about myself. It was the first thing I had accomplished on my own, and it made sense to me. I mean, in the Navy I would get merit badges, and everybody thought that was just great. But I really didn't know *what* I was

doing. With the drawings, I could identify with something. Of course, it was student work, student realism. Still, it was all mine."

Youngerman received a Navy commission, and was sent to the Atlantic Fleet where he was to serve for one year. But World War II had ended, and he was released within six months. Out of the Navy, and now eligible for the G.I. Bill, Youngerman returned to the University of Missouri. Despite the "high" he experienced in the drawing classes at Chapel Hill, the thought of becoming an artist still eluded him.

"Being an artist was not among the possibilities that I could imagine," he said. "It somehow wasn't a profession, and therefore it wasn't a possible choice. So, I chose something that was within the realm of possibility, and that was journalism. I received a degree in journalism in 1947. What I was going to do with it, I didn't know."

At the university, Youngerman befriended a student who had been in the Army, and who happened to speak fluent French. Also eligible for the G.I. Bill, this friend decided to pursue graduate work in Paris, studying at the Ecole des Sciences Politiques. To Youngerman, it seemed a daring and adventurous move. It started him thinking. He still had three years of the G.I. Bill available to him. Perhaps this was the moment to give his dormant love of art a chance. Perhaps he *should* apply to an art school, take the plunge, and see what happened.

"Somehow, and for the first time in my life, I felt I could do what I wanted. The G.I. Bill gave me time to breathe. I was suddenly free to go after something I could call my own. Mind you, I had no intention of going to Paris like my friend Howard—that just never entered my head. So I applied to the Art Students League in New York, which was the only art school I had ever heard of. And, for some strange reason, I also applied to Black Mountain College, because the name Black Mountain intrigued me. It was in North Carolina, and I had been at Chapel Hill in North Carolina, so I could sort of relate to it. Well, both places were full up with G.I.s. There was no room.

"As it turned out, my friend Howard had not yet left for Paris, and he said, 'Why don't I write a letter for you to the

Académie des Beaux Arts—you can go there on the G.I. Bill.' I thought, 'Why not?' To my astonishment, I was given temporary admission, and told that when I got to Paris I would have to submit a drawing to be fully qualified."

In October 1947, Jack Youngerman, aged 21, arrived in Paris. He had enough money to see him through one year. He stayed for nine.

"I remember the day I arrived in Paris. I was met by my friend Howard at the Gare St. Lazare. We took a bus, and even though I had my luggage with me, we got off at the Pont du Louvre, and I remember standing right in the middle of the bridge on a very beautiful October afternoon looking toward the Ile de la Cité and Notre Dame, and it was an amazing moment. I just couldn't believe it. It was so beautiful! I found a room in the Hotel Bourgogne, which is right in the middle of the Ile St. Louis. After I left there, Ellsworth Kelly took my room. Ellsworth told me that John Cage and Merce Cunningham, whom I'd never heard of before, had also lived in that hotel.

"Well, I presented myself at the Beaux Arts, and was told I had to do a drawing of *The Discus Thrower*. I did it in that amazing room of Greek and Roman copies, which was totally unchanged since Poussin had founded the school in the mid-17th century. When I handed in the drawing, the French professor said, '*Pas mal pour un Americain*—Not bad for an American.' "

In Paris, Jack Youngerman reinvented himself. He acclimatized himself; he began studying French. Paris in the '40s was still the intellectual center of the world. Jean-Paul Sartre and Jean Genet were in their prime, and Existentialism was going strong. Youngerman began meeting these people. The art scene was just as stimulating. He could see the latest Picassos, Braques, Matisses, Mirós—works completed in the recent months. He plunged right into that world and educated himself. He had never taken an art history course in his life—now he did so on a firsthand basis. When he began to be interested in Romanesque art, he'd get on a train to Autun, then hitchhike to Vezelay. Later, he would travel to Belgium, Holland, Italy, and Spain to look at art. Later still, he would go to the Middle East.

Said Youngerman, "It was in Paris that I realized it was possible to be an artist—that it could be a life. It was a risk, of course, but it was a possibility. Anyway, I began taking classes at the Beaux Arts. Working there was like being in a time warp. I painted in the studio where Henri Toulouse-Lautrec had been a student, and the teacher before my teacher had been his teacher. It was all incredibly traditional. I took anatomy classes. The Beaux Arts was connected with a school of medicine; they would ship cadavers to us, and medical students would come and give us anatomy lessons. They would open up a cadaver and show us what muscles make the arms move—things like that. It was really great. And it was all *so* amazing to me. I mean, I was still a country kid from Kentucky, and here I was in Paris, completely on my own. It was the first time I was ever independent, had ever lived in a big city, and could make my own choices. I lived very intensely. I felt my education really began once I got out of college."

Youngerman's earliest paintings were academic and followed in the traditional precepts of the Beaux Arts: carefully executed figures and still-lifes. They were talented works, but basically still in the student mold. He would continue in this way for one year. Then, feeling restricted by the disciplines of the Académie, he began attending classes only sporadically. What had happened, of course, was that the modern art presence in Paris had impinged itself on a young artist impatient to explore things on his own. Painting alone in his room, Youngerman produced works in a wide variety of modern styles. He was determined to test his wings, and find his own voice.

By 1950, Youngerman's allowance from the G.I. Bill ran out. "It was hard existing in Paris without it," he said. "And it was hard for an American to get a job. You couldn't even get a part-time job the way you can in America. You couldn't even become a waiter, because in France being a waiter was a serious profession for full-grown men."

If Jack Youngerman did not precisely follow in the young-artist-starving-in-a-garret syndrome (there was on-and-off work in an advertising agency), he *did* have a very hard time of it. But as often happens in romantic French novels, there were

compensations. For one, he fell in love. For another, he married the girl he fell in love with. She was a beautiful young actress named Delphine Seyrig, destined, in years to come, to be a celebrated French stage and film star.

"I met Delphine in 1950, which was also the year we got married," said Youngerman. "It was all very romantic. We used to meet in a Paris restaurant called Chez Amour. The woman who ran it was named Madame Amour! Well, it was love all right—and it lasted a long time. But then, years later, we divorced. There were two careers on two different continents, and that was just too hard. Anyway, being with Delphine in Paris was wonderful, and it made the struggle easier. At the time, Delphine's father, Henri Seyrig, was director of all the antiquities in Lebanon and Syria during the French mandate. It was a government post, which he obtained under de Gaulle. Earlier on, after the fall of France, de Gaulle sent him to New York as his cultural representative. So, Delphine spent four years in New York as a teenager. She had become quite Americanized, spoke New Yorkese, and knew all the latest Frank Sinatra albums.

"So, I married Delphine, and for the next five years decided to go for broke as a painter. Of course, I was still pretty naive about contemporary art. But not knowing a lot about it wasn't all that bad, because you didn't have a lot of overlays and points of reference. So it hit me all fresh. I saw modern art before I read about it. I learned about it from looking at it. The one thing I regretted was not having had those adolescent years of studio work and a real teacher. But then, I read somewhere that Cézanne at 70 had said that during his whole life he never had a *maître,* and that he wished he had. Because, you know, Cézanne was not admitted to the Beaux Arts as a student. He was not considered talented enough. *My* drawing got in, but *his* didn't!"

In 1955, Youngerman centered in on abstraction. By then he had become friends with Ellsworth Kelly, and with him had visited the studios of Constantin Brancusi and Jean Arp. He met Alexander Calder, and learned about the work of Sophie Tauber and Sonia Delauney. In the early '50s, he became intrigued by the exhibitions being held at the Salon des Réalitiés

Nouvelles and the Salon de Mai, and by such geometric abstractionists as Max Bill, Auguste Herbin, and Richard Lohse. The posters of Toulouse-Lautrec and the works of Matisse and Kandinsky became revelations; 19th-century Japanese woodcuts became a passion. In 1954, the Youngermans traveled to Beirut to visit Henri Seyrig, where he was director of the Institut Francais d'Archéologie. Later, they journeyed to Iraq, Syria, Jordan, and Turkey. Youngerman's education was intense and lasting. And what emerged was the conviction that painting abstractly was his only recourse.

"The reason I opted for abstraction was that Picasso had simply exhausted the possibilities of figuration—single-handedly," Youngerman maintained. "Picasso had crushed a whole generation, and figuration was no longer a viable option. You see, he had really taken on the big things that figuration can do. He sorted them out and dominated them. For my generation, abstraction was the road to adventure. It was going into the unknown. I mean, what else was there? Surrealism was out of the question. I remember seeing André Breton walking on the street, and Max Ernst and Man Ray—and even *they* felt it was over. Let's face it, World War II, the Holocaust, and the atomic bomb made Surrealism look puny. Reality became so much further out than anything they could dream up. So we wanted to do something more constructive, purer, and more positive. It wasn't about making a commentary or being at odds with the bourgeoisie. Abstraction took off as a reaction."

Youngerman's earliest abstractions were quasi-geometric, and they were exhibited in 1951 at the Galerie Arnaud—a small gallery in a bookshop run by the still active Jean Claude Arnaud. (Ellsworth Kelly would show there the same year.)

"My show was premature—the work wasn't focused," said Youngerman. "Later, by groping and elimination and stumbling around and intuition, I hit on *organic* abstraction—for lack of a better word. It's what I concentrated on, and where I found I had something to say. For the next five years, I integrated my influences, particularly the ink drawings of Matisse and the starkness of Mondrian. But something was still missing."

What had been missing was the thrust, immediacy, and

excitement of American abstract painting, which Youngerman had been hearing about during his expatriate years. Ellsworth Kelly had returned to the States in 1954, and he would write Youngerman of what was going on in New York. There were other echoes. In *Life* magazine, he read of the new painting, with quotes from Clement Greenberg and with reproductions of Rothko, Pollock, de Kooning, and Kline. He sensed the excitement.

"I had been wanting to return to America for several years," Youngerman said. "After the first five years, I began to feel more and more alienated in Paris. I had lived there so intensively. I had learned French. I read a lot. I caught up on French history. I even became a father: Our son, Duncan, was born in 1956. And I began to feel kind of homesick. And in France, you're always made to feel a foreigner, because you always have your accent, and you're always made to feel it.

"What happened was this: Ellsworth had had a show at the Betty Parsons Gallery in New York. He told Betty about me, and sent her to see me when she came to Paris in the summer of 1956. Betty came to my studio, and after about five minutes she said, 'I'll give you a show, but you have to move to New York.' On those words I packed up about two months later, and came to New York. I had no other prospects except Betty's promise of a show. That was enough to convince me to return. And how right she was! I felt immediately it was what I needed. So Delphine and the baby and I came back in 1956. I've been here ever since. I've lived in New York for 30 years!"

Being thrust into the ferment of New York painting had an altogether salutary effect on Youngerman's work. In her introductory essay on the artist's Guggenheim retrospective, Diane Waldman put it this way: "It was not the jagged edges or knifed impasto that most impressed him about New York School painting, for he had already incorporated such elements into his Parisian painting. Rather it was the massing of forms, inspired by the examples of Clyfford Still and Robert Motherwell, that had the greatest impact on his work."

The massing of forms and the *invention* of forms became Youngerman's focus as he slowly began to integrate himself into New York's art scene of the late '50s. Gregarious and

hard-working, he settled with his wife and son in a house near the Battery at Coenties Slip. His friends and neighbors included Robert Indiana, Jasper Johns, Ellsworth Kelly, Fred Mitchell, Robert Rauschenberg, and Agnes Martin. In 1958, he had his first of seven shows at the Betty Parsons Gallery. In 1959, he was included in the Museum of Modern Art's seminal show, *Sixteen Americans*. Throughout the '60s and '70s, he exhibited in major galleries and museums throughout Europe and the United States. And throughout the years, Youngerman's zeal for experimentation would find him creating circular and elliptical shaped paintings, freestanding sculpture in laminated fiberglass and resin, folding screens of unprimed linen and wood, and—at the invitation of Tygart Steel in Pittsburgh— freestanding steel and aluminum sculptures and open-form metal screens.

Indeed, the Guggenheim exhibit, consisting of some 70 works—including paintings, sculpture, wall reliefs, folding screens, and drawings—vividly demonstrated Youngerman's deep and ongoing concern for the expressive components found in organic shapes. In electric reds, blues, blacks, and yellows, in forms that coil, flare, swirl, or spin, Youngerman's works emit a vibrant sense of life. Like banners in the wind, they suggest a continuum of motion, a carefully articulated yet dizzying dialogue in which space, color, and form produce an abstract art of emblematic strength and vitality.

Whether working with oils, acrylics, or such mediums as epoxy, polystyrene, and fiberglass—whether painting, sculpting, or drawing—Youngerman's vision is centered on the invention of form. It is a vocabulary that does not rely on recognizable shapes as such, but on a language that suggests the energy and tensions found in the phenomenons of nature. It is, in fact, the *geometry* of nature that so tellingly preoccupies the artist.

Said Youngerman, "One of my cultural heros is a British scientist named Darcy Thompson, who was the president of the Royal Academy around World War I. He once wrote a book called *On Growth and Form*. He's been a great inspiration, because he looked at natural forms from the point of view of physical laws, and came up with a lot of great insights. He's

credited with having inspired Buckminster Fuller and his geodesic dome, which follows in the study of how leaves maintain themselves—the ribs and structure of a leaf. So, in my work, you'll see no cubes, no squares, and no circles. I'm more interested in the laws of natural form. That sounds more studious than it is. You see, I'm not interested in *particular* form in nature. The fact is, forms can transcend categories. You can have a similar form existing as weather or plant or animal. The spiral, for example, exists in all those forms. And that's what interests me.

"Some people have called my work decorative; some have called it elegant. I don't mind having my work called that, but I have my own ideas about what it means. For example, to me the word 'elegant' has nothing to do with fashion. I think of it more in terms of, say, an elegant theory in mathematics. Or where everything unnecessary has been excluded—something that works in a clear way. Djuna Barnes, in *Nightwood*, has a phrase about an animal which had its foot lifted in 'the elegance of fear.' In a way, it's about efficiency—a kind of visual efficiency or intellectual efficiency.

"So I feel that's what my work is about. You could say I'm a geometrist—but one that hopefully transcends geometry itself. Anyway, I think I have created a language for myself. And I have a lot more to say. I have a very productive future planned. I may be 60, but what I've done so far is only the beginning!"

1987

ROY
LICHTENSTEIN

There is nothing at all Pop about Pop artist Roy Lichtenstein. Unlike Andy Warhol, he maintains no "Factory," does not move with an entourage, is never seen with society's haut monde, attends no chic parties, nor has he transformed his person into a persona whose mystique is an international phenomenon.

Defying the cult tendencies engendered by Pop, Lichtenstein is that refreshing anomaly, a man of conservative taste in a movement long noted for its outrageous, if by now clichéd, lifestyle and creative expression. A man of gentle disposition and appearance, Lichtenstein prefers privacy, solitude, and the inconspicuous pleasures of a low social profile. He lives and works quietly the year round in Southampton, Long Island, in a house and studio that, while elegant and comfortable in the extreme, bear no resemblance to the up-to-the-minute ostentatiousness that marks the modus vivendi of some of his more "with-it" contemporaries.

A recent visit with the 52-year-old artist offered entry into a personality that eschews connection with pretentiousness or ego-ridden flamboyance, qualities that could come naturally to a hugely successful Pop artist, whose paintings sell from

$20,000 to $80,000 each, and whose market value for early works has recently risen to $250,000 per large canvas. But wealth and its trappings make themselves known with consummate understatement in a handsomely appointed Cape Cod house, painted pristine white, and standing in symmetrical austerity in the winter landscape of the more manicured section of Southampton. Its interior is at once spacious and intimate. A large living room holds modern furnishings in subdued colors, some of them designed by Lichtenstein himself. The glass coffee table, for example, has four gold metal Art Deco motifs protruding from each side, bearing the distinct Lichtenstein style. A number of small Ben Day-dotted Lichtenstein cups, saucers, and spoons, in bright colors, are discreetly placed about the room, while a larger sculpture made of black metal, and resembling a cartoon emblem, stands on the coffee table.

A grand piano stands in one corner of the room and, on the wall, to its right, hangs the only Lichtenstein painting in the entire downstairs of the house. It is a bright-yellow cartoon landscape, its two hills outlined in black. The rest of the art belongs to other painters: A Warhol portrait of Warhol's mother; a superb early Léger, under glass; a vintage Amédée Ozenfant print; two tiny floral oils by Robert Kulicke; two small early American cityscapes. The nearby dining room, now drenched in a cold light, and almost overwhelmed by a small forest of house plants, is dominated by a roughly hewn wood dining table, and a huge double-portrait by Warhol of Lichtenstein's pretty young wife, Dorothy. Below it, hangs a small Warhol portrait of Chairman Mao. Yet another Warhol, of four anemones, is adjacent to a handsome early American corner cabinet. The presence of so many Warhols within this verdant and homey setting lends his work the appeal and nostalgia of fading, 19th-century postcards.

Roy Lichtenstein, dressed in a heavy green-blue turtleneck over jeans, tells me that he's been very much on his own during the past weeks, his wife having decided to join a friend on an archaeological trek in Africa. ("Dorothy loves to travel. I much prefer staying put!"). The artist's two sons by a former marriage—Mitchell, 19 and David, 21—now live on their own. The serenity and silence of the house seems reflected in

Lichtenstein's own peaceful demeanor, and particularly in a face that bears the forceful tranquility of a Matisse portrait.

Over steaming cups of coffee, Lichtenstein tells me something of his background.

"I was born in New York, and as a child I had absolutely no idea what I wanted to do or be. But from about the age of 15, I did an awful lot of drawing. In fact, I took a painting class at the Art Students League, because there were no art courses given in the high school I attended. It was a life class taught by Reginald Marsh, and I did sort of appalling paintings. I hadn't the faintest idea what I was doing, but it was a kind of Reginald Marsh realism, built on a sort of Renaissance technique. I attended the League just for one summer; it was either 1939 or 1940. In the meantime, my parents wanted me to get some sort of degree, and I was all too willing to get out of New York. And so, I went to Ohio State University. I got a Bachelor's degree, as well as a master's degree in painting. In the middle of all that—in 1943—I was drafted into the Army and stayed until 1946. When it was over, I returned to Ohio State to finish up my schooling. I graduated with my master's in 1946, and returned to New York, not really knowing what to do."

As it turned out, Lichtenstein set about to become a painter, albeit of unfocused intent or direction. Abstract Expressionism had just begun to attract attention, and the young artist was a frequent visitor to the Egan Gallery and the Parsons Gallery. He was fascinated by what he saw. While the style attracted him, and while abstraction would insinuate itself into his own work, he did not abandon recognizable subject matter.

"I did paintings of cowboys and Indians. They looked like official American paintings, but also looked Cubist, on their way toward becoming Expressionist. Actually, they were influenced by just about everybody, from Pablo Picasso to Paul Klee. The fact is, I was sort of nowhere. What somehow saved me was a telegram from Ohio State, asking me if I'd be interested in returning there to teach. I accepted instantly, and stayed for five years."

Lichtenstein settled into teaching art and, later, met and married his first wife, who, in time, bore him their two sons. It seemed that teaching would become Lichtenstein's permanent

vocation. However, in 1951, the teachers who were up for tenure, were denied it—Lichtenstein among them.

"My wife found work as a decorator in Cleveland, and so, we all moved there. We lived in Cleveland for six years. I held various jobs. I worked in sheet-metal design for Republic Steel. I did window displays. At one point, I worked for the Hickock Electrical Instrument Company doing some drafting. At another time, I made maps for an architectural firm. These were odd jobs, lasting about six months each. All along I painted. I would make enough money at one job, then I'd quit and just paint. During those six years in Cleveland, I had painted enough to have about seven shows at the Heller Gallery in New York, as well as one show at the Carlebach Gallery. So, I would come to New York as frequently as possible, hoping also to find a teaching job in the East. In 1957, I came back to live in New York. My painting, at that time, was completely abstract."

In 1960, Roy Lichtenstein found a teaching job at Rutgers University, only an hour's drive from New York City. There, he met Allan Kaprow, Robert Watts, and Claes Oldenburg, among other young artists, all of whom were also teaching and working at Rutgers. The encounter with these gifted experimentalists proved felicitous.

"Suddenly, I found myself in the stream of an entirely new and exciting creative outlook. Kaprow was inventing the Happening. Oldenburg set up his "Store" on New York's Second Avenue. Of course, I was influenced by it all. Actually, at the time, I didn't realize that I was being influenced. When I started doing my first cartoon paintings, I was unaware of any connection with Kaprow or Watts or Oldenburg. I mean, I was doing these abstract paintings, except that I started to introduce some comic-book figures into them. I used Donald Duck and Mickey Mouse, but they were also done quite abstractly. I was, of course, aware that Oldenburg, Kaprow, Rauschenberg, and Johns were using objects of a merchandising or "junk" nature— Oldenburgs' *Bacon and Eggs*, Kaprow's *Tires*—things like that. But I really didn't make that connection—not immediately.

"Ultimately, what I did was to copy things from commercial art—from bubble-gum wrappers, and so forth. It was

something that just occurred to me, and I don't really know why. It seemed somehow appropriate, although I'm sure 'appropriate' isn't the word. Anyway, I taught at Rutgers for about three years, and I had my first show at Leo Castelli's in 1962. I showed those first cartoons, and paintings of commercial products, like a Roto-Broil, an engagement ring, a golf ball, and a round picture of a cat, copied from a Kitty-Litter box."

The by-now famous Lichtenstein style had coalesced into what looked like a totally daring and outrageous personal statement. Was this dramatic stylistic departure conceived in a spirit of revolt against Abstract Expressionism? Was it done out of a sense of personal frustration—perhaps desperation—over the stagnant elements of his previous work? Did Lichtenstein decide to put something over on the public?

"No, no! None of those things. It's true that when I looked at what I was doing, it offended my own sense of taste. I mean, I realize that you don't paint through taste, that taste develops as you work, and that you have respect for other people's art, and all the things you've learned. Well, this was, without question, contrary to everything one had been taught about matters of style and substance, and so forth. And, of course, I realized that what I was doing would look hysterical. In fact, when people saw my show at Castelli, they said it was the end of Abstract Expressionism. But I didn't really feel that, because, as far as I was concerned, I was just happily working away in my own way. As a matter of fact, when I did those things, I thought they would just be a temporary phase . . . just to see what that kind of thing would look like. It wasn't a transition, or anything like that. It was just that . . . well, *something* made me do it. And I was very keyed up about it.

"Somehow, once I did those paintings, I couldn't work in any other way. I just couldn't go back to what I was doing before. And so, I kept doing these paintings, and they stood around my studio, and they were just too insistent. Actually, I didn't think anyone would be interested in them—and I didn't really care. That part wasn't important. What was important was that I was doing them."

The early critical reaction to Lichtenstein's new work was,

if anything, skeptical. Indeed, the art press seemed nothing if not aloof to the early stirrings of Pop Art (which had, in fact, received its earliest and quite independent attention in Britain, and was given reverential treatment by the English critic Lawrence Alloway). In America, it was not the art press that publicized this new movement, but the general press. Even as American art critics derided these seemingly foolish and simplistic works, newspaper columnists, fashion writers, and the like, took it up as entertaining copy, finding the likes of Warhol, Oldenburg, Kaprow, Jim Dine, Lichtenstein, Tom Wesselman, Robert Indiana, James Rosenquist, et al., diverting and amusing subjects of highbrow trivia.

"We received a tremendous amount of publicity, and the New York art critics thought that was just terrible. The fact is, almost none of them took us very seriously. Then, little by little, we did receive some serious attention. But, mainly, we Pop artists were sort of taken up by the media. I'm sure I personally loved the idea, but I also thought a lot of it was pretty silly. Actually, the people in the movement didn't band together very much. Oh, we met at parties or after an opening, but it wasn't anything like in the '50s, when artists had a real struggle and felt they were doing something significant, but that nobody was looking. With us, *everybody* was looking, and a lot of it was simply a matter of luck."

The development of Roy Lichtenstein's imagery and style has moved in varying directions throughout the years. But whatever its tendencies, the look of his work remains uniquely his own. There is no mistaking a Lichtenstein painting, whether his aesthetic dialogue deals in cartoons, landscapes, "Brush Strokes," diagrams after Paul Cézanne, or the "commercial-ized" re-interpretations of Mondrian, Picasso, Monet, Greek temples, Donald Duck, Ben Day sunsets, Art Deco themes, or his more recent involvement with *Entablatures*, *The Artist's Studio*, or Futurism. Given his wide variety of subject matter and stylistic approach, Lichtenstein's oeuvre remains firmly and affectionately fixed in cultural parody.

No matter how irreverent or banal his attitude toward the art historical past, Lichtenstein has never presumed to deride

his subject matter. Instead, he has reduced the "sacred" to the commonplace, which, in his hands (and as time has proven), has resulted in a genre bearing its own aesthetic weight and significance.

"I suppose all my work is a kind of short hand. I mean, I wasn't putting down Picasso or Mondrian or Cézanne or Monet or anyone else. What I think I was doing was to take a kind of idiot's view of, say, Picasso, and making a painting of that. The subject for me wasn't Picasso, but someone's funny idea of Cubism. I certainly didn't think my paintings were competing with Picasso, or that they were as good as Picasso. I did those Cubist works, because Cubism had been repeated again and again and again, by so many painters, that it finally lost its significance, and it was this nonsignificance that appealed to me. It was the same with Monet. I didn't set out to put down Monet. I just liked the notion that I could make something look like Impressionism out of Ben Day dots. It was a humorous notion that industry could produce something that looked like Impressionism—the simple way. Actually, I think it took me ten times as long to do it in my 'simple way' then it took Monet to do it in his way."

What, in Lichtenstein's view, is his art really saying?

"I guess what it's saying is that we're living in an industrial-scientific age, and that art is heavily influenced by that. Abstract Expressionism was very human looking. My work is the opposite. It has a pseudomechanical look—as though it were done by a machine . . . that it was thoughtless. It makes a definite statement, like: 'This is red,' or 'this is blue.' The lines are unyielding, and it gives a sense of complete insensitivity. Of course, when I'm painting, I'm trying to be sensitive. It's just that I'm doing it in a style that seems not to be, and which may occasionally not be, which is a fault. But, basically, I was taking subject matter from the past or from the present, and making an absurd statement, although not intending to make my work look absurd, because I hope it's well put together and well-organized.

"Stylistically, my work is devoid of emotional content. And it's what I want. Of course, the work has its own emotion, but,

as I said, it relates more to modern technology. Don't forget, that during the '60s there was a tremendous interest in the scientific—the space program, etc. But, at the same time, there was something rather sinister and pessimistic about that interest. Artists didn't look to technology in a do-good sense, as with the Bauhaus people, who really believed that factories could produce works of aesthetic quality. During the '60s, the artist's view of technology was that it wasn't all that beneficial. There was a feeling of futility connected to it, even though, at first, it seemed very positive and forward-looking . . . you know, the Kennedy years . . . the glamour.

"In retrospect, I feel that the Pop Art movement was not an optimistic movement at all, and, of course, it didn't last all that long. Once the movement was understood, it declined. It really attracted very few younger artists who stuck with it for any length of time. What is more, the movement was never really popular, either critically or intellectually. There were very few serious critics of the movement. Frankly, I don't think Pop Art has led anywhere. The statement was made, and those of us who are still in it, are just moving in whatever direction it's leading us to. Actually, I don't think that what we're doing can be called Pop Art anymore. I mean, it would be like calling Matisse a Fauve for the rest of his life! My recent work—things like the *Entablatures,* for example—can't really be called Pop anymore. It's using an architectural motif to make an abstraction, and that's the furthest thing from Pop. The label just doesn't fit anymore, and that holds true for Warhol as much as for any of the other artists who were part of the movement."

Having admitted, in so many words, that Pop Art is dead, Lichtenstein nonetheless remains the movement's most classic and enduring exponent. These days, his work is neither shocking nor passé. Its so-called irreverence has passed into an almost taken-for-granted iconographic elegance. Indeed, his paintings, prints, and sculptures have become object lessons in meticulous stylistic refinement, masterfully welding the industrial look to the age-old precepts of fine art. It is work that gives a special depth and resonance to what is most viable in the cliché and the ironic. It is decorative art that *commercial*

decorative art seldom achieves. In short, Lichtenstein has become a master, possessed of an ambiguous sensibility. Even as he simplifies, the results harbor a complexity as unique as it is, finally, undefinable.

1976

LUCAS
SAMARAS

Lucas Samaras does not so much look at you as spy on you. It is not a matter of voyeurism or suspicion or mistrust, but rather a byproduct of a strongly guarded, self-imposed isolation. In a sense, to be in Samaras's presence is to be objectified; you are "material" for the possible release of fantasies. The sensation opens you to a curious mixture of intense self-awareness and doubtful welcome. You feel an intruder in the face of Samaras's scrutiny and attendant composure, his deliberate and measured speech, his frequent pauses, and the pressure of his intense introspection.

Our interview, lengthy, convoluted, and marked by false starts, seems suspended in time, and takes the semblance of a theatrical experience. We sit across a table, facing each other like two characters in a play by Beckett, Ionesco, Pinter, or . . . Samaras. The table between us, and the chairs we sit on, have been designed by the artist. They resemble props, producing their own theatrical atmosphere. Our "set" is Samaras's one-room studio apartment in a brownstone on Manhattan's upper West side. Modest and compact in every way, it bears no resemblance to the cluttered, grimy, and claustrophobic room in which Samaras lived during the '60s and, in 1964, reproduced

and exhibited as a work of art at the Green Gallery. Indeed, the present quarters, with their parquet floor, two slim couches, each placed against a separate wall, and an asymmetrically rising bookcase, containing an accumulation of small Samarases and other varying objects, is nothing if not a study in compulsive orderliness.

Beyond this room is the small kitchen, which has frequently served the artist as an environment for his series of *Autopolaroids* and *Photo-Transformations*. But then, every corner of Samaras's habitat seems possessed of its own secrets, and the aura of a charged stillness is everywhere.

And so, sitting like two cats silently surveying each other, we do not begin speaking for several long minutes. This silent appraisal reveals Samaras to have light-brown eyes, set in a bearded face of considerable beauty—an actor's face sensitive to role playing. It is a face Samaras has explored with infinitesimal attention to its every shape and contour, treating it like uncharted territory, revealing its potential as an arena of physical and emotional transmogrification, transfiguration, and transmutation. In his traveling exhibition of *Photo-Transformations,* Samaras is himself the subject of varying metamorphoses, in which both his face and naked body are seen in apocalyptic disguises, with photoemulsions manipulated in ways that create illusions as bizarre and terrifying as they are visually riveting and disquietingly gorgeous.

The artist's fascination with transformation and multiplicity has led him to invent a wide range of large and small works that in his hands have become mysterious and dangerous parables and metaphors. Razor blades, pins, chairs, knives, forks, eyeglasses, scissors, combs, nails, shoes, books, hand mirrors, drinking glasses, religious icons, and more are transmuted into an anxiety-ridden dream imagery that, while aligned to Dada and Surrealist movements, contain their own, highly evocative resonance. All his objects contain a threat—an ambiguous force, demanding caution. The pieces seem possessed of an atavistic life of their own. Mainly, they do not bode well. Even the most ravishing and well-crafted of his objects seem charged with something sinister—a signal announcing an

evil omen—a symbol of bad luck. And yet, these works are immensely seductive and, in a way, demand to be possessed.

Thus it is with Samaras himself.

"You may like my work," he says, in a softly accented voice. "You may find, however, that you do not like me."

Samaras instantly sets a distance between us. He senses danger. A question regarding his childhood, confirms this odd withdrawal.

"I have not yet accepted the fact that I am an adult. I think I have also decided that I want to be a child forever. Some people have always wanted to be fathers, others have wanted to be mistresses, others want to be saints. I prefer the cover of childhood. Because, being a child can be used as a weapon to destroy a part of my psyche, which I continually build up. And so, I revert back to being a child—to knowing nothing. Also, as a real child, the things that were available to me were so difficult and so unacceptable, that making art was the only way I could survive. I mean, I could not commit suicide, but I could survive by making art. And so, by remaining a child, I can survive anything. The thing that is pertinent to me, in my psychology, is that I am the child, and everyone else is the mother and the father. I am a child in the sense that I want what I want from them both—or from neither. I want distance—distance to let them into my work, and distance to continue my fantasy life."

Lucas Samaras was born on September 14, 1936, in Kastoria, Macedonia, Greece. After a harrowing wartime childhood in his native land, he was brought to America, where, in 1948, he settled with his family in West New York, New Jersey. In 1955, he entered Rutgers University on a scholarship. There, he met Allan Kaprow, George Segal, and Robert Whitman, whose experiments led him to join in the performances of Happenings at New York's Reuben Gallery. Although a loner from the first, he willingly participated in the Reuben Gallery's Happening events (notably those staged by Claes Oldenburg). Concurrently, he studied acting with Stella Adler, and also painted in oils and pastels. In 1959, he entered Columbia University, and studied art history under Meyer Schapiro. In 1960, Samaras exhibited plaster and cloth pieces at

the Reuben Gallery, which centered on food and eating utensils. These mysterious and somewhat repulsive fabrications revealed an imagination that fixed on a predilection for the grotesque.

Throughout the '60s, Samaras produced pieces marked by the obsessive aggregation of materials that shaped boxes encrusted by pins, feathers, and tacks. These boxes contained a wide assortment of objects—bits of mirror, cotton, photographs, jewels, strands of hair—mementos of personal significance that, in combination, offered entry into dazzling craftsmanship, while also recalling the elegantly and eloquently dislocating enclosures of Joseph Cornell. He began to write bizarre stories, published in private editions, in which wartime memories combined with hallucinatory, terror-filled fantasies, mirroring Samaras's psychic dislocations. Working in progressively restrictive solitude, he also continued to produce magic talismans fashioned out of colored yarn, pin-covered books, drawings made on X-ray film, and, in time, a spectacular *Mirror Room* first exhibited at the Pace Gallery in 1965.

A key work, the *Mirror Room,* which, when entered, endlessly multiplied the viewer, brought one into palpable contact with Samaras's own relentless and thrilling self-involvement. The drama of self-encounter, with its erotic overtones, gave one access to the artist's search for the self—a search that deepened with the years. The film, *Self,* produced in 1969 in collaboration with Kim Levin, began this quest, and culminated in 1971, with a large exhibition of the *Autopolaroids,* also shown at the Pace. As one quickly noted, the celebration of the self was not centered on narcissistic self-adoration, but, far more intriguingly, on the obsessive scrutiny of Samaras's anatomy, every part of which was photographed in highly distorted perspective and focus, and examined with terrifying clarity. These *Autopolaroids* were, in effect, transformations, both of the self and of the photographic process. Samaras added colored inks—dots, dashes, squiggles—to the colored photoemulsions, and thus produced an entirely original photographic genre—an originality that would find even greater release in the *Photo-Transformations* of 1975.

Samaras has made of solitude a fetish. His apartment is his

secret domain. It is where he works, eats, sleeps, and thinks. Being alone is a psychological necessity.

"In college, I lived with people, and it wasn't very good," he says. "Actually, living alone is different than it used to be. When I started living alone, it was mostly due to a state of sadness. It was a state of deprivation—of nostalgia and melancholia. With the years, however, all that subsided. Now there's a calmness to my living alone. It's not that you're living alone because you couldn't see someone, but because you like it, and because you know it's best for you. Basically, I have two periods during the year—the period when I'm working, and the period when I'm not. Right now, I'm not working, because I've recently closed a show. But the stoppage is an artificial one. I go on thinking about work, and I think about what I've done. If it's a nice day, I take a walk through the park. If I can't do that, I pace up and down in my kitchen. I usually don't pace in my living room, because the floor squeaks, and I have friends living downstairs, and I don't want them to be noticing my pacing. Consequently, I pace in the kitchen. It's a very small area, but some of my pressures relax.

"Also, living alone, doesn't mean you're by yourself. There are always sounds. You hear people walking in the other apartments. You hear sirens. Or rain. Or the refrigerator. So there is a world of information that's always attacking you. Then, if you have a little theatrical gene, you feel that every time you're looking at something, 10 million people are also looking at it. I mean, if I pick up a glass of tea, I also know that 10 million people are doing it with me. Then, I think maybe 10 million people are *not* doing this. So I pick up my camera and record this action. When the picture is published and looked at, then I'm certain that 10 million people have done this with me. Because I'm living alone, I want everybody else to know it also. Not because I want them to say 'Oh, poor guy, he's all alone!' but because it shows them they could do it also."

Why does Samaras produce art that so often deals in danger? Why the pins, the razor blades—things lethal?

"When I look at a razor blade, it has associations with being cut, but it's also a wonderful looking object in itself. Or a glass. If it is broken, it could cut you. But it also has strange qualities

that have to do with transparency, translucency—a beautiful way of catching color. If you took your head and knocked it against a nail, you would be hurt. But a nail is also a wonderful object. So, it really has to do with what you read into these things. I use these objects partly for psychological reasons and partly for aesthetic reasons. Also, it introduces something a little different into the art language. But I don't limit myself to these things. I don't compartmentalize myself. In fact, I function as though there were no other living artists around, although I do look at the artists of the past. I will go to a museum or buy a book and say to myself, 'Yes, this is the art of Greece or the art of Asia or the art of Africa.' Well, the combined arts of the past are fantastic. They are fantastically varied, and touch on all aspects of human existence. They touch the body and the environment—everything. Well, then I say, 'Samaras, you're an artist. What are *you* going to do?'

"My answer is that I'm going to do *everything*. It is not necessary that I express myself within one convention. You see artists around you, and they all seem to sort themselves out. This one will be a de Kooning. This one a Mark Rothko. That one a Clyfford Still, and that one a Jackson Pollock. Each one has his specialty. I am not a specialist. I'm a general practitioner!"

Talk now turns to his photographic work—the Polaroids. Why is Samaras the exclusive subject of these disturbing pictures?

"It has to do with the lack of information available on autobiographic portraiture. I have found for myself an uncultivated field to which I can go and do my stuff. That uncultivated field is the self. Most of us have evaded the body. Now, there is a certain word that has negative connotations: narcissism. You know: 'Don't look in the mirror!' Well, when you live alone, you don't have people saying 'Don't do this' and 'Don't do that.' You can do whatever the hell you like, and if you want to look in the mirror, it's not all that dangerous, and not even all that erotic. For me, looking in the mirror, produces a sense of wonder. I say, 'Who is that?' I look at my hand or at my rear end and say, 'What is that?' The idea of the mirror being an area of erotic conflict is an idea for those who *don't* look into mirrors.

"And so, I started photographing myself, and found that I could see portions of myself that I had never seen before. Since I face just my face in the mirror, I know pretty much what it's like. When I see a side-view, I'm not used to it, and find it peculiar. Or the back of my head—it's very strange to see it. So, photographing myself and discovering unknown territories of my surface self causes an interesting psychological confrontation. You face certain facts about yourself. Although we all live in fantasies, and we all know that we will die some day, we have to come to terms with other unknown facts about us. At any rate, when I began photographing myself, I could place myself in poses that had not been investigated by other artists. It was an area other artists hadn't touched, and that was a wonderful discovery. Then, I went on from there. I manipulated my image—distorting it, brutalizing it. People thought I was mad, but I had to tell these things about myself. It gave me a kind of excitement."

Because anger, terror, cruelty, and beauty are inextricably interwoven in Samaras's work as a whole, I ask him whether his childhood war experiences have colored his outlook on both his art and private life.

"Of course, being alone can be crazy-fying. But then, being with people can be equally crazy-fying. I would say that disappointment and anger have something to do with my work and with my choice of existence. I tend to be a careful person, because one never knows what might befall you. During the war years in Greece, I experienced military attacks. To this day, when I'm not paying attention to myself, I can spook myself with the thought that airplanes are coming to drop bombs. I have only to hear a plane at night to experience this fear. There's no way of eliminating that. And I do have nightmares, although they now come infrequently. During my adolescence, my own shadow would scare me—especially at night. Now, night has lost its danger. In fact, now the anticipation of going to bed and dreaming is very pleasant.

"As for personal relationships . . . I have come to learn who I am. Earlier on, when I presented myself to others—to real human beings—I had the feeling of not being appreciated enough, that I was not being given my due. When I *did* fall in

love with somebody, I invariably discovered that I did not receive from them what my education and fantasy required. As a result, I shifted myself to myself. I suppose for me, a relationship is good when it's bad. It's almost a moral thing. I feel you mustn't have too much pleasure, you mustn't have too much success, you mustn't have too many good thoughts, you mustn't feel too good. The fact is, I've become very greedy. I want things as I want them, not as somebody else wants them. Being with other people means having to make compromises. Well, I do not want to make certain compromises, and that's that."

Then, work and more work is the answer?

"Well, I have the choice of either spending my time analyzing what's bothering me, which can get boring, or go on and do some work. Usually, I end up working. And when I'm working, I find myself being in a more or less unconscious state. That is, you couldn't call it good or bad or anything else. It's just *working*. Although I have conversations with myself while I work, it's on a different time level. There is the talking to myself, and then there is the making of art. On other occasions, my anger or passion or excitement or whatever is very much connected with the art-making process."

In certain of Samaras's pastels, night-time interiors show images of men and women in what seem erotic confrontations. The couples might be engaged in sexual battles—perhaps rape—or they may give the illusion of tenderness. These scenes, riddled with ambiguity, suggest Samaras's own conflict vis-a-vis women.

"We all have mothers, right? Women give me information. Although I am male, I don't know many things about maleness. And, because I am male and not female, I don't know many things about femaleness. Generally, I surround myself with independent and intelligent women. When I am around them, I can learn a great many things, and then see how those things apply to me.

"But an artist must have an involvement with everything that is in front of him, whether it's a woman, a man, a cup, a dog, a string, or a tree. If an artist does not have an erotic

involvement with everything that he sees, he may as well give up. To be a human being may be a very messy thing, but to be an artist is something else entirely, because art is religion, art is sex, art is society. Art is everything.''

1976

CATHERINE
MURPHY

L ooking at any work by Catherine Murphy, the young
 American realist painter, one is placed in touch with a
sensibility that perceives nature, the figure, or everyday objects
with a clarity that borders on the uncanny. So acute and
uncompromising is Murphy's vision that her images seem to
assume an eerie life of their own—as though their existence on
the canvas were preordained, the inevitable result of some
mysterious transmutation that makes of a tree, a rose bush, a
person, or a view of the city an entity possessed of a wholly
self-contained and self-sufficient life-force.

 And yet, for all their intensity and sharpness of focus, these
paintings contain one added element that renders them unique:
an ambiguous and mesmerizing stillness. It is this sense of
quietude, this play between the relentlessly accurate and the
pictorially serene that places Catherine Murphy's work apart.
At a time when realist painting is enjoying an unprecedented
renaissance, Murphy's particular brand of realism differs from
other precisionist styles in that mood and atmosphere take
precedence over technical virtuosity. The fact is, Murphy is not
a so-called photo-realist where literalness is all, but an artist
who insists on projecting an emotional reality first. Indeed,

emotional viability is never sacrificed for artifice of technique and illusion. Clarity of detail serves only to heighten the emotional validity of the subject matter.

"I think I have a clarity of vision," says Catherine Murphy, who at only 32 has won major recognition in an astonishing short span of time. "At first, I couldn't attain this clarity, because I couldn't paint well enough to get it. Then I got to the point where I *could* achieve it . . . this clearness which I love and which moves me. But I don't paint detail for detail's sake. What moves me is lucidness of surface—and making the parts equal the whole."

Catherine Murphy is an amply, even majestically built woman of great charm and vitality. A native of Lexington, Massachusetts, she resides there with her husband of ten years, the sculptor Harry Roseman. Preferring to live and work outside the hub of the New York art scene, she nevertheless received her early training at Pratt Institute in Brooklyn and held her first New York exhibition in 1972 at the First Street Gallery. Because it takes her nearly a year to complete a single canvas, Murphy has held only three exhibitions to date. Following her first show in 1972, she exhibited in 1975 (at the Xavier Fourcade Gallery, her present dealer), and again in May 1979.

Critical reception of Murphy's work has run high from the first. So enthusiastic were most of her reviews that collectors and museum curators lost little time in acquiring her paintings that today command as much as $25,000 for a canvas measuring 40 × 45 inches. In 1976, she was given a retrospective exhibition organized by the Phillips Collection in Washington, D.C. and at the Institute of Contemporary Art in Boston. Her work hangs in the permanent collections of The Whitney Museum, the Hirshhorn Museum, and the Newark Museum, among other public and private collections. All of Murphy's paintings and drawings in her last show at the Fourcade Gallery were sold prior to the opening and collectors have placed "reserves" on canvases not yet painted.

This dizzying rise of a painter who only seven short years ago was totally unknown leaves Catherine Murphy unfazed. As

she put it, her concern is in maintaining a sense of privacy so that concentration on her work remains unimpeded.

"You see, it takes me forever to do a painting, and for that you need peace and quiet. The fact is, my husband and I have separate studios in my parents' house here in Lexington. That makes life easy because I don't have to cope with keeping house or worry about the shopping—it's provided for us so that we can be free to work and, of course, that's a fabulous arrangement. So I paint morning, noon, and night. I do that for months and months on a single painting and when I think it's done, I start on another one."

Murphy's working methods have remained constant throughout the years, something she sees no reason to change.

"I record reality as I perceive it and I'm very selective," says Murphy. "Once I fix on a subject I don't alter it. The procedure is always the same: I first block in the chosen scene or object with broad brushstrokes. Then I begin using brushes of diminishing sizes that are gradually reduced to the smallest sable point. This helps me to bring about the desired moment of precision, and that's what takes forever—closing in on the minutest detail and still have it be part of the whole. As far as subject matter is concerned, I've always found myself living in lower middle-class circumstances, and that's what I painted— backyards, frame houses, or housing projects, and portraits of my friends and my family. I never paint strangers; I can't. I'm too nervous. The reason I don't hire models is that, when I'm not in solitude, I'm extremely chatty. I like to talk to people. I want to be their friend. I want them to like me. So I can't have models in my studio, because I'd talk to them and then I couldn't concentrate on what I was doing. So I paint people I don't have to talk to, and who understand that."

Despite unqualified success, Catherine Murphy has her detractors, artists and certain critics who claim that her work is obsessive, claustrophobic, and to some extent laden with an overwrought abundance of detail that undermines the very clarity she aims for. To these charges, Murphy has a ready reply.

"The minute something is good, people call it obsessive.

It's a word that's been coined by people who can't do anything for longer than 15 minutes. I mean, was Leonardo da Vinci obsessive? Or Jan Vermeer? It's people dismissing your capacity for concentration. No. I don't think my work is obsessive or claustrophobic. I want my work to be excellent—to reach its peak of tension. I just paint what I see. And I never put in more than I see—ever! Most of the time I put in much less than I see. I put in only as much as I need to make things clear. My way of painting is a natural outgrowth of my vision."

As a reclusive person, Murphy admits to finding it difficult looking at other people's art—including the old masters. She finds museum going exhausting and more often than not unfulfilling. There are few paintings, either contemporary or of the past she actually likes. "To tell you the truth, it's a mystery to my why art is so liked!"

Seemingly content to pursue an inner, private vision, Catherine Murphy thrives on complete isolation, a factor that may either intensify the already charged quality of her work or eventually lead her into a stylistic cul-de-sac. For an artist still so young, this might mean settling for self-imposed limitations that may rob her future work of risks that could yield broader, more daring results.

Still, Murphy is an original. Her impeccably executed paintings and drawings—with their oddly transfixing compositional thrust, their strangely muted light, and sensuous stillness—offer entry into a world that transforms the banal and familiar into mysterious reveries at once compelling and disquieting.

1979

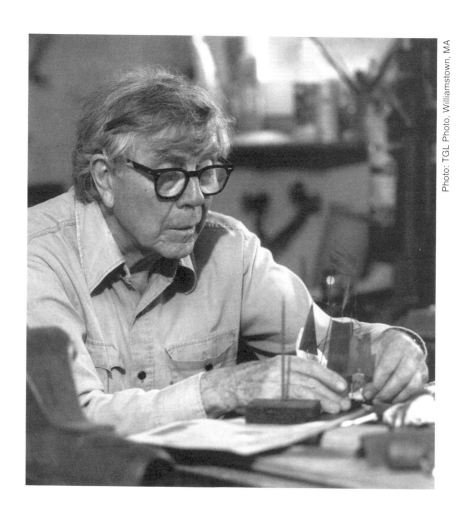

GEORGE
RICKEY

*I hope none of my pieces
demonstrates skill.*
 George Rickey

A mong the best attended exhibitions of 1979 was the
sculpture retrospective by George Rickey seen at the
Solomon R. Guggenheim Museum. Toward the show's conclu-
sion in October, long lines formed at the museum entrance,
with guards cordoning-off the flow of people eager to witness
the work of an artist who, at 72, had made of sculpture a
metaphor for movement in space—a clear and lucid geometry
where line and shape produced their own metaphysical dy-
namics.

What Rickey had created, and what the public responded
to with such fervor, was a tensile, mesmerizing, and altogether
astonishing definition of the way shape through motion can
alter our perception of space and how simple linear forms can of
their own accord produce an aesthetic that strikes chords of
utmost harmony.

In effect, what the public saw were some 90 works, from
small kinetic jewelry to large hanging mobiles, which made

clear Rickey's technical explorations and achievements over the last 30 years. They provided an indepth presentation of what has become the artist's private vision—a vision that saw pure, spare, stainless-steel shapes being activated and balanced through a system of meticulously engineered counterweights and bearings as well as by air currents and the pull of gravity.

These silently moving objects, so majestically crafted, created an atmosphere at once theatrical and subtly atavistic. And what made viewing them so compelling was the mysterious way in which they continually captured and redefined space, for as they moved a spacial counterpoint was set in motion, and it was the relationship of these spacial forms that constituted the drama and beauty of Rickey's art.

Looking at these works it was difficult to believe that George Rickey had come to sculpture at the age of 42. Twenty years before that, he had been a painter of only relative success—an artist still seeking for a voice of his own. Then, in 1949, he began making his first kinetic works from window glass and the experience was a revelation.

"I committed myself to a completely new technology," says Rickey, "a new aesthetic, new criteria, a new kind of response from others and a new antiphony between myself and the new object I held in my hand. I had to wonder whether Alexander Calder had said it all; when I found he had not, I had to choose among the many doors I then found open. I had to learn to be a mechanic and to recall the physics I had learned at 16."

Once Rickey had fixed on sculpture that moved, he wanted this movement to contain an aesthetic all its own: "I wanted movement which would declare itself quietly, slowly, deliberately—calling attention only to itself. I rejected jerks, bumps, bounces, vibrations, and for the most part, all sound. I also gave up, except for a very few lapses, color, optical effects, spots, stripes, calligraphy. . . . I had embarked on a long-term project—to make an art in which every object had to be preconceived and had to be able to go through its motions completely and satisfactorily, or I had made nothing at all. Though the object was preconceived, I wanted its motion to be unpredictable. So I rejected motors. I chose to have only air currents

provide the energy. The random impulses of the wind compensated for the discipline. Meanwhile, whatever I did, whatever I planned, whatever fantasy I conceived, I had to face the stern reality of gravity, always pulling, pulling, pulling downward, toward stability, toward stasis."

Clearly, George Rickey knew what he wanted, but it would take years . . . indeed, almost half a lifetime. It would take a long and circuitous journey which found the artist inhabiting several highly diversified personae, each of which contributed to a creative denouement that would ultimately produce a lasting and distinctive statement in which craft and vision combined to yield an art of undisputed individuality.

From the beginning, George Rickey's life veered sharply from that of any other American artist of his generation. Born in 1907 in South Bend, Indiana, he spent only five short years on native soil before being taken to Scotland, where he spent his formative years. Europe would be the continent that nurtured him.

"I was one of six children—the only male," Rickey began. "I had five redheaded sisters, but I was not a redhead. I was third in line, sandwiched between bigger and littler sisters. My father was an engineer who had gone to M.I.T. After working at a couple of jobs, he was hired by the Singer Sewing Machine Company, which took him to South Bend, Indiana, where I was born. Ours was a rather intellectual family. My mother was a reader. She read everything and remembered everything and was my cultural mentor. All of us were reminded constantly of our obligation to read. My maternal grandfather was a lawyer and then became a judge in the New York State Supreme Court. Two of my uncles were lawyers and my mother and her sister went to Smith College. Mother was a suffragette. While she was not a demonstrative person, she was very liberal. At any rate, when I turned five, the Singer Company sent my father to their factory in Scotland and we all moved to a place called Helensborough, about 30 miles from Glasgow. That's where I grew up—as a Scottish little boy."

Rickey's father had always harbored the hope that his only son would follow in his footsteps. He had wanted him to become an engineer, attend M.I.T., and in general look to a

practical and sensible life. But Scotland was now the boy's home and M.I.T. seemed a distant dream. Young George attended Scottish schools, and when he entered his teens was sent to Glenalmond, a public school founded by William Gladstone. There, he undertook the study of mathematics, physics, and chemistry.

"I was a reasonably good student," recalls Rickey. "My mathematics master singled me out as most promising and he pushed and groomed me, hoping I would make mathematics my field. But a point came where I revolted. I was 17, and could now choose what I wanted to study. In my last year at Glenalmond, I decided to concentrate on history. I dropped all my mathematics and I've never had anything more to do with it."

As a child growing up in Helensborough, George Rickey began to draw. It was a family pastime and, throughout the years, drawing would become one of Rickey's major sources of diversion and pleasure. At school, he drew battleships and airplanes in the margins of his books and also took a drawing class offered by a teacher who came in from Edinburgh twice a week. Rickey also visited the Glasgow Art Gallery and admired the portraits of Sir Henry Raeburn and, in particular, Rembrandt's *The Man with the Helmet*. Best of all, he loved looking at models of sailing ships, with their intricate construction and finely polished woods. Still, young Rickey harbored no thoughts of ever becoming an artist.

"Of course, at school, becoming an artist *did* vaguely cross my mind, but at home it was always impressed on me that artists were people of exceptional talent. It was all about great art—the masters displayed at the Louvre or the Uffizi. So, for me to become an artist would be irresponsible—and of course it was."

When George Rickey turned 19, he was admitted to Balliol College at Oxford, and he declared his intentions of becoming a teacher of history. This his father did not welcome but tolerated. At this moment in his life, Rickey was a rugged young man and, as he put it, fairly tough, coming from those Scottish mountains, moors, and seas. Although relatively shy, he easily fit into college life and even played rugby football on

the college team. He was a diligent student, applying himself to the study of Medieval and English constitutional history. Then, toward the end of his stay at Balliol, he concentrated on the subjects of the American Revolution and the Italian Renaissance. It was the latter that gave him his first serious taste for art and art history. But even more meaningful was Rickey's introduction to the Ruskin School of Drawing, which was housed in the Ashmolian Museum, just across from Balliol College. During his second term, he decided to enroll in it.

"Neither the college nor my parents knew about it. For the first few weeks I drew from casts and then they moved me on to the live model. It was at the Ruskin School that I learned about making art—and I did it secretly. I also learned something about the English art world. There was the Royal Academy, which was intensely traditional, and the New English Art Club, which was the avant-garde and where artists had heard about Cézanne. Well, out of the New English Art Club in London, two sets of brothers came to teach at the Ruskin School. They were John and Paul Nash and Sydney and Richard Carline, and they were the people who taught me drawing. As it turned out, Richard Carline took me under his wing and treated me almost as a private pupil. He was the corrupter, and he was the one who said, 'You must go to Paris. England does not hold what you need!' He quite turned my head and I seriously thought of giving up my college studies. But my Yankee common sense exerted itself and I thought that having gone this far I should at least finish and get my credentials—which I did. I graduated from Oxford with third class honors in history. All the while I had of course continued my drawing classes at the Ruskin School. Finally, at Richard Carline's urging, I resolved to go to Paris. The year was 1929 and I was 22."

Throughout his years at Oxford, Rickey had spent part of his summers with his family in Scotland. At his father's insistence, he worked at the Singer Sewing Machine factory and was able to save a substantial amount of money, which he would now spend on his stay in Paris. Upon his graduation, he announced to his family that he intended to become an artist.

"My family was appalled. There was a confrontation. My father thought I had gone mad. But I was adamant. However,

I did give myself eight years to see if I *could* become an artist. I gave myself until the age of 30, which was a very New England type of idea. Also, in my caution, I decided to speak to the master at Balliol, telling him that I was interested in eventually finding a teaching job in America. I told him I was off to Paris to paint, but was nevertheless eager in having some job in America. Well, before leaving England, he set up an interview between me and a professor of history at Harvard by the name of Roger ('Frisky') Merriman, who years before had been to Balliol. I went up to London to see him, we talked, and he asked me to send him a short biography of myself—which I did. Then, I left for Paris."

George Rickey's work as a fledgling art student had followed closely in the precepts of the Ruskin School. He drew from the cast and from the figure, and the results were precise renderings of what he saw. Still, there were hints of individuality—a special sensitivity for line and contour and a warmth of feeling for the subjects at hand. His teacher, Richard Carline, saw promise in Rickey's work and gave him several names of artists to look up in Paris. One of these was William Hayter.

"I can remember arriving in Paris and going to see Hayter. I recall visiting him in Montparnasse, climbing a flight of stairs and entering a large room, and there was this man with an enormous canvas on the floor, and he was painting on it on the floor! Well, it was a revelation, because it made me realize that a painting didn't have to be vertical and have a top and a bottom and a left and a right. That was my first lesson in Paris. Hayter was very nice to me but there was really nothing he could do for me. And so, again following Carline's advice, I enrolled in the Académie Lhote. For the next eight months, I was exposed to the teaching of André Lhote, which was the academics of Cubism, brilliantly offered—witty, clear, sharp, and also very corrupting.

"I tried to do exactly what he said and so did everybody else. My paintings were Cubist paintings and although I was very conscientious, I soon felt the need to expand. In the meantime, I had visited the Louvre, went to the Luxembourg, and saw endless exhibitions. One of the artists who struck me was Léger. I learned that Léger was teaching at the Académie

Moderne, and I decided *that's* where I wanted to continue my studies. I left Lhote, enrolled in the Académie, and began working with Léger.

"It was a disappointment, because after a couple of weeks, Léger's criticism was very critical indeed. The fact is, I came there to learn how to do modern painting, and he wasn't interested in that at all. He told me that what I needed was to go out and paint from nature. Of course, it was good advice, but at the time, it was the last thing I wanted to do. I suppose Léger must have thought, 'You don't begin where I end!' And he was right. Nevertheless, I left Léger and began taking instruction from Amédée Ozenfent, who was also teaching at the Académie. I can't honestly remember what I learned from him, except that my paintings all looked vaguely Cubist. What I *do* remember is that after studying at the Académie Moderne, I was through with my schooling. I didn't do any more of it until many years later."

George Rickey remained in Paris from the summer of 1929 to the summer of 1930. Midway, he received a letter from his master at Balliol, saying that a school in New England with which "Frisky" Merriman was connected was interested in having someone come and teach history. He added that, although Rickey was a good candidate, the school was somewhat concerned over his being an artist. Rickey instantly wrote to the school informing them that while he was indeed studying painting in Paris, this would in no way interfere with his full commitment to the teaching of history. Some weeks later, he received word that he was hired for the following September. The school, which Rickey had never heard of, was The Groton School, located some 39 miles west of Boston. In the late summer of 1930, he sailed for America. It was the first time since the age of five that George Rickey had set foot on his native soil.

"I taught English and European history at the Groton School, and I did that for three years. I was paid $2,000.00 a year, which was a lot of money at that time, and I was able to save quite a bit of it. I was serious teacher and I think I did it quite well. Of course, I did not abandon painting. I painted whenever I could—portraits of some of my students and more of my Cubist things. At that time, I also met a young woman

who became my first wife. So, there I was, teaching, painting, and being married. Then, after three years, I left Groton. It wasn't a wrangle, not a dispute, not a difference of opinion but, in a way, a slight contest of will with the headmaster, the Reverend Endicott Peabody. The issue he put to me was whether I could be of greater service as an artist or in remaining a schoolmaster. Well, the matter resolved itself by my decision to return to Paris and continue painting."

In 1933, Rickey and his wife left for Europe. They found an atelier in Paris—at Mont Rouge—and Rickey now began painting full time. As he put it, he was getting over André Lhote and Cubism and returned to nature by way of Cézanne. He painted landscapes, still-lifes, and the figure. He also painted portraits, some of which he sold. He was also witness to the discontent in Paris during 1933–1934, when riots broke out as a result of the Stavisky affair.

"I saw barricades in the streets, policemen shooting, horses galloping about, buses overturned and burned, and an insurrection at the Place de la Concorde, where several people were killed. I saw it all, but I didn't know *what* was going on. It was like Stendahl in *Le Rouge et le Noir,* where he goes through the whole battle of Waterloo and doesn't know it's been going on!"

In Paris, Rickey exhibited twice at the Salon des Independents and also at the American Center on the Boulevard Raspail—it was a beginning, but it was short-lived. In 1934, with his money running out and with the break up of his marriage, he resolved to return to America—this time, to New York.

"It was still the time of the Depression and of the WPA. I was not on WPA, and I was very disgruntled about that, because I was disqualified. You see, I still had a little money in the bank and that disqualified me. But all the people I met were on the Project. Of course, I continued to paint. At one point, I had a show at the Uptown Gallery, and that's where I met Philip Evergood, Paul Cadmus, and Gregorio Prestopino. The gallery was run by a Russian woman called Rosa Persin. I remember her showing an artist I had never heard of, whose paintings I thought were extremely interesting: Alfred Maurer.

There was also Theodore Roszak, who was then showing paintings.

"In those years, the New York art scene was very political, what with the Artists Congress, the Artists Union, and the WPA, and the struggle between the people administering the Project. There was the pressure towards the left, and I was quite interested in how it all worked. But I had a certain detachment from it. I would go occasionally to meetings at the Artists Union, and it was marvelous when Phil Evergood was president. He had such a great voice and authority! But he was politically innocent—an awfully decent man. I think they used him a bit. Anyway, I went to some of those meetings and participated in some of the exhibitions, and I had a studio on Union Square which looked down on 13th Street. Quite a few artists worked there: Kenneth Hayes Miller, Rico Lebrun, Arnold Blanch, Doris Lee, and Whitney Darrow, Jr."

Rickey, now firmly entrenched in the New York art world, painted his landscapes, still-lifes, figures, and portraits, and briefly held down a job at *Newsweek* magazine, working in the editorial department. In 1937, he obtained a Carnegie Grant to be a visiting artist at Olivet College in Michigan, where he remained until 1939. Also, in 1939, he developed a strong interest in mural painting. Wishing to learn more about fresco techniques, he traveled to Mexico to study with a pupil of Diego Rivera. Rickey says that he was now painting farm-life subjects in the style of John Stuart Curry. After his Mexican sojourn, he obtained a post at Kalamazoo College, teaching painting, drawing, and art history. Then, in 1940, following his divorce, he took a sabbatical from teaching . . . and from people in general.

"I lived quite alone in a cottage by Lake Michigan through a whole winter. I had read about people living in solitude—Thoreau, for example—and it was a way of getting close to nature. I remember walking along the shore of Lake Michigan with the ice piled up, like in a painting of Kasper David Friederich. It was a very lovely time. I was not lonely. It was a chosen detachment. I read a lot—Proust, Dostoevsky, and everything Frank Lloyd Wright had ever written. You see, I was still learning!"

This self-imposed exile ended toward the end of 1940, at which point another Carnegie Grant found Rickey being artist-in-residence at Knox College in Galesburg, Illinois. It would be a one-year residency. In 1941, he was asked to organize the art department at Muhlenberg College in Allentown, Pennsylvania, and, in 1942, with World War II in progress, George Rickey was drafted into the Army. It was an event that would dramatically alter the course of his life.

"After induction, I ended up in Miami Beach and took a lot of tests in which I received very high scores. It seems I had great mechanical aptitude, and I was shunted off to Denver, where I was taught the operation and maintenance of hydraulic gun turrets for aircraft. I seemed to have been quite good at it, because they asked me to stay on as an instructor, with a rank of Staff-Sergeant. Ultimately, I became a teacher in a school in Denver where there was a 16-week course in the operation and maintenance of electronically controlled gun turrets for B-29 aircraft, which was the aircraft being designed to fly over the Himalayas to Japan. I was in on that—and I did this teaching for the rest of the war.

"Toward the early part of 1945, I was sent to Laredo, Texas, where there was an Army airfield where they were teaching gunnery with the system in which I was a specialist. I was the only one who knew how those systems worked. Well, in Laredo, I rented a studio and continued painting. I also had access to a machine shop containing lots of tools. I began making things that looked like Alexander Calder's things. Of course, I had heard of Calder and had seen his work and liked it. But what I was doing was just a diversion . . . I did those things for fun. It wasn't at all serious. The fact was, I considered myself a painter and I was a painter for several more years to come."

George Rickey received his Army discharge in 1945. He was now eligible for the G.I. Bill, and he enrolled in the graduate Art History Department at the Institute of Fine Arts at New York University. In 1946, he returned to Muhlenberg College as Chairman of the Art Department, and in 1947, he met and married his present wife, Edith Leighton. Although Rickey continued to teach at Muhlenberg, he rented an

apartment in New York, where he painted and could still be part of the New York art scene. During the summer of 1947, he and his wife decided to travel to Iowa City. Rickey wanted to study printmaking with Maurizio Lasansky at the University of Iowa.

"A friend of mine, the artist Ulfert Wilke, was also studying at Iowa. When Edie and I arrived, we rented a sorority house—there was no other housing to be found—and we shared it with Ulfert and his wife. Well, the whole Art Department, from Lester Longman on down, thought this was a fine place to have parties. Ray Parker was around and Mary Holmes, Jimmy Lechay, Albert Albrizio, Malcolm Myers, and everybody else. I studied very hard—intaglio, etc.—and it was a very productive summer. When it was over, I spent a brief period teaching at the University of Washington in Seattle, and I also spent a whole year studying at the Institute of Design in Chicago. Finally, in 1949, I accepted a post as Associate Professor in the Fine Arts Department of Indiana University in Bloomington. I taught design and art history, and I did that for six long years."

It was in Bloomington that George Rickey became a sculptor. He was now 42, and the artist claims that he doesn't know just why he relinquished painting. He began to make moveable structures and they elicited a vital response in him. With characteristic thoroughness, he immersed himself in the metiers of soldering and welding and eventually extended this technology to suit his needs. There was no question that Rickey's first pieces owed their strongest debt to Alexander Calder. But he recognized that Calder was principally interested in shape and that his aesthetic was open to other possibilities, both actual and theoretical. Rickey thus set about clarifying and emphasizing his interest in movement per se. He wanted movement itself to be the operative factor in his work.

"I embarked on endless experiments and found that I had to both eliminate and add. What I eliminated was color and sound. I also began reducing the form of the object itself to thin lines or very simple, obvious geometrical shapes in order to leave the emphasis to the movement. This became clear to me. Although I had an interest in complexity, it was the complexity

of adding up units in such a way that one could not anticipate what the addition would look like. So, I was trying to work with a larger range of possibilities, and I also made larger pieces. What was paramount was that I did not consider making any sculpture that didn't move. In fact, I didn't care whether it was called sculpture or not. I didn't classify myself."

Rickey's stay in Bloomington proved a major turning point in his career and in his outlook as an artist. He had now fixed upon an aesthetic that would soon coalesce into a major statement. He had clearly profited from the technology he practiced in the Army, and his inquisitive and theoretical mind began to yield an art that quickly garnered serious attention. Still, he could not yet abandon teaching. He and his wife had recently become parents of their first son, Stuart, and a family had to be supported. In 1955, George Rickey left Bloomington and accepted a post at Tulane University in New Orleans, where he set up a graduate program in art. That same year, he became affiliated with the Kraushaar Gallery in New York, an association which extended for a period of 10 years.

At Tulane, Rickey continued to produce sculptures of ever greater variety, and his reputation continued to grow. He was invited to participate in various major exhibitions throughout the country and several commissions came his way, notably for the Belle Boas Memorial Library at the Baltimore Museum and for the Union Carbide Building in Toronto, Canada. A Guggenheim Fellowship came to him in 1960, which was renewed in 1961. In the meantime, a second son, Philip, was born and the Rickeys decided it was time to settle in a place they could call their own. In 1961, they bought a farmhouse in East Chatham, N.Y. where they still reside.

The '60s found George Rickey hard at work, both as artist and teacher. There were teaching stints at the University of California in Santa Barbara and at the School of Architecture of the Rensselaer Polytechnic Institute in Troy, N.Y. as well as at Dartmouth. In 1964, Rickey joined the Staempfli Gallery in New York, where he exhibited through the early '70s. As his reputation increased, many more worldwide exhibitions and commissions came his way. There were commissions from Joseph H. Hirshhorn, the Westland Center in Detroit, the

Siemens Research Center in Erlangen, Germany, the Rijksmuseum Kroller-Muller in Otterlo, The Netherlands, the Nordpark in Dusseldorf, and from collections, institutions, and museums in Washington, D.C., Omaha, Berlin, Atlanta, Munich, Glasgow, Fort Worth, Heidelberg, and Honolulu, among many other cities.

The '70s were equally productive, with Rickey receiving more commissions and showing his works in countless exhibitions throughout the world. Any number of honors have been bestowed upon him, including Honorary Degrees from Knox College, Williams College, Union College, Indiana University, Kalamazoo College, and York University in Toronto. In 1974, he was elected to the National Institute of Arts and Letters, and, in 1979, he was awarded the Brandeis University Creative Arts Medal in sculpture.

Since 1968, George Rickey has divided his time between his home and studio in East Chatham and West Berlin, where he works and lives for several months out of the year. He is no longer affiliated with any single gallery, but works with several dealers in America and Europe. His wife, Edie, manages his wide-ranging and far-flung activities. Their sons, now grown, have their own careers. The eldest, Stuart, is a cinematographer, and Philip, a stone carver.

Asked to describe his working methods, Rickey says, "My works have to be preconceived. I cannot improvise as I go along anymore than you can improvise the making of a propeller or a washing machine. I make the larger proportion of mistakes on paper first. The next step is going to some rather crude model, often made in five minutes, to see how I can get the traffic organized, because there are certain things you cannot draw, even in perspective. Certain parts are made for me outside, otherwise they are made in my studio. Although I work with assistants, nothing is fabricated by somebody else. It all comes to its end in the studio."

Reflecting on the philosophy and aesthetics of his work, George Rickey maintains that it is simply the pursuit of what is possible.

"I make things now that I would never have thought of as possible. If I have been working on the development of a

language, which in some ways I have, at the same time I've become more and more aware of what it is possible to say with that language. For example, for years I accepted what I would call linear movement or movement along a straight line. Then I came to realize that one can design an object in which the movement is along a curve. It's like a phrase of music that takes an unexpected turn.

"Finally, I did not want merely to set a static art in motion, nor did I want to describe the dynamic world around me with a series of moving images. I wanted the whole range of movements themselves at my disposal, not to describe what I observed in the world around me, but to be themselves, performing in a world of their own."

1980

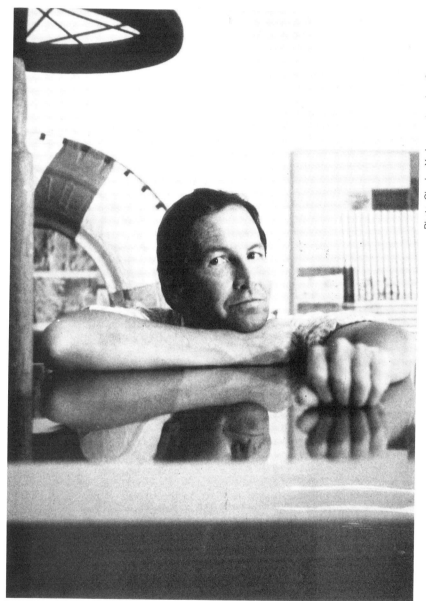

Photo: Charles Yoder, courtesy Leo Castelli Gallery

ROBERT
RAUSCHENBERG

R obert Rauschenberg has emerged as America's most note-
worthy and newsworthy artist—an enfant terrible who has
come of age, and whose contribution to the ethos of contempo-
rary art has placed him in the forefront of international
acceptance and recognition.

Standing at the center of his extraordinary réclame,
Rauschenberg is the lone bystander of his fame, a figure
detached from the worldwide influence engendered by his
work, a man oddly disengaged from his past, yet fully
immersed in the present, and highly involved in the future. An
ingenuous sense of wonderment clings to Texas-born Rausch-
enberg as he contemplates his achievement. The occasion for
our discussion was a 25-year retrospective show of his works,
which opened in Washington, D.C., in 1976. Rauschenberg was
genuinely surprised by his own—and the public's—reaction to
the show.

"Before all the galleries were hung in Washington, and all
the pieces were just lying around on the floor, still in their
wrappings, I had a very serious emotional, psychological
twinge about the show," he told me. "I was terrified that the
opening would resemble a funeral, because, as it turned out,

people were sending flowers, taxis and limousines were lined up around the museum, everybody was all dressed up, and my mother arrived from Louisiana, wearing her best dress. Well, it was like death. I thought, 'I'm not so sure that this is the best direction to go.' Then, when I myself arrived, expecting just a normal turnout, I saw this ocean of excited and friendly people. I couldn't believe it! Instead of it being like a funeral, it was as though the works were giving a party for me!"

Rauschenberg and I were sitting in the kitchen of his studio/building on New York's Lafayette Street. It was a setting strongly reminiscent of a Rauschenberg combine. A dead-black cast-iron stove dominated one wall, its chimney, burners, and oven doors, a study in turn-of-the century craftsmanship. A vase, containing a violent shock of tiger lilies, stood on a long, heavy kitchen table, laden with plates of mozzarella cheese, sliced tomatoes, and hot sausages. A huge solarium, containing a plethora of burgeoning plants and warmed by artificial light, stood at the opposite end of the room. ("I refer to it as one of the largest lamps in town," said Rauschenberg.) In one corner of the floor, a live turtle made tentative forays across the room ("He guards the place"). During our interview several people, including Rauschenberg's former wife, the painter Sue Weil, artist Robert Peterson, and an oriental mother and child, wandered in and out of the kitchen. But Rauschenberg's concentration was unwavering, as he sat across from me, discussing the effect his retrospective had on him.

"The first reaction was one of relief, because most of the pieces, except for the very recent ones, I hadn't seen in years and years. I kept thinking, 'What would they look like?' because they had gotten very dusty in my mind. I think you almost had to have a mistaken idea about a piece that's 25 years old, especially if you're still working. Well, as I looked around the installation, brilliantly conceived, by the way, by Walter Hopps [curator of contemporary art at the Smithsonian's National Collection of Fine Arts], I could almost recall the smells of the particular studios in which certain pieces were made. And I got terribly nostalgic about the people that I knew during those particular periods—people I was very close to. Unfortunately, the more active you are, the harder it is to maintain solid

relationships. I mean, your relationships change with your appetite. Anyway, I had an experience that, naturally, no one else could have, because I'm the only one who has been with me that long."

At 51, Rauschenberg looked back on a career that has consistently defied categorization. Never content with pursuing a single idiom, he has produced works that for their time seemed entirely scandalous, and totally out of kilter with the going trends. An insatiable curiosity led him far afield from the stylistic schools of the 1950s and '60s, a time when American art came into its own through Abstract Expressionism, Color-Field painting, Pop Art, Op Art, Conceptual, and Minimal art. As it turned out, Rauschenberg, fully aware of the tides of stylistic change, took each variety just that one step further, incorporating its loud echo into his own, highly individual works, and inventively manipulating its basic intonation to suit his own needs. Working in extremes, he would use actual objects, affixing them onto canvases—thus inventing his famous combines. In a work such as the 1955 *Bed*, paint-splattered quilt, sheet, and pillow were glued on a canvas, producing an image of reckless and bizarre realism. In *Monogram* (1955–1959), perhaps his most outrageous combine, a stuffed goat encircled by a rubber tire and standing on a sculptured collage, offered shades of Duchamp while simultaneously suggesting an atavistic presence, at once outlandish and deeply disturbing.

In work after work, Rauschenberg shaped visual monuments that stayed fixed in the mind through the very peculiarity and immediacy that gave them life. His vision is such that the everyday—a crumpled scrap of paper, a photograph, a newspaper headline, a postcard, a rusty bucket, a door, or, indeed, a stuffed goat—becomes transmuted into an expressive metaphor, the meaning of which is as elusive as it is somehow charged with clarity and myriad inner meanings. As printmaker, Rauschenberg has few equals. While size does not always equal monumentality, he has nevertheless produced the largest hand-rolled print in existence—a color lithograph and silkscreen on paper entitled *Sky Garden*. It is a lesson in technical bravura, equaled only by a 17-foot-long print *Autobiography*, produced by an offset billboard press. But these bold and

startling essays in tour-de-force printmaking conceal an alto-
gether loving and intimate approach to the sheer "making" of
something, for Rauschenberg is first and foremost an artisan—
someone whose love of craft is constantly placed at the service
of his unpredictable inventiveness.

If the artist has consistently struck out on his own within
the framework of painting, sculpture, and printmaking, he has
done no less as an explorer in other creative fields. In the late
'50s and early '60s, he aligned himself with the musical,
theatrical, and dance avant-garde of the day, not only creating
sets and costumes for the choreographic and musical experi-
ments of Merce Cunningham and John Cage, but actually
appearing with these artists in performance. During the middle
'60s, Rauschenberg met Billy Klüver, a Swedish laser research
scientist from the Bell Telephone Laboratories, and together
they formed a foundation called Experiments in Art and
Technology (E.A.T.) whose purpose was "to catalyze the
inevitable active involvement of industry, technology, and the
arts." Here again, Rauschenberg's sense of adventure was
coupled with an intense curiosity about the possibilities of
expanding the creative act—via scientific collaboration. Ulti-
mately, it served the artist to coalesce his ideas about electronic
multimedia as a viable creative force, which, during the '70s,
would give rise to the proliferation of video art, among other
electronic experiments.

Milton Rauschenberg (he changed his name to Robert as a
young man) was born on October 22, 1925 in Port Arthur,
Texas, an oil-refinery town on the Gulf of Mexico. His father,
the son of a German-born doctor, was something of a drifter.
His mother is a Cherokee.

"As a child, I always drew a lot, and I was always terrible
at sports, and I thought I was just a sissy. I had no advantage
over anyone else. Well, you know how painful it is to get
through things like school! I became very quickly a very bad
student, and it was always a struggle for me to study. So, all my
school books are filled with drawings. It wasn't until I left
home, and went into the Navy, that I came to know that there
was such a thing as an artist. I more or less thought that
everyone liked to draw as much as I did. When I got out of the

Navy, I just traveled around, not really knowing what to do. Well, in the mid-'40s, I landed in California, and I found a job as a packer in a bathing suit factory. There, I made a friend, who convinced me that I was an artist, but that I needed training. She was a student at the Kansas City Art Institute, and she said she'd try to get me into it, which, to my astonishment, she did. What I *really* wanted to do, was to go to Paris because . . . well, it was the Mecca. So, after about a year at the Kansas Institute, that's just what I did.

"In Paris, I studied very briefly at the Académie Julian, but I couldn't speak a word of French, and, as an art student, I was as lousy as anyone could possibly be. I was embarrassed by the sophistication of the other students, and so took to painting on the streets, and in the room of a cheap pension. While in Paris, I met an American art student, Sue Weil, whom I married in 1950. One year later, our son Christopher was born. He's 25 now, and a fantastic photographer. Anyway, when I met Sue, she was going back to the States, to attend Black Mountain College in North Carolina. I had never heard of it, except that I had read in *Time* magazine that Josef Albers was teaching there, and that Albers was the greatest disciplinarian in the world. Well, I really needed discipline. You see, I had enough sense to be able to recognize that art isn't made out of passion alone. That surprises me even today, thinking about how completely indulgent I was when I started painting. At the time I found it too distant to even use a brush. I needed the immediate contact. If I could have been the canvas too, that wouldn't have been close enough for me. I mean, all the marks on my clothes on which I wiped my hands were much better composed than any of my canvases.

"Anyway at Black Mountain College, I had a year of extreme happiness with my wife, but a great deal of misery with Josef Albers. Of course, I learned a lot . . . but the intimidation! I was his pet student to intimidate and, in some way, for a disciplinarian, that was really quite generous. So, I was privileged but humiliated. Again, I met very sophisticated people. Buckminster Fuller passed through, there were great mathematicians, and John Cage and Merce Cunningham came and went. I was still much too shy to come forward and make

friends with these people, but there were moments when I could see a similarity in our thinking. Eventually, I did make friends with John and Merce. I think John Cage was already a Zen by choice, and I had tendencies toward an aesthetic that was leading me into a raw Zen. It was just an attitude about materials that was strong enough not to submit to Albers' dictum of 'It's the *man* who does the painting.'

"The fact is, I still work attempting to be invisible. Often, I have to start off attempting to do something by slipping into another consciousness that allows me to be the spectator while I'm working, so that there's at least an audience of one. And sometimes *that* can be a crowd. At any rate, Sue and I remained at Black Mountain for about a year, and then there came a point when I really had to face the city—New York. I still had so little possibility as an artist, that the Art Students League was really the only place that could cradle me."

Rauschenberg's arrival in New York in 1949 did not immediately bring about a change in his work, but he quickly became aware of the burgeoning of Abstract Expressionism, and began attending exhibitions of Pollock, de Kooning, Rothko, and Kline at the Betty Parsons and Egan galleries. Still, he kept to a rigorous painting schedule at the League, where he studied with Vaclav Vytlacil and Morris Kantor.

"I still think that going to a school is a much better way to start out as a young artist than doing the battle of the landlords. I mean, it's very nice to have your lofts first, but it doesn't quite work that way, because an awful lot of frustration and energy is put into just trying to survive. Anyway, at the Art Students League, there were always three or four people that appeared like gods. I had no idea how they ever learned to paint so beautifully, when everything *I* was doing was turning to mud. I was still so shy that it was easy for me to slip and hide in the shadow of nearly anyone. However, I wasn't unobservant, and it began to affect my work. I'd go and look at the New York painters, trying to figure out something, because I had no background to understand their work. I mean, I responded emotionally, but with confusion, not knowing why these particular works could excite one so much.

"Finally, one day I picked up a bunch of paintings I had

done, and walked down the street to Betty Parsons. These were allegorical cartoons, using abstract forms. They were mostly black, white, and yellow. One of them I called *The Garden of Eden*, which was like a cartoon series of flower stems, with a circle on top. They were very simpleminded paintings. Well, I brought these in to Betty, and she said, 'I only look at work on Thursdays.' You see, it was a Monday. I said, 'Couldn't you look at them, and make believe it's Thursday?' And she said, 'All right, all right, put them in that small room there, and I'll look at them.' I was getting my first dose of what it is to be an artist in New York, and I thought, 'God, this *must* be the dumbest thing I've ever done.' Well, Betty Parsons looked at the work and said, 'I can't give you a show right away.' I told her that I hadn't come to ask for a show, but only because there were so many things going on in her gallery that I didn't understand, and that I wanted her eyes to get on to my work too, to see if there was anything like that there. She said, 'Well, I can't possibly give you a show until May!' So, that's where I showed first in 1951.''

Betty Parsons herself recalls the young man arriving at her gallery with a stack of paintings under his arm. ''The moment I met Bob, I could tell he was alive, perceptive, and aware of everything that was going on,'' said Parsons. ''He was the most charming and endearing boy. Very shy. I loved him right away. Of course, looking at those early pictures I knew he still had a long way to go. But I sensed that spark—I knew there was a big talent there. All that was needed was encouragement and time for that talent to develop. God knows, he's proved himself! I was happy to have given him his first show in New York, and happy we're still good friends.''

With a one-man show in New York in one of the city's most prestigious galleries, did Rauschenberg now consider himself in the stream of New York art—a full-fledged artist of unusual promise?

''Not at all. I was much too naive for that. Also, by that time, my wife and I had broken up, and I lived quite alone. It wasn't until I started going to the old Cedar Bar that I got some sense that there was a kind of life-style that made you an artist or not. I looked and listened very carefully to all that, but I sort

of revolted. You see, early on, at the Cedar Bar, guys like de Kooning, Kline, Pollock, and Guston never talked about anything except painting and the painting experience. And that was wonderful, and very exotic to me. But then, almost overnight, when the world had to acknowledge that there was such a thing as American art, and when all those artists became successful and famous, all you heard them talk about was money and taxes, or 'This collector is in town, and he's *my* collector!' Well, I was revolted by this. I just found it very offensive, and so I kind of removed myself."

During the early '50s, Rauschenberg met Jasper Johns, with whom he formed a close friendship. "Jasper was just beginning as an artist too. Even though our ideas were very far apart, the thing we had in common was that we were not in the Abstract Expressionist movement. Neither did we fit in the Tibor de Nagy group, with people like Fairfield Porter, Grace Hartigan, Helen Frankenthaler, and Larry Rivers. So, we really didn't have to fight to stay off by ourselves. In a way, it made us stronger than if we had had immediate acceptance. Our isolation was forced on us through our differences and atti- tudes. Also, it was the time of Kerouac and Ginsberg, and 'The Sad Cup of Coffee,' and I hated all that. I mean, people whining about their condition, and then glorifying it in extravagant language. I hated all that metaphoric suffering. And it was the time of the Artist's Club! Talk about suffering! Well, I couldn't stand any of that. So, during that period, Jasper and I didn't much get along with other artists—not by choice, but by aesthetics.

"And so, that's when I got close to the Cunningham dancers, and to Merce himself, and to John Cage, and to the musicians just budding then, like Christopher Woolf and Morton Feldman and Earl Brown. In my conscious struggle to do something without the sponsor of one single ego, I began to work in consort with these people. I've always been attracted and tempted into nearly any situation where the final work was the result of more than one person's doing. That's why I like dance, music, theater, and that's why I like printmaking, because none of these things can exist as solo endeavors. Also,

the best way to know people is to work with them, and that's a very sensitive form of intimacy."

If Rauschenberg placed both his art and his person at the service of joint avant-garde experiments, he did not make this his exclusive province of creativity. Indeed, by the time he joined the Leo Castelli Gallery (still his dealer) in 1958, he had produced a large body of works, including paintings, combines, drawings, and prints, done in the solitude of his studio. For Rauschenberg, the solitary creative act is a matter of stepping outside of himself—of allowing his consciousness to be in some way suspended and diverted.

"I have various tricks for myself to actually reach that point of solitary creativity. One of them is pretending that I have an idea. But that trick doesn't survive very long, because I don't really trust ideas—especially good ones. Rather, I put my trust in the materials that confront me, because they put me in touch with the unknown. It's then that I begin to work . . . when I don't have the comfort of sureness and certainty. Sometimes Jack Daniels helps too. Another good trick is fatigue. I like to start working when it's almost too late . . . when nothing else helps . . . when my sense of efficiency is exhausted. It's then that I find myself in another state, quite outside of myself, and when that happens, there's such a joy! It's an incredible high, and things just start flowing, and you have no idea of the source. If there's a break in that, I usually think of some way to leave the work. I go into the other room, fix myself another drink, and then I go back and hit it again from another direction . . . as though I were someone else, who hadn't been there before."

The recent years have found Rauschenberg tied more to his work than to his friends. "As each person matures, and gains a certain success, and gets more into his own style of living, it almost forces one apart. There are lots of people I felt very close to, that I rarely see. Jasper is one of them. Frank Stella is another. I knew Frank when he was painting completely differently—just beginning as a student at Princeton. I used to drop by his studio, and see what he was doing. Now, the way our lives have developed, or decayed, I have to make an

appointment to see him. I must say, I miss the feedback of such friendships. I made *Barge* through the excitement of seeing an incredible Jim Dine. I was just passing by and dropped up to his studio to see what he was doing. He had done the piece with the big aluminum chair and sofa. Well, I was so moved by that piece, and about the lousy lighting he had in his studio, that I ran all the way to Rosenthal's art store to get the largest piece of canvas they had, and started *Barge* that very evening. I finished it the next day . . . with nonstop painting for 48 hours. So I miss that kind of feedback.

"Now, I have lots of new friends who are just beginning, and it's really nice to go to their studios, but it's not the same. There's not that kind of dependency, and I really can't talk to a young painter the way I can to a colleague. It makes me feel sad and rather isolated. I was talking to Brice Marden the other day, and I told him he'd better get used to loneliness. Actually, I don't really think that's sad. I just think it comes from some kind of mysterious drive that almost eliminates all the other things that are, of course, a lot more fun. That's the price you pay for those incredible highs. I mean, just before you've finished a painting that just surprises the devil out of you, there isn't anything that I can think of that you can acquire or have that would come anywhere close to that.

"I am basically a corrupt person, and I've investigated these things, so, I'm sure that if there was something to take its place, I would have found it. And so, the most precious thing to me now is time to work. But I almost have less and less of that, because whenever I have an exhibition, I like to be there. I like to be part of hanging it. That's where you can see the work more rawly, and in a foreign situation. I also like to talk, and be with the people who are looking at it, as part of my inheritance for having done the work. And I'm always open to what people say—I have 380 degree hearing, and I have to keep myself in an exposed position, because I never know at what moment someone is going to say something or I'm going to see something that's going to change my entire attitude. The thing that's most consistent in my work, is that, fortunately, I've not been cursed with talent, which could be a great inhibitor.

"Even at this late date, I go into my studio, and think 'Is this going to be *it?* Is it the end?' You see, nearly everything terrorizes me. I think that when an artist loses that terror, he's through. For me, there are no guarantees, which of course adds to the thrill. One of the things I got out of the retrospective as an artist was, OK, everything was all right. The works have brought *me* up-to-date, and I feel liberated. I can go on to the next thing. But my changes are always arbitrary. It's when you've found out how to do certain things, that it's time to stop doing them, because what's missing is that you're not including the risk. The fact is, risk is essential to me."

Although he makes frequent visits to New York, Rauschenberg now lives in Florida, on Captiva, a five-mile-long island, south of Fort Myers, on the Gulf of Mexico.

"I was really very worried when I left the city. I was very concerned how anybody who is as social as I *can* be could go and live in isolation on a fairly deserted island. It was a very dangerous thing to do. But then, I found it wasn't dangerous at all. In fact, it makes New York so much richer for me. I mean, New York is not its skyline, but its people. It's all happening on the sidewalks—on the asphalt, in the taxis. It's a very abusive place to live in. But its irritations and threats keep you alive. And the unpredictability of it! So, I was concerned about leaving the city. And I was worried about the idea of owning land, which seemed too abstract an idea for me to understand. But in order to live there, I had to buy property. So, I live on Captiva, and I've lived there for eight years. The slowest thing I do there is swim and fish. Of course, I also work—mainly on prints. These days, I'm also making a change. It's a gift to myself for having survived the retrospective. I'm making what I'm calling 'Spreads'—and I'm going to allow myself to be as eccentric as I please, and as indulgent."

Robert Rauschenberg laughs, and falls into a silence. "You know, I don't take success for granted at all. The art business is so fickle! Public opinion and taste can change tomorrow, and before you know it, you're out pawning everything you own. But I'll tell you something. In many ways, I was much happier when I had much less responsibility . . . when my only

responsibility was to my work and to myself. Now, my life has become so frantic and so complicated. And the anxieties . . . ! I guess what saves me is that I have a very strong survival instinct. When that's gone, God knows *what* will happen!''

1977

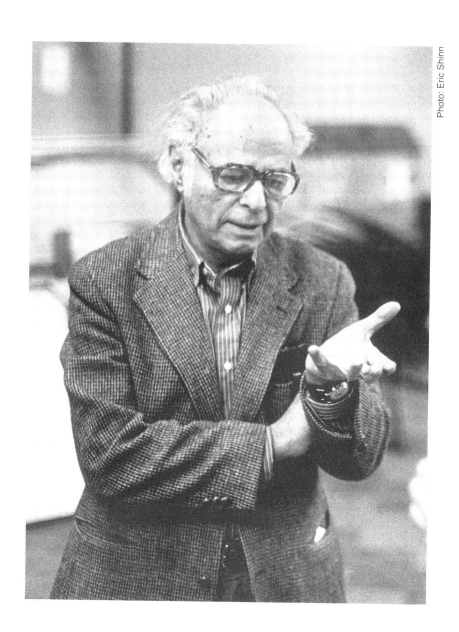

GEORGE
SUGARMAN

The awkward logic of George Sugarman's sculpture has riled, puzzled, and bewildered a generation of art cognoscenti. They never quite knew what to make of works that had consistently defied categorization. Was it Cubist, Baroque, or Surrealist? Perhaps it was Expressionist or just straight out of Matisse. Then again, it might be pure decoration—just a lot of odd shapes strung together, painted in bright colors, and really quite pretty to look at. Or—was it possible?—a commanding breakthrough in the notion of what sculpture should really be about.

Sugarman himself was confounded by the reaction his work elicited when it was first shown in the late 1950s.

"I felt I was a traditional artist coming out of the 20th-century aesthetic," he says. "And yet, people looked at my pieces and said I was crazy. They said I was a maverick—they didn't know where to place me. You see, all through the '60s and '70s I had no label. I wasn't Pop. I wasn't Minimal. And Maximal was a word that wasn't used. Yet I *was* a Maximalist. I said I wanted to put *everything* in my work—even the kitchen sink. My motto has always been, 'Never throw anything away.' I feel that more *is* more and less *is* less, no matter how the saying

goes. So, I was given a very hard time early on. I mean, the critics looked at my work—my first colored sculptures—and they found it just incredibly ugly and vulgar. I couldn't understand it. I was furious. Why the fuss about color on sculpture? Color has always been used—from the Greeks on! And *their* color was vulgar—purple and gold! Boutique colors! Well, I was crucified. The critics, the public, and fellow artists laughed at my stuff. It was horrible."

Although he recalled it all with a smile, George Sugarman, at 73, could not mask a certain bitterness. While critical abuse has long given way to praise and acclaim, a residue of anger remains. And with reason. From the first, his work had been deemed perverse. Sugarman never opted for the safety of hallowed traditional sculptural modes—the sacrosanctity of materials, the basic verticality and two-dimensionality of figurative styles. Not for him the heavy, black, "I'm-an-important-artist-and-you-must-be-in-awe" kind of sculpture.

What he was after was obtusely daring. He wanted to make sculpture that would combine the open forms of late Cézanne watercolors, the clarity of Michelangelo's *David*, and, most of all, the open-ended rush of light and seeming weightlessness of Baroque sculpture. He wanted to create a sculptural language that would do away with distinctions—the shocks of instant recognition. When he began to use color, it was solely to enhance and separate form. When he first used it, he had no idea that it would also have a strong emotional effect. All Sugarman knew was that with color each form would act as a separate piece of sculpture, and a continuum would be generated—a continuum in which a progression of forms produced a jazzy and jaunty totality.

Thus the look of a Sugarman sculpture has the momentum, rhythm, and sonority of musical improvisation—an almost foot-tapping movement through space that seems to follow the serendipitous dictates of a convoluted riff. The improvisation could meander, run, stop short, spiral downwards, upward, backwards, forward, curl about itself, then shoot out again in propulsive bursts. What it never did was remain static or fixed in space.

By the same token, the work has a kind of undefined

structural base, one that becomes evident when one realizes that, for all its precipitousness, any Sugarman piece is engineered to firmly support itself. Indeed, everything coheres. And the coherence comes about because the relationship of the forms is painstakingly thought through. No matter how disguised, the structural backbone is always present.

George Sugarman lives and works in a studio loft on Bond Street in lower Manhattan. It's a long climb. When you're finally there, the sight is singularly modest: a spare, somewhat drab living area with a table, a few chairs, a sleeping cot, a bookcase, a stove, and a bathroom. The studio space is conventionally large, but eons away from the supra-dimensional, big-bucks working lofts currently favored by big-gun and even little-gun artists. The place is decidedly not meant to impress. Nor is Sugarman the kind of person to flaunt his celebrity or stature. Clearly, pretentiousness and self-importance are not in his makeup.

A most convivial man, the artist has the good-natured, puckish face of an aging Mickey Rooney. Frequent smiles and bursts of laughter punctuate his story-telling. He obviously enjoys company, although he quickly admits that he prefers living alone. "I'm better alone," he says. "I enjoy people very much, but when I come home I want to be alone—it's the kind of person I am."

Perhaps the most unusual fact about Sugarman is that he did not seriously embrace art until the age of 39.

"It just took me a very long time to mature," he declares. "I was really very innocent for a long time. Even when I did become an artist, I was innocent. I knew nothing of the art world—people had to tell me about it."

Born on May 11, 1912, in the Bronx, George Sugarman nevertheless developed an early passion for drawing, sketching, and looking at art. The son of an Oriental rug dealer, he would often accompany his father on rug-selling trips and, from the first, loved the color and pattern of Persian and Turkish rugs. But young George's burning ambition was to get out of the Bronx. ("With my first nickel I took the subway and went to the Metropolitan Museum of Art.")

Following his graduation from Bronx Morris High School in

1928, he enrolled in the City College of New York, emerging with a B.A. in 1934. There were various jobs: teaching arts and crafts for the WPA; being a welfare department investigator. During World War II, Sugarman served in the U.S. Navy (from 1941 to 1945), and, following his discharge, attended evening art classes at the Museum of Modern Art. Still, Sugarman never thought of himself as an artist.

"I decided to be an artist in Paris," he says. "I went to Paris in 1951 and lived there until 1955 on the G.I. Bill. Actually, my plan was to become a painter, but I didn't like any of the painters I could study with, and so I went to study with Ossip Zadkine, who was the only sculptor I knew. I didn't much like Zadkine. He was a destructive person. He'd scratch people's bronzes—he'd destroy their work. He didn't much care for what I was doing either. He used to say, 'If it weren't for your drawings, George, I'd kick you out of the school.' Finally, I quit going to him and went to study at the Académie de la Grande Chaumière. Soon after, I knew I would be a sculptor.

"At the Grande Chaumière, I did nothing but draw from the figure. I did this four nights a week for an entire year. I drew the figure every which way—realistically, abstractly—in every possible manner. At the end of that, I made the decision that the abstract mode was what interested me most. I felt that if you were going to work figuratively, you've got to be able to say something about the human condition. I wasn't sure that I had anything to add to that long tradition of figurative art. I felt I was more interested in pursuing abstract art. I must say, Paris was disappointing in those years. There was very little art there. Picasso and Matisse were working in the south of France, and were not available to young artists. I *did* meet Constantin Brancusi, and I really loved his work at the time. He was charming in his white gown and white beard and white cap. He uncovered all his pieces and led me around his studio. *That* was wonderful. But other than that, nothing much was going on. And so, I traveled—throughout France, Spain, Italy, and Germany. It was the greatest schooling."

Steeping himself in European art, Sugarman's commitment to sculpture deepened. Thinking, learning, and looking for a direction, he came to the conclusion that the radiant and open

forms of Baroque sculpture would be one of his major sources of influence. He looked at the work of Bernini and realized that open space *is* form. ("Just because there's nothing there doesn't mean it's empty.")

With this in mind, Sugarman began to produce works that in their complexity and extensions echoed the Baroque precept. Some of his earliest wood carvings and terra cottas offered abstract shapes that, in the words of Holliday T. Day (writing in his introduction to Sugarman's 1981 retrospective at the Joslyn Art Museum in Omaha, Nebraska), "adopted Picasso's juxtapositions of discrete, clear forms to rebuild space as well as Archipenko's use of voids to imply form. While Sugarman rejected the figurative nature of Cubist sculpture, he, like the Cubists, believed artists should invent forms not imitate nature. Sculpture should be invented and abstract, not referential."

Thus it was that Sugarman's thinking coalesced—and his work took wing.

Returning to New York in 1955, the artist was suddenly thrust back into the exhilarations of his native city and into the ferment of Abstract Expressionism. It was a rejuvenating experience.

"It was thrilling being back," remembers Sugarman. "You see, Paris is a very composed city. Haussman put his stamp on it. It's lovely, symmetrical, logical. You come to New York and there is the cacophony of one kind of building next to another kind of building. It's completely crazy! And the traffic on the streets! And the ethnic diversity! I just loved it. I said, 'I'm a New Yorker after all!' So, I looked around and thought, 'Why can't I do this in sculpture?' After all, space is the key to sculpture. But no one was doing it. I mean, Ibram Lassaw was doing his Cubist thing, but there was no extension into space. There was David Smith. But I always felt Smith was basically figurative and two-dimensional. There was Alexander Calder— and Calder I loved. I liked the wit and joy. But I said, 'My work is going to be three-dimensional.' And I worked toward that."

If Sugarman re-encountered the city in all its elating vibrancy, he also re-encountered poverty. A miserably paying job teaching shop in a small private school hardly took care of the rent, let alone sculpture materials. He remembers going out

late at night, picking up wooden pallets used by truckers to hoist merchandise onto forklift trucks, putting them on his back, climbing up to his tiny studio, then breaking up the wood so he could use it the next day.

"I did everything by hand," recalls Sugarman. "I didn't have the tools. I couldn't even afford a bandsaw or an electric drill. I was working with logs or one trunk of a tree. But it was too limiting. It didn't give me the space. I wanted to use space as material—as a form. So I started to laminate the wood. I glued it together and screwed it together and put dowels in it—stuff like that. And I began to show those pieces. Around 1957, I joined the Brata Gallery and also helped to found the New Sculpture Group. I showed at the Hansa Gallery. These were all co-operative galleries down near Tenth Street. Then I was picked up by the Stephen Radich Gallery, and had a one-man show, which was warmly received. As a result, I was invited to show at the Carnegie Institute in Pittsburgh—it was the international prize show—and I won second prize. Alberto Giacometti won first prize and David Smith won third. I couldn't believe it!

"Well, a lot of people resented me for that, as though it was my fault for winning a prize. But you see, all of a sudden I was having a one-man show at Radich, and I'm ahead of David Smith. I just couldn't understand the resentment. I had to work so hard. I didn't have time to go out and socialize. I couldn't afford to. I had to worry about the carfare in those days. The fact is, I didn't understand about the art world. I was an innocent. It never occurred to me I was competing with David Smith, and I certainly was not competing with Giacometti. And then, when I showed my first colored pieces in 1959, people just hated those things. I mean, art officials and the critics were enraged. It was terrible. Still, a few people caught on. And the Abstract Expressionist painters liked my work—especially Philip Guston. He was very friendly.

"Of course, I myself related very strongly to the Abstract Expressionists. After all, I'm an Expressionist. No question about it. And I related most strongly to Jackson Pollock. He's *still* a beautiful artist. He's profound. de Kooning I admire tremendously, but the lessons in terms of space are Pollock.

Anyway, I felt very much a part of the movement. As for my use of color, I did that deliberately to make the forms more disjunctive—a term used now, which sounds like a disease . . . you know, 'multiple disjunction.' When I first heard that applied to me, I thought I'd better see a doctor!"

Throughout the 1960s, the dazzling bluntness of Sugarman's sculpture—its vitality and energy—began to impose itself upon an art world still somewhat reluctant to fully accept it. But with each subsequent show (at the Radich, briefly at the Zabriskie Gallery and at Fischbach, and, ultimately, at the Robert Miller Gallery, Sugarman's dealer since 1977), collectors came around, and European galleries, notably in Switzerland, Germany, and Holland, exhibited the work. In 1963, Sugarman showed at the Sao Paulo Biennale. In 1965, he was awarded a Ford Foundation Grant. In 1967, he was a visiting associate professor of sculpture at the Yale School of Art. In 1969, he had his first major retrospective in Europe, exhibiting in Basel, Berlin, and at the Stedlijk Museum in Amsterdam. And it was during the '60s that Sugarman created his first large-scale outdoor sculpture.

"I wanted to get away from wood, and I wanted to do big sculpture—get away from the smaller indoor things. I just *had* to get out of doors. It all happened at a very good time, through Amy Goldin, one of the critics who really loved my work, who introduced me to someone called Max Palevsky. He was looking for a large outdoor work for the new Xerox building in El Segundo, California. Amy brought him up to my studio, where I was working on a big piece in wood called *From Yellow to White to Blue to Black*. Well, Palevsky commissioned me to do that piece in metal—and that became my first outdoor sculpture. Then, I was asked to do a piece for the First National Bank of St. Paul, Minnesota, and other commissions followed. I got better known."

Indeed, the outdoor sculpture of Sugarman, with its vivid color, its suggestion of playful utilitarianism, its fugue-like progressions of interior and exterior space, and great sense of lightness, all harks back to the sculptor's belief in the releasing aesthetics of the Baroque—the gradual opening up of form and the revelation of light. Certainly, the inventiveness of such New

York City pieces as *Doubles* (at 780 Third Avenue) and *Yellow and Purple* (at Fifth Avenue and 60th Street), or *People's Sculpture* at the Baltimore Federal Center, and the Will's Eye Hospital commission in Philadelphia all make clear Sugarman's great capacity for turning public sculpture into visually provocative and highly entertaining explorations in space, form, and color.

As the critic Kay Larson recently put it in *New York* magazine: "Sugarman's outdoor sculptures can meander through the space at the base of an architectural colossus without being forced to bring their peregrinations to an end or to compete with the scale of the building behind them. They survive because, like origami, they generate their own space. Perhaps this isn't a brilliant new definition of sculpture, but it's a highly adaptable one that has allowed Sugarman to prosper through several decades of being poised on the brink of arrival."

It has often been said of George Sugarman's work that it rides dangerously close to pure decoration—that its sprawling, lighthearted twists and turns are frankly superficial and lacking in depth. Sugarman has a ready answer:

"I'm not insulted when people say the work is decorative. I think it's a very valid kind of art. But the charge is superficial, because people are responding just to the superficiality of the color, not to the forms. You see, I feel that decorative art is never as vigorous as my work is, and it's never composed of big, jolting discontinuities. It never wants you to think how a piece is put together or why it was done in the first place. Decorative art is meant to be comforting. People may find joy in my stuff, but it's never comforting. It's never a nice, quiet background for a home. And there's the difference.

"Of course, I'm never totally happy with what I do. I'm always searching. Also, I've never really been a part of any movement. I have no label, and I'm never trendy. And yet, I seem to have touched base with practically every movement— Abstract Expressionism, Pop, Op, Minimalism—you name it! Perhaps it's because the work is so all-inclusive. The complexity is there. I believe in complexity.

"You see, I believe that art is a continuum—from the scribble a kid makes to advertising art to decorative art—there's

a whole continuum of visual expression. I think it's wrong to break down all those distinctions. There are all kinds of in-betweens. Of course, there is the glorious art of the great masters, and of course we all aspire to that glorious condition. But it is a falseness to make these abrupt distinctions. That's just not what the human condition is. But the critics do that; they make distinctions. The trouble is, words are not art. Art is very specific and words are not."

George Sugarman smiles, and when asked what keeps him going, what, at 73, gives him impetus to make the search ever more viable and important, he responds with his usual candor:

"I just enjoy doing things. I enjoy being involved. I enjoy commitment. In spite of all this horrible, horrible world, I feel we're going to survive. I know this sounds silly, but when I walk along the street, and I see a little crack in the sidewalk, and there's a blade of grass growing, I say, 'Gee, maybe that bomb won't knock us out altogether.' I just feel that human beings find an 'out' for everything. Maybe I'm an optimist at heart.

"Of course, there's no perfection. But I feel I still have a lot to say. I'm just struggling like mad to say it. I think I've managed not to be cynical about art. I still believe. And it keeps me going. And I'm fed—especially by music. I listen to music all the time. It's taught me so much about rhythm and pacing and form. I get visual ideas from listening to music. So, I would say I have a contentment. But, of course, the struggle continues."

1986

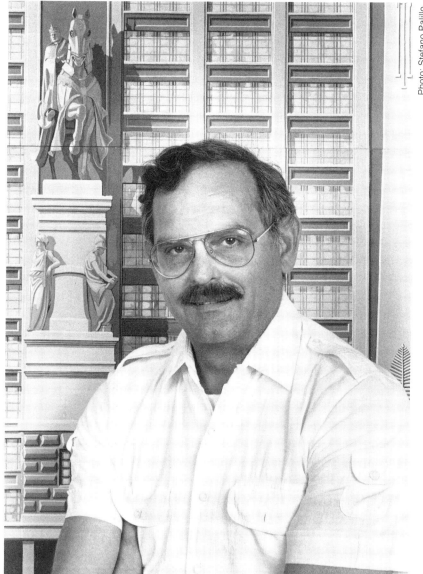

RICHARD
HAAS

R ichard Haas's studio on Greene Street in Soho is an atelier in the old-world tradition—a world inhabited by the accoutrements of 19th-century imagination and sensibility. Divided into interconnecting working and living spaces, each area reflects the artist's keen involvement with his metier and personal vision of life. During the daytime hours, three assistants labor intently at various tasks pertaining to Haas's ongoing projects that will ultimately result in the grandiose illusionist wall-paintings that will transform exterior portions of drab city buildings or sections of large public and private interiors into startling trompe l'oeil architectural facades.

Easels, work tables, stands, cabinets, and other assorted equipment fill the light-drenched front studio in which John Williams, Kathleen Loe, and Jane Nisselson, together with Haas, combine to make of photographs, sketches, drawings, and paintings a final visualization of what will eventually become a finished and fully realized gigantic work of art. John Williams, who has assisted Haas for some three years, is in charge of photographic documentation. Kathleen Loe, a painting graduate from Queens College, stretches canvases, then sets to work enlarging Haas's sketch-drawings, turning them

into full-scale paintings, gridding them up and blocking them onto the canvas, mixing colors and applying these according to Haas's specifications. Jane Nisselson is in charge of the written documentation of any given site: its history, condition, size, etc. This bustle of activity usually takes place to the sound of soft classical music emanating from a hi-fi system in a corner of the studio. The atmosphere is intense, concentrated, and entirely peaceable.

To the rear of the loft are Richard Haas's living quarters. Here, one enters a world of fantasy. On facing walls, the artist has painted illusionist murals giving the long room the semblance of deceptive spaciousness. The wall behind the dining-room table has been transformed into a Palladian balcony that, in trompe l'oeil fashion, overlooks Spring Street, duplicating the actual view were the bricks of that wall removed. On the opposite wall, Haas has painted a doorway that, again in trompe l'oeil fashion, leads into two connecting rooms with false rear windows that look out on the World Trade Center. Once more, this would be the actual view if real windows were situated there. Elsewhere, a painted fireplace with burning logs again gives the semblance of reality. This playful admixture of what *is* and what *seems* is at once amusing and astonishing, giving a visitor an altogether pleasant and slightly eerie sense of dislocation.

Richard Haas came into prominence in 1975 when he created a mural for a cast-iron building located at 114 Prince Street in Soho, commissioned by City Walls, Inc. The building's real facade, structurally elegant in every way, did not continue all the way around the site. The wall facing the corner of Greene Street was empty and blighted, and Haas conceived of the idea of continuing the building's cast-iron motif by way of a gigantic mural that, through an illusionistic copy of the structure's real facade, would render the building complete. The result was (and still is) an extraordinary tour-de-force, giving immense vitality to the Soho streetscape. Indeed, the work is among the most logical and beautiful examples of a wall-painting, combining as it does the architecturally viable with the purely decorative.

Between 1976 and 1977, Haas completed an even more

elaborate commission, this one from the Boston Architectural Center. Its directors asked the artist to cover the building's bleak back wall, a task that Haas handled with unusual élan. *The New York Times'* design and architectural critic Paul Goldberger considered it among Haas's best work: "The building has a high, blank wall to its rear that until recently was simply a curtain of beige bricks set within a concrete frame. Mr. Haas made of it a delightful fantasy, an inner view of an imaginary classical structure with balustrades and columns and arches and a great central dome. Since the back of the Boston Architectural Center looks rather like a cutoff part of a building, the artist decided he would make his mural look cutoff, too. Thus the mural is a cutaway view, putting us in the middle of the classical building, as if a great knife had sliced its way through the structure."

Other Haas wall projects include a series of trompe l'oeil storefronts running along a section of Mulberry Street in New York; an interior and exterior mural for Barney's Clothing store on 17th Street and 7th Avenue; murals for Prospect Place, Brooklyn; The Strand, in Galveston, Texas; the Hyatt Regency Hotel in Cambridge, Massachusetts; an indoor trompe l'oeil room for the New York residence of Peter Nelson; and a mural at Peck Slip, beside the East River just south of the Brooklyn Bridge, that covers the blank south wall of a Con Edison substation.

In each of these works, Richard Haas masterfully toys with perception, making urban statements at once resplendent and in many ways ironic. Through his imaginary facades, he seems to tell the city dweller as much as the city architect how decay, blight, and the passage of time plays havoc with the urban landscape, and how this havoc must and should be remedied. His murals are, in fact, suggestions as well as clever reprimands. Even as he offers illusions of the real, he seems to point the way toward a concrete reality that the working architect might take to heart and act upon.

By transforming the wasteful into the seemingly functional, by turning the bleak into the beautiful, and by transmuting the empty into the substantial, Richard Haas offers credence to the possibility of change. Because his architectural illusion-

ism is so persuasively realistic, the next step might indeed be the real, where artists and architects could combine their talents to erect sites and buildings with the sort of flair and inventiveness that have become Haas's intriguing province and that Haas himself would decidedly welcome.

"I would like to be able to work with architects who are sympathetic and where we could collaborate on a one-to-one basis," says Haas. "But I'm not very optimistic, because I've become aware that artists and architects never *did* collaborate like that—it's a myth. The artists were usually under someone's thumb and they always had to conform to certain architectural problems. The American Renaissance was really the last period where it could still work and where it was in full bloom. There were some magnificent things being done during the Deco era, but after that such magnificence literally died."

Richard Haas is a stocky man of medium height. Brown, wavy hair frames a sensitive, interesting face in which smiling, alert eyes reflect good humor and intelligence. Sitting on a comfortable Victorian couch and surrounded by the mirage of his trompe l'oeil walls, he recounted the circuitous events that led up to his current celebrity as one of the day's most successful and respected printmakers and muralists.

"I was born on August 29, 1936, in a little town of 875 people called Spring Green, Wisconsin," he began. "At the time of my birth, my father was the butcher in the local general store. My mother was a housewife. I have two older brothers and a younger sister. My eldest brother is a priest, the other is an executive in charge of all the golf links in Wisconsin. My sister is a secretary. My whole family lives in Milwaukee—I'm the only renegade . . . the artist! Anyway, one peculiarity about the place I was born in was that across the river—the Wisconsin—lived Frank Lloyd Wright, and Taliesin was just down the hill.

"My uncle George was Wright's stonemason, and he would take us kids over there on various trips. We had access to Taliesin at any time. I remember being taken through Taliesin at the age of seven, and there were all those Chinese and Japanese artifacts—the Buddhas, the screens, and scrolls. There were harpsichords and harps and a lot of strange paraphernalia. The

old man was around, too, and I remember seeing him coming into town on Friday nights to go to the movies, wearing his cape and flat hat and cane. He would come in his rust-colored Lincoln Continental with the special cut-out windows, which he had designed himself. And his students would all come in with their little rust-colored Austin Healys! Well, Wright was mostly about mystery and every time we saw him it was an event.

"I was about eight when my father, in order to escape the draft during World War II, went to work in an ordnance plant in Milwaukee. So we all moved there and that's where I grew up. There was no real art in my house, but I had an aunt who made paintings, and I remember them very well. They were of long, Art Deco swans and storks, and we had some of them around the house. But that was about *it* as far as art was concerned."

As a little boy, Richard attended kindergarten at a Catholic parochial school and, by the age of six, showed an aptitude for drawing. He recalls having made pictures of the Capitol building in Washington, D.C., already evincing an interest in things architectural. When he turned 11, he submitted a painting to a juried show at the University of Wisconsin. It was of a row of tenement houses, and it won a prize. Throughout high school, Haas continued to draw and paint. Often he would make the hour-long trip back to his home town and visit Taliesen, making sketches of the buildings and occasionally helping his uncle George with his work as Wright's stonemason. In time, he began to show an interest in becoming an architect.

"At Taliesin, I had the opportunity of becoming involved in the day-by-day operation of the work being done there. I worked in stonemasonry, but mostly I hung around the drafting room. What finally happened was that, although becoming an architect seemed a wonderful idea, I got very scared of the whole math and engineering aspect of it. It did not inspire me and ultimately I lost interest. Still, by the time I reached college, I felt I ought to take a chance at becoming an artist. At 18, I entered the University of Wisconsin in Milwaukee and worked with an instructor by the name of Joseph Friebert, who was a painter and who encouraged my watercolor

work. One of the best things Friebert did for us was to take us on field trips to visit museums. It was my first real exposure to art. I remember our visiting the Chicago Art Institute, and that's when my major museum addiction began. Eventually, I studied the whole collection and knew where everything hung. The one painting that made a huge impression on me was El Greco's *Ascension,* and I fell in love with Grünewald, Bosch, and Brueghel. I also looked at Cézanne, Gauguin, Van Gogh, and Ensor, and they were my first influences. At one point I wrote a 30-page essay comparing Ensor to Bosch. So, I was very involved.

"Another thing that absolutely fascinated me was looking at dioramas, those small, lit boxes, which were displayed at the Public Museum in Milwaukee. These were miniature city-views, and a series of them were devoted to the invention of the typewriter. Well, dioramas became terribly important to me, because later on I began to make them myself."

Following his graduation from the University of Wisconsin in 1959, Richard Haas volunteered for the draft—a six-month training period that, upon completion, would exempt him from further military duty. (This was just after the Korean War and prior to Vietnam). Upon completing his army training, Haas applied for postgraduate work at various universities. He finally chose the University of Minnesota in Minneapolis because, as he put it, he liked the look of the city and because its art faculty included artists such as Jack Tworkov, Cameron Booth, Walter Quirt, Malcolm Myers, and Peter Busa.

"I had opted to become a painter and did large, bold abstract paintings. I think my biggest influence at the time was the California School of Painting—especially Richard Die-benkorn and Elmer Bischoff—the simple figure in the land-scape. So that was the focus for about two years. Then came a crazy period of influence. Whatever was coming in, I was trying out: Hard-Edge; Op; Color-Field . . . I did it all for about three to four years.

"But in those days I was actually doing two things, which I called my 'serious' side and my 'closet' side. The 'serious' side was the isolation of being in the Midwest, away from the center, where I *really* wanted to be—in New York—and of believing all

those influences that came my way through *ARTnews Magazine,* and the feeling of the Importance-Of-It-All! The 'closet' part was that I always drew and was also very hooked on Ingres and Vermeer. I would do collages based on their work, which eventually led me into doing my dioramic boxes. These boxes were small interiors that became very complicated in their trapping of real space. I did a series of them based on various artists in their studios. One of them was of David Smith's studio at Bolton's Landing. At another time I made a diorama based on Gertrude Stein's collection. I made little miniature copies of all the works that were hanging in one of her rooms in Paris, and I put Gertrude in a corner of it. So that was my 'closet' work—the drawings, collages, and boxes—and I did that right along side with all those big abstract paintings that I considered my 'serious' work."

Richard Haas received his M.F.A. degree from the University of Minnesota in 1964. Although he was deeply drawn to New York, he somehow felt unready to face it. Instead, he applied for a teaching job at various universities. At the same time, he had met and fallen in love with a young woman whom he married shortly after obtaining his degree. In due course, Haas was offered a job at Michigan State University, which he readily accepted.

"The pay was very good and my bride and I took off. I was made an Assistant Professor in painting at Michigan State, and the first year was very exciting. I met a lot of interesting people—Jackson Pollock's brother Charlie taught there, and he kept a lot of things going. He brought in people like Clem Greenberg and Barney Newman. So I taught and also continued painting my large, abstract, Hard-Edge, Color-Field acrylics on cotton duck. And I continued to do my dioramas, which got more and more interesting. Well, I stayed at Michigan State for four long years—until 1968—and a lot of things started changing in my life, some of them for the worse.

"For one thing, my marriage fell apart. My wife had begun to take a lot of college courses. She went from political science to economics to psychology in a matter of a year. Ultimately, she wound up becoming a psychologist. I think our growing apart had to do with our separate professions. She was completely

involved in her area of work and I was totally locked into mine. Also, it was the beginning of the women's movement, and it all came too fast. I didn't really understand it, and I don't think my wife did either. Whatever it was, she went on with her careerism and I went on with mine and we were definitely at odds emotionally. What followed was a divorce.

"At just about that time, I was also getting very fed up with Michigan State and wanted out. I couldn't stand the teaching and that whole academic life. It all became something of a trauma and finally I decided to take that tentative risk of coming to New York. Also, in the middle of all this, I met a girl who was interested in coming to New York with me, and that seemed like a fine idea. So we came to the big city! What helped was that Charlie Pollock had already moved to New York some time earlier, and, being a good friend, he let us share his apartment until I found a loft down in the Bowery.

"Well, living in New York was very exciting, except that it was almost *too* much. There seemed to be a crisis a week: the crisis of settling into the city; the crisis of the art scene in general; and all that ingestion of New York activity. There was also a crisis of living with my new friend. At one point, she got stars in her eyes and wanted to get involved in all that New York madness, the Max's Kansas City crowd, stuff like that. Finally, we split up and that, of course, was yet another crisis."

During this period of turmoil and adjustment, Richard Haas learned of a job opening at Bennington College. The post would be in the printmaking department. On the suggestion of friends, he applied for it.

"I drove up there, and showed them my work. Well, I got the job and I've been teaching there ever since. From 1968 on, I've been commuting back and forth from New York to Bennington and the experience is quite fulfilling. Still, I'm kind of removed from the milieu and from the influences of the place. I mean, early on, there were lots of people with whom I got involved—Clem Greenberg and his criticism and painters like Sidney Tillim, Kenneth Noland, Jules Olitski, Pat Adams, and Isaac Witkin. I don't quite know why this happened, but I suddenly came to the realization that the very thing that intrigued me about Bennington also repelled me. I found myself

moving away from it more and more. I retreated into myself and after a time discovered that what *really* grabbed me and what *really* held my interest was the visual impact of the city—of what I was seeing outside my loft window in New York. What I saw and what I loved was this orchestration of 19th-century leftovers—the cast-iron buildings that, at the time, were very rusty and really falling apart.

"My loft on Broome Street had these huge windows. They served as a kind of observatory looking out on that incredible drama of architecture, and I was engulfed by it. I began to make drypoints of the facades—they were very simple and direct— and I loved that subtle, frontal play of geometric and illusionistic form. So that's what I started to make in my studio and I felt good about what I was doing. In fact, I rolled up all of my paintings, put them away, and never painted again. Somehow, doing those architectural drawings, prints, and drypoints was all that mattered. And all of what was happening out there in the art world seemed unimportant. I decided I didn't have to think about it anymore."

Richard Haas had clearly fixed on the images that would henceforth become his primary interest. When he began to exhibit his prints at the Hundred Acres Gallery in 1970, the critical reception was extraordinary. The critics all agreed that these works with their punctiliously observed architectural detail and illusionistic finesse offered great singularity of vision, one that harked back to Piranesi and other masters. The energy of composition and technique was such that Haas's work soon found itself in the permanent collections of such institutions as the Metropolitan Museum, the Museum of Modern Art, the Art Institute of Chicago, The Whitney Museum, the Wadsworth Atheneum, the Boston Museum of Fine Arts, the Library of Congress, and the San Francisco Museum, among others. Concurrently, Haas's works began to be exhibited in important national and international print shows, and in 1973, he became affiliated with the New York dealer Brooke Alexander. One year later, Richard Haas began to give some thought to "putting things on walls."

"The idea really intrigued me and I talked to a number of friends about this and they all agreed it might be interesting to

approach City Walls, Inc. Well, before doing that I decided to walk around Soho with a photographer friend of mine and scouted various walls. Then I did a whole series of 'before-and-after' drawings, and took them up to Doris Freedman at City Walls. I told her I wanted to do these things and she said, 'All right, do this one!' And the one she picked was the Prince Street project.

"It was my first City Walls facade, and I knew that building inch by inch. I measured the whole thing, and it was a real devil of a problem, because I had to change my thinking about making everything come out just right. Then I had to translate my ideas to the sign painters who would actually execute the work, and they weren't used to anything like that. They were used to big color blocks, but I threw it at them and finally they said, 'OK, don't worry about a thing!' I left town, and when I came back it was finished. It took them two weeks in the winter!"

How does Richard Haas assess the concept behind his wall paintings?

"I see them as reinventions of things that didn't deserve to die . . . of concepts and traditions that answer very definite needs today. Many of my reinventions came out of an analysis of the city structure and of what was *not* happening: City as fantasy. That is, city as *plausible* fantasy. I really feel that, in order for anything to work in the outdoor environment, it has to have that plausible connection to what else exists in conjunction with it. Therefore, I'm very sensitive not just to the general feel of the environment but to the minutest details as well. Everything I do has to lock in totally to the shape of the space it occupies.

"Of course, when I talk about the city as fantasy, I'm really talking of architectural concepts of the past which, for me, began with Andrea Palladio. I'm also moved by Victorian architecture and by Edwardian architecture. The American Renaissance is interesting too—buildings that were done between 1875 and 1910—because of the grandeur that occurred. So those are the main periods I focus on, and that's what my work is mainly about. I'm interested in retranslating periods of the past."

Richard Haas does not consider himself to be an artist within the mainstream of current-day stylistic preoccupations: "I'm an artist in my own corner," he says. "If you want to put a tag on me, you can say I'm an environmental artist, because my work tries to link itself directly to architecture. Also, I consider myself a decorator, which I don't for a moment think of as a pejorative term. As far as I'm concerned, an artist *is* a decorator. There's just no two ways about it!"

1979

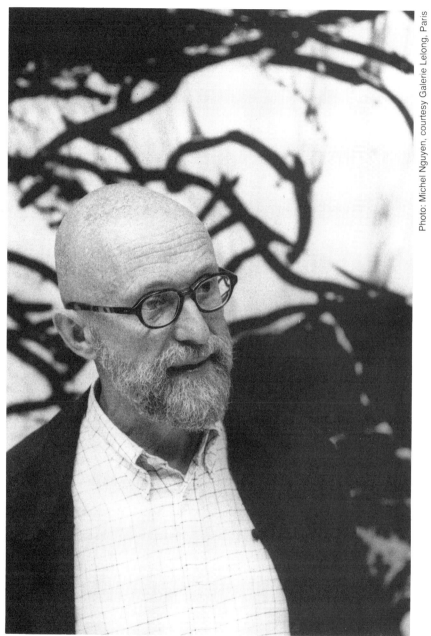

PIERRE
ALECHINSKY

Everything that you paint may be
used as evidence against you.
 Pierre Alechinsky

The work of Pierre Alechinsky is a writer's dream. A writer can invent whatever he wants about it, for Alechinsky's fantasies unleash ours. The rush of his images—those restless, untamed swervings and convolutions drenched in brilliant color or those cryptic beasts and faces out of childhood imaginings—evoke a stream of personal responses that need no sophistry to interpret and just possibly no foreknowledge of art.

Viewing Alechinsky, we are in the realm of a fluid and amorphous subconscious, traveling through an ephemeral landscape of the emotions where unspecified feelings and instincts converge to form wild scenarios of the senses. It is conceivable that this vivid, unbridled art, practiced for some 30 years, has persuaded his admirers that Pierre Alechinsky is half prankster, half genius, an artist who matured into an irresistible fabulist, a man, who, at last, grew up to be a child.

For this not inconsiderable achievement, the Carnegie Institute's Museum of Art in Pittsburgh has awarded Ale-

chinsky the first Andrew W. Mellon Prize ($50,000) for "excellence of output." The prize, given to artists who "do not enjoy the world-wide recognition they deserve," is to be awarded biannually and will include a retrospective exhibition to be known as the *Pittsburgh International Series,* an offshoot of the well-known *Pittsburgh Internationals,* which have been in existence since 1896.

In October 1976, Alechinsky flew in from Paris, stopping briefly in New York before heading for Pittsburgh to collect his prize and to be present at his retrospective. While in New York, the artist made time for an interview at the Lefebre Gallery, where he has been exhibiting for many years. As it turned out, the day of our interview fell precisely one day prior to Alechinsky's 50th birthday, a happenstance that found the artist entirely calm and unperturbed.

"Of course, if 30 people came up to me and said I was getting old, then I'd begin to worry," declared Alechinsky with a wry smile. "As it is, turning 50 holds very little reality for me. It's just another day. Besides, as of today, I'm still only 49!"

Pierre Alechinsky, a man of acute perception and intelligence, has the look of a punctilious, slightly tense schoolmaster. Bald-headed and bearded, with alert brown eyes peering out of thin-rimmed glasses, he offers the image of someone keenly in touch with the process of thought—a man for whom ideas and the word are as vital as the lines of a drawing or the strokes of a painting. Indeed, Alechinsky is the author of several books of prose and poetry, the latest of which is the elaborate and superbly printed catalogue that accompanies his Pittsburgh retrospective. The catalogue, containing many drawings, photographs, and color reproductions of major works, is also an account of Alechinsky the writer, the artist, and the man. There are stories, aphorisms, and poems as well as a dense and highly detailed autobiography written by Alechinsky in the third person. For so relatively young a man, the artist's life has been nothing if not dizzying, and a mere article could not possibly do justice to so eventful a career. The fact is, little is known in America about Alechinsky's life, something the Pittsburgh catalogue has now remedied.

Born in Brussels on October 19, 1927, Pierre Alechinsky

was the only child of a Russian Jewish immigrant father and a Belgian mother. Both parents were physicians, and the boy grew up in a milieu of order, discipline, and, fortuitously, considerable creative activity. The household included an aunt who painted and a grandmother who played the piano. There were prints and paintings on the walls, and endless books in the bookshelves. The youngster was sent to a primary school in Brussels and was educated according to the Decroly method. Alechinsky writes: "There were tests upon tests; reading taught by means of an overall approach, the ancient Ba-Ba replaced by sentences such as 'The young lady brings in a hyacinth bulb.'"

It was at school that the boy became acutely aware of the fact that he was left-handed: "At that time, children were not allowed to be left-handed, and I was instantly dubbed a dunce. Luckily, certain of the teachers allowed me to use my left hand freely and fully."

During the World War II years, members of Alechinsky's family were imprisoned or deported. His father was dismissed from the hospital in which he worked. Bombing raids on Brussels disrupted Alechinsky's life and education; there was suffering, deprivation, and terror.

With the Liberation in 1944, some sense of order was restored and, at the age of 17, Alechinsky enrolled in La Cambre, the National College of Architecture and Decorative Arts. There, he learned to design posters, wrappings, and labels. Ultimately, he concentrated on courses in book illustration and soon found himself illustrating books by such poets as Lecomte and Apollinaire.

In 1947, Alechinsky, not yet 20, held his first solo exhibition at the Galerie Lou Cosyn in Brussels at which time he had occasion to meet a number of the Surrealists, including René Magritte, Camille Goemans, and André Souris. The works he exhibited consisted of paintings done on paper. ("They were portraits of girls whom I monstrified.") Later that year, the artist participated in the last exhibition by the Young Belgian Painters at the Palais des Beaux-Arts in Brussels.

In 1948, Alechinsky received his diploma from La Combre and soon after met and married his present wife, Michele, whom he nicknamed Micky. (Two sons, Ivan and Nicolas were

born in 1952 and 1958, respectively). The year 1949 was seminal
in the artist's life, for it was during March of that year that he
met the poet Christian Dotremont, who was then organizing
the first COBRA exhibition at Le Atelier du Marais in Brussels.
The movement, which was founded in 1948, instantly appealed
to Alechinsky, and its viewpoint, centering on the revolt against
Communist-approved social realism and geometric formalist
art, prompted Alechinsky to join its ranks. The name COBRA
was derived from the three dominant cities represented in the
group: COpenhagen, BRussels, and Amsterdam. The major
artists of the movement included Asger Jorn, Karel Appel,
Constant, Corneille, and Carl Henning Pedersen, among
others.

In his Pittsburgh catalogue, Alechinsky writes: "COBRA
means spontaneity; total opposition to the calculations of cold
abstraction, the sordid or 'optimistic' speculation of social
realism, and to all forms of split between free thought and the
action of painting freely; it also means a step toward interna-
tionalism and a desire for de-specialization (painters write,
writers paint)."

In effect, "painting freely" are the key words that best
characterize the movement—*that*, and an uninhibited boldness
of image and color which, in combination, produce explosive,
often radiant graffiti-like statements. Certainly, from the mo-
ment Alechinsky joined the COBRA group, his work celebrated
a joyousness and positivism of spirit. For all of his involvement
with depicting the fantastic and phantasmagorical, his paint-
ings and drawings do not scream in horror but squeal in glee.
They do not threaten or scare us, but revel in the absurdity of
fear. Our demons, Alechinsky seems to say, make their
appearance merely to mock us—to alert us of our groundless
anxieties—to tell us that, finally, we create our own follies and
that being foolish is man's natural tendency.

When the COBRA group disbanded in 1951, Alechinsky
left Belgium and settled in Paris, where, on a grant from the
French government, he studied engraving. At one point, he
worked at Stanley William Hayter's famous Atelier 17. ("To Bill
Hayter I owe my taste for copper and acid.") During this
period, Alechinsky met Joan Miró, Alexander Calder, Alberto

Giacometti, and other painters, sculptors, and poets living and working in Paris. More influential than these, however, were a number of Paris-based calligraphers from Japan. They instilled in the artist a life-long passion for the art of Oriental calligraphy at which he himself became brilliantly adept. Indeed, in 1955, the artist traveled to Kyoto and Tokyo and undertook to shoot a film entitled "Japanese Calligraphy," considered to be a unique documentary on the subject. (During a lengthy sojourn in New York in the '60s, Alechinsky collaborated with the Chinese artist Walasse Ting on numerous books and etchings, deepening his concern with Oriental art and calligraphy.)

For the next 20 years, Pierre Alechinsky produced countless works of art in all mediums, exhibiting with regularity in major galleries and museums throughout Europe, the United States, Asia, and Latin America, establishing a reputation that ultimately led to the Mellon Prize and the Pittsburgh retrospective.

What strikes one most upon meeting Alechinsky is the discrepancy between the man and his work. Alechinsky the man does not reflect the abandon of Alechinsky the artist. The man is contained, controlled, reserved—an intellectual. The artist is open, flamboyant, often outrageous, and seemingly anti-intellectual. Asked to comment on this dramatic contrast, Alechinsky spoke with Gallic clarity and often metaphorically.

"I have observed that when a painter is very young, his paintings seem like those of an old man. As he begins to age, he attempts to find a true youthfulness in his work—he tries to find pleasure in keeping his work young. You see, when one is young, one feels the pressures of one's culture impinging itself on one's work. One has few choices. But as time moves on, you try to hold on to what interests you most—what amuses you most. Of course, this is nothing new. When one looks at Matisse's early paintings, they resemble those of a much older man, and just before his death, he made pictures that look like the work of children—colorful cutouts done with a scissor as he lay in bed.

"As for myself, my aim has always been to paint or draw that which gives me pleasure, the principle being that if an artist is not happy with his work then others will not be happy with

it either. This pleasure and happiness with one's work is graphologically legible in a work of art. For example, if I draw a line that displeases me, I reject it, because this line is the memory of something unpleasant. The fact is, I don't like to keep the traces of displeasure in any of my works. One would have to be a masochist to retain them, and I'm not a masochist."

Alechinsky was willing to analyze and dissect his working methods.

"What interests me most about the act of painting is that it is a solitary act. What is even more interesting is that you become the sole spectator of this act. The difficulty comes with putting oneself into motion to *begin* the act. You see, there is no one standing behind you, telling you to begin something. You must make that decision yourself. A very young painter is seldom alone. If he is an art student, he is in an art school with other students. He does not as yet know that one day he will have to face himself as a solitary creature enclosed in a space of four walls. At this moment he will realize that time itself is something different than he thought it was, and that he will have to be a self-propelled being, with no one at his side. Of course, when one is faced with a canvas, one is no longer alone, and the sense of solitude diminishes. This can be an agreeable passage of time. In fact, solitude then becomes a kind of companion.

"But as for my own work, I do not wish to produce images that find their equivalent in reality. And I do not wish to fix my images within the confines of only one reality. I apply myself to seeking out images that I do not know. When I begin to work, a chain reaction is set off. One image leads to the next. But it's absolutely impossible to predict what the next image will be. Indeed, it would be sad to know in advance that which is to come, for the simple reason that it deprives one of the sense of discovery. This does not mean that I reject the planned imagery of other artists.

"For example, I have a great deal of respect and admiration for the work of Magritte. Clearly, Magritte was the kind of painter who could plan his imagery well in advance. All he had to do was to paint it. There were no surprises in store for Magritte. He knew exactly what he wanted and went ahead and

executed the image he had preconceived. The result was magnificent and posed no problems.

"But for me this does not work. I do not wish to know what the end product will look like. As in life, my paintings do not know their own future. Yes, there are certain leit-motifs in my work—certain animal shapes that appear again and again. But I cannot explain why this happens. It's something I don't understand myself. It's a mystery even to me! As for the monsters that so frequently make their appearance in my work, they are benign monsters—they're not meant to scare anybody. For some reason, it gives me pleasure to paint them and, again, I don't know why."

How did Alechinsky feel when faced with the nearly 170 works that constitute his retrospective?

"A retrospective makes it possible for an artist to reread himself. You see, an artist is someone who keeps a journal in the form of paintings in a book that one cannot leaf through. An artist is always forced to separate himself from his 'manuscript.' It took nearly a year and a half to put the retrospective together, and it was very hard work for me and for my friends. It meant finding out where all the pictures were located, and it all amounted to an archaeological expedition, the subject of which was myself. Of course, it was a shock to see all those pictures . . . I felt like a student facing a series of tests the answer to which suddenly all came back to me."

In discussing this youth, Alechinsky fixed on the phenomenon of his left-handedness, a subject that seemed of very special interest to him.

"Being left-handed is an affliction, and it has had a profound effect on me. Oddly enough, I have a son, aged 19, who is also left-handed, while my other son, the eldest, is not. At any rate, when one has an affliction, one tries to get some excitement out of it. I was very fortunate during my childhood to have had the help of certain teachers who insisted that I make my left hand serve me totally. No one forced me to use my right hand. Nevertheless it was a psychological problem for me, because from the first I was made to realize that everything connected with the word 'left' had a pejorative meaning. In French the word for 'left' is 'gauche,' and, of course, to be

'gauche' means to be awkward. In Italian, the word is 'sinistra' which, again, translates as sinister.

"In France, the right hand is called 'la belle main'—the beautiful hand! A mother will tell her small child to greet someone by offering 'la belle main.' In other words, there is something ugly attached to the left hand—something shameful. This is, of course, the fault of society never the fault of the individual. So it was society that instructed me to hold my pen or pencil or brush in my right hand. Instead, I placed it in my left hand. The strange thing about my situation is that I discovered quite by accident that my left hand contained what I might call a magic quality. Without any training whatsoever, I was able to write backwards—and with tremendous speed and without any hesitation. It was totally instinctive.

"The handwriting was incredibly neat and legible. It was just as legible as my handwriting from left to right. What this boils down to is that I can write from left to right, like everybody else does, but I can also write backwards, which *nobody* does. What is very peculiar is that when I write backwards, I cannot read what I have written, because my eyes have been trained to read from left to right. I'm totally incapable of reading what I've written without the help of a mirror, which reverses the writing. And talking of that, I have noticed that in my work, if I let myself go completely, I can also reverse my images. This led me to become extremely interested in the art of engraving and lithography, because the finished product is reversed automatically."

Asked whether he had ever been psychoanalyzed, Alechinsky said, "No, I have never been analyzed, because a painter is in a state of permanent self-analysis. By being in contact with his own work, he quickly comes to the realization that there are no solutions. The key to life, it seems to me, is that there are no answers. Too often, people enter analysis in search of answers. But there is no such thing."

Returning to the subject of his retrospective and the $50,000 Mellon prize, the artist claimed that the exhibition meant far more to him than the prize money.

"Basically, money to me is an abstraction, and I have no idea what I will do with it. Perhaps it will give me the

opportunity to write more and not paint as much. Writing is very important to me, and money will give me some peace to do this, because writing is far more difficult than painting."

Alechinsky and his family live in Bougival, outside Paris. The artist is something of a recluse, preferring the solitude of his studio and the pleasures of the countryside.

"I seldom socialize. I am not a public person. To escape the classic solitude of the studio, I go and work at my printers in Paris. It's like going to a *bistro* for me. When I push open the door and smell the odor of the inks, I am in another world. With the other people around me, I have the illusion of not being totally responsible to myself. My work there becomes a shared experience.

"Occasionally, I make forays to certain events. Just recently I received what amounted to military orders from one of my friends to attend a performance given in Paris by Merce Cunningham and his company. He did well to send me there, because Cunningham is an admirable artist. He is the oldest member of his company, but he appears to be the youngest. He has found a new grace. And this gives him an enormous power."

When asked to name the American artists who interest him most, Alechinsky paused and did not speak for several minutes. Then, he said, "Although I am not a sectarian, I think that the most important artist working in America today is Claes Oldenburg. I admire him tremendously. He is a man of enormous talent and imagination. I also respect and admire the work of Sam Francis."

Alechinsky was anxious to draw the interview to a close. But he was detained by one last question: Did he feel that he deserved the Pittsburgh/Mellon prize?

"A prize is always unjust," he said. "Basically, it changes nothing. It does not alter the problem faced by a painter who wishes to say something. And it is no consolation to a painter who has nothing more to say."

1977

DOROTHEA ROCKBURNE

T he metaphysical ambience of Dorothea Rockburne's structures (they are not paintings, they are not sculptures, they are not drawings, they are not Minimalist, they are not abstract, they are not even Constructivist), offer opportunity for theoretical invention.

Rockburne's structures (I will insist on calling them that) exist in a world apart. They entice, beckon, and lure the viewer in ways that are neither didactic nor aggressive. The shapes—one superimposed upon the other—form units announcing reserve and independence. There is about them a strange peace—the peace that comes after struggle. One senses agitation, even violence. And yet, they remain still, self-contained, suspended in space and time like an obsessive thought.

The identity of Rockburne's geometry translates into pure ideas. By pure, I mean an intuitive rationale that allows for speculation upon the qualities of order and clarity. Rockburne does not deal in the mundane. She is not interested in portraying love, hate, anger, madness, or desire. She does not "express" herself. She explores other realms: the why-ness of an object; the how-ness of art activity; the what-ness of thought

itself. She deals with fragments of feelings that add up to unanswered questions.

"I think of my work as preparatory," she says. "There's the preparation in my work to *know* how to do something. But the reason to *want* to know how to do it is to deal with it in a nonemotive way. I deal with emotions that don't have a name—that can't be codified."

Dorothea Rockburne lives and works in abject luxury in a huge, superbly proportioned loft in Soho. The light in it is the light found in her structures, somewhat glary, slightly discomfiting—not exactly harsh, but bright enough to produce alertness. Rockburne claims to be disorganized, but no studio or living-quarter has greater symmetry or order. Like her work, the place reverberates with a disquieting peace.

The artist is a small-boned woman, who may be in her 50s, but has the aspect of someone far younger. (She was once a dancer, which may account for her radiance.) Her eyes are sky blue. She has a ready, friendly smile. She is always on the brink of registering some private delight.

Born and raised in Montreal, she began life a sickly child, but emerged healthy and fiercely independent. Indeed, from the first, she was inhabited by curiosity and a desire to understand.

"Actually, we lived in a suburb of Montreal. We had a house on the St. Lawrence River. There wasn't much money, but there was fun. There was no art milieu. I learned to read very early. I read constantly. As a child, I was isolated by illness. I had susceptibility to pneumonia. I had pneumonia. I had double pneumonia. I was in bed a lot. But I had the radio. At age five or six, I'd be lying there listening to late Beethoven quartets. I liked the abstract quality of that music.

"In the summers, I liked being in nature. In the winters there was skiing. I'm convinced that I learned how to draw by skiing. The experience of skiing through new snow had a lot to do with drawing fine lines on white paper. As time went on, I stopped being sick. I had learned to be a very, very good swimmer, and that seemed to conquer all that sickness. By 12, I was going to an art school—I liked it. It's where I found a part of myself that wasn't fulfilled in any other way. It had to do with making things. All along I've been interested in the

making of objects, and how those objects function and enter the world. I feel that an object is really an emotional experience."

In her late teens, Rockburne decided to leave home and attend school far from Montreal. She had three choices: Black Mountain College in North Carolina, the Institute of Design in Chicago, or the Slade School in London. She chose the now defunct Black Mountain, a seminal school of the arts which produced John Cage, Merce Cunningham, Robert Rauschenberg, and Cy Twombly, among many other well-known alumni.

"I came away from Black Mountain with far more than I bargained for," recalls Rockburne. "I was married there, and my baby was born there. My husband and I divorced when our daughter was two-and-a-half. Clearly, I had learned to run risks at Black Mountain. But I very much wanted a child, because I knew I'd be enriched by it . . . because it was wonderful and informative and life-giving.

"I was given encouragement at Black Mountain. My teachers were Philip Guston, Esteban Vicente, and Jack Tworkov. My friends were Twombly, Rauschenberg, and Franz Kline. I was painting, but I thought what I painted wasn't any good. It was abstract stuff. Also at Black Mountain, I took dance classes with Merce Cunningham. *That* was wonderful! But I was fairly isolated, because I had a child and I had to care for her. Still, Black Mountain was the beginning."

Rockburne and baby moved to New York in the mid-'50s. When she had lived in Montreal, she thought she hated cities. When she went to Black Mountain, which was in the country, she began to abhor the insistent greenery. She felt that if she never saw another tree again, it wouldn't be too soon. Even in New York, it took her a while to accept Central Park. Finally, she thought of it as just another potted plant, and New York became her permanent home. "It's where I was supposed to be," she had concluded.

"Of course, at the time, it was easier *not* to make art as a woman than to make art as a woman. It seemed you got applause for doing nothing and criticized for doing something. Well, I was struggling. I had to support Christine and myself. I had to have jobs. But I was making art—always. I was painting and I was doing photography. When I couldn't figure out my

paintings, I would take black and white photographs. I had a Minox camera and a Minox enlarger. I photographed abstract things—snow on the street, marsh grass. I was trying to find out about color by looking at things that were black and white."

In New York, isolation was the theme of Rockburne's existence. She was raising a child alone, and she was making art alone. But the isolation prompted ideas. Her work going badly, she wondered just how bad it could get.

"I decided to do paintings that were *purposefully* bad. A painting that was too red. A painting that was too big—that sort of thing. What I wanted was a lot of experience. I didn't want successful paintings, because I could see from people who were making successful paintings that they were denying themselves the excitement of daring and originality. So, I did these awful paintings, which finally got to be *so* terrible that I said, 'Hey, wait a minute! Guess what? Maybe you're not a painter!' And I stopped."

It was now the mid-'60s. New York was just emerging from the thrall of Abstract Expressionism. It was now experiencing the frissons of Pop Art, Op Art, Color-Field, the Shaped Canvas, Happenings, Minimalism, and Conceptualism. Rockburne looked at it all, and decided to dance.

"I had a lot of energy, and I started to take some dance classes. I fooled around at the Judson Theater down in the Village, dancing with Carolee Schneeman, Bob Morris, Steve Paxton, Bob Rauschenberg, and appearing in some of Claes Oldenburg's Happenings. I did this for three years, and from that I found out what to do in my work.

"First of all, in dancing you're basically working in a grid on the floor. This made me understand more about the surface of a canvas. It also freed my energy in some way that I can't describe. It was a great experience. And those people were terrific—Barbara and Alex Hay, Yvonne Rainer, and, of course, Trisha Brown, who was such a marvelous dancer! She was very young then, and it was so fabulous to see her move! Dancing put me in touch with my early years—the skiing, the swimming. And dancing taught me the way the body folds . . . how the arms fold . . . how folding produces emotion. And that went into my art. So dancing was a big, big journey.

"By 1968, I was approaching confidence. Also, in the late '60s, I met Mel Bochner, and he was wonderfully encouraging. I did a work called *Tropical Tan,* which was a metal painting. It was big—and I did a series of those. Also, I had a spray-booth at the time, and I lined the spray-booth with brown paper. One day, I picked up the brown paper and put it up on the wall, and I thought, 'Now *here's* something!' I looked at that paper for a very long time. Paper began to assume terrific importance to me. One time, I locked myself up in my studio and just stared at sheets of paper. I thought that the paper would tell me something—something I needed to know. Finally, I felt as though I *became* the paper.

"This whole notion of working with paper came out of my dance experience, and also out of the reading I was doing—scientific journals, books on mathematics, philosophy. I read things that dealt with questions like: 'How do you encounter an object or thought, an object of another person, an object of a material thing; what are the dimensions?' And the whole Aristotelian thing of: 'How does something go from one place to another within its own framework?' I pondered all that, and I experimented. I came to realize that a piece of paper is a metaphysical object. You write on it, you draw on it, you fold it.

"I've always had an enormous impulse to draw. On the other hand, I never did a drawing that completely satisfied me. When I draw, it's as though I'm eating a meal, but I never get full; I never get the full satisfaction of it. I just keep on wanting to do it in various ways. At the time, I wanted to do a drawing that only described itself—that didn't have any other subject matter except itself. I finally did that, and it came out of the experience of skiing."

Dorothea Rockburne began experimenting with painted structures in the early '70s. One of her earliest decisions was to produce structures that would *not* eliminate the space between the work and the viewer. She had looked at Ad Reinhardt and Mark Rothko and, while greatly admiring their work, felt that their paintings tended to enfold the viewer, both through color and intent. This was something she wished to avoid.

"I didn't want my work to 'move.' I wanted it to sit back on the wall, with a distance between me and it. I did not want my

work to be an intrusion into anybody's space or life. I didn't want it to blast. I wanted it to sit and beckon."

This distance, both real and metaphysical, attends all of Rockburne's work to date, from the folded paper work to the *Golden Section* paintings, the *Robe* series, the *Egyptian* series, the *Angels* series, and the structures with which she is currently preoccupied.

While they bear titles and contain points of reference—the *Golden Section* from her studies of the so-called "Golden Mean," based on the Greek theory of proportional inter-relationships; the *Robe* series from the study of folds as seen on figures in medieval paintings; the *Egyptian* series from bas-relief; the *Angels* series from the hierarchy of rank within the canon of angels—all her work seems nevertheless to suggest mathematics being juggled by some unknowable inner impulse, some instinctive, undefinable thought process.

Shape, form, color, space, and material combine to produce a mathematical energy, which, in turn, emits a kind of transcendent sense of equilibrium. Every structure, regardless of title or reference, forms an awkward logic that seems unnervingly inevitable. It is work that in intonation rings true, but that in meaning leaves the door wide open.

"I've never wanted to understand my work in a so-called logical way," Rockburne maintains. "I don't want to pigeonhole an experience. I don't like my work to be defined. Like love, it should remain undefined.

"What I do is make a physical shape which has its emotional shape within me. I'm trying to make those two things correspond in the hope it's the same emotional shape that other people have, and that they will recognize. I think I have an 18th-century mind and the kind of humanism that goes with it. I'm interested in the abstract and in universal structures. I think I was born with all of that whole and intact. What I didn't have were the tools to reach it—to reach that inner plateau. Now I feel the tools are getting better and better. Come to think of it, a painting of mine works when it looks as though I had nothing to do with it . . . when something else took over."

1986

LUCIAN
FREUD

It is entirely likely that the most elusive, most insular, and puzzling figure in British contemporary art is Berlin-born Lucian Freud, one of three London-based grandsons of Sigmund Freud. Fiercely private, notoriously independent, and obsessively secretive, Freud, at 55, makes no concessions to the trappings of careerism, public recognition, or fame. He rigorously shuns personal publicity, preferring to let his work be the sole access to his highly guarded creative and private life.

To assume that one can "get in touch" with Lucian Freud is to be deluded. Freud's whereabouts are known only to himself. While he maintains various London addresses, including a studio-building in a remote section of the city, none has a telephone, and no one—not his children, former wives, friends, or gallery dealer—ever knows precisely where he can be found. As has been his wont for years, it is Freud himself who does the communicating—calling from a street phone, or simply appearing on the doorsteps of relatives, friends, or at the Anthony D'Offay Gallery, where he exhibits.

Should anyone wish to reach him, telegrams are sent to each of Freud's domiciles. If so inclined, the artist will respond. More often than not, however, he remains aloof, relinquishing

isolation only when it best suits him. This insistence on complete freedom of mobility and an unswerving claim to the solitary existence has intensified, if not magnified, Freud's reputation as an eccentric—a man so thoroughly impervious to and disengaged from the taken-for-granted modus vivendi of the "successful artist," that those desiring his acquaintance, let alone his friendship, have, in recent years, quite given up on him.

Thus it was that to seek an interview with Lucian Freud was tantamount to scaling a craggy and difficult cliff without a rope. Still, the rope, in the form of Freud's dealer, Anthony D'Offay, was gratefully at hand, and, though warned that one was asking for the impossible, an attempt was made in the direction of an introduction at least.

On a brisk London morning, D'Offay telephoned to say that Freud would be coming into the gallery that afternoon to deliver a recently completed painting. Were I to be on hand, Freud might be amenable to a brief chat. On the other hand, given the artist's quixotic moods, nothing at all might come of the meeting. On the appointed hour, I appeared at 9 Dering Street, where the D'Offay Gallery is located. A small, intimate space, the gallery did not boast the luxury or international ambience of the Marlborough Fine Art Ltd. gallery, Freud's London dealer since 1968. No clear reason was given for Freud's decision to move to the D'Offay in 1972, although the dealer intimated that Freud considered the Marlborough "too big," and its roster of artists too stylistically diversified for his taste.

At precisely 4:45 P. M. on that September afternoon, a slim, rather unkempt figure entered the D'Offay Gallery, carrying a medium-sized painting, wrapped in a sheet. This was Lucian Freud. Wearing dark-brown, baggy corduroy pants, a loose tweed jacket, and a dark wool scarf knotted around his neck, he had the crumpled look of someone who had gone without sleep for days. The face, covered with what appeared to be a three-day stubble, was extraordinary—a composite of the poetic features of Jean-Louis Barrault and Charles Baudelaire. The eyes, a watery blue-green, were restless and intelligent. D'Offay offered introductions.

"I'm afraid I can't oblige with an interview," said Freud curtly, in reply to my request for a taping session. "Interviews mean nothing to me. I only do things that have some meaning to me. Besides, I find it disagreeable to read what I may have said. It's an embarrassment. You can, of course, write about my work."

Could I, then, have a look at the new painting?

Freud removed the sheet that covered the new work. It was startling: an old, gray-haired woman lying on a bed, her hands clenched and reaching up toward her face. Cut off at the legs, the reclining figure wore a dress dotted with a lively paisley design. In contrast to the gaily patterned dress, the face was in deep and troubled thought. The expression suggested someone burdened with secrets too unbearable to be told. As a work of art, the painting was dominated by minute brushstrokes shaping, almost architecturally, every detail of the face and hands. The work had a silence about it that bordered on the sinister. Who was this strange old woman in a fancy party dress lying almost catatonically on a small studio cot?

"It's my mother," said Freud. "I've done several portraits of her recently. She's nearly 80, and very abstracted. I pick her up in the mornings, and we have breakfast somewhere. Then we come up to my studio, and I paint her. It's strange. She used to be a very aggressive woman. She was like that all her life, and I saw very little of her—didn't want to see her . . . didn't like being with her. Then, when my father died, she tried to kill herself. She was saved by a rather nasty relative of ours, a woman who enjoys tormenting me. Anyway, after that, my mother changed radically, and became very docile. I began to see her, and, for the first time, painted her."

This sudden personal revelation made clear Freud's seemingly ongoing attachment to his past. In a way, it offered entry into a sensibility still cognizant of the scars of childhood and the dilemmas of maturity. Indeed, despite Freud's great reluctance to divulge information relating to his private life, it was obvious that, in conversation, it was the personal and the intimate that seemed to him the only worthwhile topics to touch on. Certainly, this would have had to be the case, considering that

Freud's work is tied to his extremely personal response to subject matter, which, for him, has been a lifelong interest in portraiture.

As early as 1956, Freud expressed this belief in personal response, in a brief article he wrote for the British literary magazine *Encounter*:

> The painter makes real to others his innermost feelings about all that he cares for. A secret becomes known to everyone who views the picture through the intensity with which it is felt. The painter must give a completely free rein to any feelings or sensations he may have and reject nothing to which he is naturally drawn. It is just this self-indulgence which acts for him as the discipline through which he discards what is unessential to him and so crystallizes his tastes. A painter's tastes must grow out of what so obsesses him in life that he never has to ask himself what it is suitable for him to do in art. . . . The painter's obsession with his subject is all that he needs to drive him to work.

Still insisting that he preferred to let his work speak for itself, Freud was next persuaded to allow me to visit his studio. "Very well then, come along. I'll drive you there," he said. "My car's just outside."

The car, as it turned out, was a magnificent Rolls-Royce—a Silver Cloud—a bit dusty for wear, yet elegant in the extreme. Its splendor was in dramatic contrast to the somewhat bedraggled figure, who now sat behind the wheel, visibly regretting his decision to allow an entirely too inquisitive journalist entry into his private world. We drove in silence for some 20 minutes, passing from neighborhood to neighborhood, until we reached a particularly desolate section of London. Freud refused to divulge the exact location of his studio, and was relieved to note that the city and its unfamiliar sections were an enigma to me. Finally, the Rolls stopped in front of a row of rundown tenement houses, facing an empty school playground. Getting out of the car, Freud led the way to one of these houses, which, I observed, bore no number, nameplate, or bell. He unlocked the front door, and we climbed a short flight of stairs.

Freud's studio consisted of two small rooms, each more or

less identical in size, and each containing a single bed, an easel, a painting table, and one or two chairs. There were newspapers, magazines, and books strewn on the unmade beds, and both rooms bore a general mustiness and untidiness. Freud told me that one of the rooms served as his daytime studio, while the other was used exclusively for nighttime painting.

"I have daytime models and nighttime models. The people who pose for me at night are encouraged to fall asleep, because I like painting the sleeping figure. I need very little sleep myself, and often paint long into the night."

In the daytime studio, the walls were splattered with multicolored dots of pigment. "It's a way of reminding me which colors I've used, before I mix the paints." Aside from the tiny splatters of paint, the walls were covered with innumerable scribbles—names, telephone numbers, addresses, and cryptic messages. Nervously, and almost too rapidly, Freud placed several small canvases on the easel. Some of the paintings were finished, others were in progress. One work was a head of his mother. As in the painting he had brought to the D'Offay, the expression of the old woman bore a feeling of terrifying withdrawal and inwardness. Another painting showed a portly, middle-aged man, sitting rigidly in a chair. "He's a business man. I liked the way he looked, and asked him to pose. He sits very, very still." Two other small portraits, one of a young sad-eyed woman, the other of a tense young man, were painted with what might be termed obsessive realism.

As in all of Freud's work, a mysterious "otherness" makes itself felt, as if each subject were somehow hypnotized by the artist—as if Freud himself transfixed his sitters in ways that rendered them vulnerable to their own states of anxiety and fear. This relentless concern with the psychological can be understood in the light of Lucian Freud's own background and artistic development.

Born in December 1922, Freud lived in Berlin until 1932. His father was Ernst Freud, an architect, and a son of Sigmund Freud. The family was well-off and privileged. Summers were spent near Potsdam, on the estate of Freud's maternal grandparents. Leading a comfortable and cultivated bourgeois life, the family soon found itself in the grip of a political atmosphere

that disrupted the pattern of its existence. From 1929, seven-year-old Lucian was exposed to schoolmates eagerly mimicking their elders in "games" of looting, lighting of fires, and placing ominous symbols on the walls. He saw destructive and dangerous street gangs jeering at Jews, and fell victim to fears he had never encountered before. The effect of these notorious circumstances marked him for life. He knew the enemy at firsthand, and his imagination was shocked into a lasting subversion and anger.

When, in 1932, the Freud family settled in London, the youngster, now aged 10, carried his confusion and anger to alien ground. Far from seeking acceptance in a new and welcoming country, he sought immediate independence, resisting the "safety" of a normal education. He was in and out of schools with regularity, preferring the color and chaos of the London street scene, through which he would roam, fixing his attention upon the faces he would much later celebrate in paint. At 17, he published his first drawing—a self-portrait—in Cyril Connolly's magazine *Horizon*. At 19, he smuggled aboard a merchant ship, and for five months was on convoy duty. Throughout, he would draw endlessly, and, upon leaving the Merchant Navy, resolved to work full-time as an artist. For some five years, he concentrated on graphics, and it was not until 1945 that he began working seriously with oil paint. Among his first important paintings was the 1945 *Woman with a Daffodil*, a somber and arresting portrait, charged with the tension and psychological penetration that would find even fuller and more cohesive expression in the years to come.

In 1974, the Hayward Gallery in London gave Freud a retrospective exhibition. Here, one could chart the artist's development as an acutely receptive investigator of a relentlessly private vision. The exhibition made clear Freud's adherence to a style that is unique by virtue of its poetic and awkward logic. Nighttime nudes contain a sealed-in, claustrophobic intimacy that suggests a threatening and perverse languor. Several portraits of naked girls, done in the '60s, recall the work of Francis Bacon, minus the stark terror. And yet, the poses and general ambience have that fearful "something" that gives Freud's ouevre its intonation of emotional disarrangement and

paralysis. Even the lush and steely still-lifes have it. Works such as *Buttercups* and *Interior with Plant*, both of 1968, seem possessed and alert to danger.

Finally, however, it is the portraits—the faces of the people he knows—that mark Freud as an artist of uncommon strength and originality. His razor-sharp vision intuits the geography of inner personality, and this geography is mapped by way of terse and compulsive brushwork, and an altogether disquieting approach to composition and color, both of which seem consistently to serve not only as echoes of his subject's inner dislocation, but of his own psychic turmoils as well.

Freud once wrote: "My work is purely autobiographical. It's about myself and my surroundings. It is an attempt at a record. I work from the people that interest me, and that I care about, in rooms that I live in and know. I use the people to invent my pictures with, and I can work more freely when they are there."

Now, as Freud and I stand in his studio, he reiterates these sentiments. "I have to be close to these people. I have to understand them. I must know what they're feeling. It's the only way to get at the essence of their character."

Freud's words are interrupted by a sudden loud knock at the downstairs door. He runs down the stairs, and returns with a telegram. "It's from one of my daughters," he tells me. "She says she's feeling blue, and wants to see me. You see, she's just broken up with her husband. I must go to her."

But, instead of making haste to see his daughter, Freud presently invites me to have a drink with him at a nearby pub. We return to the Rolls, and drive a short distance, before stopping at yet another rundown section of London. We enter what appears to be a laborer's bar.

"I don't really have a neighborhood pub. But this is the one I like." The place is very large, and boasts a billiard table, standing near a spacious rectangular bar. Workmen of all sorts seem to know Freud. There are greetings all around. We sit at the bar, and Freud enters into a brief conversation with a burly house builder. He chats amiably with the bartender, a husky man with friendly eyes. Freud orders absinthe. At the same time, he orders a drink for an old, stooped man sitting at some

distance from us. When the drink is placed before him, the old man looks up, and feebly waves to Freud in silent thanks. Freud seems moderately relaxed as we sit drinking, amidst the clicking of billiard balls.

In this atmosphere of congenial cameraderie, I venture to question Freud about his childhood, his family, his life.

"What kind of boy was I? Well, I had a very conventional childhood in Berlin. Then, around 1929, I became aware of being a Jew. Suddenly, one was an outsider, someone to be hunted down. I rebelled, of course, and became very resentful. I would disappear from home, and let no one know where I was. I was very secretive, and would drive my parents wild. Anyway, in 1932, we came to England. I have two brothers, one younger, one older. The eldest, Stephen, has become conventional to the point of eccentricity. He plays golf, and never does anything out of the ordinary. My younger brother, Clement, has become a very public figure. He's a household word in London. He's a member of the House of Parliament. He lectures. He writes. He's a TV personality. He makes dog-food commercials. Everybody knows who he is. I can't really tolerate him. He's become absurd. My mother says it's all my doing. But I don't see how. Anyway, I never see him.

"I've been married several times. Once, to Jacob Epstein's daughter, another time to a titled girl. I hated the society part of all that. I have several children strewn about. But I only get the pleasure out of them. I take them out, or go to see them. Basically, I'm a loner. I do as I please. My day starts early. I like working in the mornings. Usually, I pick up my mother and see her or paint her. In the afternoons, I wander about. I like walking the streets. I call people from street phones. I see very few people, actually. I have rooms in various places. I don't have one permanent address—no house."

Freud speaks quickly, and in staccato sentences. Though relatively at his ease, an undercurrent of impatience makes itself felt. It is almost as if the very sound of his words grate on him, or, more likely, that the allusions to his private life seem an irritant that renders him uncomfortable. Still, the answers come—and with unusual candor.

"My family has never forgiven me for not attending my

grandfather's funeral. But I found that doing so would have been utterly meaningless to me. I don't carry the burden of being Sigmund Freud's grandson. It is not a weight on me. Of course, I remember him, and I knew him to be always very good, very kind, very modest. He had two children, Anna, and my father, Ernst. Anna Freud has become a most eccentric and strange woman. Freud wanted her to lead a normal life, but she decided to dedicate her life entirely to him. She never married. After her father's death, she became a world famous lecturer and writer on Freud. But she also became a complete recluse—never going out, never seeing a play, a movie, an exhibition. I was told that, as a child, she had strange habits. For example, she would never put on a single garment unless it was first crumpled and crushed by her governess. As she grew older, she became a very harsh and formidable woman. I must say, I never really liked her. She could also be cruel. When my mother married my father, Anna told her that she would find Ernst 'nothing much,' once she got to know him—things like that.

"Now, Anna has become an old woman. She looks very strange, all stooped over, like a hunchback. She has little use for me or my brothers. And I resent her. I remember when I went to art school here in London, she once expressed admiration for a portrait drawing I did. I must have been about 16. I decided to give her the portrait as a gift, but told her that she would have to have it framed, because I hadn't any money at the time. Well, she was unwilling to spend the money on the frame, and never took the drawing. That left its mark, of course. But my memories of my grandfather are very good. He was a gentle man, very full of love for us."

Lucian Freud paused. Then, taking several more sips of absinthe, continued to reflect on his illustrious relative.

"My grandfather always knew that drugs would ultimately help to alleviate psychological problems. But he also knew that the human element would, at times, prevent drugs from being effective. Anyway, when he was still alive, he never realized that his writings and his books would one day be read the world over. When he drew up his will, he stated that if there should ever be any royalties from his writings, they would be divided between his three grandchildren. Well, you can imagine! The

royalties became astronomical, and we, the three grandchildren, receive quite a large income. Naturally, his *own* children—my father, and especially Anna—were furious. Anna felt it was a grave, grave injustice for the grandchildren to receive all that money, particularly since she feels that none of us care a hoot about Freud's writings.

"I must confess that I've not read many of my grandfather's works. I read his *Studies in Hysteria,* which I liked very much, but I've not read much beyond that. I've never been psychoanalyzed myself. I'm very wary of it."

Turning to his life as an artist, Freud claims that he is as much of a loner among his fellow artists as with people in general. "If I *have* a best friend, it must be Francis . . . Francis Bacon. I've known him a very long time. We went to school together. Of course, he has a very different personality. He is very gregarious, and can do things I could never do. He is a less private person. Back in the '50s I did what I think is a rather successful portrait of him. Actually, I don't see much of Bacon these days. You see, I don't see much of anyone. If I see anyone, it's the people I paint."

Freud finishes his absinthe. He rises, pays for the drinks, and makes brief farewells to his pub acquaintances. "I suppose I'd better go and see my daughter. She'll need some comforting. Come along . . . I'll drop you at your flat."

Back in the Rolls, Lucian Freud drives in silence. Indeed, the artist seems to have fallen into a long revery that emphatically excludes the stranger next to him. At my door Freud stops the car. My departing "thank yous" draw no response. He merely stares at me, then drives away.

1977

Also Available from a cappella books:

DANCE CLASSICS
**A Viewer's Guide to the Best-Loved Ballets
and Modern Dances**
Nancy Reynolds and Susan Reimer-Torn
paper, $14.95 ISBN 1-55652-106-5
cloth, $29.95 ISBN 1-55652-109-X

MARTHA GRAHAM
The Evolution of her Dance Theory and Training
Compiled by Marian Horosko
paper, $14.95 ISBN 1-55652-141-3
cloth, $29.95 ISBN 1-55652-142-1

THE NEW BOHEMIA
John Gruen
paper, $11.95 ISBN 1-55652-097-2

QUINTERO DIRECTS O'NEILL
Edwin J. McDonough
cloth, $29.95 ISBN 1-55652-105-7

prices subject to change—please confirm when ordering
To order toll-free, call 1-800-888-4741